Lives of — The Great Photographers

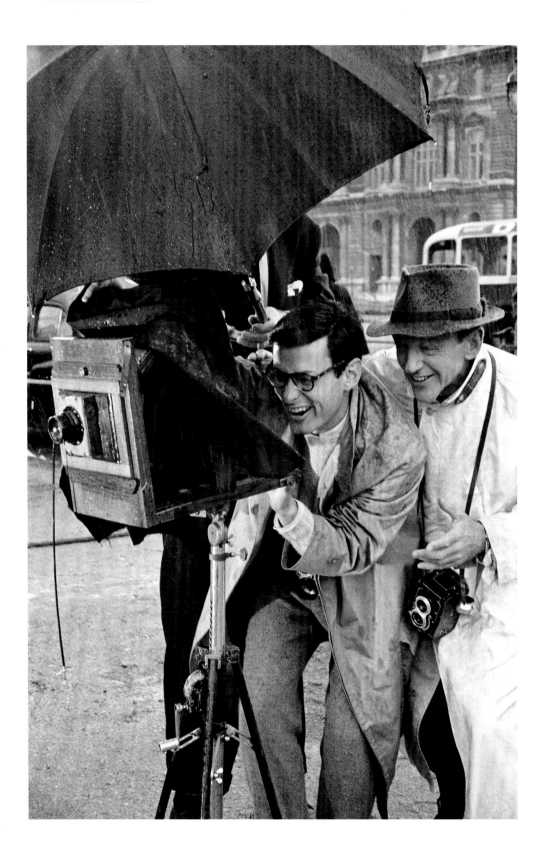

Lives of — The Great Photographers

by Juliet Hacking

Thames & Hudson

Contents

Introduction

I t could be said that art history in the West began with biography: for his *Lives of the Most Eminent Painters, Sculptors and Architects* (1550), Giorgio Vasari has been identified as the first historian of Western art. Vasari's lives are moralized tales of personal artistic evolution, with Michelangelo Buonarroti, as heroic as he is original, identified as the greatest artist of the Italian Renaissance. Across the romantic and modernist periods, the idea of the artist-hero evolved into that of the solitary genius on a personal quest for self-expression, a lone figure who was increasingly at war with both aesthetic and societal convention. As traditional models of patronage declined and artists became ever more reliant on the art market, it was the penniless, rather than the successful, artist who came to be celebrated. In the twentieth century, artistic biography (including literary) was steadily transformed into the psycho-biography of the tortured genius, as exemplified by Vincent Van Gogh. By the 1980s this modernist approach was underpinning blockbuster exhibitions and multimillion-dollar auction sales. Biography was both an exemplary tale of personal and artistic struggle and an important resource for decoding the possible meanings of the (increasingly abstracted) work of art.

In the last quarter of the twentieth century, a period marked by the postmodernist turn in cultural theory, it became more and more difficult to ignore the fact that the artists who had been canonized by art history as old or modern masters constituted a very narrow demographic: almost all of them, to modify the standard phrase, were 'dead white heterosexual males'. Feminist art practice and scholarship led the way in claiming ground for previously marginalized subjectivities, including those of women, black, ethnic-minority and LGBT (lesbian, gay, bisexual and transgender) artists, whose imagery, materials and working practices did not always conform to the modernist model. Photography, long identified with both reproduction and popular culture, was newly invigorated as a medium that could offer a critique of the key terms of modernism, such as originality, uniqueness and authenticity. Identity was now performed in front of the camera, often in series and sequences, the act of repetition arguing for selfhood to

be understood as shifting and multiple. Artistic inspiration was no longer to be found only in the psyche but also in both high and low art, as well as in the wider culture, society and politics. Biography, with its emphasis on interiority and singularity, was pushed to the margins.

All the artists included in this volume, whether born in the nineteenth or the twentieth century, used photography to give form and substance to their subjectivity. Those who lived and died before Freudian ideas became widespread were no less conflicted than those who came later. The potent challenges to the Christian world view that emerged in the nineteenth century reverberated psychically even for those who did not lose their faith, such as the Reverend Charles Lutwidge Dodgson (better known by his pseudonym, 'Lewis Carroll'). We can see Dodgson's extensive practice of photography as one of a number of activities – his voluminous letter-writing and meticulous keeping of a diary among them – that allowed him to advance his desires and quell his anxieties. Edward Weston's diaries (known as his 'daybooks'), written in the next century, appear at first glance to be the key by which to unlock the meanings of his photographs, and yet we now know that these seemingly private outpourings were subject to rewriting, editing by others and even publication. Both Dodgson and Weston were, in their pictures and their writings, negotiating lived experience and their responses to it by reference to the convention, first Christian and then psychoanalytic, of life as a spiritual journey.

In the early twentieth century, the wish to conceptualize modernity in positive terms, and yet also to express a disdain for its soulless manifestations, led to not a rejection but a reworking of philosophic conventions. Alfred Stieglitz, the presiding genius of American photography, conceived of 'the Idea',[1] a romantic concept that raised a commitment to Art to the level of a secular spiritual cause. At the same time, he was exemplary in his commitment to (his own version of) self-analysis. Romanticism was also central to the philosophical outlooks of August Sander and Albert Renger-Patzsch, both of whom are, generally, uniquely identified with the modern.

The many parallels to be found between the lives chronicled here are much more pronounced among those who lived in the twentieth century. This is undoubtedly because it was much easier by then to make a living from photography. For those who had aspirations to make art with a camera, the obvious way to support themselves

was to simultaneously seek commercial work. Unlike now, however, photography did not have a secure position in the art world. Those who were attracted to photography for reasons of creative fulfilment or economic need, or both, were often troubled by its low social and cultural status: Man Ray, for example, chose to identify all the commercial aspects of his artistic practice with his photographic one, in order to present Man Ray the artist as living for art alone.

As hard to divine as the commercial imperatives at stake in the art practice of the great photographers of the last century is the extent of their entanglement with left-wing politics. Determining the depth of the subject's commitment to communism and/or the cause of fighting fascism is difficult because, first of all, left-wing views were de rigueur in the Western art world of the 1930s, and, secondly, in the 1950s those who had escaped fascism in Europe by emigrating to the United States found themselves at risk of being denounced as communists. Moreover, the very terms of the enquiry (i.e. were they or weren't they a communist?) may to some degree be wrongheaded. The example of Paul Strand is cautionary in this regard: that he was politically committed was never lost to art history, but even today the precise shading of his left-wing views is still subject to debate.

The desires at work in fashioning one's self-image in letters, diaries and autobiographies, and the impulse to present one's self differently to different interlocutors, means that we do not have, for example, one Brassaï but two. The man we think of when we use this name appears in his writings in two incarnations: 'Gyula Halász', as he was born, and 'Brassaï', his public persona. If the projections of self could be multiple, the public persona was often one dimensional: a number of the figures presented here became prisoners of their own reputation. Richard Avedon's series 'In the American West' (1979–84), now acknowledged as one of the most significant portrait projects (photographic or otherwise) of the twentieth century, was greeted with hostility by an East Coast press that could not see sincerity and purpose in the work of a celebrity photographer.

In order to narrow down around 180 years of photographic image-making – which, in the case of Henri Cartier-Bresson, amounted to the creation of more than half a million negatives in just one lifetime – to less than forty names, the biographies presented here are of those who have passed into posterity. The thirty-eight individuals documented

in these pages all created extraordinary imagery by means of photography. Yet they are by no means the only great photographers who have ever lived. This book is a product of an English-speaking photo-historical tradition that privileges England, France and the United States; given that caveat there are still, however, some noteworthy omissions. The book does not include, for example, William Henry Fox Talbot or Louis-Jacques-Mandé Daguerre – the best known of the rival claimants to the title of the inventor of photography – nor such early artists in photography as Oscar Rejlander, Henry Peach Robinson or the partnership of David Octavius Hill and Robert Adamson. Among twentieth-century names, the absence of Alvin Langdon Coburn, Lewis Hine and Garry Winogrand may be queried. Some of these individuals were not included on the basis that they are the subject of new or current research projects, others to ensure a greater balance as regards nationality and gender. Nonetheless, the United States is better represented here than other countries, and the reader will not find entries for, among other famous female photographers, Berenice Abbott, Lisette Model and Dorothea Lange. It is, of course, impossible to be comprehensive.

These lives are based on the secondary literature on the subjects, as well as the published primary sources, and not on original research: to investigate just one life in this way might take the biographer, to use the example of Walker Evans, up to five years.[2] Although abbreviated in length, the essays are not dry chronologies. There are very few irrefutable biographical facts, dates included, and such primary sources as letters, diaries and autobiographies are not windows into the soul but crafted projections of the self. In the writing of biography (and of art history), nearly all is interpretation; as such, I have felt free, at times, to offer my own.

The intention of this volume is to remind the reader of some of the pleasures and virtues of biography in relation to art history: not only its accessibility and interest, but also its role as a corrective to the current fashion for chronologies (with their putative factual nature). Hopefully, the essays will help to counter the prevailing idea that biography is anti-intellectual. While the classical aphorism *ars longa, vita brevis* (art is long, life is short) still resonates, we are now inclined to see an artist's life and work not in opposition to each other, but as two arenas in which they create compelling forms. ■

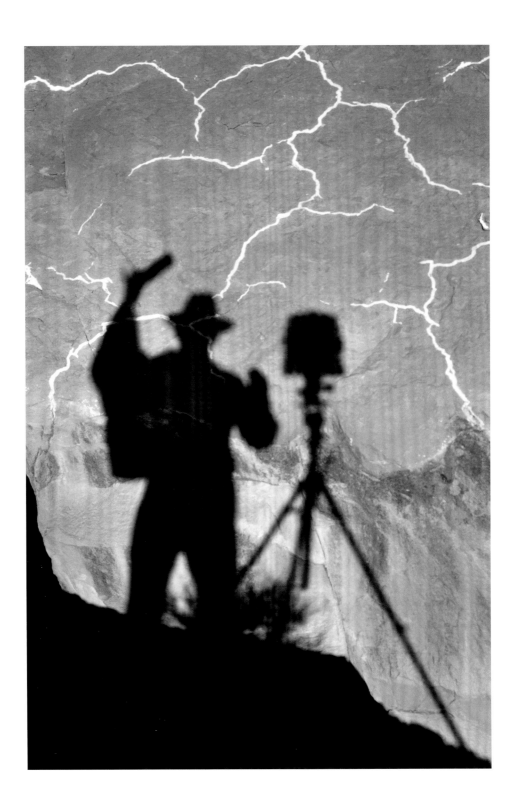

Self-Portrait, Monument Valley, 1958

Ansel *Adams*

1902–1984

*The beauty of the world results in a constant vibration of
the spirit: the Shapes of nature – through the magic of art –
become the Forms of the imagination.*

ANSEL ADAMS

Ansel Adams may have done more for photography than any other photographer. His images of dramatic natural beauty – printed with a bravura technical virtuosity – introduced many to the idea that photography could be an expressive medium. He was a tireless advocate of creative photography, of the redeeming power of nature and of the need to preserve its untamed forms. Towards the end of his life he was celebrated as an American figurehead: his photography had become a new art for a new country. Scholars have linked Adams's pantheistic (or, as it is sometimes called, 'monistic') view of nature to that of the writers he admired, such as Walt Whitman, Edward Carpenter and William James. An agnostic from childhood, Adams was drawn to those who expressed themselves in a revelatory manner, while he himself was unable to refrain from the occasional bout of sermonizing. His legendary 'Zone System' offered the photographer a more extensive and thus expressive monochromatic palette. Adams wrote in his autobiography that his 'childhood was very much the father to the man I became',[1] and indeed almost every aspect of his later life appears to have been determined by the time he was thirty. It also seems that he was only able to sustain the high ideals of his upbringing by assuming, both metaphorically and literally, a lofty position.

In the year following Ansel's birth, his parents, Charles Hitchcock Adams and Olive Adams (née Bray), moved into the house that Charles had been building near San Francisco. Adams's childhood was marked by long, solitary rambles along the local shore and regular spells in bed owing to his predisposition to illness. He said of his childhood, 'My mental state [was] precarious', concluding that 'today I would be labelled hyperactive', but evidence suggests that his high energy levels, and occasional low moods, continued into

adulthood.[2] Illness was, in effect, responsible for Adams's interest in both photography and the depiction of the natural world. Suffering from the measles at the age of twelve, he was confined to bed with the shade drawn. There, he discovered that 'the spaces between the shade and the top of the windows ... served as crude pinholes', projecting vague images of the outside world on to the ceiling.[3] His father explained the phenomenon by turning his Kodak Bulls-Eye camera into a camera obscura.

Adams was riled by the suggestion, made by <u>Alfred Stieglitz</u>, that what he needed was some suffering in his life.[4] And yet, in his autobiography, he recalled that his 'closest experience with profound human suffering' was the San Francisco earthquake of 1906, which cost his family little more than minor structural damage to their home and him, a young child, a broken nose.[5] In fact, although he was largely shielded from the details at the time, a form of tragedy did befall his family: the collapse of his father's chemical business. According to Adams, his father was betrayed by his partners – Ansel Easton, his brother-in-law, and George Wright, his friend and attorney. This, Adams believed, was the cause of his father's decline into social and financial embarrassment and his mother's withdrawal into bitterness and depression. Charles Adams tried to make a living by exploiting other business ideas but eventually conceded defeat, becoming, among other things, an insurance salesman and an office manager.

Ansel Adams was a much-loved only child, and the family correspondence that survives suggests that everything was done to ensure that he lived the life his mother and father had wanted for him. In turn, he developed a strong need to please his parents. His mother played the piano, and in around 1914 Adams began to show an interest in the instrument. He claimed in his autobiography that the experience of learning scales finally installed in him a sense of discipline.[6] The fact that he saw his erratic schooling (and his graduation with an eighth-grade diploma) as the result of his inability to apply himself, and not owing to his parents' problems, may be evidence that the excuse of a delicate child was used to avoid facing financial and social embarrassment. Adams decided he would become a concert pianist, and in 1923 purchased a Mason & Hamlin grand piano at a cost of $6,700. The down payment came from the sale of a piece of land given to him by his Uncle Ansel. That the instalments were met when his father was

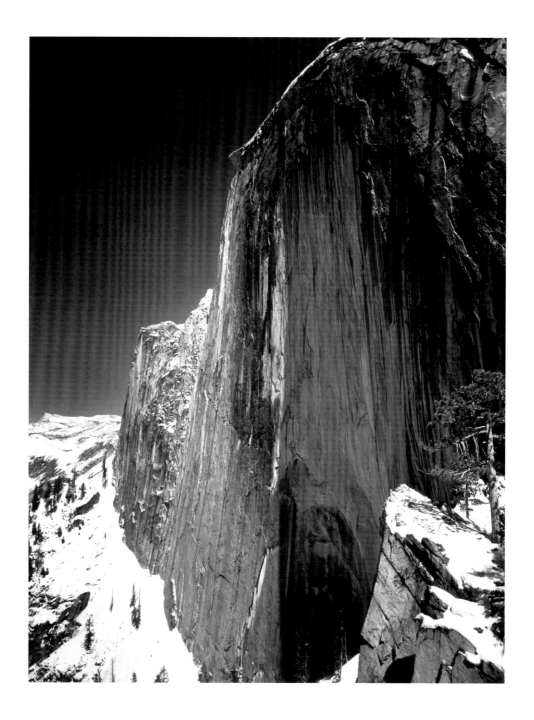

Monolith, the Face of Half Dome, Yosemite National Park, 1927

struggling to support his family suggests quite how important it was to the Adamses that their son maintain both his lofty goals and his ignorance of hard financial reality.

According to Adams, it was a book on the High Sierra, loaned to him by his Aunt Mary in early 1916, that led to his insistence that the family vacation planned for that year be to Yosemite National Park.[7] The splendour of the Californian wilderness was to be mediated by photography: shortly after their arrival in Yosemite, Adams was given his first camera, a Kodak Box Brownie. The financial troubles experienced by his father the following year were put to one side so that there could be another family holiday to the park.[8] In around 1918 Adams was working part-time at a photo-finishing service near his suburban San Francisco home; in the summer of that year he made his first visit to Yosemite alone. Not only was he starting to distance himself from his family and the material world of the city, but also he was beginning to convince both himself and others that Yosemite was essential to his physical, emotional and spiritual development.[9]

In 1919 Adams joined the Sierra Club, the environmental organization with which he would be involved for the rest of his life. It was Adams's membership of the club that fostered his growing interest in photography, and by the summer of 1920 he was taking his large-format Graflex camera on the shorter club trips into the high country, developing and printing his negatives in Yosemite, and making albums of photographs that commemorated the dramatic scenery. It was also through the Sierra Club that he became friends with Cedric Wright, a violinist and amateur photographer – and the son of his father's former business partner. Together, Adams and Wright mediated their experiences of the American wilderness through the texts they were reading and the photographs they were taking. Adams, significantly, began to realize that it might be possible to make photography pay: in 1928, on a club trip to the Canadian Rockies, he had his expenses met in return for acting as official photographer.

Adams's letters from the first half of the 1920s, as well as his later account of the period, present him as torn between his planned career as a concert pianist and his newfound love of the wilderness. This dilemma, and the desire to sell his photographs, led him to the studio of Harry Cassie Best, a piano-owning landscape artist who had

found a market for his paintings of Yosemite. Best, a widower, had a seventeen-year-old daughter, Virginia, and she and Adams soon became engaged. Faced with the demands of parental expectation, looming marital responsibilities and the desire to live for art and nature alone, Adams became even more grandiloquent in his mode of expression. Writing to Virginia in September 1925, he said: 'The world distracts me from my purpose; I know I am not understood.'[10] When the realities of life got too close for comfort, Adams responded by occupying the metaphorical high ground.

The second half of the 1920s was the most intense period of Adams's life. Cedric Wright introduced Adams to Albert M. Bender, a partner in an insurance firm and a committed patron of the arts. Bender, in turn, introduced Adams to the San Francisco cultural scene and, in 1926, enabled him to publish a portfolio of his photographs. *Parmelian Prints of the High Sierras* (*sic*; 1927) was the prototype of the limited-edition portfolios that Adams would begin to issue in 1948. In 1927 Adams and Bender travelled to Santa Fe, New Mexico, to visit the writer Mary Hunter Austin. This, and at least one subsequent visit

Tom Kobayashi, landscape, south fields, Manzanar Relocation Center, 1943

to the region, resulted in *Taos Pueblo* (1930), a collaboration between Austin and Adams. It was on a visit to the region to finalize the book that Adams encountered Paul Strand, who showed Adams some of his negatives. This meeting, according to Adams, was an epiphany: his 'destiny' was now photography, not music.[11] Adams's mother and aunt appealed to him not to give up the piano, declaring that 'The camera cannot express the human soul!'[12] His response was to spend the rest of his life proving them wrong.

By 1930 Adams had already developed the basis of what would become his distinctive photographic style. Some three years earlier, on 17 April 1927 during a trip to Yosemite, he had experienced a moment of inspiration. While endeavouring to work out how to convey in a photographic print what he felt in the presence of Half Dome, an enormous granite dome at the eastern end of Yosemite Valley, it occurred to him to use a red filter, which, in the resulting print, would produce a darkened sky. 'I had achieved my first true visualization!' he would subsequently declare.[13] 'Visualization', or, as he later called it, 'pre-visualization', became one of the two central tenets of his aesthetic creed. The other was the Zone System: 'the pre-visualized photograph is rendered in terms of the final print by a series of processes particular to the medium.'[14] Drawing on his musical background, he said: 'The negative is the score, and the print is the performance.'[15]

Three photographers in particular exerted considerable influence over Adams: Strand, Stieglitz and Edward Weston. By 1930 Weston, whom Adams had met through Bender, was part of a coterie of West Coast photographers – among them Imogen Cunningham, Henry Swift and John Paul Edwards – who were increasingly rejecting pictorialism in favour of a 'straight' aesthetic. Adams, who would become a pivotal member of the group, attributed to himself the invention of its name: f/64.[16] After writing an article on the 'new photography' for the London-based annual *Modern Photography*, Adams was commissioned by the publishers to write *Making a Photograph: An Introduction to Photography* (1935), with a foreword by Weston. Exhibitions and other articles followed. In 1933 Adams and Virginia travelled to New York so he could show his work to Stieglitz. The meeting clearly made an impression on Adams: 'I would not believe before I met him', he wrote to Strand, 'that a man could be so psychically and emotionally powerful.'[17] Three years later, Stieglitz gave Adams a solo show.

To characterize Adams as a landscape photographer is to ignore the commercial practice close to the city that enabled him to escape to Yosemite. In February 1941, in a letter to the influential patron of photography David McAlpin III, he wrote that, in the last decade or so, 'I have done advertising, Commercial, Portrait, Architectural, Illustrative, Reproductions of works of art, Photo-Micrographs … an Eclipse of the sun, color photography, landscape, naturalistic details, cities, people, animals, clouds, news, nostalgics.'[18] To this we might add his work on assignment for *Life* and *Fortune* magazines, both of which are usually associated with the socially engaged photographers, such as Dorothea Lange, with whom he is generally contrasted. That Adams could be socially engaged is demonstrated by his photographs of life inside Manzanar – a Second World War internment camp in central California for Japanese-Americans – published as *Born Free and Equal* (1944). He was passionate about raising his country-men's awareness of the danger of succumbing to the 'race hate' that motivated the enemy.[19]

To focus on Adams's early life is not to endorse the view, promoted by the curator John Szarkowski, that Adams was an anti-intellectual who did his best work in his first twenty years as a photographer and then spent the rest of his life repeating himself.[20] The photography historian Anne Hammond's reading of Adams restores to him the idealism and intellectualism of his youth and twenties, and, crucially, their mature expressions.[21] The recognition of Adams's philosophical approach to photography should not, however, eclipse the psychological dimension. As a youth he appears to have been driven by the need to please his parents at a time when he sensed, but was protected from, their unhappiness. Unable to recognize his own unhappiness, he identified the High Sierra as a place where a delicate youth could thrive. Away from the miseries of the material world, he was able to shine physically and artistically, turning reality – through the magic of art – into pseudo-religious and spiritual forms. To note that he was partial to bourbon, and to repeat his story that once, while drunk, he played the piano with his 'derriere', is not to undermine him as a man of high ideals.[22] Rather, it serves to suggest that while his working practices and coping strategies were in place by 1930, he did in fact continue to grow emotionally – eventually becoming secure enough to reveal that he did not always take the high ground. ∎

Photographer unknown, *Portrait of Manuel Álvarez Bravo*, 1980s

Manuel *Álvarez Bravo*

1902–2002

There is time. There is time.

MANUEL ÁLVAREZ BRAVO

Manuel Álvarez Bravo's *œuvre* is conventionally examined in relation to those North American and European photographers with whose work his own displays strong affinities, such as <u>Edward Weston</u>, <u>Eugène Atget</u> and <u>André Kertész</u>. Recent scholarship on Álvarez Bravo has sought to address this Western bias by stressing his engagement with contemporary Mexican culture. While he was closely associated with the Mexican artistic revolution of the 1920s and 1930s, through such figures as Diego Rivera and Frida Kahlo, his art was not designed to serve a nationalist project; indeed, at one stage he chose to embrace the surrealism of André Breton. The suggestion that Álvarez Bravo's subject matter is 'Mexico' is a function of his being, for a long time, the only Mexican photographer celebrated in English-language accounts of twentieth-century photography. Most recently, previously unseen material has led to a reappraisal not only of his intellectual and aesthetic influences but also of the significance of his involvement with film. Further biographical details have come to light, some of which contradict the standard account of his life and work. Nonetheless, the possible links between the meanings of his poetically titled photographs and his personal life are not clear. Described as 'verbal arrows, flaming signs', his titles direct the viewer to the correspondences between the specific and the universal.[1] Álvarez Bravo's photographs have been likened to dreams, visions and metaphors,[2] yet the personal dreams, visions and metaphors that inspired his images remain, in common with the precise dates of his negatives, elusive.

The fifth child of eight, Álvarez Bravo grew up in Mexico City. Despite his father being a head teacher, he received formal schooling only until he was thirteen, later identifying himself as an autodidact.[3] 'I was so shy', he said of himself, 'it bordered on psychosis. I read from the time I was a little boy; that is how I came to know the world.'[4] As a

young man he spent time in flea markets and bookshops, buying old photographs and second-hand books by, among others, Cervantes, Freud and Voltaire. When the Mexican Revolution broke out in 1910, Álvarez Bravo was attending the Patricio Saénz boarding school in Tlalpan. He recalled that classes were sometimes disrupted and that he and his friends would come across dead bodies on their walk to and from school.[5] It has been suggested that these experiences 'fostered his distaste for political causes', but it could also be argued that when Álvarez Bravo encountered the world, he did so through the filter of art and literature.[6] His maternal grandfather was a portraitist, and his father was an amateur painter, playwright and photographer. As a boy, Álvarez Bravo, 'interested since always in art',[7] would frequent two museums close to the family home: the Anthropology and History Museum, and the San Carlos Museum. The former specialized in pre-Hispanic artefacts, the latter in European art, and one could say that he dedicated his artistic life to creating a synthesis of the two cultures.

For the first fifteen years of his working life Álvarez Bravo culti-vated his love of art, music and photography in his spare time. Aged fourteen he became an accountant in the Ministry of Finance. In the following year, 1917, he attended night classes in literature and music at the Academia de San Carlos. He also studied painting. In the early to mid-1920s he had access to both Spanish and English-language pho-tography journals, and was working in a pictorialist style, eschewing the modern. His main influence during this period was the German-born Hugo Brehme, then the leading photographer in Mexico. Just how closely Álvarez Bravo modelled his photography on that of Brehme we will never know: he would later renounce pictorialism and destroy the photographs he had made under its influence. 'Picasso and his cubism', he explained, 'offered me another type of reality.'[8]

Álvarez Bravo's conversion to modernism in the mid-1920s drew on the diverse strands of his cultural education. On the one hand, it is evidence of his increasing engagement with the contemporary cul-tural scene in Mexico City. It also relates, according to Roberto Tejada, to 'the turn to Mexico [that] can be viewed as forming an important piece in the assemblage of European and American cultural moder-nity'.[9] This fascination with Mexico saw Edward Weston, in 1923, leave behind his domestic responsibilities and move to Mexico City with his lover, Tina Modotti. Álvarez Bravo saw an exhibition

Parábola óptica (Optical Parable), 1930–4

of Weston's photographs as early as 1923 but did not meet Weston himself. He did, however, become friends with Modotti after he and his first wife, Dolores 'Lola' Martinez de Anda, returned to the capital city in 1927 after a year in Oaxaca occasioned by his ministerial work. In 1928 some of his photographs, together with works by Weston and Modotti, were included in the First Mexican Salon of Photography at the Galería de Arte Moderno del Teatro Nacional, Mexico City (now the Palacio de Bellas Artes). A year later the three were represented again in an exhibition in California. Despite these connections, Álvarez Bravo's photography from this period was closest in style and spirit to that of the German Neue Sachlichkeit (New Objectivity) photographer <u>Albert Renger-Patzsch</u>.

At the beginning of the 1930s Álvarez Bravo's working and artistic life became more integrated. He resigned his job at the Ministry of Finance in 1931 and began to earn part of his living from making photographic records for other government departments and institutions. From 1929 to 1930 he taught photography at the Academia de San Carlos, and did so again from 1938 to 1940, when Diego Rivera was director. In 1930, when Modotti was deported from Mexico for her political activities, he took over her job taking photographs for the journal *Mexican Folkways*. In 1931 Álvarez Bravo and Lola, by now a photographer in her own right, opened an informal gallery in their home in the Tacubaya area of Mexico City, where they exhibited work by, among others, Rivera, David Alfaro Siqueiros and José Clemente Orozco. Beginning in 1935 Álvarez Bravo would work over many years to provide the illustrations to Emily Edwards's *Painted Walls of Mexico: From Prehistoric Times until Today* (1966). Such activities and connections are undoubtedly responsible, in part at least, for the identification of his art as a form of 'Mexicanism'. One must also consider, however, Siqueiros's attack on Álvarez Bravo, in an article of 1945, for what he saw as his apolitical and pseudo-intellectual attraction to European surrealism.

Somewhere towards the end of the 1920s and the beginning of the 1930s, Álvarez Bravo became what would later be called a 'street photographer'. Some scholars frame this in relation to his discovery of Eugène Atget, to whom he freely acknowledged his artistic debt; consider, for example, his Atget-like shop-window photographs, including his best-known work, *Parábola óptica* (Optical Parable; 1930-4). Then

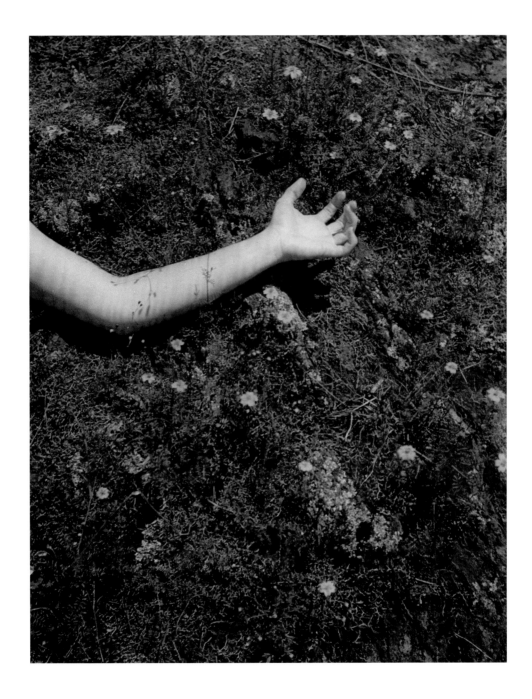

Brazo con margaritas (Arm with Daisies), *c.* 1940

living at 20 Calle de Guatemala, Álvarez Bravo later said, 'I am happy to have lived in those streets. There everything was food for my camera, everything had an inherent social content.'[10] The question as to whether he was a surrealist or a socially concerned artist was addressed by the photographer in 1984: 'The works that represent unmediated reality … are just as invented, just as created … one comes from the outside and the other originates within himself.'[11] *Parábola óptica* was included in Álvarez Bravo's joint exhibition with Henri Cartier-Bresson at the Palacio de Bellas Artes in March 1935. Despite the similarities between the two men's photographs of the period, it is important to note that Álvarez Bravo rejected the use of such hand-held cameras as the Leica in favour of a Graflex mounted on a tripod.

André Breton called Álvarez Bravo a 'natural surrealist'.[12] The two men met each other in 1938 at Diego Rivera's house in Mexico City. The following year Breton wrote about Álvarez Bravo's photographs in the last issue of the surrealist journal *Minotaure*, and selected his work for inclusion in the exhibition 'Mexique' at the Galerie Renou et Colle in Paris. It was probably in 1938 that, according to anecdote, Álvarez Bravo received a phone call from a Spanish-speaking intermediary asking him on Breton's behalf to supply an image for the cover of the catalogue to the forthcoming 'International Surrealist Exhibition' at Inés Amor's Galería de Arte Mexicano in Mexico City. Álvarez Bravo got to work immediately, setting up a shoot on the roof of the Academia de San Carlos, and creating the image *The Good Reputation Sleeping* (1938–9), which featured a partially nude model. Owing to issues of censorship, however, he had to supply an alternative image for the cover. Siqueiros's view, that this photograph was an aberration on behalf of Álvarez Bravo, fails to acknowledge the centrality of the nude to his practice of making poetic images in response to both interior and exterior stimuli.

Álvarez Bravo was a founder member of the Cine Club Mexicano, which promoted national and international experimental film-making. His application to become a film cameraman was resisted by the union and he worked instead, from around 1945 to 1960, as a stills photographer producing publicity images for films; the first and only full-length film he made himself, *Tehuantepec* (1933), is now lost. In 1945 he was one of the founder members of the film company Coatlicue, which made José Revueltas's *How Great Will the Darkness*

Be? (1945), the look of which is known only from Álvarez Bravo's stills. He was assisted on set by Doris Heyden, an American scholar of pre-Columbian Mesoamerican culture whom he had married in 1942. Recent research has revealed that, from the 1950s to the 1970s, he made his own amateur films on 8 mm and Super 8, some of which feature his third wife, Colette Álvarez Urbajtel, whom he married in 1962, and their two daughters. It has been suggested that Álvarez Bravo, who said 'cinema equals photography plus movement',[13] intended 'to narrate solely through images'.[14]

The idea of Álvarez Bravo as a Mexican modernist in mono-chrome is complicated by the fact that he also worked in colour, first in autochrome in the 1920s and then for a short phase, beginning in 1938, in dye-transfer. Such works as *Brazo con margaritas* (Arm with Daisies; *c.* 1940) are not colourized versions of his better-known images but instead fully exploit the possibilities of colour for their own sake. As early as 1928 he was printing in platinum, imparting to his negatives a completely different register from that of the high-contrast silver gelatin prints favoured by the majority of his modernist contemporaries. The fact that he returned to working in colour and printing in platinum in the 1960s and 1970s respectively suggests he only gave them up because of their relative expense. The foundation in 2005 of the Asociacion Manuel Álvarez Bravo by his daughter Aurelia (from his third marriage) has shifted the emphasis of scholarship towards a more integrated view of his work that embraces both colour photography and film.

It is a commonplace to assert that Álvarez Bravo was 'the father of Mexican photography'.[15] But to see him in these terms is to overlook what has been called his 'search for synthesis'.[16] His photographs 'have been identified as surrealist, political, or humanist', whereas they were surrealist, political *and* humanist.[17] One scholar has argued that the 'complexity and local Mexican iconography often make [Álvarez Bravo's photography] hermetic, inaccessible and incomprehensible to the foreigner. Álvarez Bravo himself regrets this purely local aspect of his work, and has sometimes wished it more universal, or at least more generally Latin American.'[18] Did Álvarez Bravo really regret his insularity? Or was he simply aware of the difficulties of the task he had set himself: that of making the specifics of his visual world into 'flaming signs' that pointed to the universal. ∎

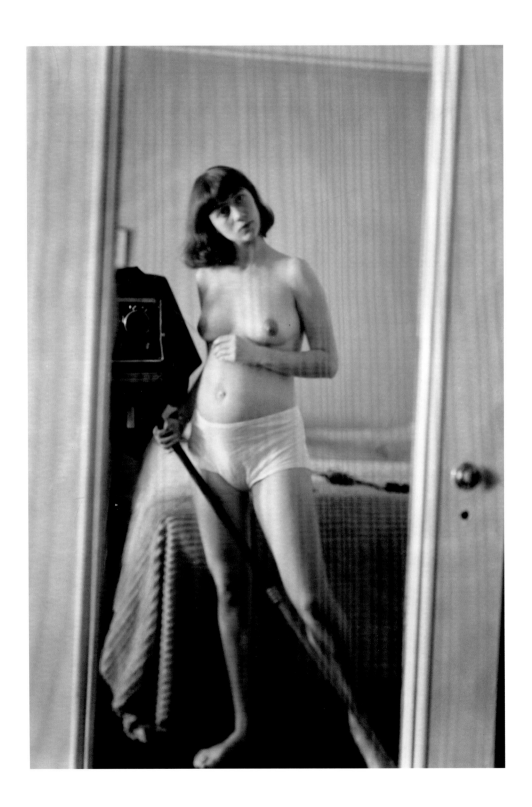

Self-portrait, pregnant, N.Y.C. 1945

Diane *Arbus*

1923–1971

*For me the subject of the picture is always more important
than the picture. And more complicated.*

DIANE ARBUS

Diane (pronounced 'dee-ann') Arbus is an elusive subject for the biog-
rapher. This is not because of a dearth of evidence: in 2003 a major
travelling exhibition, 'Diane Arbus Revelations', and an accompanying
book of the same name, put together by the Arbus estate and published
by Random House, gave new insights into both her working and her
personal life. The publication, with its 103-page chronology of the
life of Arbus (substantively composed of excerpts from her own writ-
ings), challenged the characterizations of the photographer that had
gained a hold on the public's imagination, such as the cold-hearted
voyeur of Susan Sontag's essay 'Freak Show' (1973), the manipula-
tive choreographer of Germaine Greer's account of sitting to Arbus
(in 1971), and the increasingly out-of-control thrill-seeker of Patricia
Bosworth's biography (1985). All of these accounts infer that Arbus's
interest in photographing 'freaks', and the lack of sentimentality that
is a hallmark of her art, are evidence that she too was a misfit. The
Arbus of these portrayals is very different from the figure who emerges
from her self-aware, humorous and eloquent writings, and from the
recollections of friends who remembered her personal magnetism and
warmth. Arbus's insatiable curiosity about others was, for some, not
intrusive but enchanting, and her lack of sentimentality can equally be
read as a symptom of her intellectualism. Indeed, it might be said that,
if anything, she had too much rather than too little empathy.

The various accounts that Arbus and her two siblings, Howard and
Renée, gave of their childhood paint a picture of their upbringing as
circumscribed by the upwardly mobile aspirations of their parents.
Their mother, Gertrude Russek, was the daughter of a Polish immi-
grant who had become a successful fur retailer. Their father, David
Nemerov, the son of Ukrainian immigrants, was a window dresser
at the store owned by Gertrude's family, the furrier Russeks, and is

credited with developing the business into a fashion emporium. Arbus would, in 1960, write to the painter, graphic designer and art director Marvin Israel (her lover for many years), whose childhood was uncannily similar to hers (his family, also Jewish, owned a chain of department stores), saying, 'Our bourgeois heritage seems to me glorious as any stigma, especially to see it reflected back and forth in the mirror of each other ... It is magic, and magic chooses any guise and ours is just perhaps more hilarious than to have been Negro or midget.'[1] Arbus would also become a close friend of Richard Avedon, whose background also bore striking similarities to hers.

Family photographs show Diane, the unusual pronunciation of whose name was, according to one biographer, derived from a character in a Broadway show,[2] to have been a very pretty child. According to her own account, she was brought up until the age of seven by her – rather severe – French governess,[3] with whom she spoke French.[4] At the age of five Arbus, like her brother before her, was enrolled at the Ethical Culture School, a progressive private elementary school on Central Park West. A visit to Central Park during the Depression brought Arbus and her governess close to the shanty town that had been erected in a drained reservoir. Arbus recalled this encounter with a potent visual image: a cosseted child observing 'the other side of the railroad tracks' while 'holding the hand of one's governess'.[5] Arbus, who recalled being 'terribly shy' as a child,[6] spoke of feeling oppressed by her position as, to use her own satirical assessment, 'the princess of Russeks',[7] as she sensed the mockery behind the staff's obsequiousness. Although it has been said that the Depression encroached very little on the Nemerovs,[8] it is perhaps worthy of note that when the family moved into a new apartment in 1932 (the third such move since Diane's birth), Gertrude's parents moved in with them soon after.

In 1934 Arbus was enrolled at Fieldston, the Ethical Culture School's Bronx-based senior school; she later recalled that she 'was always considered the most daring but I am sure I was more afraid than the others'.[9] Her family encouraged her to think of herself as a talented artist, a calling that she felt was imposed on her.[10] At the age of thirteen she met Allan Arbus; five years her senior, he was the nephew of David Nemerov's business partner and was working in the advertising department at Russeks. They met weekly, going for walks in Central Park and visiting exhibitions at the Museum of

Modern Art (MoMA), including 'Photography 1839–1937' (1937) and 'Walker Evans: American Photographs' (1938). In 1938 Arbus attended Cummington, a summer school for the arts in Massachusetts, and, the following year, chose art as her major for her senior year at Fieldston. Also in her senior year she was selected for the advanced-level English seminar taught by Elbert Lenrow of the New School, and on graduation took private painting classes arranged for her by her father. Her own writings, even such brief jottings as the postcard she wrote to Israel, quoted above, reveal her delight in the written word.

Diane and Allan were married on 10 April 1941, a month after Diane's eighteenth birthday, and spent their honeymoon on a farm in upstate New York. The marriage was announced in the *New York Times*. Sometime later that year, Diane received from her husband a Graflex 2¼ × 3¼-in. camera, and she in turn taught Allan what she had learned about photography at a class given by Berenice Abbott. A series of fashion photographs taken by Allan in 1941, using Diane as a model, is said to have inspired her father to hire the pair to make images for Russeks' newspaper advertisements.[11] After enlisting in the army in 1942, Allan did his basic training in Missouri and was then transferred to Fort Monmouth, New Jersey, where he was joined by his wife. When he was reassigned to the photography division of the Signal Corps, the couple moved back to Manhattan, to a rented apartment on the East Side.

In 1944 Allan was posted overseas, and Diane, now pregnant, moved in with her parents at 888 Park Avenue. Although the young couple chafed at the bourgeois values of the Nemerovs, they would periodically accept support from them, only to again assert their independence, as Diane did when she disappeared to New York Hospital to give birth alone, leaving a note for her parents: 'since I can't have Allan I don't want anyone'.[12] Doon Arbus, the couple's first daughter, was born in April 1945. We know of Diane's initial impressions of motherhood from the note she wrote to Alfred Stieglitz – whom she had first met four years earlier – five days after the birth: finding herself unchanged by pregnancy and the birth, she declared, 'I trust myself better as I am.'[13] When Allan was discharged from the army in January 1946, he joined the extended family living on Park Avenue.

Later in 1946 the Arbuses moved into their own apartment, on West 70th Street, and, with help from the Nemerovs, rented a studio. The

couple resumed working for Russeks, using the credit line 'Diane and Allan Arbus', and were soon getting work from advertising agencies and magazines, including *Vogue*. They also began to take photographs individually, which, in 1946, they saw as worthy of showing to Nancy Newhall, then acting curator of photography at MoMA. The following year they showed some of their pictures to Alexander Liberman at Condé Nast, and were met with an enthusiastic response. In addition to getting more work for *Vogue*, they picked up commissions for, among other magazines, *Seventeen* and *Glamour*. Allan later recalled, 'For some reason, we couldn't work without an idea and ninety percent of them were Diane's.'[14]

Beginning in the spring of 1951, the Arbuses took a year-long sabbatical. They sublet the studio and sailed to Europe, taking with them Doon, now six, and their car. Based in Paris, they explored nearby regions of France and travelled to Spain, later relocating to Italy (first Florence and then Frascati, where they rented a farmhouse). They ended up soliciting some commercial assignments so they could extend their stay. The Arbuses returned to New York in April 1952, and were soon renting a triplex at 319 East 72nd Street, where they both lived and worked. Their second daughter, Amy, was born two years later. In 1955 one of their co-authored photographs was selected for inclusion in 'The Family of Man' exhibition at MoMA.

It was in the mid-1950s that Diane began to emerge as a photographer in her own right. The first manifestation of this was her decision, in 1955, to study photography with Alexey Brodovitch, art director of *Harper's Bazaar* from 1934 to 1958. In 1956 she began to number her negatives and the corresponding contact sheets (on her death, she had produced more than 80,000 negatives). It was also in 1956 that the Arbuses ended their photographic partnership, with Allan continuing alone. Diane, having responded to an ad for a photography course taught by Lisette Model (she would take a second course with Model in 1957-8), later credited the sessions with leading to a breakthrough in her work: 'I began to get terribly hyped on clarity.'[15] Diane and Allan's professional separation was followed by a personal one, with the couple moving into separate apartments in Greenwich Village in the summer of 1959. Diane continued to use the darkroom in Allan's home, while he would join Diane and his daughters for Sunday breakfasts at hers. It was later that year that she met and began a relationship with Israel.

Arbus's first major commission as an independent photographer was 'The Vertical Journey: Six Movements of a Moment within the Heart of the City', an article for *Esquire* magazine of July 1960 (begun the previous October). Although a follow-up piece for *Esquire* on the same theme of social extremities in New York was dropped, it was eventually published by *Harper's Bazaar* in November 1961. At the same time as seeking commissioned work, Arbus was developing her reputation and career as an artist in photography. In 1963

Lady bartender at home with a souvenir dog, New Orleans, La. 1964

she was awarded a Guggenheim Fellowship for the project 'American Rites, Manners, and Customs'; her application was supported by Walker Evans, Lisette Model, Robert Frank and Lee Friedlander. Three years later she received a second grant to extend the project under the title 'The Interior Landscape'. Seven of her photographs were acquired by MoMA in 1964, and at least two were shown in the 'Recent Acquisitions' exhibition held there in 1965. 'New Documents', the legendary MoMA show of 1967 that grouped her with Friedlander and Garry Winogrand, featured thirty of her pictures. By this time, Arbus had long ceased cropping her negatives and had also given up her 35mm camera, preferring instead the square format (offered by the likes of the Rolleiflex) that became a hallmark of her mature style.

Despite conceptualizing stigma as possible across the social spectrum, and seeking out correspondences between the privileged and the underprivileged or marginal, Arbus found herself labelled as a photographer of 'freaks', conceding that 'Freaks was a thing I photographed a lot.'[16] In her influential essay 'Freak Show' (better known by its later title, 'America, Seen through Photographs, Darkly'), the critic Susan Sontag characterized Arbus as a tourist in hell, combating the ennui of her bourgeois existence with tests of her courage.[17] More recently, the scholar Philip Charrier has argued that the identification of her photographs as the product of a personal odyssey fails to acknowledge the relationship between her work and the 'New Journalism' of the period, associated with such figures as Norman Mailer and Tom Wolfe. Charrier claims that '[Arbus] should be regarded as someone who formed part of a trend of deeply researched, more "personal" journalism focused upon non-conventional, "non-authority" subjects'; he also links her working methods to those of Bruce Davidson, Danny Lyon and Larry Clark, each of whom immersed themselves in youth subcultures.[18] This analysis is one of the few that look beyond psychobiography as a means of elucidating the work.

Arbus, who was well versed in the history of photography, began to work part-time as a teacher of the subject. By 1965 she was teaching at Parsons School of Design in Manhattan, and would later teach at the nearby Cooper Union. Her decision to teach was borne of economic need. In the summer of 1966, around the time she was supposed to start her second Guggenheim project, Arbus contracted hepatitis, which laid her very low for several months; two years later, on the

brink of a physical collapse, she was hospitalized for three weeks. In 1969, after years of taking acting classes, Allan gave up photography, obtained a 'Mexican divorce' from Diane (a relatively cheap and quick divorce that could be acquired in Mexico in the 1960s), and moved to Hollywood with the actress Mariclare Costello. A combination of physical strain, emotional loss and money worries took its toll on Arbus. By 1970 she had embarked on what would prove her most controversial project (posthumously published as *Untitled*): photographing the residents of a home in Vineland, New Jersey, for the mentally impaired – a project that, at the time of its making, she believed might be her best work. The following year, in late July, Arbus committed suicide.

The clarity of delineation that spoke of her sitters' assent to be photographed, lending the self-presentation of studio portraiture to what was sometimes street photography and sometimes candid 'at home' sittings, seemingly made specimens of Arbus's subjects – 'the butterfly collection', as she told her brother she privately called her 'photographing'.[19] Such words as these, read through her suicide, take on a negative cast and become fodder for the idea that she was taking a personal safari through the trauma of others in order to come to terms with her own demons. When recording for posterity the metropolitan social ladder, and the rituals and customs of life in the present day, imaging those who are different serves to de-naturalize, and to interrogate, the normative. Just as a butterfly collection makes no sense if the butterflies are considered in isolation, it makes little sense to detach individual photographs by Arbus from the body of work, or to isolate her from the social context of her time. Similarly, we need to situate her *œuvre* in relation to other typological projects (that she knew of and admired), such as that of August Sander, who was equally unsentimental in his depiction of contemporary society.

That Arbus was on a personal odyssey there can be little doubt, but the view that hers was a compulsion grounded in trauma takes almost no account of the positive desires that are equally likely to have been at stake in her work: intellectual satisfaction, the play of ideas and the pleasures of sociality. As a young woman, Arbus wrote, 'That is what I love: the differentness, the uniqueness of all things and the importance of life.'[20] Attuned to both light and shade, and everything on the scale between, the subject of this picture is undoubtedly more complicated than even we know. ∎

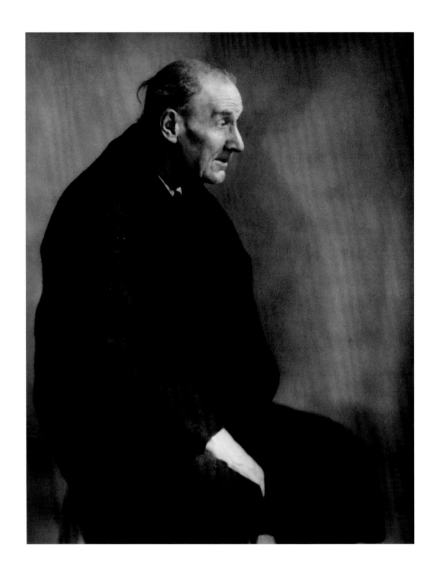

Berenice Abbott, *Portrait of Eugène Atget*, 1927

Eugène *Atget*

1857–1927

These are simply documents I make.

Eugène Atget

Eugène Atget is one of the most influential photographers of all time. Many of the photographers in these pages – and many who are not – have been identified as his direct or indirect artistic descendants. Examples of his work were shown at the groundbreaking 'Film und Foto' exhibition held in Stuttgart in 1929, while his personal archive is in the collection of New York's Museum of Modern Art (MoMA). He has also been the subject of numerous monographs, the first of which, with an essay by the French writer Pierre Mac Orlan, was published in 1930, at a time when monographs on photographers were a rarity. His images are highly prized by collectors, and a small number have been sold at auction for six-figure sums. And yet none of this acclaim occurred during Atget's lifetime. A working photographer with no art practice, Atget died without issue in 1927; his funeral, it is said, was poorly attended.[1] There are, therefore, two biographies of Atget: that of his life, and that of his posthumous reputation. For some commentators, such as the French collector and photography historian André Jammes, Atget is one of the fathers of photography, whose life's work was to document Old Paris according to his unique vision. For others, this characterization of Atget – indeed, the very person we think of as Atget – relies on a wilful reframing of worker as artist and inventory as *œuvre*. Turning to the biographical evidence that has been preserved, it would seem that neither characterization is just.

Jean-Eugène-Auguste Atget was of relatively humble origins, and suffered personal misfortune that would have made him even more socially marginal, but his aspirations outstripped the circumstances of his birth and upbringing. Born in Libourne near Bordeaux, he was brought up by his maternal grandparents, having been orphaned by the age of five. His first choice of vocation, so he himself said, was as a sailor, and he is thought to have spent a number of years in the merchant navy. His next appearance in the historical record is an

unlikely one for a young man of his background. In 1878 he applied
to the Conservatoire de Paris, and, following a second attempt to gain
entrance a year later, was admitted. His teacher there, the acclaimed
actor François Jules Edmond Got, noted that Atget was trying to juggle
his studies with national service; he also noted that his pupil retained
his Gascon accent. Got's assessment of Atget's prospects was at first
hopeful but later pessimistic, and in 1881 he was asked not to return.

The next few years of Atget's life are known from anecdote. We do
know that in 1882, the year in which he is recorded as living on the
rue des Beaux-Arts in Paris, he was the editor of the comic journal *Le
Flâneur*. He is said to have also spent a few years as an actor in provin-
cial companies, sometimes playing the suburbs of Paris. Atget would
still refer to himself as a 'dramatic artist' as late as 1912,[2] and would
say that he had been forced to give up the theatre because of a problem
with his vocal cords.[3] When asked about his time treading the boards,
he summed it up by saying 'Robert Macaire' (the archetypal villain of
French theatre), but others claim that he played only minor parts.[4]
Whatever the facts of his time as an actor, it is known that it brought
him into contact, around 1886, with the woman who would become his
lifelong companion, the actress Valentine Delafosse Compagnon. It is
also known that he had a camera at this time, but not how he learned
to use it. The man said to retire to his bedroom to declaim passages
from Shakespeare and Molière is seemingly at odds with the taci-
turn figure that the American photographers Man Ray and Berenice
Abbott encountered in the mid-1920s. Perhaps the latter, who visited
Atget in his workroom, only encountered Atget the working photog-
rapher; when he withdrew to the private spaces of his apartment, he
was able to give full vent to his artistic aspirations.

When in 1926 Man Ray decided to reproduce four of Atget's photo-
graphs in *La Révolution surréaliste* (no. 7, 15 June), Atget, according
to the American, asked not to be credited, saying, 'These are simply
documents I make.'[5] This statement has been made much of by art his-
torians, particularly those who wish to paint Atget as a naive genius,
as Man Ray's 'Sunday painter',[6] as the Douanier Rousseau of photog-
raphy (as the surrealist poet Robert Desnos is said to have described
him) or as 'the old street pedlar' of Mac Orlan's account.[7] The photog-
rapher and critic Emmanuel Sougez allegedly said of him: 'Atget never
realised he was Atget.'[8] Others have recognized that Atget's declaration

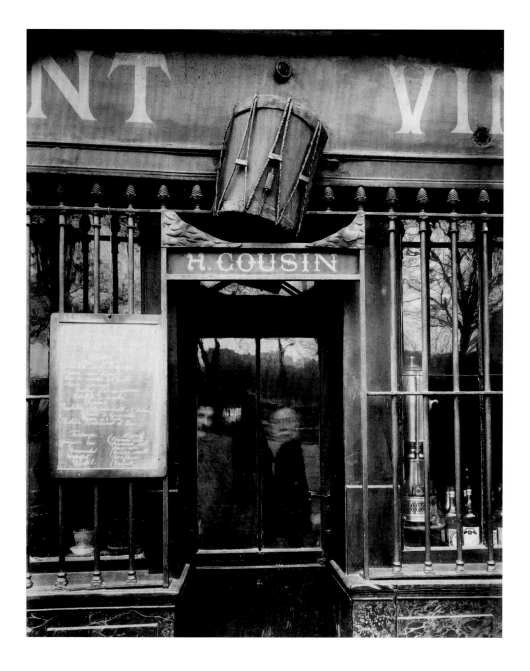

Au tambour, 63 quai de la Tournelle, 1908, from the series 'Art dans le vieux Paris'

may have been strategic, a way of avoiding association with Man Ray's circle of bohemian pranksters. When Atget's *During the eclipse, Place de la Bastille, 17 April 1912* appeared on the front cover of *La Révolution surréaliste*, the appended title, *Les Dernières Conversions*, transformed the record of Parisians caught viewing a solar eclipse through paper glasses into a surrealistic tableau. Many subsequent commentators have likewise transformed our perception of Atget's photographs; one of the most famous observations, made by the writer Camille Recht and taken up by the cultural theorist Walter Benjamin, is that they are akin to photographs of a crime scene.[9]

An amateur painter who, it is said, considered becoming an artist, Atget found in photography a means to make a living that would also provide him with an outlet for his artistic leanings. In either 1890 or 1891 he put up a sign outside his apartment on the rue de la Pitié, Paris, that read 'Documents pour Artistes'. It was in around 1897, when he was forty or thereabouts, that he began systematically photographing the subject that would occupy him for the remainder of his life: Paris. He used an old-fashioned view camera mounted on a tripod, and is said to have employed wide-angle lenses, which resulted in one of the most distinctive features of his photographs, the heightening of perspectival effects.[10] This subtle yet surreal distortion, together with the warm hue of his prints, was in tension with the clarity of delineation resulting from contact-printing his 18 × 24-cm Lumière glass-plate negatives.

A breakthrough came when a sale totalling 15 francs was made;[11] from this point on, it seems that Atget was more mindful of commercial imperatives (and that the preservation of Old Paris was becoming a high-profile issue). This is not to say that he sacrificed his subjectivity for commercial reasons. To understand his work one needs to see it as a dialogue between the wish to create a higher practice of topographic photography and the shaping of that practice according to the needs of the clientele. Atget hawked his photographs to as many clients as he could (his *repertoire*, or client address book, has survived), but this does not mean they were produced simply on the basis of what the client wanted. He organized and reorganized his inventory regularly, reframing the subjects according to the titles he gave the newly constituted series. Atget's clients included the Bibliothèque Nationale de France, the Musée Carnavalet in Paris and the Victoria and Albert

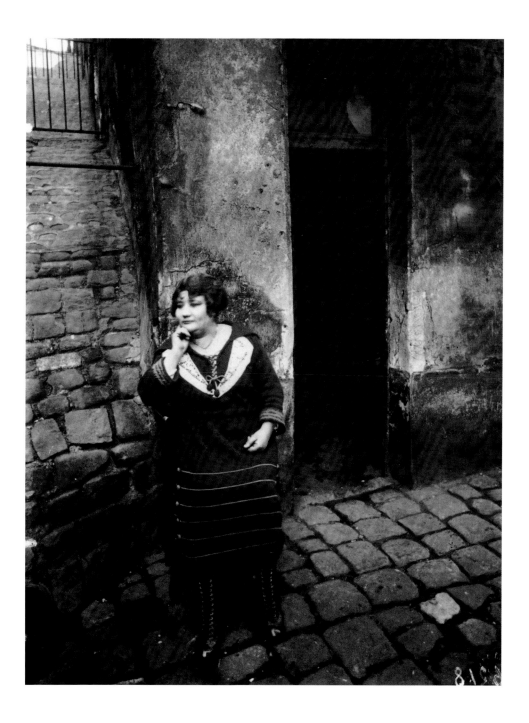

Prostitute on her shift, rue Asselin, La Villette, 1921

Museum in London, as well as numerous designers, illustrators and artists, including Maurice de Vlaminck, Georges Braque and Foujita.[12] The fact that such contrived images achieved currency as reference or source material suggests that Atget knew how to exploit the faith in the superiority of French architecture and design.

Atget's archive is so vast and so various that it is impossible to generalize about his choice of subject: although many of the scenes are devoid of sitters (like crime scenes), there are many street scenes that are peopled, and many topographic studies that feature lone figures or groups. The attempt to understand Atget's output (around 8,500 individual images) has led scholars to divide his work into five main categories: Landscape Documents, Picturesque Paris, Art in Old Paris, Environs and Topography. To these have been added the subsidiary series of Old France, Costumes/Religious Art, Interiors, Tuileries, Saint-Cloud, Versailles, Paris Parks and Sceaux. It is also instructive to consider Atget's *œuvre* in terms of what is not pictured – most notably any visual information as regards how Paris and its environs were being transformed by industrialization. Atget's archive is about the picturesque past that survives in the present: those formations, whether old café fronts or street sellers, that were destined to be eclipsed. Atget, the darling of modernist photography, had very little time for the modern.

Although he maintained his photographic practice for thirty years, always using the same equipment, Atget was not always able to make a living. The Great War was a particular time of hardship: Valentine's son from a previous relationship was killed almost immediately upon arrival at the front, and it appears that Atget did not take any photographs in the last two years of the war. The privations of wartime may have had a lasting effect: friends and neighbours remembered him as existing on very little food. That said, he was also remembered as someone who had strong and unconventional ideas on most subjects, including diet. He died a year after Valentine, and, again according to his neighbours, the end was theatrical: he appeared on the landing of his apartment block saying, 'I am dying.'[13]

The most detailed account of Atget is the one that deals with his posthumous reputation. This account begins in the last two years of his life, when Berenice Abbott starts to visit his studio, becomes an ardent admirer of his work and, after his death, spends much of the

rest of her life trying to secure the recognition of his genius. Her pur-
chase in 1928 of the photographs in Atget's possession at his death
would eventually lead to the acquisition of the archive by MoMA
forty years later. Atget's posthumous canonization means that we
have a wealth of evidence from which to create a more nuanced por-
trait. Given Atget's lowly beginnings, the suggestion that he retained
his provincial accent when studying drama in Paris paints him as
a man torn between metropolitan aspiration and provincial pride.
That he used photographic studies of his own apartment on the rue
Campagne-Première (ascribed to a fictional occupant) suggests a level
of self-satisfaction in his collection of *objets d'art* and leather-bound
plays. Photography enabled Atget to become both a Parisian and an
antiquarian. Was he also a working-class radical? There is evidence
to suggest that he was. If we go by the journals and cuttings he col-
lected, he was both anti-military and a supporter of Alfred Dreyfus,
the French army officer of Jewish descent who was falsely accused
of treason in 1894. These and other affiliations have made 'Atget' an
attractive figure to postmodernists as well as modernists. One scholar
has posed the question, 'If Eugène Atget had not existed, would he
have had to be invented?'[14]

Atget conceived of himself as neither an artist nor a documen-
tarian. Instead, he found a way to make photographs that could be
said to partake of both the artistic and the antiquarian, but which
did not compromise the documentary needs of the market. It was
important to Atget to assert that he never worked on commission,[15]
despite clear evidence to the contrary (including the celebrated series
of photographs of prostitutes in their doorways partly commissioned
by the artist André Dignimont). Atget kept his photographs in albums
with diverse titles of his own choosing; when these albums entered
museum or government collections, Atget could indeed conceive of
himself as the 'auteur-editeur' (author-publisher) of his business card.
In common with other working photographers before him, he used
the medium to assert the head-work of which he was capable, rather
than the hand-work that for some defined the métier. Moreover, in his
navigation of aspiration and necessity, Atget created a body of work
that has become a touchstone of the 'documentary style' we associate
with <u>Walker Evans</u>: not the 'realism unadorned' of Abbott's account,
but poetry in the guise of prose.[16] ∎

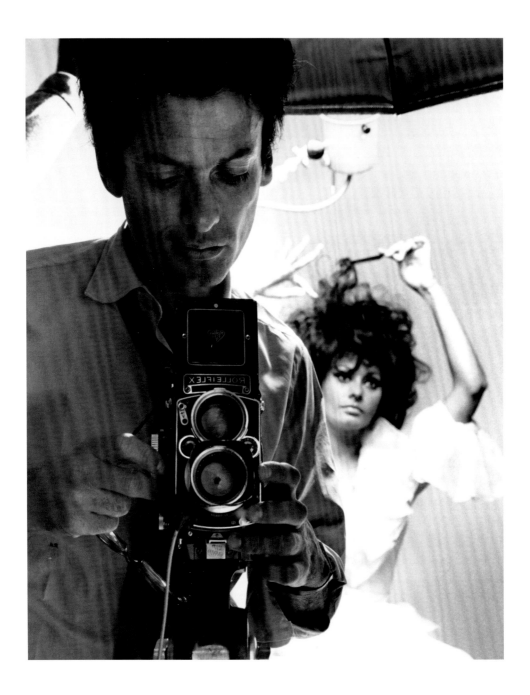

Richard Avedon and Sophia Loren, New York, 27 May 1966

Richard *Avedon*

1923–2004

People, unprotected by their roles, become isolated
in beauty and intellect and illness and confusion.

RICHARD AVEDON

Celebrated for having brought movement and dynamism to American fashion photography, Richard Avedon is equally renowned for his static, pin-sharp portraits that made icons of even the most marginal members of American society. Pivotal to his career as a photographer was his twenty-year stint, beginning in 1945, as staff photographer at *Harper's Bazaar*, a role that provided him with financial security, equipment and assistants, a mentor in Alexey Brodovitch, and international commissions that broadened his horizons beyond those of his native country. Avedon's distinctive style of photography, alternating between the poles of stasis and motion, developed early and was remarkably stable throughout his sixty-year career. Like Dick Avery, the character from the film *Funny Face* (1957) that was based on him – and like Jacques-Henri Lartigue, the amateur photographer whom he brought to public notice – Avedon was attractive, charming and urbane. As played by Avery, he both enjoyed the trappings of his success and was cognizant of the intellectual and spiritual impoverishment of the world that he served to project. Avedon's attraction to the superficial was not evidence of a shallow or untroubled mind.

Avedon's father, Jacob Israel Avedon, was a Russian-born Jew who grew up in an orphanage on New York's Lower East Side. In Avedon's youth, Jacob and his brother Sam were the proprietors of Avedon's Fifth Avenue, a women's department store located between 39th and 40th streets. According to the writer Adam Gopnik, it was from his father that Avedon 'absorbed a sense that a man is a "provider" or he is nothing'.[1] The young Avedon was also surrounded by a number of key female figures: his mother, Anna; his cousin Margie, who came to live with them; and his younger sister, Louise, who was his first model. Avedon later recalled that 'Louise's beauty ... was the event of our family and the destruction of her life ... She was treated as if there

was no one inside her perfect skin.'[2] Louise, who developed serious mental-health issues, would die in a home at the age of forty-two. Avedon claimed that 'All my first models ... were all memories of my sister.'[3] There can be little doubt that he felt guilty about his complicity in the family dynamic that (he believed) destroyed his sister, and regarding his lifelong commitment to the fetishization of beauty.

Like so many of his contemporaries in photography, Avedon grew up in a household that dramatized the tensions between commerce and art. While his father provided for the family through trade, his mother, who allegedly 'hated businessmen and adored artists', privileged the liberal, cosmopolitan accomplishments that money could not buy.[4] According to his profile in an edition of *Newsweek* from 1993, 'Avedon, an avid autograph hound, put on plays in the garage, tap-danced after dinner, recited poetry in the kitchen.'[5] Anna Avedon would bring the children into Manhattan from their home in Cedarhurst, Long Island, to visit museums and attend concerts[6] (the family later lived on the Upper East Side, at 55 East 86th Street). According to Avedon, it was at the Frick Collection at the age of nine that he saw Rembrandt's *Polish Rider* (*c.* 1655), a work that, 'for a long time ... meant everything in the world to me. I was that young man.'[7]

Avedon, who was the owner of a Kodak Box Brownie at the age of twelve – the same age at which he joined the camera club of the Young Men's Hebrew Association – claimed to have been taught to use a camera by his father. He also claimed that his first portrait was the image of his sister that he created on his body by attaching a negative to his shoulder with surgical tape, keeping it there for two or three days.[8] In his senior year at DeWitt Clinton High School in the Bronx, Avedon was appointed editor-in-chief of the school's cultural magazine, the literary editor of which was the future author and civil-rights activist James Baldwin. What he did after graduating from high school is unclear; according to Avedon, he worked as an errand boy and assistant in a neighbour's photography studio.[9]

In 1942 Avedon joined the US Merchant Marine and became Photographer's Mate, Second Class. Stationed in Sheepshead Bay, Brooklyn, he took photographs for identity cards; he also worked for the mariners' magazine *The Helm*. Following his discharge from the service in 1944, he decided to try and make a living from photography using the Rolleiflex his father had given him. According to one

account, his very first attempt involved an approach to Bonwit Teller, the upmarket women's department store in Manhattan, to loan him some clothes; these he photographed on a hired model before selling the photographs to the store, which used them in one of its elevators.[10] Like the story of his job as an errand boy, the story of Bonwit Teller honoured his father's values: good business sense married to humility. At the same time, Avedon's claim that he was taught to use a camera by his father indicts the latter in Avedon's fate as a creative.

Avedon, who had allegedly cut out his favourite images from *Vogue* and *Harper's Bazaar* as a boy, decided to show his portfolio to *Harper's* then art director, Alexey Brodovitch. Avedon began to attend Brodovitch's 'Design Laboratory' classes at the New School for Social Research in Manhattan, where Brodovitch propounded the idea that commerce and art could and did have a productive relationship. Avedon found in Brodovitch a severe character, 'much like my father', under whose influence he could thrive.[11] It was in November 1944 that Avedon's first fashion photos appeared in *Harper's*, in the 'Junior Bazaar' section. As Avedon began to develop a style of his own, he deployed variable focus, blur and poses suggestive of verve and energy, drawing heavily on the example of the Hungarian émigré Martin Munkácsi, the hallmarks of whose fashion work were movement and outdoor settings. At the age of twenty-five Avedon was identified by *U.S. Camera* magazine as 'the most controversial figure in photography'.[12]

The other major genre in which Avedon worked was portraiture. He took his first white-background portrait in November 1946, and in 1953 debuted in the pages of *Harper's* the bleached-out style that made elegant sculptures of such sitters as Audrey Hepburn and Gloria Vanderbilt. Something of his impact on contemporary style is suggested by the anecdote that it was Avedon's portrait of Marella Agnelli in this mode (1953) that provided the inspiration for Christian Dior's H-Line collection of autumn/winter 1954-5.[13] Avedon's fame was compounded when, in the spring of 1956, filming began on Stanley Donen's musical comedy *Funny Face*, the screenplay for which had been inspired by Avedon and his first wife, the model Dorcas Nowell. He and Doe, as she was known, had divorced in 1949; two years later, Avedon had married Evelyn Franklin, with whom he had a son, John. Hired as a special visual consultant to Donen, Avedon, then only

thirty-two, said of Fred Astaire, who played the lead character, 'It's all very strange. I'd learned to be me by pretending to be him and then I had to teach him how to pretend to be me.'[14]

According to the curator and scholar Carol Squiers, Avedon's commissioned work pushed at the boundaries of both aesthetic and social convention.[15] Despite William Randolph Hearst's injunction, made in 1964, banning his various publications from including pictures featuring black Americans, Avedon was responsible for choosing and photographing the first black model to appear in *Harper's*. He had also made, in 1946, a series of photographs called 'Harlem Doorways' for an unfinished project with James Baldwin. In the early 1990s it became known that, beginning in 1949, Avedon had made a body of street photographs, some of which featured African Americans and other ethnic minorities. The project had begun as a commission for *Life* magazine to shoot an issue dedicated to New York City. According to Avedon, after 'six months I returned the money, put the pictures in an envelope and never looked at them again'.[16] He did not want to tread the established path of the street photographer.

Avedon's career and interests were much more varied than the characterization of him as a style-bible photographer would suggest. In 1949 he became an editorial associate at *Theatre Arts Magazine*, and would later collaborate with Doon Arbus, the daughter of his close friend Diane, on a book documenting the production of *Alice in Wonderland* by Andre Gregory and his Manhattan Project theatre group (1970). In late 1962 Avedon had his first solo show, at the Smithsonian Institution in Washington DC. The exhibition was jointly designed by him and the artist and teacher Marvin Israel, who had been appointed art director at *Harper's* in 1961, Brodovitch having been dismissed three years earlier. Avedon claimed that the design of the show, which saw the photographs hung in an informal arrangement suggestive of their role as working documents in a design or magazine studio, 'reinvented the photographic exhibition'.[17]

In early 1963 Avedon began working on a series of portraits for a book project with Israel and James Baldwin. *Nothing Personal* (1964), which included such provocative juxtapositions as the leader of the American Nazi Party with a nude Allen Ginsberg, as well as portraits of such diverse figures as Marilyn Monroe and Malcolm X, featured an essay by Baldwin that attacked the illiberal values of the United

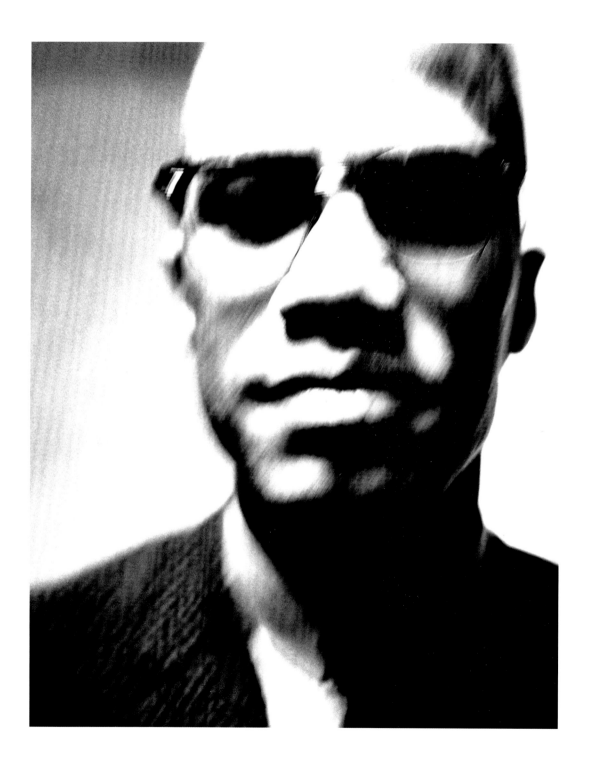

Malcolm X, black nationalist leader, New York, 27 March 1963

States. The book, which also included Avedon's photographs of the inmates of a hospital for the mentally ill, was treated harshly by the critics. Perhaps Avedon's name was too closely associated with empty glamour for such photographs to be received on their own terms.

In 1965 *Harper's* commemorated Avedon's twenty years at the magazine with a special issue photographed and guest-edited by him. The issue testified to his wide-ranging interests but was not well received by readers; in addition, the use of a black model offended some of the magazine's Southern advertisers. During the renegotiation of his contract with *Harper's*, Diana Vreeland, his former boss at the magazine and now editor-in-chief at *Vogue*, poached him for the rival style bible with a million-dollar advance.[18] There, Avedon was to work in the same stable as his great rival, Irving Penn, and Penn's mentor, Alexander Liberman. Vreeland's vision for the magazine was in line with the 'youthquake' of the sixties, and Avedon was encouraged to blur the boundaries between fashion and celebrity. His photographs first appeared in *Vogue* on 1 March 1966 and would appear in nearly every issue until the mid-1970s.

Avedon claimed that it was during his time at *Vogue* that a split occurred between his commissioned and personal work, whereas at *Harper's* his creative energies had been channelled into his commercial output.[19] This is an interesting anecdote since he had worked on other, more personal projects, such as 'Harlem Doorways', while at the latter publication. Perhaps he wished to create a separation between the two types of work in order to rescue his personal projects from the taint of superficiality. His magnum opus, 'In the American West', a collection of 125 portraits taken over a period of five years beginning in 1979, was sponsored by the Amon Carter Museum in Fort Worth, Texas. Using his by-now signature white backdrop, Avedon demonstrated that blue-collar workers and such marginal figures as drifters were equally as capable of mesmerizing the viewer as any figure in the public eye. He did so, in part, by placing his camera below the sitter's eyeline and having the images blown up to mural size. The photographs, which have echoes of August Sander's typological project, drew on ethnographic and documentary conventions, but were also subject to creative manipulation at the printing stage. The series, made during the presidency of Ronald Reagan and suggestive of a critique of the effects of economic depression, again elicited reviews that found fault

with Avedon for his presumed insincerity. And yet the political aspect of the project may not have been the key driver for him.

In the last two decades of his life Avedon continued to be closely associated with glamour, and to lend his glamour to more serious subjects. From 1980 for twenty years he created, according to his own brief, biannual campaigns for Gianni Versace, with much of the work in colour and often featuring the first generation of super-models. He also, in the 1980s, directed television ads for Calvin Klein's perfume Obsession. From 1985 to 1992 his editorial work appeared exclusively in the French literary and art magazine *Egoïste*, for which he photographed the unification of East and West Berlin on New Year's Eve 1989. In 1992 he became the *New Yorker*'s first and only staff photographer, working with Tina Brown. He died, in 2004, from a cerebral haemorrhage while on assignment for the magazine in San Antonio, Texas.

In the short, confessional-style introduction to the compendium of his work that he called *An Autobiography* (1993), Avedon speaks of illusions: the impact of their power and of their loss. His early enthralment with beauty and celebrity was later accompanied by a liberal conscience that took him to Vietnam in 1971 and, the following year, saw him arrested during an anti-war demonstration (he was subsequently jailed for civil disobedience). In 1973 Avedon was making portraits of his father, sometimes smartly dressed, sometimes in a hospital gown; the following year, his father now dead, these portraits formed the subject of an exhibition at the Museum of Modern Art, Avedon's first in New York. More than twenty years later, in 1995, Avedon would introduce Death into a fashion spread for the *New Yorker*, 'In Memory of the Late Mr and Mrs Comfort', featuring the model Nadja Auermann and a skeleton. At first glance these images can appear as a trite meditation on the relationship between beauty and death in a world in which earnestness is a crime. For Avedon, however, this was not a renunciation of the superficial but a homage to it. Fashion, beauty, glamour, illusion: these could be false friends but they could also be a refuge from trauma. Was Avedon's trauma, as he saw it, that of his sister's objectification? His willingness to tell the story suggests it was a shield against further probing of his psyche. Perhaps his preoccupation with death was not only about beauty and its inverse but also about a father preparing himself to one day take leave of his son. ■

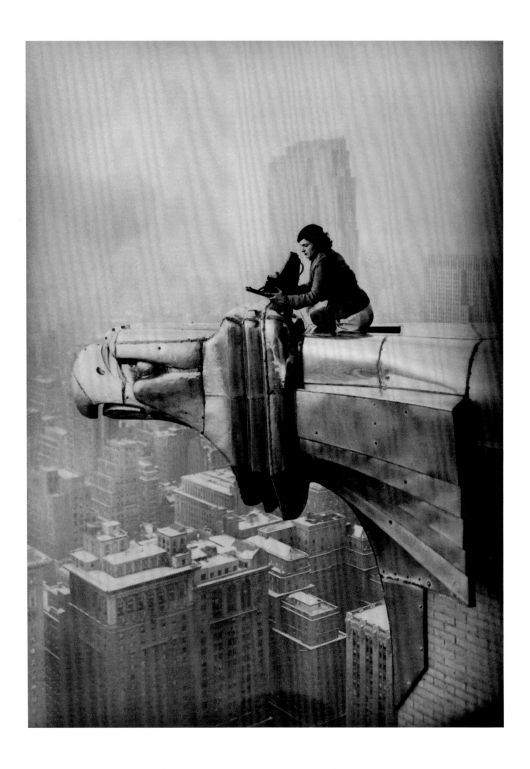

Oscar Graubner, *Margaret Bourke-White atop the Chrysler Building, New York*, 1934

Margaret *Bourke-White*

1904–1971

I want to become famous and I want to become wealthy.

MARGARET BOURKE-WHITE

It is impossible to encompass in a brief biographical sketch the extent of Margaret Bourke-White's photographic career. She was responsible for the cover image and lead story for the first ever edition of *Life* magazine, whose runaway success on its launch in 1936 initiated a news-media revolution. In 1955, having been a star photographer at *Life* for two decades, she elicited from the magazine's founder, Henry Luce, the promise that it would be she who would cover the first trip to the moon. Many of her assignments and personal projects featured people and events that would play a decisive role in the history of the twentieth century, such as Mahatma Gandhi and the partition of India in 1947. Her autobiography presents her as pioneering, fearless, indomitable and, ultimately, in possession of a strong social conscience.[1] Her account is frank enough to suggest that nothing has been omitted. Yet as the scholar Vicki Goldberg discovered when researching her extensive biography of Bourke-White,[2] the autobiography features significant evasions and elisions. Like her professional persona, the book was a projection: not just of her own aspirations but also of the high-minded expectations of her parents.

Minnie Bourke and Joseph White were both children of immigrants. Joseph, rejecting his Jewish ancestry, was inspired by the ideas of 'ethical culture', and found himself a wife who was equally modern, rational and unbending in her outlook. They were married, it is said, by an atheist minister, and set out, in Joseph's words, 'to create a perfect mental and moral home'.[3] Bourke-White, the second of three children, was born in the Bronx; not long afterwards, while she was still a young girl, the family moved to Bound Brook, New Jersey, to be closer to Joseph's workplace.

The upbringing of the three White children was singular. Their father, an engineer and inventor who believed that work was one's salvation, was rarely present. Their mother, who struggled with having to

give up her education to have children, dedicated herself to inculcat-
ing them with rational values. Bourke-White, who soon became the
very model of self-sufficiency, remembered her mother exhorting her
children to 'Open all the doors!' and 'Reject the easy path! Do it the
hard way!' while her father's motto was 'You can.'[4] Passionate about
nature and modern machinery, Joseph was also an amateur photog-
rapher who allowed his middle daughter to assist him with developing
pictures in the bath.

Bourke-White was, she said, thinking of her father, who died in
1922, when she signed up for a two-week course in photography with
the now legendary Clarence H. White while studying at Columbia
University in New York.[5] Photography was, however, still an adjunct
to her desire to become a herpetologist – a consequence, perhaps, of
her childhood pride in her lack of fear of snakes and reptiles. When,
having enrolled anew at the University of Michigan, the zoologist
Alexander G. Ruthven told her that she was not cut out to be a her-
petologist, she agreed with him and articulated another ambition:
'I should like to be a news-photographer-reporter and a good one.'[6]

Peggy, or Peg, White, as she was known at college, was unable
to accept the marriage proposal of fellow Michigan student Everett
'Chappie' Chapman until she had confessed to him – on the advice of
her psychiatrist – that her father was Jewish. They married in 1924,
the day before her twentieth birthday, and supported themselves by
selling the photographs they made and printed together. Later that
year they moved to Purdue University in Indiana, where Chapman
had secured a teaching position, and where Bourke-White enrolled for
the third time as a freshman student. Although she sometimes longed
for a child, when she did get pregnant she succeeded in inducing a
miscarriage; when the couple moved to Cleveland, Ohio, in 1925, she
somewhat poignantly studied and worked in education. The mar-
riage ultimately failed. Later, she described how it felt to be 'facing life
again as an individual': 'I had risen from the sickbed, walked out into
the light, and found the world was green again.'[7]

Having enrolled, in 1926, at Cornell University in Ithaca, New York,
to study biology, Bourke-White returned to Cleveland in September of
the following year to work professionally as a photographer. There,
under the influence of her friend Ralph Steiner, her style evolved
from pictorial to something more hard-edged. Another mentor was

Alfred Hall Bemis, the owner of a local camera shop. With her own small apartment, her own car, a studio in the voguish Terminal Tower and a fashionable appearance, she found herself also in possession of heightened powers of attraction, which she happily used to her advantage. Her major triumph was persuading Elroy Kulas, president of Otis Steel, to allow her to photograph in the company's mill at night. With the assistance of 'Beme' and others, she overcame the many challenges involved and took pictures that she sold to Kulas for $100 each.

In May 1929 Henry Luce, who had been shown the Otis Steel images, invited Bourke-White to New York. Luce was planning the first issue of *Fortune* magazine, and Bourke-White eventually signed a contract that would pay her $1,000 a month to work for the periodical part-time. Despite the financial crash of October that year, Luce persevered with *Fortune* and launched it in February 1930. As its readership grew, Bourke-White was finally persuaded to move to New York, choosing for her home and studio the Chrysler Building, the construction of which she had been photographing. Her rooms were on the sixty-first floor, at the height of the famous gargoyles atop one of which she was photographed by her assistant Oscar Graubner. Bourke-White, whose interest in both natural science and making an impression never waned, allegedly kept two alligators on the terrace of her new studio.

In the summer of 1930 Bourke-White was sent by *Fortune* to take photographs in Germany. From there, she managed to enter Russia, where she discovered that it was the photographer who was considered '*the* artist of the machine age'.[8] This coup brought her a lecture tour and a book, *Eyes on Russia* (1931). On her third trip to the country, in 1932, she produced 6,000 m (20,000 ft) of silent film, which she could have sold for a fortune but instead insisted on cutting herself. Her mounting debts saw her downsize to a smaller studio, build up her practice of advertising photography and even make commercial endorsements, including one for Maxwell House coffee in 1933. In the summer of the following year *Fortune* dispatched her to Oklahoma and the prairie states to document the effects of drought. Moved by the deprivation she encountered there, she increasingly came to support leftist causes and to speak admiringly of Russia. Whether this alienated her from her lucrative advertising work we do not know; her decision to abandon it was, she said, the result of a nightmare in which she was being chased by the cars that she photographed.

Fort Peck Dam, Montana, 1936

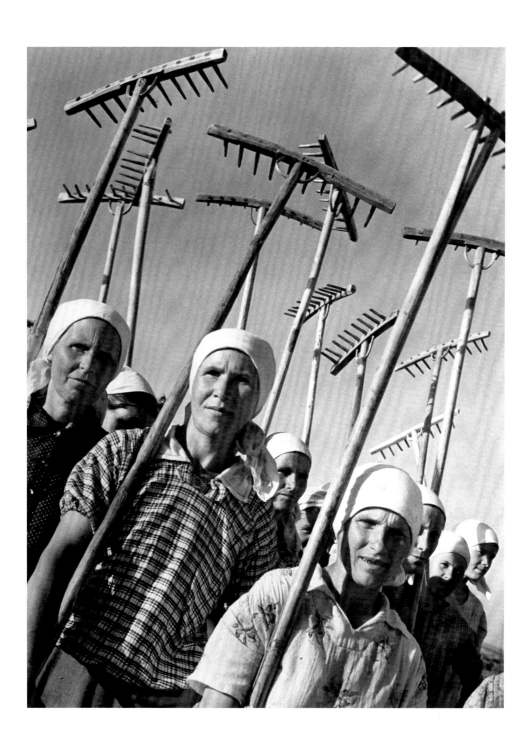

Women on a collective farm, Russia, 1941

In January 1936 Bourke-White approached Maxim Lieber, a literary agent, and told him how much she would like to collaborate on a project with the writer Erskine Caldwell. Caldwell had gained a degree of notoriety after his novel *Tobacco Road* (1932) had been turned into a successful stage play; however, his literary indictments of the exploitation and racism of the agricultural Deep South were denounced, mainly by influential Southerners, as grossly exaggerated. He was now looking to write a factual book with photographic illustrations that would add weight to his assertions. The differing accounts surrounding Bourke-White's collaboration with Caldwell, which would lead to *You Have Seen Their Faces* (1937) and, eventually, their marriage, are perhaps the most instructive as regards the elisions in her autobiography; of particular note are the discrepancies between her and others' account of the circumstances under which her relationship with Caldwell began. Whether or not Bourke-White wanted a serious book to her name more than she wanted Caldwell, whom she finally agreed to marry in the spring of 1939, is a moot point.

About two weeks after completing a tour of the South with Caldwell, Bourke-White signed a contract with Time Inc. to work on a new magazine. The arrangement saw her transfer her studio, darkroom and four of her studio team, including Graubner, to the company's offices. She was one of four photographers contracted to the magazine – the only woman, the only photographer using a large-format camera, and the only one able (at first) to print images in-house. Her cover image for the first issue of *Life* in November 1936 was a striking geometric composition featuring the Fort Peck Dam on the Missouri River; the related picture story, also by her, was 'a human document of American frontier life.'[9] Both were testaments to her aesthetic and social development.

In 1940 Bourke-White was described by the journal *U.S. Camera* as 'the most famous on-the-spot reporter the world over'.[10] *Life* capitalized on this reputation during the Second World War, sending her to London, Romania, Turkey, Syria and, after a brief spell away from the magazine, Russia. There she became the only Western photographer to document the bombing raids on Moscow. The remaining years of the war were equally as eventful for Bourke-White: she was accredited through *Life*, at her own request, to the US Army Air Forces; was rescued after the ship on which she was sailing to North Africa was struck by a torpedo; joined a combat mission; and travelled

to Italy to photograph at the front amid the shelling. It was also during this period, in November 1942, that her marriage to Caldwell came to an end. In 1945 she was assigned to the Allied advance into Germany, arriving at Buchenwald shortly after General Patten and his forces. Her photographs of Buchenwald and other concentration camps were, for the majority of Americans, the first decisive evidence of the Holocaust.

Whether in India for the run-up to the partition (1946–7), in South Africa documenting racial injustice (1950) or in Korea photographing life under war (1952) – an assignment she requested to clear her name of the suggestion that she was a communist – Bourke-White would overcome every obstacle put in her way to get the pictures she wanted, often risking her life to do so. She would repeatedly achieve the accolade of 'first woman to', convince powerful men to do her bidding, form romantic relationships in the field, and return to the United States to give lectures and write books. At the age of forty-nine she was diagnosed with Parkinson's disease; it was around this time, too, that she began to write her autobiography.

In attempting to highlight the dire conditions under which rural Southerners were living in the 1930s, *You Have Seen Their Faces* included captions purporting to be direct quotations from the people photographed by Bourke-White. These quotations were, however, invented by the book's authors. This use of fiction to impart a greater truth is instructive when we read Bourke-White's autobiography. Her own account of her rise to fame and fortune, the awakening of her social conscience and her refusal to be beaten by Parkinson's disease is such a seamless, heroic narrative that it leads one to ask exactly what it cost her to live such a life. This is not to suggest that she was unfulfilled because she was not a wife and mother; one of her greatest pleasures was the solitary life she led, between assignments, at her home in rural Connecticut. If in her autobiography she chose to omit those biographical details that would have disrupted her narrative, such as her alleged indifference to her mother's death in 1936, the imaginary child that she and Caldwell invented, and the therapy she underwent periodically from 1931 to 1955, we should remind ourselves that she was raised to believe in human perfectibility. She proved herself worthy of her father's love by giving him what he wanted: a child that embodied the American spirit. ∎

Self-Portrait, 1966

Bill *Brandt*

1904–1983

Photography is not a sport. It has no rules.

BILL BRANDT

Often acclaimed as the greatest British photographer of the twentieth century, Bill Brandt was born Hermann Wilhelm Brandt in Hamburg and did not visit England until he was in his twenties. He was, nonetheless, a British citizen, and when he eventually settled in London he did so with the curious eye of a foreigner and the sympathy of an ally. Brandt divided his *œuvre* into two phases: the documentary work of the late 1930s to the late 1940s, and the artistic imagery he made thereafter. But there was much more continuity between these two phases than he suggested. When he began, in around 1951, to print old and new negatives in a more high-contrast style, it became apparent that the social realism of his early work was married to a highly subjective aesthetic. The landscapes, portraits and nudes that he made from the mid-to-late 1940s onwards also evolved from commissions. For both his early commissioned work and the photography books that made his name as an artist, he was as much an auteur as an eyewitness, often premeditating and sometimes staging his scenes. The distorted nudes he made from 1945, his alternation between disclosure and evasion, and the psychoanalysis he undertook in Vienna during the 1920s have suggested to scholars that his dark, brooding vision was the result of subconscious desires. It remains uncertain, however, whether the hidden identity he was seeking to protect was that of a German or of a sexual fetishist, or both.

Brandt was the second of four boys born to Ludwig Walther Brandt, a wealthy merchant, and Louise 'Lilli' Merck. Ludwig and his siblings had been born in London, where his father was managing a branch of the family merchant bank; thus, according to the law, he was British, as became Lilli on their marriage and later their children. During the First World War, this alien identity caused problems for the family. Ludwig was one of the 5,000 'English' men of military age resident in Germany who were interned in 1914, and spent six months

living in a stable with five other men. When, in 1919, his son Willy, as Bill Brandt was then known, was sent to board at the Bismarckschule Realgymnasium in Elmshorn, north Germany, he was issued with a registration card identifying him as British and had to report his movements to the police. While these trials might have turned the Brandts against the United Kingdom, they instead furthered the family's identification with the country.

Brandt's British citizenship was not the only thing that set him apart from his peers. The only boarder at his school, he was so sickly that in one term he missed, so it is said, eighty lessons through illness.[1] After three years he had to leave the school because of the gravity of his tuberculosis. Brandt was first treated for the condition in early 1923, at the Agra sanatorium in Switzerland. Having gained some strength, he was transferred by his mother, in the autumn of the following year, to the Schweizerhof sanatorium in Davos. After two and a half years at Davos, most of which he recalled spending in bed,[2] Brandt decided to try a psychoanalytic cure. Travelling to Vienna, he embarked on a course of therapy with Wilhelm Stekel, an early disciple of Freud. Brandt lodged close to Stekel's home in Salmannsdorf, a wine village outside Vienna. There, he grew close to Lyena Barjansky, a young Russian woman to whom he had been introduced by his brother Rolf. Brandt's friendship with Barjansky precipitated the end of his sessions with Stekel, who told Brandt that he must not pursue it. Remarkably, a medical examination conducted a few months later showed that Brandt was free of tuberculosis.

According to anecdote, Brandt was given the idea of training as a photographer by Dr Eugenie Schwarzwald, whose summer retreat at Grundlsee in central Austria he and Rolf attended in the late 1920s. In 1927 Brandt was taken on as an apprentice by Grete Kolliner at her Vienna studio. A year later, Kolliner took on another apprentice, Eva Boros, a young Hungarian woman who had lost her mother and sister to tuberculosis and was suffering from it herself; Boros had also briefly served as an apprentice under André Kertész in Budapest. She and Barjansky became good friends, and Boros became romantically involved with Brandt. In 1930 the trio relocated to Paris, where Brandt became, for a brief period, Man Ray's 'pupil', or informal apprentice.[3] While Brandt claimed to have learned much from Man Ray,[4] and produced at least one nude in his style (of Eva, 1930), the

Paris-based photographer who most directly inspired him was <u>Brassaï</u>. Whether Brandt joined Brassaï and Kertész in the Café du Dôme in Montparnasse is a matter of speculation; there is no strong evidence to suggest that the comfortably off and somewhat fastidious Brandt, who travelled to Montparnasse each day from Passy, had anything to do with bohemian Paris.

In 1934, following a period of travel in Europe, Brandt moved to London, where Rolf and his wife, Ester, had been living since 1933 owing to their repugnance at the rise of National Socialism. Bill and Eva Brandt – the couple had married in Barcelona in April 1932 – lived separately in the same London neighbourhood, an arrangement that has been variously interpreted as stemming either from his fear of re-contracting tuberculosis or from his fear of commitment. Two of the Brandt brothers' paternal uncles had settled in England, and some of the photographs taken by Brandt for his first book, *The English at Home* (1936), feature Rolf, Eva, Ester and other émigré family and friends posing as characters in purportedly unmediated scenes of British social life.

'Billy' or 'Bill', as Brandt became known, contributed photographs to *Weekly Illustrated* at least as early as 1936, to *Lilliput* from its foundation in 1937, and to *Picture Post* from its establishment the following year. On the pages of these illustrated magazines, Brandt's (uncredited) images were in the service of the often left-leaning editorial picture-story. Despite creating such searing photographs as *Coal-Searcher Going Home to Jarrow* (1937), which shows a man bent almost double as he pushes along a bicycle weighed down by a bag of scavenged coal, Brandt was keen to deny having a social or political agenda. 'I was probably inspired to take these pictures', he later said, 'because the social contrast of the thirties was visually very exciting for me. I never intended them, as has sometimes been suggested, for political propaganda.'[5]

Influenced by Brassaï's *Paris de nuit* of 1933, Brandt published *A Night in London* in 1938. A year later, his pleasure in night photography – 'watching without being noticed, catching glimpses of everything' – took him on to the streets of London during the black-outs.[6] The following year he was commissioned by the Ministry of Information to photograph Londoners sheltering from the Blitz at night in Tube stations and other underground shelters. Towards the

end of the war, Brandt's style began to change. He was drawn back to the poetic school of photography to which he claimed to have adhered in his early years on the Continent. A strong influence at this time, so he later suggested, was the look of Orson Welles's *Citizen Kane* (1941).[7] In 1944 he acquired a second-hand Kodak Angle Camera, its fixed lens of 110 degrees resulting in 'an unrealistically steep perspective'.[8] He used the camera to create a series of nude studies featuring *Alice in Wonderland*-type distortions of size and scale. The device of boxing imposing nudes within Victorian-style interiors with doll's house-like proportions, as in *The Policeman's Daughter, Hampstead* (1945), was both surrealistic and suggestive of a twisted eroticism. Such images became well known only after the publication of *Perspective of Nudes* (1961). In the book's introduction, Chapman Mortimer stressed that Brandt's photography was not a mirror held up to reality, but a 'Looking Glass' world of visual fairy tales.[9]

In his introduction to his third book, *Camera in London* (1948), the first for which he supplied some of the text, Brandt wrote of seeking out conditions that would allow him to portray his subjects 'as familiar and yet strange'.[10] According to Brandt, he had lost his taste for documentary photography in part because of the war's leavening of the social contrasts that had so fascinated him in the 1930s.[11] That Brandt more or less gave up social documentary at the beginning of the 1950s may have been for a more prosaic reason: in 1950 his second wife, Marjorie Beckett, the then fashion editor at *Picture Post*, resigned from the magazine together with its editor, Tom Hopkinson, a friend and ardent supporter of Brandt, in protest at the pulling of a feature on the Korean War. In the second phase of his career, in which he published the books that made his name as an artist – *Literary Britain* (1951), *Perspective of Nudes* and *Shadow of Light* (1966) – it was Norman Hall, the editor of *Photography* magazine from 1952 to 1962, who was his most important supporter. If it had not been for Hall, Brandt said, 'I would probably still be an unknown photographer'.[12]

Brandt's success as a photographer was dependent on the support not just of his male friends. Beginning with his friendship with Lyena Barjansky, he established a pattern of having two women in his life. Brandt's *ménages à trois* – first with Eva and Lyena, then with Eva and Marjorie – together with two spells of Freudian analysis, his sadomasochistic-like nudes of 1977–80 and the suggestion that some

Eva and Lyena on the balcony, 1934

of his models were prostitutes whose services he engaged, have led to the inference that Brandt had a repressed sexuality that increasingly found its way into his pictures. This is the view taken by Brandt's biographer Paul Delany, who has suggested a link between *The Policeman's Daughter* and the unpublished erotic novel by Swinburne of the same name.[13] Whatever his sexual predilections or fantasies, it seems clear that Brandt was sometimes dependent and passive in his dealings with the women in his life, and sometimes evasive of their authority. After Eva and Brandt divorced in 1948, Brandt became totally dependent on Beckett, both personally and professionally, and yet he married her only after more than thirty years together. When she died of cancer in 1971, he proposed almost immediately to her sister (and was rebuffed); in the following year, he was introduced to the Russian divorcee Noya Kernot, and soon fell in love. When the two were married in December 1972, Eva signed the register. She and Kernot then entered into a war of attrition over the question of with whom Brandt's loyalties lay.

When Brandt claimed photography had no rules, he meant that the photographer was entitled to use any means available to them in order to embody their vision. Such a view was anachronistic in the post-war period, as many influential figures in the photographic community believed that the only way to elevate the medium was by codifying a single aesthetic practice, that of 'straight' (unmediated) photography. By emphasizing the documentary nature of some of his early work, he paid lip service to this orthodoxy; by emphasizing the artistic nature of later work, he made it clear that, by temperament, he was an artist, not a reporter. Brandt's evasions, both personal and professional, may have been the result of the 'persecution mania' from which he claimed to suffer.[14] We should be wary, however, of casting him as the classic mid-twentieth-century European intellectual – a label, with its suggestion of neuroticism, he rejected. According to Brandt, 'too much self-examination or self-consciousness' might inhibit the excitement that fuelled his aesthetic drive.[15] He believed that a photographer 'must have and keep within him something of the receptiveness of a child who looks at the world for the first time or of the traveler who enters a strange country'.[16] As significant as his psychoanalysis may seem, we also need to recognize that he spent very little time on the couch. ■

The Policeman's Daughter, Hampstead, 1945

Self-Portrait, Boulevard Saint-Jacques, Paris, c. 1931

Claude *Cahun*

1894–1954

*Under this mask, another mask. I will never
be finished removing all these faces.*

CLAUDE CAHUN

Claude Cahun, today celebrated for her extraordinary images made in the 1920s and 1930s, was only 'discovered', posthumously, half a century later. This is despite the fact that she was well connected in both established and avant-garde Parisian cultural circles, became a dedicated surrealist, and was acclaimed by André Breton as 'one of the most inquiring minds of our time'.[1] Cahun expressed herself in a variety of media, including poetry, prose, criticism, acting, sculpture and photography, often blurring the lines between them. Born into a literary family, she would probably have seen herself as an author; today, however, she is best known for her photographic self-portraits. Witty and intelligent visual explorations of gender and artistic identity, these self-portraits, in which she inhabits a range of personas, are suggestive of a life lived without concern for convention, social mores, prejudice or personal safety. She saw art and literature as projections, not mirrors, and was radical in both her life and her art. In the early 1930s Cahun became committed to the idea that left-wing artists and intellectuals could and should use art for political ends. When she found herself living under Nazi rule during the Second World War, she risked her life in a campaign to spread her own, highly creative, anti-fascist propaganda.

The woman known to us by her pseudonym was born Lucy Renée Mathilde Schwob in the French city of Nantes. As a child, she lived mainly with her paternal grandmother, Mathilde Cahun; her mother, Marie-Antoinette, suffered from mental illness and was eventually committed. Despite coming from an Alsatian-Jewish family that had produced several rabbis, Cahun's father and uncle were agnostic.[2] Her paternal grandfather, Georges Schwob, had bought and managed the republican newspaper *La Phare de la Loire*, and her father, Maurice, a political and economic commentator, had taken over its running

following Georges's death in 1892. Two years earlier her uncle, the influential symbolist novelist Marcel Schwob, had helped to establish the literary review *Mercure de France*. It seems that Cahun strongly identified with the intellectualism of her male relatives but found herself in a complex relationship with its patriarchal basis.

The tide of anti-Semitism that arose during the Dreyfus affair (the political scandal that erupted in 1894 when Alfred Dreyfus, a French army officer of Jewish descent, was falsely accused of treason) appears to have affected Cahun directly, and in about 1906 she was sent to live in Surrey, where she continued her schooling. Her grandmother died the following year, and on her return to Nantes in 1908 she was cared for by her father. It was at the city's *lycée*, in 1909, that Cahun met Suzanne Malherbe (also known by her pseudonym, 'Marcel Moore'), who was to become her lifelong artistic collaborator and lover. Cahun spent much of her time in the archive of her father's newspaper, absorbing the literature it contained, and in 1914 she enrolled at the Sorbonne to study literature and philosophy. Her first published work, 'Vues et visions', appeared in *Mercure de France* in May 1914 under the name 'Claude Courlis'; it was later published, in 1919, as a book dedicated to and illustrated by Malherbe. From the outset, Malherbe and Cahun addressed the themes that would preoccupy Cahun for the rest of her life, at first drawing on the symbolism of her parents' generation, and later creating surrealist objects, photographs and writings.

Suffering from anorexia and depression, Cahun did not complete her university studies. In 1917 her father married Malherbe's widowed mother, making Cahun and Malherbe not only lovers but also step-sisters; they responded by setting up home together. As well as being in a lesbian relationship – to which, it is said, her father was opposed – Cahun flaunted convention in ways that were much more visible. In 1918 she had herself photographed with her head shaved; later, in Paris, she would sport a pink crew cut.[3] This was not simply a case of youthful rebellion, but a response to, among other things, the marginalized place of women in a chauvinistic intelligentsia. Cahun continued to write for the press using the pseudonyms 'Claude Cahun' and 'Daniel Douglas', the latter a reference to Lord Alfred Douglas, the lover of Oscar Wilde. Between 1918 and 1921 she also contributed texts to her father's short-lived journal, *La Gerbe*, while she and Malherbe collaborated on written works, sculptures, photomontages and collages.

When living in Nantes, Cahun established connections with such Paris-based literary figures as Philippe Soupault and Sylvia Beach, whose informal salons she would sometimes attend. She kept up these connections when, in 1922, she and Malherbe moved to the capital and settled in Montparnasse. It was with the move to Paris that Lucy Schwob became Claude Cahun. In 1925, having published little since 1921, Cahun released some of the stories in her 'Héroïnes' series – subversive retellings of the lives of well-known women from history, mythology and the Bible. Both Cahun's literary works and her portraits are considered explorations of the fluid and constructed nature of identity and gender. Yet despite her lifelong artistic collaboration with Malherbe, including a period of involvement with the theatre, almost all of Cahun's *œuvre* is driven by a narcissistic exploration of her *own* selfhood. Her most sustained investigation of interiority is the text *Aveux non avenus* (*Disavowals; or, Cancelled Confessions*; 1930), with photomontages by her and Malherbe. It begins, 'Indiscreet and brutal, I enjoy looking at what's underneath, the crossed-out bits of my soul.'[4]

Cahun's alignment with surrealism in the 1930s is inseparable from both her political radicalization and her association with André Breton, to whom she was introduced in 1932. That year she became a member, like Breton, of the Association des Écrivains et Artistes Révolutionnaires. She remained ideologically allied with the founder of surrealism even as he became alienated from many of his artistic and political confrères; like Breton, she was both anti-fascist and anti-communist. In 1934 she published *Les Paris sont ouverts* (*Place Your Bets*), a short polemic in which she wrote, 'Indirect action to me seems the only efficient action, from the point of view of propaganda and poetry.'[5] She also argued for an art that was accessible to everyone.

According to the writer Gavin James Bower, it was in 1936 that Cahun emerged as a fully fledged surrealist.[6] A participant that year in the 'Exposition Surréaliste d'Objets' at Galerie Charles Ratton in Paris, Cahun at this time was working less with self-portraiture and more with sculpture, or rather (*pace* Salvador Dalí) 'objets à fonctionnement symbolique', objects that become surrealist by being taken out of context. She had begun making assemblages in 1926, hybridizing portraiture and sculpture for the series 'Entre nous'. The first of her (known) images of objects arranged entirely for the camera date

Self-Portrait (Sleeping in Compactum Wardrobe), c. 1932

from 1935. The following year, Cahun began to create plastic objects, some of which she documented in photographs. Also in 1936 she travelled with Breton to London and assisted in the organization of the 'International Surrealist Exhibition' at the New Burlington Galleries. Surrealism was a 'men's club',[7] and her acceptance by its adherents must have been bittersweet; for her part, Cahun asserted that she had always been a surrealist, even as a child.[8]

In 1937 Cahun and Malherbe left Paris for the British island of Jersey, where Cahun had holidayed in her youth and to which she and Malherbe had been regular visitors. They acquired a house, La Rocquaise, and moved in the following summer. With the fall of France in 1940, Cahun and Malherbe did not leave Jersey, but stayed and lived under the German occupation of the island. Now, the indirect action of the artist became the covert action of the self-appointed resistance worker. Spurning approved propaganda, Cahun and Malherbe chose to create their own, distributing treasonous injunctions that appeared to have been written by a disillusioned German soldier, and endeavouring to suggest (through variations in the typing) that theirs was the work of many. Cahun and Malherbe were finally arrested for their activities on 25 July 1944; both attempted suicide by cyanide but survived. Following a successful appeal against their death sentences, they remained in prison until the liberation of the island on 8 May 1945. They returned to La Rocquaise only to find that many of their works, papers and possessions had been destroyed during a raid on the house.

In 1953 Cahun and Malherbe visited Paris, to which Cahun wished to return. Her failing health is likely to have prevented her from doing so, however, and she died in Jersey the following year. Malherbe, who gave up their house and moved to nearby Beaumont, committed suicide in 1972. Malherbe is much less well known than Cahun, despite evidence to suggest that she collaborated on many of the works attributed to her lover, including the celebrated self-portraits. Cahun knew she was a narcissist, and although she evinced concern that her decision to distribute anti-Nazi propaganda had made Malherbe vulnerable, it seems that it was her own needs and wishes – psychological, creative, intellectual, political – that took priority. Or perhaps this is a fiction of both their making. After all, the most enduring work of art of both their careers was 'Claude Cahun'. ■

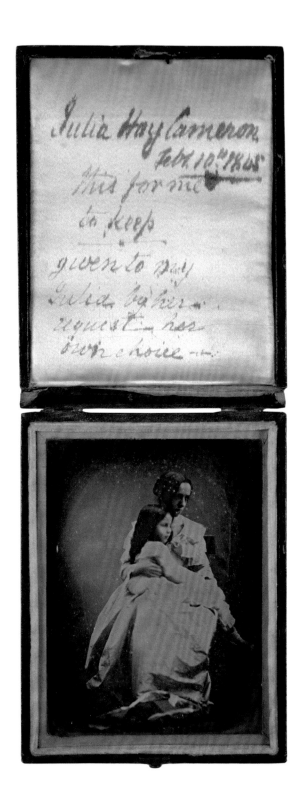

Photographer unknown, *Portrait of Julia Margaret Cameron with her daughter, Julia*, 1845

Julia Margaret *Cameron*

1815–1879

*My aspirations are to enoble photography and to secure
for it the character of high art by combining the real
and the ideal and sacrificing nothing of Truth by all
possible devotion to poetry and beauty.*

JULIA MARGARET CAMERON

In 'Annals of My Glass House', the unfinished memoir that Julia Margaret Cameron (née Pattle) began in 1874, she wrote that authors of such accounts should avoid including 'details strictly personal and touching the affections'. That she could not refrain from doing so is symptomatic of her lifelong concern with the relationship between life and art. A happily married woman, and a doting (if somewhat overbearing) mother of six, she took up photography as an amateur at the age of forty-eight. It is often said that Cameron embodied the typical English upper-middle-class values of the day, but she did not fit any of the normative categories of the time, social or otherwise. She grew up in India, she was close to her French grandmother, her family and that of her husband were moving down rather than up the socio-economic scale, and her taste in dress and decor was progressive. Central to her photography was a refusal to separate the creative realm from that of the familial, domestic and personal, and her remarkable *œuvre* blurred the lines between the artistic and the social distinctions of her time. In subjecting all her sitters, whether high-born or low-born, to her characteristically authored, differentially focused style, Cameron claimed a mark of distinction for them on the basis of their beauty or their talents. In an increasingly secular society, her photography attempted to secure for both the sitter and the photographer a life after death.

Cameron was friends with, among many others, the poets Alfred Tennyson, Henry Taylor and Robert Browning, the writers Anthony Trollope, William Makepeace Thackeray and Thomas Carlyle, the artist George Frederic Watts, and the scientists Sir John Herschel and Sir Charles Darwin (with the exception of Thackeray, she also

photographed all of the above). The fact that we identify such figures as belonging to the same intellectual milieu owes a good deal to Cameron's desire to bind herself to others in intimate friendship. The first clique to which she belonged was that of 'Pattledom', the name that, it is said, Thackeray coined to describe the world of the Pattle sisters: Adeline, Julia, Sara, Maria, Louisa, Virginia and Sophia. The sisters' sense of a shared identity would appear to be, on one level, a response to their unusual upbringing. They were born and brought up in Calcutta in British India; their father was James Pattle, an Englishman who worked for the East India Company; and six of the seven sisters would marry colonials. And yet the values of Pattledom were not simply those of the British expatriate: their mother, Adeline de l'Étang, was of French descent, and Adeline, Julia, Sara and Maria each spent significant portions of their childhood in Versailles at the home of their maternal grandmother, who had been born in India and whose great-grandmother was Bengali. Growing up between Calcutta, Versailles, Paris and London, Cameron learned to speak English, French and Hindi (and later German), but it is thought that she and her sisters had a haphazard education. The Pattle sisters were evidently proud of their mixed heritage and unconventional upbringing; Cameron used the term 'English' to characterize a sensibility that she did not share.

In 1837 Julia Margaret Pattle was at the Cape of Good Hope recuperating from a breakdown. The cause is unknown, but it came shortly after the death of her elder sister, Adeline, from complications arising from childbirth; it also occurred at a time when, as one commentator has observed, she was desperate to get away from her reputedly drunken and unscrupulous father. At the Cape, she made the acquaintance of two of the most important figures in her life: the astronomer Sir John Herschel and Charles Cameron, a legal scholar twenty years her senior. In February 1838 she and Cameron were married in Calcutta, and in December that year their first child, Julia, was born. The following year, in Paris and London respectively, two different methods of capturing the image produced by a camera obscura were announced. Herschel, now back in England, was an important early photographic experimenter: he coined the term 'photography' for the new process, as well as 'negative' and 'positive', and discovered that hypo (sodium thiosulphate) could be

Brassaï

1899–1984

I invent nothing, I imagine everything.

BRASSAÏ

As a young man, Gyula Halász – known to us by his pseudonym, Brassaï – was preoccupied with artistic self-expression. Born in Brassó in Transylvania, at that time part of Hungary, he trained as an artist in Budapest and then Berlin. In both Berlin and Paris, to which he moved in early 1924, his commitment to finding his own creative voice was in tension with the work he undertook to supplement the money he received from his parents: first journalism, then photojournalism and art photography. Photography brought Brassaï (meaning 'from Brassó') both fame and financial independence. That it did so troubled him greatly; what he really wanted was to be an artist like Picasso.[1] We might conceive of the photographer as two distinct characters: 'Gyula Halász', the would-be avant-garde artist who became a photographer by accident, and 'Brassaï', the Renaissance man who chose photography as his primary means of self-expression. His eventual identification of his true self with his pseudonym, and with France, was probably a deliberate response to a highly fractured sense of identity.

Brassaï's obsession with selfhood was shaped by both youthful self-absorption and the political upheavals of the early twentieth century. In 1918, following the collapse of the Austro-Hungarian Empire and the emergence of a (briefly) independent Hungary, Brassaï travelled to Budapest and enrolled in the Academy of Fine Arts. There, he fell under the spell of the avant-garde artist János Mattis-Teutsch. In the autumn of 1919 he joined the Hungarian Red Army – as a military telephonist – to resist the alliance of Czech, Serb, French and Romanian forces opposed to the recently formed Hungarian Soviet Republic. The defeat of the Hungarian revolutionaries by the Romanian army saw him, so it is said, held as a military prisoner for several weeks,[2] while the failure of the short-lived republic led to the repression of communist sympizers. In 1920 the Treaty of Trianon was signed, and Transylvania became Romanian and Brassó became

Braşov. It is no surprise that Brassaï, now a citizen of an enemy country, wished to continue his studies elsewhere.

The frank, boastful and sometimes petulant letters that Brassaï sent to his parents and brothers begin in December 1920 on his arrival in Berlin, to which he had moved to find 'his own means of expression'.[3] After working in a private atelier for a while, he applied, successfully, for a place at the School of Arts and Crafts. In mid-1921, having been advised by the artist Emil Orlik (or so he said) that his work was more suited to 'the academy', he enrolled in the Akademische Hochschule in Berlin-Charlottenburg.[4] By this point he had already had a number of articles accepted for publication in the Hungarian press, and in late 1921 he was granted his first exhibition, featuring his drawings. It was around this time that he began to reject expressionism in favour of Neue Sachlichkeit (New Objectivity).

In early 1924 Brassaï arrived in Paris, immersing himself in its expatriate Hungarian community. In his letters home he talks of both his pleasure and his frustration at having to adopt myriad personas in order to sustain his life in the French capital. One of those guises was as the escort of Marianne Delaunay-Belleville, a middle-aged woman of means separated from her car-manufacturer husband. Despite his mixed feelings about his activities in Paris, it was a city to which he had a strong emotional attachment. In 1903 his father, a professor of French literature who had studied at the Sorbonne, had moved the family to Paris as part of a year-long sabbatical. Writing about the experience some fifty years later, Brassaï recalls his sense of wonder at encountering, as a child, the 'plus beau spectacle au monde', the Parisian boulevards.[5]

Brassaï liked to say, 'I invent nothing, I imagine everything', a paraphrase of the expression used by the biographer George D. Painter to describe Proust's retelling of his life in *In Search of Lost Time* (1913–27): 'though he invented nothing, he altered everything'.[6] Brassaï's reworking of Painter's words is an astute description of the nature of his engagement with reality. For a man who worked (at first) with a tripod, and who sometimes stage-managed the scenarios he photographed, it was not about capturing a fleeting moment of street life, but about recreating by photographic means a scene either witnessed or imagined. It is clear from his letters home that Brassaï knew that he was not holding up a mirror to Paris in his early journalism and photography,

but was instead speaking to the idea of the city as formed in the minds of a European readership.

As early as 1925 it had been suggested to Brassaï, by a German publisher, that he take up photography instead of supplying the work of others through his one-man photo agency.[7] It appears that he finally did so at the end of 1929. His preface to the published collection of his early letters (1978) tells the reader not to be fooled by the suggestion that he took up photography for pragmatic reasons.[8] Indeed, across the preceding twenty-five years, he had identified this decision as one made for art, not money, 'Because I could no longer hold the pictures in me.'[9] He also presented it as one made in anticipation of his first, decisive success: the book *Paris de nuit* (1932).[10] Brassaï claimed that the moment he adopted photography as a means of self-expression, he lost interest in photojournalism – a convenient piece of fiction that served to elevate his art practice.

According to Brassaï, 1932–3 marked a 'turning point' in his life, not only because of the success of *Paris de nuit*, but also because of the access his work for the journal *Minotaure*, edited by André Breton, gave him to the lions of the Parisian art world.[11] The Greek critic and publisher Efstratios Eleftheriades, aka Tériade, commissioned him to photograph artists and their studios for *Minotaure*, and many of these encounters led to the friendships he would write about in *The Artists of My Life* (1982). That these friendships were brokered by work rather than art is no doubt partly responsible for his later insistence on his intellectual and aesthetic proximity to such figures as Man Ray and Picasso. It was likewise important to him to stress the degree of control he was given by Carmel Snow, editor of *Harper's Bazaar* from 1933 to 1957, in his long association with the magazine.

Brassaï's claim that he embraced photography as a means of creative expression in 1930 is at odds with his journal of 1937. On 6 March that year he wrote: 'I must get back to the plastic arts ... Photography is really only a starting point ... It is choice and not expression.'[12] We can infer some of the causes of this crisis from his writings: the continuing chastisement of his mother for wasting his life, the admiration expressed by Picasso and others for his drawings from his Berlin period, and the (unrecorded) ultimatum he set himself at thirty regarding where he would be at forty.[13] It seems that the crisis was resolved, in the short term at least, for pragmatic reasons. He had been working

for the Rapho photo agency since 1934, and by 1937 was seeing the fruits of his work for *Harper's*; that summer, he made '40,000 francs in two or three months from magazine work'.[14]

It could be said that Brassaï, who took French citizenship in 1949, effectively became French during the Second World War. Unlike many of his circle, he did not leave Paris in the late 1930s, and it was only in June 1940, when the bombing of the city began, that he took temporary refuge in the south-west of France. When in July 1948 he married Gilberte-Mercédès Boyer, an archivist at *Volonté* magazine, it is said that she made it a condition of the marriage that he become a French citizen.[15] This may have been in order to help him overcome his reluctance to leave France: his wife later speculated that the reason he would not travel was in case he was barred from re-entry.[16]

Brassaï never practised photography exclusively, also engaging in film-making, poetry and sculpture. Yet despite his activities in these and other media, it was only for his photography that he gained the recognition he had craved as a young man. In 1937 some of his photographs were included in 'Photography 1839–1937' at New York's Museum of Modern Art (MoMA). In 1956 a monographic show of his 'Graffiti' photographs opened at MoMA, and in the following year he was awarded a gold medal at the Venice Biennale. Major shows in Paris, New York and London followed in the 1960s and 1970s, and in 1978, a few years after receiving the Légion d'Honneur, he was awarded the Grand Prix National de la Photographie.

The young Brassaï was intent on finding a voice of his own. Alienated from the country of his birth, he made a virtue of his position as an outsider and observer. One of the many guises he adopted to make his way in the world was that of photographer, but instead of abandoning the practice as he had intended, it came to define him. Because in his youth he was so concerned with appeasing his parents, and in maturity with rewriting his biography to suggest that his choice of photography was a deliberate one, it is necessary to read between the lines. For the last ten years of his life he worked on *Proust in the Power of Photography* (1997), in which he sought to demonstrate that this giant of French culture had been enthralled by photography and had used it as a key plot device in his magnum opus. The elevation of photography to the level of a classic of French literature was, perhaps, his way of making peace with both his father and his younger self. ∎

The Daughter of Joy at Russian Billiards, Montmartre, 1933

Self-Portrait, 1927

used to stabilize, or 'fix', an image. In 1842 Herschel sent specimens of 'Talbotypes' (photographs on paper) to Cameron, who, still in Calcutta at that time, complained of the lack of intellectual stimulation there. When in 1845 the time came for young Julia to be sent to Europe for her health, as was the custom, Cameron turned to photography for consolation, commissioning a daguerreotype (a photograph on metal) of her and her daughter.

In 1848, three years after the deaths of Cameron's parents, one after the other, she and Charles settled in England with their children Julia, Eugene, Ewen and Hardinge (they would have two more boys: Charlie in 1849 and Henry in 1852). Two of Cameron's sisters, Sara and Virginia, were already based there, and Maria returned to England that same year. After meeting the poet Henry Taylor in 1849, Cameron, likely jealous of the social success enjoyed by her sisters Sara and Virginia, immediately embarked on a campaign to secure a place for herself in both Taylor's and his wife's affections. It was through the Taylors that Cameron was introduced to an even greater literary figure, Alfred Tennyson. In 1852, when Emily Tennyson went into premature labour at the Tennyson's home in Twickenham, Cameron set off immediately for central London to fetch the doctor. It was this act that finally conquered the last vestiges of the poet laureate's resistance to her persistent attempts at intimacy. Cameron would repeatedly perform 'an utter and exhausting sacrifice of self' in order to bind to her in obligation those she desired as intimate friends.[1] It was only when their resistance had been overcome in this way that they came to characterize Cameron's 'great gift [as] that of loving others and forgetting herself'.[2]

In 1853 Tennyson and his family moved to Freshwater, a village at the western end of the Isle of Wight. Seven years later, after Charles had recovered from a long period of ill health brought about by a visit to the family's coffee estates in Ceylon (now Sri Lanka), the Camerons also settled there. It was at Freshwater that Cameron took up photography; it was there too, according to the English essayist and biographer Wilfred Ward, that she entered into a battle of will and wit with Tennyson.[3] The clashes between Cameron and the poet were expressions of the dynamic on which Cameron thrived: the encounter with resistance when attempting to subject both people and experience to her will. Writing to Herschel about an English prejudice

against iambic pentameters, and claiming that 'the more violent the resistance the more likely the success', she might have been formulating a personal and aesthetic credo.[4] Her words also speak to the lengthy and uncomfortable photographic sittings to which she subjected her sitters. The poses and expressions she directed her subjects to adopt were very difficult to maintain during the long exposures that her method demanded. Tennyson consented to sit for her a number of times, but vexed her by claiming that he preferred the portraits taken of him by the commercial studio of Mayall & Co.

When Cameron took up photography in late 1863, she was at pains to present herself as a novice who created her imagery without regard to contemporary practice, commercial or otherwise. Yet in the late 1850s she was using photographs in increasingly active ways, commissioning portrait photographs from commercial practitioners both of her family and of Tennyson and Taylor, compiling elaborate photograph albums for family and friends, and even printing (and cropping) from some of Oscar Rejlander's negatives. In 'Annals of My Glass House', she wrote that she was given a camera for Christmas 1863 by her son-in-law and daughter, with the words, 'It may amuse you Mother to photograph during your solitude at Freshwater.'[5] A wooden sliding box camera designed to take 11 × 9-in. plates was a very expensive (and very large) gift, and so it seems likely that it did not come as a complete surprise to Cameron.

The mention of Cameron's 'solitude at Freshwater' is intriguing. It may be a reference to the fact that, a year or two later, the last of the Cameron children either would be at boarding school or would have left home entirely. It is also possible that it was an allusion to the change that came over her husband following the move to Freshwater. Writing to her sister Maria from Ceylon in 1878, she noted that Charles was aware of 'the dormouse state in which he passed 10 I might say 15 years of his life at Freshwater'.[6] The 'dormouse state' to which Cameron refers was characterized by visitors to Freshwater as a retreat by Charles to his bedroom and into the realm of the intellect. Charles's advancing years and general ill-health may have been responsible for this period in his life, but it is also likely that it was brought about by his addiction to the laudanum he had been prescribed as a painkiller. Whatever the reason for his withdrawal from his wife, it seems clear that the loss of intimacy and intellectual

I Wait (Rachel Gurney), 1872

company was deeply felt by her, and that this significantly shaped her art practice.

Cameron rarely photographed her female sitters as themselves, instead depicting them as characters drawn from history, mythology, the Bible or fiction; and for those male figures who could not be persuaded to playact in front of the camera, she generally used a cloak or blanket so that the resultant image would appear timeless. One of her sitters claimed that Cameron the woman awoke others to their ideal nature;[7] another claimed that Cameron the photographer taught her sitters to recognize this nature in themselves by transforming them into fictional characters who embodied elevated qualities.[8] When Henry Taylor spent a few weeks in Freshwater in (probably)

Parting of Sir Lancelot and Queen Guinevere, 1874

1864, and was, so he claimed, photographed every day of his visit, his wife wrote of the results: 'most of them I think very grand; decidedly grander than anything you have yet written or lived; so I begin to expect great things of you.'[9] It is believed that Cameron wrote to her niece Julia Jackson saying, 'When the spirit is with me, I must praise those I love.'[10] Such praise, it is generally assumed, was a genuine expression of admiration; however, in common with everything Cameron did to excess, her praise had a strategic element. George Frederic Watts complained to Taylor in 1859 that 'Mrs Cameron's enthusiastic and extravagant admiration is really painful to me, for I feel as if I were practising a deception upon her. She describes a great picture, but it is hers & not mine.'[11] For Cameron, who 'allowed herself in life and on paper more space than is usually accorded to other people', photography served as an alibi for intervention, both intellectual and emotional, in the life and art of others.[12]

As a photographer, Cameron made more than a thousand exposures, each of which would have taken considerable skill to produce. Her success at selling her photographs, which, from 1864, she exhibited regularly, was negated by her generosity in giving them away. The Camerons' finances were decimated by the poor returns on their investments in Ceylon and by the expensive education of their sons, and in 1875 they relocated to Ceylon - where four of their five sons were already living and working - owing to the need to economize. When the couple, accompanied by their son Hardinge, boarded ship at Southampton, among their possessions was a pair of coffins, a dairy cow and Cameron's camera. A few months after a visit to England in mid-1878, Cameron died at the Ceylon home of her youngest son, Henry. Some years later, Henry, her 'Benjamin', returned to London and set up as a professional photographer. Cameron's photography was much admired by the pictorialists of Henry's generation, who saw in it a historical lineage for their artistic conception of photography. What initially secured her claim on posterity, however, was not her remarkable photographic aesthetic or her formidable intellect and wit; rather, it was her proximity to the 'famous men and fair women' of her time.[13] We can now see her role as an acolyte as a pose: in both her life and her art, Julia Margaret Cameron sought to transform everyone and everything in her own image. ■

Photographer unknown, *Portrait of Robert Capa*, 1940

Robert *Capa*

1913–1954

It is not enough to have talent.
You also have to be Hungarian.

ROBERT CAPA

In the field of photography, the biographical elements that distinguish the lives of so many of the practitioners of the early twentieth century – a Jewish ancestry, a changed name, a youthful allegiance to the Left, a life-changing sojourn in Paris, a peripatetic existence, the threat in the 1950s of denunciation as a communist, and a rewriting of biography both for dramatic effect and to neutralize youthful left-wing allegiances – are exemplified by the life of Robert Capa. Arguably the most famous war photographer of all time, Capa is celebrated for the unvarnished veracity of his images and his unprecedented proximity to the action, whether military or political. And yet his memoirs of his time as a US Army photographer in the Second World War are so exaggerated as to border on fiction. One of his most famous images, known popularly as 'The Falling Soldier', is now suspected of being faked. Photojournalism gave meaning and purpose to the vagabond existence imposed on many of his generation by the political and personal turmoil of the two world wars; it also offered the shield of neutrality. For Capa, who had lived on his wits since childhood, photography was his freedom of passage.

Born Endre Ernő Friedmann, Capa was the second son of Julianna (Julia) Berkovits and Dezső Friedmann. The Friedmanns were an upwardly mobile couple who had begun their working lives as apprentices, she to a dressmaker and he to a ladies' tailor. After their marriage, in 1910, the couple opened a custom dressmaking salon in the fashionable Belváros district of Budapest. While Capa is said to have characterized his parents' marriage as 'one long, pitched battle', it seems that the behaviour that his mother deplored in his father (such as gambling, idling and blagging) she encouraged in her favourite son.[1] In the difficult times that followed the collapse of the Hungarian Soviet Republic in the summer of 1919, it was his father's ingenuity

that helped feed the family.[2] Within only a matter of months that year, the five-year-old Capa would have experienced the optimism of the communist republic, the nightmare of the White Terror (the violent repression of communist sympathizers) and, shortly afterwards, the starting of school. Beyond the classroom, the boy nicknamed 'Cápa' ('Shark') ran wild with his friends, pulling pranks and evading capture.

The teenage Capa was drawn into avant-garde culture and politics through the journal *Munka*, joining the protest marches (against the hardships caused by the Depression) that its supporters endorsed. The anecdote in which he flirted with joining the Communist Party but decided against it is perhaps the earliest in Capa's biography for which there is strong evidence that he was embroidering the truth.[3] An abortive meeting with a party recruiter led, so the legend goes, to him being taken to an interrogation room and beaten, thrown in a cell, and released only when his father impersonated a secret policeman.[4] Capa's subsequent departure for Berlin, on 12 July 1931, was identified by his brother Kornell (later 'Cornell Capa') as a condition of his liberty.[5] Like so much of Capa's biography, this may be a fabrication: the evidence suggests that he would not let the truth get in the way of a good story.

Once in Berlin, Capa made contact with members of the extensive network of expatriate Hungarians, including the photographer Éva Besnyő, his childhood friend, and the artist, designer and teacher György Kepes. Capa was enrolled at the Deutsche Hochschule für Politik, but had been there for only a few months when the Hungarian economy collapsed. With his family no longer able to afford the allowance they had been sending him, he managed to get a job as a darkroom assistant at the Dephot (Deutscher Photodienst) photo agency. The various accounts of how Capa graduated to photographer for the agency are rather too anecdotal to ring true. What we do know is that in November 1932 he travelled to Copenhagen to cover Leon Trotsky's first public appearance since his expulsion from the Soviet Union, a major coup for such a young and inexperienced photographer.

In February 1933 Capa left an increasingly dangerous Berlin for Vienna. That June, he travelled to Budapest for the summer and produced scenic photographs for a travel agency. He then returned to Vienna with his friend Csiki (Imre Weiss) and worked as a news photographer for another photo agency. By now, a pattern had emerged

that would remain constant for the rest of Capa's life: long periods
without money would be broken by sudden windfalls, and when cash
was received it would often be squandered on short bursts of high
living. A loan from a loyal client of his mother's is said to have pro-
vided Capa and Csiki with the means to travel to Paris in September
1933.[6] Once these funds had been exhausted, the pair resorted to petty
crime.[7] The stories about this early period in Paris are, like all anec-
dotes about Capa, colourful and entertaining. It is also likely that they
were strategic: the more he appeared as a lovable, impoverished mav-
erick, the more latitude he was afforded by friends and strangers alike.

Ingrid Bergman on the set of 'Arch of Triumph', 1946

The friends that Capa (then known as André Friedmann) made in Paris included the photographers David Szymin (later David Seymour, known as 'Chim'), Henri Cartier-Bresson and Gisèle Freund. Later in life he would also move in celebrity circles, becoming close to the likes of Ernest Hemingway, Gene Kelly and John Huston. The characterization of Capa as a louche charmer, interested only in the next adrenalin rush, is one that must have served him well when, in 1953, he had to prepare an affidavit for the FBI regarding whether or not he had been a communist.[8] Despite the efforts of Richard Whelan, Capa's official biographer, to underplay the evidence of his commitment to left-wing politics, there is plenty of evidence to suggest that Capa was indeed politicized. On one reading, he was radicalized in Berlin and maintained an active commitment to the cause while living in Vienna and then Paris. It was in the latter that he got to know Gerta Pohorylle, a Jewish woman originally from Stuttgart who had been arrested by the Nazis as a communist agitator. Capa and Pohorylle fell in love, and, in 1935, moved in together; according to legend, he taught her to use a camera and she took on the role of his manager. By March of 1936 Capa had secured regular work from the Alliance photo agency. That spring and summer he produced numerous features for the left-wing illustrated press on the rise to power of the Front Populaire.

Around 1936 André Friedmann became Robert Capa, and Gerta Pohorylle became Gerda Taro. Capa's pseudonym, according to Capa himself, was invented as a way of increasing the fees he was paid as a photojournalist.[9] He and Taro now claimed to represent a celebrated – and elusive – American photographer called Robert Capa. Although the ruse was soon exposed, the gamble paid off: before long, 'Robert Capa' would be even more celebrated than his inventors had claimed. It was the Spanish Civil War (1936-9) that, literally, made his name. Capa and Taro arrived in Barcelona in August 1936 (after surviving a plane crash) and travelled to the region of Aragon. It was, so the story goes, on 5 September at Cerro Muriano, north of Córdoba, that he took his most famous photograph, allegedly capturing the moment when a Loyalist militiaman was felled and killed by a bullet. Today, there are conflicting accounts of the making of this icon of photojournalism. In one version, Capa is plagued by guilt after staging a scene that turns from fiction to fact. This coheres with the idea that the tall stories he told about himself, and perhaps his heavy drinking,

were means to assuage his feelings of guilt. Not only did he leave Budapest for Berlin instead of helping with the family business (as his elder brother, László, had), but also it was he who introduced Taro to photojournalism. In 1938 Capa published *Death in the Making*, with 'The Falling Soldier' on its cover, as a tribute to Taro, who had died in the field the previous year.[10]

The standard characterization of Capa as a war photographer neglects the fact that central to his output were the human-interest stories that formed the mainstay of the popular illustrated press. During the Spanish Civil War, much of his work was humanist in tone, focusing on the effects of the conflict on the Spanish population. Nor was he in Spain for the duration of hostilities. In January 1938, in addition to trips to Paris, New York and Brussels at other times in the war, Capa travelled to China with the Dutch film-maker Joris Ivens to make a documentary about the communist and nationalist alliance that was resisting the Japanese invasion. He stayed in China for around seven months, also supplying stills to the Western illustrated press. He arrived back in Spain in time to photograph, in October 1938, the International Brigades (the pro-Republican military units composed of volunteers) prior to their disbandment.

At the outbreak of the Second World War Capa left Europe for New York, where his brother Cornell was now based. He managed to circumvent the expiration of his temporary US visa by a marriage of convenience to a woman called Toni Sorel, whom he had met through friends. Capa then worked out the necessary six-month leave of absence by going to Mexico in April 1940 and photographing the political unrest around the elections there. He returned to America – his resident status now secured – via Texas, eventually making his way back to New York. In the summer of 1941 he arrived in London to collaborate with Diana Forbes-Robertson on *The Battle of Waterloo Road* (1941), a book about the working-class Londoners who had endured the Blitz. Capa returned to Britain the following summer and stayed until the spring of 1943, not only because of his wartime photojournalistic work but also because he had fallen in love with Elaine Justin, a young, married Englishwoman known to her friends as 'Pinky'.[11]

Capa's unreliable memoir, *Slightly Out of Focus* (1947), begins with the story of how he managed to become an accredited war photographer with the US Army despite being classified, as a Hungarian,

as an enemy alien. Having received his full accreditation in March 1943, Capa spent the next twelve months documenting various Allied operations in Europe, including the liberation of Naples in September 1943 (for *Life* magazine) and the amphibious landing at Anzio, south of Rome, on 22 January 1944. By April that year, Capa was in London; a few weeks later, he was with the 116th Infantry on a US Coastguard transport ship as they prepared for D-Day. He crossed the English Channel on 5 June, was transferred to a landing craft, and arrived on Omaha Beach with the first wave of American troops. Recent scholarship suggests that the standard account of this terrifying posting – which claims that Capa took more than a hundred negatives, and that all but eleven were destroyed in a darkroom accident – is substantially untrue. It is speculated that Capa, a prisoner of the myth of his own fearlessness, may in fact have lost his nerve.[12]

Capa returned to Omaha Beach on 8 June, and was in Bayeux by that evening. He remained with US forces throughout the gruelling campaign in Normandy, and, after a brief sojourn in London, returned for the push towards Paris and the subsequent liberation of the French capital on 25 August 1944. In December of that year he was at the Battle of the Bulge. In the following March he parachuted into Germany with the US 17th Airborne Division, travelling with the Allied invasion to Leipzig, Nuremberg and, ultimately, Berlin, the now-decimated city that had once been his home. Arriving in Berlin in 1931 he had been a Hungarian; in 1945, he was an American.

Capa's next major adventure was romantic: a daring overture made to the actress Ingrid Bergman (at that time married to Petter Lindstrom) led to a two-year affair. It was in 1947 that Capa, together with Chim, Cartier-Bresson, George Rodger and William Vandivert, helped to establish Magnum, the cooperative photo agency in whose running Capa has been credited with playing a major role.[13] In the late summer of that year he travelled to Russia with the American novelist John Steinbeck on a trip financed by the *New York Herald Tribune*. Between 1948 and 1950 Capa visited the Levant three times, covering the foundation of Israel and the subsequent Arab-Israeli War. His mainstay in the late 1940s and early 1950s was *Holiday* magazine, which offered a generally upbeat image (often in colour) of post-war European leisure. His last major affair was with the American divorcee Jemison McBride Hammond, whom he met at a party in early 1949.

Capa was an inveterate gambler: at the poker table, at the racetrack and in life. In May 1954 he was offered the role of war correspondent for *Life* magazine in Indochina (now Vietnam). Despite having renounced both war and war photography many times (or so it is said), he accepted. On 25 May he joined a French convoy on a mission to demolish two forts in the Red River Delta. When the convoy was halted on the road, Capa walked on, stopping to photograph the French platoon advancing through the grass. These would be his final photographs: he stepped on a Viet Minh anti-personnel mine and died, aged forty-one, from his injuries. With his tendency for braggadocio, Capa has been characterized as 'the man who invented himself'[14] and, to borrow the title of Patrick Jeudy's documentary of 2004, 'The Man Who Believed His Own Legend'. Yet, like Tim Bara, the character in Martha Gellhorn's novella *Till Death Do Us Part* (1958) said to be based on Capa, he was 'the sort of person people claimed to know when they didn't, made up stories about, quoted, were proud to be seen with, happy to be used by'.[15] Both the character known as 'Capa' and the much-vaunted unimpeachable veracity of his photographs owe a great deal to the projection of others. ∎

On the road from Namdinh to Thaibinh, Indochina (Vietnam), May 1954

Genevieve Naylor, *Cartier-Bresson outside a warehouse, New York, 1946*

Henri *Cartier-Bresson*

1908–2004

Photography is a form of intelligence.

HENRI CARTIER-BRESSON

Henri Cartier-Bresson's photographic *œuvre* – consisting of more than half a million negatives taken over the course of fifty-plus years in more than forty different countries – is a significant visual chronicle of the mid-twentieth century. Two early books of his photographs, *Images à la sauvette* (1952) and *Les Européens* (1955), demonstrated that street and reportage photography were capable of both informing the brain and pleasing the eye. Cartier-Bresson's name is practically synonymous with photography, and yet the man himself is elusive. He has been characterized as the 'master of photographic reportage',[1] but said of himself, 'I am not a reporter.'[2] Photographs by him first appeared in the illustrated press in 1932, the same year in which his images were first hung in a gallery. The greatest paradox presented by Cartier-Bresson is that photography was not his passion: he preferred, instead, to draw and paint. To one of the most widely acclaimed photographers the world has ever known, photography was simply 'accelerated drawing'.[3] Cartier-Bresson is elusive not because he did not speak about himself or his work, but because what he said was often contradictory or provocative. The man behind the camera was hiding in plain sight.

Born in Chanteloup-en-Brie, a village close to Marne-la-Vallée near Paris, Cartier-Bresson grew up in the French capital. The family business was the production of thread, and 'Cartier-Bresson' was a household name. According to the novelist and biographer Pierre Assouline, after Cartier-Bresson was caught reading Arthur Rimbaud's poetry at the École Fénelon by its chief supervisor, he found himself rebuked in public but privately encouraged to indulge his passion for literature.[4] He was originally intended for a leading business school and then the family business, but completed only a preparatory course in business studies. He also contrived to fail his baccalaureate three times. This youthful revolt set the pattern for the rest of his life: he would neither fully conform to the system nor entirely reject it.

Cartier-Bresson said, 'when I was a child I painted every Thursday and Sunday. The rest of the time I dreamt about it.'[5] His parents appear to have conceded to his wish to train as an artist in 1925. The following year he took private lessons from the painter Jean Cottenet; also around this time he received instruction, together with his cousin Louis, from Jacques-Émile Blanche. In the autumn of 1926 he enrolled at the Montparnasse art academy of André Lhote, and would remain enrolled until early 1928. It could be said that while Cartier-Bresson's training as an artist was conventional, his education was not. Through Blanche he met an array of figures from the worlds of art and literature, including the writer René Crevel, who introduced him to the surrealists. Cartier-Bresson attended their meetings in the Café de la Dame Blanche in Montmartre but apparently remained silent.[6] He later recalled that 'I liked [André] Breton's conception of surrealism a great deal, the role of spontaneous expression and intuition and, above all, the attitude of revolt.'[7]

In the spring of 1929 Cartier-Bresson began his national service at Le Bourget airfield outside Paris. In October 1930 he left France for the Ivory Coast. Arriving in November, he travelled widely – in Cameroon, in Togo and along the Niger River – and read extensively, including Rimbaud, Lautréamont and Blaise Cendrars. He returned to France the following spring. Only a very small number of photographs from this period, taken with a 30 × 44-mm Eka Krauss camera, survive; those that do are atypical for the period in that they resist ethnographic stereotyping. These works entered his official *œuvre* only at the end of his life; it was another photograph taken in Africa – *Three Boys at Lake Tanganyika* (c. 1929) by the Hungarian photographer Martin Munkácsi, showing local children running into the surf – that became the touchstone for Cartier-Bresson's nascent aesthetic.

Cartier-Bresson continued his travels in late 1931 in the company of the writer André Pieyre de Mandiargues, his childhood friend. In the summer of 1932 the two men also travelled with the artist Leonor Fini. Cartier-Bresson divided his work into two portfolios, each representing a different phase of his career: the 'First Album' (compiled in the summer of 1931), which consists of his early, Eugène Atget-influenced images from Paris, as well as the photographs he took in Africa; and the so-called Scrapbook (compiled in 1946). The latter begins in 1932 – the year in which Cartier-Bresson acquired a Leica, the camera he

would favour for the rest of his life – and the early pictures demonstrate the influence of the 'New Vision'. There can be little doubt that 1931 was a watershed: it was then that Cartier-Bresson, who wished to live freely and to travel widely, recognized that photography could be the means to do so.

The vagabond existence that Cartier-Bresson pursued in the 1930s was mapped out for him by the connections he made in Paris between 1929 and 1930. He became a regular fixture at the decadent house parties hosted by the Americans Caresse and Henry Crosby at their medieval mill outside Paris; there, he mixed with the likes of Breton, Crevel, Max Ernst and Salvador Dalí, among many others. It was through the Crosbys that he met Gretchen and Peter Powel, of whom little is known other than the fact that Cartier-Bresson claimed to have taken up photography seriously under their influence,[8] and that he and Gretchen were lovers.[9] It was also through the Crosbys that Cartier-Bresson met Julien Levy, who, having opened his New York gallery in 1932, put on 'Photographs by Henri Cartier-Bresson and an Exhibition of Anti-graphic Photography' the following year. Levy coined the term 'anti-graphic' to describe photographs that, in contrast to the distinctly arty, hand-worked prints associated with Alfred Stieglitz, were provocatively casual in both execution and composition.

In 1934, after becoming attached to an abortive ethnographic expedition, Cartier-Bresson travelled to Mexico, where he lived for several months in Mexico City. In March 1935 he and Manuel Álvarez Bravo staged a joint exhibition at the city's Palacio de Bellas Artes. The following month Cartier-Bresson left Mexico for the United States, ending up in New York. There, his works were exhibited with those of Álvarez Bravo and Walker Evans at the Levy Gallery.

Pieyre de Mandiargues said that in the first few years of their friendship, one of the many things that he and Cartier-Bresson encountered together was communism.[10] In a recent study of Cartier-Bresson, the curator and author Clément Chéroux is at pains to present him as having become, in the 1930s, an ideologue. Chéroux claims that Cartier-Bresson came to communism through the surrealists, or rather those surrealists who were aligning themselves with the cultural activities of the French Communist Party. Chéroux has pieced together the web of connections between Cartier-Bresson, his photojournalistic and film-making activities of the 1930s, and

communist proponents, organizations and causes in France, Mexico and New York, arguing that the photographer was radicalized in Central America and New York. While Chéroux's evidence is compelling, it could equally be argued that Cartier-Bresson's personal commitment was to culture as a weapon with which to fight fascism, rather than to a particular ideology. As he later said of the period, 'Hitler was at our backs. We were all on the Left. There is nothing to be ashamed of. Nothing to be proud of.'[11] For Cartier-Bresson at the end of the 1930s, now married to the Javanese dancer and poet Carolina Jeanne de Souza-Ijke (known as 'Eli'), the question of commitment was whether to be a photographer or a film-maker.

The day after the signing of the Franco-German armistice, 23 June 1940, Cartier-Bresson, a corporal in the French army assigned to the new film and photography unit in Metz, was taken prisoner. In February 1943, having spent almost three years in captivity, he finally succeeded in escaping from the prison camp. After hiding in a farmhouse in Loches, Indre-et-Loire, with other escapees, he made contact with what would eventually be called the National Movement of War Prisoners and Deportees, and obtained false demobilization papers. In September 1944, now in Paris to photograph the city's liberation, he obtained permission to make what would become *La Retour*, a film about the repatriation of POWs. 'The return' for Cartier-Bresson was back to Germany, for further filming in May and June of 1945. In the following year he and Eli travelled to New York. There, he helped prepare for the exhibition of his photographs that would be held at the Museum of Modern Art in early 1947, and which had been planned at a time when it was thought he had been killed in the war. It was also in New York that he began to work regularly on assignment for *Harper's Bazaar*. In what would become his modus operandi, Cartier-Bresson moved seamlessly, and successfully, between photographic art and photographic commerce.

Prior to the war, Robert Capa had proposed the establishment of a photographers' cooperative that would allow its members to retain copyright in their own images. This finally took shape with the incorporation of Magnum Photos in May 1947. The other central tenet of the cooperative was that the photographers, not their editors, should decide where they travelled. They therefore divided up the world among themselves: Europe for Capa and David Seymour ('Chim'),

Trafalgar Square on the Day of the Coronation of George VI, London, 1937

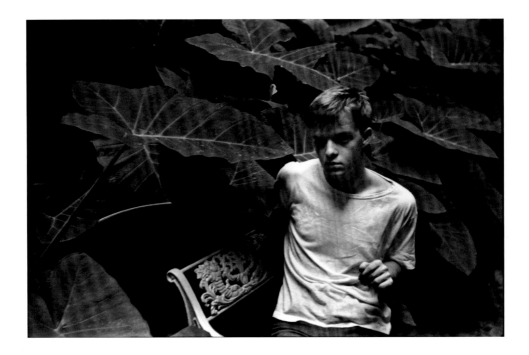

Africa and the Middle East for George Rodger, and Asia for Cartier-Bresson. In August 1947 he and Eli left New York on a ship bound for India and Pakistan and travelled for the next four years.

In January 1948 Cartier-Bresson met Mahatma Gandhi a few hours before his assassination and then remained in India to document the independence leader's funeral and the scattering of his ashes. Later in 1948, having travelled to Burma (Myanmar), Cartier-Bresson received a telegram from Magnum requesting that he go to China for *Life* magazine to record 'the last days of the Kuomintang'. In October 1949, having left China just as Shanghai fell to the communists, he photographed the independence of Indonesia. He and Eli then travelled to Sumatra, Bali, Singapore, Malaysia and Ceylon (now Sri Lanka), heading back to southern India in March 1950 before returning to France via Pakistan, Iran, Iraq, Syria and Lebanon, with a detour to Egypt. Magnum meant Cartier-Bresson could live, almost, like a free spirit.

In the early 1950s Cartier-Bresson was back in Europe but still on the move between countries. The year 1952 saw the publication of *Images à la sauvette*, with a cover designed by Matisse. The original title, which roughly translates as 'images on the sly', was a reference to Cartier-Bresson's working methods. These were described by the

Truman Capote, New Orleans, 1947

writer Truman Capote, with whom he was sent on assignment to New Orleans in July 1946: 'I remember once watching Bresson at work on a street in New Orleans – dancing along the pavement like an agitated dragonfly, three Leicas swinging from straps around his neck, a fourth one hugged to his eye: click-click-click (the camera seems a part of his own body), clicking away with a joyous intensity, a religious absorption.'[12] A television documentary on Cartier-Bresson from 1962 shows the photographer taking pictures in the street, and it is indeed a dance; his feet are in near-constant motion. It was in *Images à la sauvette* that Cartier-Bresson wrote: 'To me, a photograph is the simultaneous recognition, in a fraction of a second, of the significance of an event as well as the precise organization of forms which give that event its proper expression.'[13] The phrase 'un moment décisif' (from a quotation by Cardinal de Retz), which became 'the decisive moment' for the English-language version of the book, has become almost as well known as the photographer whose methods it describes.

In the summer of 1954, travelling on a visa secured for him by a Russian film-maker, Cartier-Bresson became the first Western photographer since 1947 to be allowed to take pictures in the Soviet Union. It is said that Magnum charged *Life* magazine a small fortune for the images.[14] In the late 1950s and the 1960s, exhibitions (most notably his first major show in Paris in 1955), books (including *Flagrants délits* in 1968) and international assignments came hand in hand. The end of the 1960s and the beginning of the 1970s, however, saw this period of art, work and adventure draw to a close. In 1967 he divorced Eli, and in 1970 married the photographer Martine Franck, with whom he had a daughter, Mélanie, in 1972. Perhaps this was the reason that Cartier-Bresson, now in his early sixties, lost his taste for roaming. In 1974, after many threats to do so, he finally resigned from Magnum. From the early 1970s onwards he took only portrait and landscape photographs, and returned to his first loves: painting and drawing.

According to anecdote, the mother of the gallerist Pierre Colle correctly predicted every major event of Cartier-Bresson's life – except, that is, for one: she said he would die young. In fact, he lived from the first decade of one century to the first decade of the next. But Mme Colle was not necessarily wrong: he may have been ninety-five when he died, but Cartier-Bresson was ever the young man with Rimbaud in his pocket. ■

Sherry Turner DeCarava, *Portrait of Roy DeCarava*, 1991

Roy *DeCarava*

1919–2009

You should be able to look at me and see my work.
You should be able to look at my work and see me.

ROY DECARAVA

Roy DeCarava's life and art confound the polarizing classifications that have been imposed on twentieth-century post-war photography. DeCarava used a 35mm handheld camera to take images on the streets of New York, in the homes of Harlem and in the bars and cafés of the jazz scene. Adopting the modus operandi of the street photographer did not mean, however, that he conceived of his photographs as reportage; rather, they are first and foremost visual poems. Frequently characterized as a 'Harlem photographer', DeCarava did not live in Harlem beyond his mid-twenties. The racial discrimination that he and his fellow African Americans were subject to (both pre-segregation and after) was one of his abiding preoccupations, and he was committed to challenging the pernicious yet largely unspoken prejudice he encountered as a black man. Dedicated to the idea of a 'black aesthetic', DeCarava was determined to make images that did not reduce the socially marginalized to ciphers of privation. His positivity and humanism were not confined to his art; his experiences of discrimination made him cherish life all the more.

Born in Harlem Hospital, DeCarava grew up in a number of multiethnic neighbourhoods: 'We had to move frequently – existing as we did on the rim of financial disaster, and dwelling in pocket areas ringed by hostile whites.'[1] When he was twelve, he and his mother – by then a widower from her second marriage – moved to a segregated area of South Harlem. In common with many of his peers, DeCarava did odd jobs as a child, such as selling newspapers and hauling ice. His mother wanted her son to be musical but was eventually reconciled to his preference for the visual arts. DeCarava, whose chalk pavement drawings gained him the respect of his peers, would spend entire days at the cinema: 'I think I absorbed the visual aesthetic of black-and-white films, so that when I started taking pictures it was natural.'[2]

DeCarava was educated at Cooper Junior High School in Harlem and then at the Textile High School, Chelsea. At the latter, African American pupils were encouraged to take practical classes, but DeCarava enrolled on a course in art appreciation – arguably the first instance of the photographer aligning himself with a mature tradition based on personal vision. After failing to obtain a scholarship to the Pratt Institute, DeCarava succeeded in winning the city-wide competition to attend the Cooper Union for the Advancement of Science and Art, which he joined in 1938. Despite this recognition of his talents, his time at Cooper Union was not a happy one. He was again one of only a few black students, and his white peers talked about art in a way that made clear the profound differences between their upbringing and his. He began to attend the free evening classes in life drawing and lithography offered by the Harlem Art Center, and left Cooper Union in 1940 to continue his art education there. From 1944 to 1945 he studied painting and drawing (again for free) at the left-leaning George Washington Carver School in Harlem, where, it has been suggested, he finally began to feel a sense of belonging. One of his teachers at the school, the painter Charles White, was an important early influence.

DeCarava's mother obtained employment from the Work Projects Administration, the New Deal scheme that aimed to secure for the long-term unemployed one job per household. At eighteen her son was allowed to replace her in a job of his own, at first in a clerical role but then in the poster division of the art project. In 1943 DeCarava married his first wife, Palma. That same year the couple's first son was born, and DeCarava was drafted into the army. After suffering a nervous breakdown, he spent a month in the psychiatric ward of the army hospital – his only experience of the army that was not segregated, and where, so he said, 'I learnt about democracy'.[3] Having spent around six months in the army, he was let out with an honourable discharge. On his return home, he endeavoured to secure a job in advertising but was unsuccessful in getting work above the level of technical illustration. He and Palma divorced in 1948, having had a second son the year before.

While at Cooper Union, DeCarava had begun to use a camera in the service of his artwork, but it was not until 1947 that he became 'seriously interested in photography as an art form'.[4] Henri

Cartier-Bresson, whose retrospective was held at the Museum of
Modern Art (MoMA) that year, was a major influence: like Cartier-
Bresson, DeCarava chose to take photographs in natural light only, but
using an Argus A rather than a Leica. In 1950 Mark Perper of the 44th
Street Gallery decided to hold an exhibition of DeCarava's Harlem
photographs. When DeCarava mounted 175 images on the walls,
Perper called in the photographer Homer Page, who re-curated the
show in sixty images. Page's influence was pivotal: their discussions
led to DeCarava's decision to print in 'a narrower range of soft tones'.[5]
Page and Perper invited Edward Steichen, at that time the curator of
photographs at MoMA, to see the show, and he purchased three works
for the museum. Steichen promoted DeCarava's photography from
that point on, first showing his work in the group exhibition 'Always
the Young Strangers' (1953).

Steichen encouraged DeCarava to apply for a Guggenheim
Fellowship, and in 1952 he became the first African American pho-
tographer to secure the award. In his proposal he declared, 'I want
to photograph Harlem through the Negro people', but added, 'I do
not want a documentary or sociological statement, I want a creative

Sun and Shade, New York, 1952

expression.'[6] Three of the resulting photographs were published in *The Columbia Historical Portrait of New York* in 1953, and there was an exhibition of the work in 1954, at the Little Gallery at the Hudson Park Branch of the New York Public Library. A year later, four of the photographs were included in 'The Family of Man', the Steichen-curated exhibition at MoMA designed to highlight what humanity had in common: love, marriage, motherhood, childhood, the landscape, work, faith and struggle.

The year 1955 was a golden one for DeCarava. In addition to being included in the MoMA show, he and his second wife, Anne, opened a gallery in their home at 48 West 84th Street. A Photographer's Gallery, which opened in March, showed the work of, among others, Berenice Abbott, Van Deren Coke and Ruth Bernhard. Perhaps the crowning achievement of 1955 was, however, the publication of *The Sweet Flypaper of Life*, a homage to life in Harlem produced in collaboration with the writer Langston Hughes. The greatest critical and commercial success of DeCarava's career, the book nonetheless turned his photographs into a visual narrative, securing for them a literality that was unintended by the photographer.

DeCarava took up photography at a time of crisis in the arts brought about by Cold War paranoia. The Committee for the Negro in the Arts, an organization that sponsored art classes for Harlem residents, and which DeCarava had joined in the 1940s, was later shut down after it was branded 'un-American'. DeCarava himself was clearly unafraid of being associated with Hughes, who was suspected by the right of being a communist. The two men shared an ideological commitment to creating a fully rounded image of black people, and to celebrating African American cultural forms. According to DeCarava, 'there is a black aesthetic'.[7] This had nothing to do with the dark register of his photographs, as was generally assumed, but instead related to his belief that African Americans had a distinctive collective cultural history. For him, the most successful art spoke of – and to – the need to explore one's selfhood.

DeCarava believed that jazz was an art form that had been significantly shaped by the legacies of African American culture. According to Benjamin Cawthra, 'in Roy DeCarava's work of the 1950s and 1960s the visual identification of jazz with African American culture that had concerned photographers and musicians since the 1930s

is complete.'[8] To DeCarava, himself an amateur saxophonist, musicians were workers who dedicated their lives to the pursuit of man's highest attainments. His jazz photographs were intended for a book, the mock-up for which, by 1964, included more than 200 photographs and a poem of his own writing. He was unable to find a publisher, however, and the first major showing of the series was not until 1983, when the Studio Museum in Harlem mounted 'The Sound I Saw: The Jazz Photographs of Roy DeCarava'. The accompanying catalogue featured only sixty images, and it was not until 2001, when DeCarava was in his eighties, that the book he had intended was finally published as *The Sound I Saw: Improvisation on a Jazz Theme*.

Throughout his life DeCarava worked to support his art practice, first as a freehand brush letterer, then as an illustrator, and then as a commercial photographer. Having repeatedly encountered racial discrimination, DeCarava believed that part of the collective black experience was a developed survival instinct: 'the person whose life is devoted to the elemental task of surviving is forced by circumstances to be more realistic and more truthful than the person who isn't.'[9] In the late 1940s he helped to establish a union at the advertising agency where he worked. He later joined the American Society of Magazine Photographers, where, in response to his complaints about racism in the organization, a committee was formed to investigate. In 1963, following an abortive attempt to organize a black trade association, DeCarava and others joined with a collection of Harlem-based photographers called Group 35 to form the Kamoinge Workshop – *kamoinge* being a Kikuyu word in the Bantu language of central and southern Kenya meaning 'a group effort'. The workshop opened a gallery on 127th Street in Harlem, and began to produce and sell group portfolios. According to Cawthra, the workshop 'located black photography in the vanguard of the black arts movement of the 1960s'.[10]

In 1969 DeCarava was asked to contribute to 'Harlem on My Mind: Cultural Capital of Black America, 1900–1968', an exhibition organized by the Metropolitan Museum of Art but not curated by its photography department. Owing to his doubts about the project, he asked for his photographs to be hung in their own room; when this was denied, he refused to loan his work and picketed the opening night. He was later quoted in *Popular Photography* as saying, 'It is evident from the physical makeup of the show that [the organizers] have

no respect for or understanding of photography, or, for that matter, any of the other media that they employed. I would also say that they have no great love or understanding for Harlem, black people, or history.'[11] It was also in 1969 that DeCarava had his own solo exhibition, 'Thru Black Eyes', at the Studio Museum in Harlem. The show featured around 180 of his photographs taken over twelve years, and was grouped into themes, one of which was white America. Committed to the positive representation of black people, he was not a separatist.

In 1969 DeCarava accepted an invitation from Cooper Union to teach a course in photography. He was now entering a phase in his career in which his art and his working life would be more consonant. In 1971, having relocated permanently to Brooklyn the previous year, DeCarava married the art historian Sherry Turner, with whom he would have three daughters. The couple, who would remain married until the artist's death nearly forty years later, collaborated on numerous books and exhibitions featuring his work. In 1975 DeCarava became a full-time professor at Hunter College in New York and was finally able to quit his commercial practice; four years later, he was given tenure. The next few decades saw him receive a number of high-profile commissions, including from the Corcoran Gallery of Art in Washington DC and the American Telephone and Telegraph Company, as well as further teaching posts. In 1996 his work was the subject of a major travelling retrospective organized by MoMA; a decade later, three years before his death, he was awarded a National Medal of Arts.

DeCarava's awareness of the uncommon weight that biography can hold in the life of an artist led him to be circumspect about details of his private life. With regards to his artistic biography, he stated: 'The major definition has been that I'm a documentary photographer. And then I became a people photographer. And then I became a street photographer. And then I became a jazz photographer. And, oh yes, I mustn't forget, I am a black photographer. And there's nothing wrong with any of those definitions. The only trouble is that I need all of them to define myself. I do want to express it all.'[12] DeCarava was an artist who saw things for what they were and opened the eyes of others not by means of propaganda or reportage, but with elegantly crafted visual poems. ∎

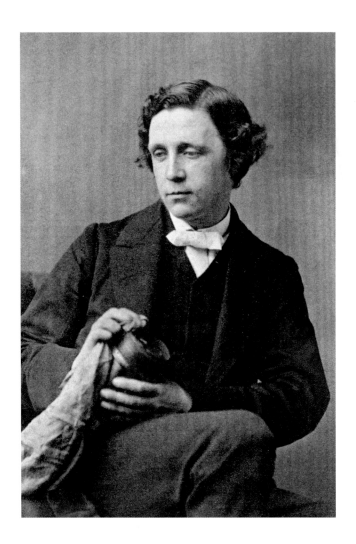

Oscar Rejlander, *Lewis Carroll polishing his lens*, 1857

Charles Lutwidge *Dodgson* aka Lewis Carroll

1832–1898

Yesterday, I took my first photo in the new studio, Julia
Arnold: I had her and Ethel with me for about three hours.
Term work is over. God bless the vacation, and my future
life, and help me to serve Him more truly. Amen.

CHARLES L. DODGSON

'Lewis Carroll', one of the most celebrated names in English literature, was the pseudonym of Charles Lutwidge Dodgson, a don (tutor) at the University of Oxford. His best-known book, *Alice's Adventures in Wonderland* (1865), commonly referred to as *Alice in Wonderland*, was based on a story he invented for Alice Liddell and her two sisters when he and a friend took them boating. In addition to publishing books, short stories and poems under his pseudonym, and mathematical treatises under his own name, Dodgson was a prolific photographer who, over the course of twenty-four years, created a remarkable body of work, consisting of, it is thought, at least 2,700 individual images.[1] By far the majority of his photographs are portraits or figure studies, and more than half of his known output is made up of pictures of children from outside his own family. These photographs play with the conventional representation of a child as an 'inanimate doll-beauty';[2] in common with the *Alice* books, they restore individuality, agency and playfulness to (what are mainly female) children. They have also prompted a debate as to whether one of the most cherished children's writers of all time was sexually attracted to underage girls. A great deal of material relating to Dodgson, including his unabridged diaries and a reconstructed photographic inventory, has become available to scholars in recent years, allowing for a reappraisal of the man still best known by his pseudonym. Charles Dodgson was a photographer for nearly a decade before he became a famous author; this hobby, like his literary endeavours, was a very serious pursuit.

Dodgson's appointment in the autumn of 1855 to the position of mathematics tutor at Christ Church, Oxford – his alma mater – allowed him to take up one of the more expensive pastimes of the day: photography. He ordered his first camera in March 1856, inspired, it would seem, by Robert Skeffington Lutwidge, his uncle, and Reginald Southey, the nephew of the poet Robert Southey and a fellow student at Christ Church. The purchase of his own photographic equipment came shortly after his decision to adopt the nom de plume of 'Lewis Carroll' when submitting humorous works for publication. Prior to owning his own camera, Dodgson enjoyed 'photographic days' with his uncle as early as the summer of 1855,[3] and with Southey in 1856.[4] These outings included, in the April of that year, three days at the deanery at Christ Church, where he cemented his friendships with the children of the dean, Dr Henry Liddell, that had begun a few months earlier. Having taken delivery of his camera outfit on 1 May 1856, Dodgson enjoyed a flurry of photographic activity with Southey. That first year of photography set the pattern for the following fifteen: Dodgson used the long Oxford vacations to travel to London and elsewhere in England, taking his camera with him. Both at Oxford and on vacation, he used photography as a means of securing introductions to those he desired either to know (or know better) or to photograph – or both.

It is often assumed that Dodgson, who had a stammer, was deaf in one ear and suffered from acute anxiety, was shy and ill at ease in the company of adults. His diaries and letters, however, reveal him to be sociable, active in college life and self-confident, sometimes to the point of arrogance. He was also a fan of contemporary (mainly comic) theatre and a 'lion-hunter', the Victorian term for those fascinated by celebrity, securing portrait sessions with, among others, John Ruskin, William Holman Hunt and Michael Faraday. His interest in gaining access to those higher up the cultural and social scale may have been an outlet for his vanity. An exceptional student used to securing prizes and awards, he seems to have been very conscious of his appearance: an assisted self-portrait of the young Dodgson in his twenties suggests not only that he styled his hair, but also that he was posing in such a way as to minimize the distinctive Dodgson large eyes and heavy jaw. According to the terms of his studentship at Oxford, Dodgson was destined to take holy orders and to remain unmarried. Although the Reverend Charles Dodgson (as he became

Rev. Thomas Childe Barker and his daughter, 1864

in late December 1861) never took full holy orders, he used his posi-
tion as a reverend and an Oxford don – and, later, his reputation as
a children's author and his advancing years – to present himself as
morally unimpeachable.

It was in July 1862 that Dodgson and his friend Robinson
Duckworth took the three Liddell sisters on the excursion during
which, so it is said, they begged Dodgson to tell them a story. It is
worth noting that, as early as 1856, Dodgson had been inspired by
another Alice – Alice Murdoch, whom he had photographed on his
first summer holiday after acquiring a camera – to write a poem,
which he then inscribed in one of his albums opposite the portrait.
Dodgson would in time create a number of albums, some composed
of mainly family portraits, some designed for 'show' and some given
to friends. These albums, although not ordered chronologically, dem-
onstrate that Dodgson soon mastered one of the greatest challenges
facing photographers of his day: that of taking naturalistic portraits
of children. Even an exposure time of a few seconds could result in
a blurred image, meaning that the production of sharp and blemish-
free negatives required skill and patience, as did the posing of children
so that they appeared at ease. If a naturalistic portrait of a single
child was a technical triumph, then one featuring multiple children
was an extraordinary feat, and both were treasured by parents and
relatives used to the standardized poses and props of the commercial
photographic studio.

It was photography that drew Dodgson closer to the Liddell family.
Indeed, his most celebrated photograph is that of Alice Liddell dressed
as a 'beggar maid' (1858). The fact that it was taken at her parents'
home, and outdoors, neutralizes some of the unconventionality of a
grown man photographing a partially dressed child, one who he would
later call his 'ideal child-friend'.[5] It is clear, however, that Dodgson's
behaviour with regard to the Liddell family could overstep the mark.
An entry in his diary for 1863 records that he had been writing a note
to Mrs Liddell 'urging her ~~either~~ to send the children to be photo-
graphed';[6] the next page of the journal is missing, and regular contact
between Dodgson and the Liddell children did not resume for another
six months. Scholars have suggested that gossip was spreading that
he was paying court to either Lorina Liddell or the girls' governess,
Miss Prickett. Dodgson made a symbolic response to this slight. He

took back the manuscript of 'Alice's Adventures Under Ground' that he had given to Alice, and published an expanded version under the title *Alice's Adventures in Wonderland*, creating a pretext even more powerful than that of an amateur photographer for gaining access to children: that of a famous children's author.

When searching for the roots of Dodgson's interest in children, it should be noted that he had ten siblings, seven of whom were girls, and it was in this company that he flourished creatively, inventing numerous ways to entertain his brothers and sisters. When Dodgson was eleven, the family moved from Daresbury in Cheshire, where Dodgson had grown up, to Croft-on-Tees in North Yorkshire, where his father, Charles, had been appointed rector. Dodgson was then separated from his family for his formal schooling; this included, from early 1846 to late 1849, an unhappy period as a boarder at Rugby in faraway Warwickshire. His diaries and letters suggest that he was what we might call 'artistic': he preferred art exhibitions and the theatre to sport, and saw himself as a connoisseur of beauty. In late January 1851 his mother, Frances, died two days after he had gone up to Oxford; he was nineteen at the time of the funeral, while his youngest sibling was four. It is not too far-fetched to see this loss as a crucial piece of the biographical puzzle that is Dodgson's attraction to the nursery, a place where he was secure and could shine.

A subject that divides Carroll scholars is that of whether Dodgson's interest in young girls, and his photographing of them, was normal for the period or transgressive. Many have noted, for example, that other Victorian men fell in love with teenage girls, including Dodgson's own brother Wilfred. Others identify the suggestion that Dodgson may have been a paedophile as a projection of present-day preoccupations on to the past. The conventions that governed contact with the opposite sex of marriageable age were so rigid and subject to so much scrutiny that childhood must have seemed to many like a lost idyll (Dodgson noted of a childhood acquaintance: 'Lucy Tate has grown from a romping girl into the most staid of young ladies').[7] For those used to emotional warmth and intimacy but denied it by the strictly gendered institutions of school and work, the opportunity to share a genuine moment of affection with a child must have been very pleasurable. The problem was determining when a young girl was subject to the rules of courtship – the point at which their future prospects in

life hinged on the avoidance of any threat to their respectability. For Dodgson, every opportunity to suspend convention, such as visiting the theatre or playing with children, restored to him as an adult the pleasures of his childhood, what Catherine Robson has called a 'lost girlhood'.[8] But despite being highly adept at getting what he wanted, using jokes, wordplay and/or gifts to overcome resistance, such pleasures did not come easily: his letters, for example, reveal evidence of sustained campaigns to gain permission from mothers to have their children photographed divested of their conventional attire. These campaigns, which usually began with a request for 'bare feet', could ultimately lead, as in the case of the daughters of P. A. W. Henderson, a fellow of Wadham College, to the subject being photographed in 'their favourite state of "nothing to wear"'.[9] There are four extant nude studies of young girls by Dodgson, and while only one of these, of Evelyn Hatch, is likely to be considered erotic by a modern-day audience, it is an unsettling image. In 1871 Dodgson had a studio and darkroom installed in his rooms at Christ Church, and from the spring of the following year more or less confined his photographic activities to these rooms, where he kept toys, children's books and dressing-up clothes. It was at this point that he began printing his own negatives for the first time since his first year as a photographer, thereby giving himself complete control over his imagery.

The suggestion that Dodgson's motives for spending time with (often unaccompanied) young girls may not be entirely appropriate was first made during his lifetime, and was closely related to his decision to give up photography. After August 1880, Dodgson would never take another photograph.[10] The following year, he wrote to Mrs Henderson of his decision to destroy the negatives and duplicate prints of those images that might be considered offensive to conventional sensibilities;[11] he also left instructions to his executors to destroy certain negatives. Although he gave up photography, Dodgson did not surrender his child-friendships; his diaries from the last years of his life are just as full as before of walks, teas, dinners and theatre visits, the difference being that now a great deal of these were with mature women whose friendship he had made when they were children.

Charles Dodgson was a highly celebrated author in his own lifetime who, owing to his adoption of a pseudonym, used both celebrity

and anonymity to his advantage. Never idle, but frequently lamenting his lack of self-discipline, he ate only one meal a day, kept a near-daily diary and was an obsessive writer of lists. He remained at Oxford after giving up his lectureship, never married, and died of pneumonia aged sixty-five. His instructions for his funeral, in common with his puritanical, obsessive habits, spoke of modesty, yet these inclinations, and his ordination as a deacon, were in tension with his love of frivolity, nonsense and theatre. Dodgson could be argumentative, difficult and socially gauche, but he was also adept at pulling back from such lapses. He also surrounded himself with those who advocated, as he did, that what passed as social convention was often social hypocrisy. Although we may never know whether Dodgson was a man-child or a paedophile, or whether little girls were an object of desire or a means to sublimate other yearnings, these are not, perhaps, the most important issues raised by his biography. Our interest in his sexuality may in essence be a Carroll-esque pretext for evading what is truly at stake in his life story: is it possible to create great art if one is immoral? And are we allowed to ignore immorality in our love of great art? ∎

Self-Portrait with a Rolleiflex, France, 1932

Robert *Doisneau*

1912–1994

The camera makes me less shy. Like a fireman's
helmet, it gives me courage.

ROBERT DOISNEAU

Robert Doisneau is celebrated as a photographer of one city: his own, Paris. His many professions of shyness, and of feeling ill at ease if away from his Montrouge home, enhance the impression that his horizons were narrow. But Doisneau treasured what he had not because it was safe but because it was so precarious. During the depressed economic climate of the 1930s, he sublimated his desire to be an independent photographer for the security of a salaried job as an industrial photographer. After five years of punching the clock, he lost his job (probably deliberately) just months before the outbreak of the Second World War. Doisneau, by then a communist, risked his life during the war working for the Resistance. Such political commitment appears to be at odds with his idealized images of the French capital. And yet his photographic vision accrued its reputation as rose-tinted only as his subjects receded into the past: early on, Doisneau recalled, he was accused of 'misérabalisme'.[1] Scholars have argued that Doisneau's sensibility was attuned to both dark and light. The brief, spontaneous pleasures his images depict gain their poignancy from what were, at the time, often banal or deprived circumstances.

Doisneau was born in Gentilly, a commune in the southern suburbs of Paris. His parents, Gaston and Sylvie (née Duval), had met through the former's work for a local building contractor, and the young family lived with Sylvie's parents in an apartment above the business. As a boy, Doisneau attended a small private school, and one of his maternal uncles was the local mayor. This seemingly secure, petit bourgeois upbringing was, however, disrupted by tragic events. Doisneau's mother, whom he later recalled as 'a very religious, very mystical woman who gave me a sense of the fantastic', contracted tuberculosis and died when he was seven or eight years old.[2] After his father remarried in 1922, Doisneau lived with the couple and his

stepbrother, Lucien Larmé, in another part of Gentilly. He said of this phase of his childhood: 'I had what I needed materially.'[3]

From the age of about thirteen, Doisneau spent four years at the École Estienne, a technical school for the book trade in the 14th arrondissement. In 1929 he obtained his diploma in lithographic engraving. From the September of that year, following a brief stint in a traditional engraving studio in Paris, he worked as a lettering artist for l'Atelier Ullmann, in the 15th arrondissement. It was there that he met Lucien Chauffard, who, although little is known about him, would play a crucial role in Doisneau's career. Doisneau began to assist Chauffard in the photographic studio he was running at the atelier, and when Chauffard left the company, Doisneau inherited his position. It is thought that he took his first pictures for himself in 1929, using a camera borrowed from his stepbrother.[4] The pictures featured, among other subjects, his bedroom in the home whose bourgeois decor he found 'oppressive'.[5] Ironically, his first commission, to document the streets and buildings of Gentilly, was given to him by the family's aspirational figurehead, his uncle the mayor. Completed in around 1930, the commission enabled Doisneau to buy his own Rolleiflex.

Doisneau claimed that it was Chauffard who told him of an opening for a camera operator in the studio of the artist and designer André Vigneau.[6] Working with Vigneau exposed Doisneau to such avant-garde cultural forms as surrealism, the architecture of Le Corbusier and Soviet film.[7] He was particularly influenced, according to the biographer Peter Hamilton, by the photography he saw in *Vu* magazine, which featured images by, among others, Brassaï, André Kertész, Germaine Krull and Henri Cartier-Bresson.[8] Doisneau's first reportage, composed of images taken in the Saint-Ouen flea market, appeared in the daily newspaper *L'Excelsior* in September 1932. This golden period was brought to an end, however, by Doisneau's military service, which began in the spring of 1933. He returned to work with Vigneau a year later to find that his mentor was now dedicating his energies to making films and books.

It is unclear whether Doisneau's decision to join Renault, the car manufacturer, was prompted by Vigneau's abandonment of photography, his own desire to marry and raise a family, or the scarcity of work in the mid-1930s. Perhaps it was all three. Chauffard's influence was once again decisive: it was he who hired Doisneau, in 1934, to

head up a new photography studio at Renault's Boulogne-Billancourt plant. It was also in 1934, on 28 November, that Robert Doisneau and Pierrette Chaumaison were married, having first met in the late 1920s.[9] Some three years later, in 1937, Doisneau was able to secure the apartment in Montrouge in which he and Pierrette, with whom he would have two daughters, would live for the rest of their lives.

According to his own account, Doisneau was a rather reluctant convert to left-wing politics. When in May 1936 the staff at Boulogne-Billancourt were planning strike action, he had to be convinced by a union worker to show his solidarity, and only then did he join a union himself.[10] In 1939 he lost his job at Renault owing to repeated lateness

The Gyrating Wanda, Paris, 14th Arrondissement, 1953

(and, allegedly, for forging his timecards), and used his severance pay to buy his own cameras and equipment. At last poised to work as an independent photographer, Doisneau contacted Charles Rado, head of the photo agency Rado-Photo (later known as 'Rapho'). Having previously advised Doisneau against the life of a freelancer, Rado nonetheless agreed to see the pictures from Doisneau's proposed reportage on canoeing, to be based on his and Pierrette's summer holiday. The holiday, however, was cut short: it was August 1939.

When Doisneau was called up, he took his pregnant wife and mother-in-law to Normandy before setting off for the Eastern Front. He suffered with chest problems and was twice evacuated to a military hospital, the second time starving himself to simulate the appearance of tuberculosis. He was demobilized in February 1940 and reunited with Pierrette at their apartment. Between June and August 1940 the couple, like most Parisians, abandoned the capital, finding refuge in Poitou. On their return, Doisneau made a series of images depicting life under German occupation. From June 1941 he was working for the Resistance, forging papers and, on two occasions, sheltering men on the run.[11] His photographs of the liberation of Paris, including Charles de Gaulle striding down the Champs-Élysées on 26 August 1944, launched his career as an independent photographer.

In early 1946 Doisneau began working for the resurrected Rapho, the agency with which he would remain for the rest of his life. His works were placed by the agency in such French magazines as *Paris Match*, *Regards* and *Réalités*, and in such international ones as *Life*, *Esquire* and *Picture Post*. At this time Doisneau was a member of the French Communist Party (Parti Communiste Français, PCF), and his images also appeared in *Action*, the weekly journal with which the PCF was aligned. According to his friend Edmonde Charles-Roux, '[Doisneau] was sympathetic to the communists in France right to the end.'[12]

The year 1949 saw the publication of *La Banlieue de Paris*, the photobook that Doisneau described as 'my self-portrait'.[13] His images of the suburbs of Paris were accompanied by the words of Blaise Cendrars, who admired the *banlieue* pictures that Doisneau had been taking since his first forays into photography. Doisneau himself said of the *banlieue* of his youth: 'it is a place you went either to play, to make love, or to commit suicide.'[14] While Cendrars's text took a satirical line, Doisneau's images, true to his ambivalence, were more oblique.

The 1950s saw Doisneau achieve a balance between artistic photography, reportage and commercial photography. In late 1946 he had joined the Groupe des XV, a collective dedicated to art photography, and he continued to exhibit with them until 1958. In 1949 he was contracted to work for French *Vogue*, and did so for around two years (and possibly longer). In 1955 several of his photographs were featured in the renowned 'Family of Man' exhibition at the Museum of Modern Art, New York. It was also in the 1950s that Doisneau collaborated on a series of photobooks that were much lighter in tone than *La Banlieue*, including *Instantanés de Paris* (1956). In the following decade he found himself, like Eugène Atget, photographing Old Paris, in his case for an abortive book project. When the images finally appeared in 1974, he was further identified with a picturesque, nostalgic past.

The photographer who was characterized as having made a career out of a single subject thrived when faced with new challenges. In 1960 commissions secured by the Rapho-Guillumette agency in New York allowed him to travel to the United States, including Palm Springs (for *Fortune* magazine) and Hollywood (to photograph Jerry Lee Lewis). In 1983, while photographing the filming of Bertrand Tavernier's *Un dimanche à la campagne* (1984), Doisneau met the actress Sabine Azéma, who became his muse; she later directed a film about him (1992). Doisneau, who experimented with video in the 1980s and made the short film *Les Visiteurs du square* in 1992, would have loved, so it is said, to have been a film director.[15] His return to photographing the *banlieue* of Paris in the 1980s and 1990s was most likely occasioned by the need to be at home with Pierrette, who had contracted Parkinson's disease in the 1970s.

Doisneau's early ambivalence about the outer suburbs of Paris in which he grew up has been lost in the identification of his name with poster-friendly photography, most famously his image of a young couple kissing in a Paris street, made for *Life* magazine in 1950. Owing to a court case over the royalties earned from this picture (a case he did not live to see determined in his favour), it became widely known that Doisneau sometimes staged his photographs; the 'angler for images', as he called himself, was also an auteur.[16] Perhaps this disclosure will help to dislodge other assumptions. The evidence suggests that Doisneau's imagery is neither saccharine nor disengaged but a humanistic response to the mundanity, and harshness, of existence. ∎

Portrait of Peter Henry Emerson, frontispiece to *The English Emersons*, 1898

Peter Henry *Emerson*

1856–1936

*The modern school of painting and photography
are at one; their aims are similar, their principles
are rational, and they link one into the other; and
will in time, I feel confident, walk hand in
hand, the two survivals of the fittest.*

PETER HENRY EMERSON

In a biographical sketch of the photographer Peter Henry Emerson, his great-grandson drew on the memories of his mother and other relatives to paint a picture of a man who, at the end of his life, was a reclusive, domineering, irritable social snob.[1] That this sensitive artist of nature could appear to his children and grandchildren as the stereotypical Victorian patriarch speaks to the many complexities of his character. His snobbery was, it seems, in part a response to an early life in which he was more of an outsider than an insider. Born and raised in Cuba to American and English parents, Pedro Enrique, as he was baptized, moved with his family to the United States when was eight. When, aged thirteen, his widowed mother decided to return to her native England, he was a Yankee who knew nothing of cricket or rugby. Emerson asserted himself by excelling in competitive sports and in his schoolwork, and became in thrall to the culture of prizes, awards and distinctions. In the early 1880s he set his sights on photography as yet another arena in which he could shine. His intention was to revolutionize photography, and in 1889 he published a treatise that sought to codify his ideas. Twelve months later he made a dramatic renunciation of the claim that photography could be art. Emerson then spent several years establishing the pedigree of his family. He was now more interested in finding a biological basis for his perceived superiority than in his reputation as a photographer and photographic theorist. It was photography, however, that would ensure the perpetuation of his name.

Emerson was born in the Villa Clara province of Cuba, then a Spanish colony, on the sugar plantation owned by his American father.

His mother, who was of Cornish descent, would have two more children, Jane (Juanita) and Just William. We know little about Emerson's early childhood in Cuba save for the fictionalized account of it as a Rousseau-esque idyll in part two of his novel *Caóba, the Guerilla Chief* (1897). Also from the novel comes the suggestion that Emerson's father, suffering from ill health, moved the family north on the advice of his doctor.[2] In 1864 they arrived in Wilmington, Delaware. It was there that Emerson's beloved sister died of typhoid aged seven; two years later, in 1867, his father died of dysentery. This second tragedy prompted a return to Cuba, but his mother soon returned to Delaware with her two boys. In June 1869 the family sailed for England, and that September Emerson was enrolled in Cranleigh, a public school in Surrey. It was then, perhaps, that 'Pedro' became 'Peter'.

Having had a somewhat erratic education to date, Emerson now dedicated himself to proving his worth both academically and physically. By 1874 he 'stood second in the school' in terms of academic achievement.[3] This claim appears in what is the 'official' biographical essay on Emerson, a work that forms part of *The English Emersons*, the family genealogy that he published in 1898. Despite being attributed to 'A. A.', possibly his wife, it is clear that the essay was in fact Emerson's own work. One of the biography's many boastful assertions is the claim that a noted medical practitioner said of Emerson's decision to abandon his medical studies that it was 'a great loss to medicine'.[4] Emerson had passed his surgical exams at King's College, London, in 1879, and, after studying the Natural Sciences Tripos at Cambridge later that year, had taken up temporary appointments in London as a medical officer. In June 1881 he married Edith Amy Ainsworth, known as Amy, with whom he would have five children.

The first five years of Emerson's married life were marked by his increasing involvement with photography and his deepening love affair with the East Anglian countryside. In late 1882 or early 1883 he began to exhibit what were probably instantaneous views from dry-plate negatives at the Photographic Society of Great Britain, of which he became a member in October 1883. Increasingly drawn to the countryside outside Cambridge, he moved his family to the Suffolk town of Southwold in 1884 before returning again to King's as a medical registrar. After completing his MB (Bachelor of Medicine) in June 1885, he and his brother went cruising on the Norfolk Broads; also in that year

he became a founding member of the Camera Club of London, for amateurs, and began to contribute articles to the journal the *Amateur Photographer*. In 1886 Emerson was elected to the council of the Photographic Society with two others; this was also the year in which he began to lecture on the subject of photography as an art form.

In 'Photography: A Pictorial Art', a lecture given on 11 March 1886 at the Camera Club and published eight days later in *Amateur Photographer*, Emerson made some very bold claims: 'Thus we see that Art has at last found a scientific basis and can be rationally discussed, and that the modern school is the school which has adopted this rational view; and I think I am right in saying that I was the first to base the claims of photography as a fine Art on these grounds.'[5] Emerson's reference to 'the modern school' is highly significant. Photographers had generally sought to validate the assertion that photography was an expressive medium by modelling the practice on established art forms. Henry Peach Robinson's *Pictorial Effect in Photography* (1869) was the most popular book to do so, and it is generally agreed that Emerson was referring to it when he said, 'in our own branch of art, one writer has served up a senseless jargon of quotations from literary writers on art matters.'[6] The idea that photography should look to the present for its aesthetic cues was both original and provocative.

Gathering Water Lilies, 1886, plate IX from Life and Landscape on the Norfolk Broads

In 1889 Emerson referred to his lecture of 1886 as the 'first gospel' of the argument in favour of a naturalistic school of photography.[7] The second gospel was a 300-page treatise. In *Naturalistic Photography for Students of the Art* (1889), Emerson wrote: 'This, then, is what we understand by naturalism, that all suggestions should come from Nature, and all techniques should be employed to give as true an *impression* as possible.'[8] Emerson's credo of 'naturalistic photography' was congruent with the painterly naturalism associated with the New English Art Club. Its members, among them Thomas Frederick Goodall and George Clausen, had trained as artists in Paris in the 1870s and now sought to reinvigorate English painting by the direct observation of nature and the application of the latest scientific theories regarding light and colour, optics and perception. Emerson first encountered Goodall in 1885 on the Broads, and the two worked side by side there to create *Life and Landscape on the Norfolk Broads* (1886), the first book to feature Emerson's photographs – and the last that he would co-author. Emerson's aesthetic position was, like that of the New English Art Club painters, rooted in the realism of Jean-François Millet, the naturalism of the Barbizon school, and the impressionism of Monet and Manet.

The Snow Garden, 1895

By the time *Naturalistic Photography* was published in November of 1889, Emerson was the author of a number of beautifully crafted, limited-edition books combining text and photographic illustrations on the subject of rural East Anglia. Emerson's official biography acclaimed his East Anglian photographs as 'destined to revolutionize photography'.[9] This assertion is a staple of accounts of Emerson's contribution to the medium, as is the photographer R. Child Bayley's alleged description of *Naturalistic Photography* as 'a bombshell dropped at a tea party'.[10] Emerson, however, renounced naturalistic photography in a pamphlet published a year after the appearance of his popular treatise. In *The Death of Naturalistic Photography* (1890), which includes a black-bordered epitaph to the memory of the practice, Emerson informs the reader of his 'misgivings' over photography's potential for subjective expression.[11]

It is often inferred that, after the publication of *Marsh Leaves* (1895), his last photo-essay on East Anglia, Emerson withdrew from photography altogether, but this is not the case. In 1913 he took up stereoscopic photography, publishing, so he said, sixty artistic studies; he also took up the autochrome colour process.[12] In 1925 he claimed that he had nearly finished a history of art photography intended for publication.[13] Some of the above is apparently confirmed by his correspondence with his ally Alfred Stieglitz, which also suggests that he continued to make photographs into the 1920s.[14] Emerson intended to reissue his published *œuvre*, but may have been prevented from so doing by (according to his own account) the writing of 214 detective stories, the two years he spent studying such diverse subjects as economic history and philosophy, and the 'long and painful illness' of which he gives no further details.[15]

Peter Henry Emerson's biography is much indebted to the myths of his own making. And yet his photographs *are* remarkable, the earlier works for their rejection of sentimentality in their rendering of rural labour, the later for their spare notations in monochrome that resonate with the graphic art of Whistler. This would have been enough to secure his place in the history of photography, and yet he was also the first theorist to align the practice with avant-gardism *and* the first to champion what would become known as 'pure' or 'straight' photography. It may be that, when it came to photography, Emerson – for once in his life – estimated himself at his true worth. ■

[Self-portrait in Automated Photobooth], 1930s

Walker *Evans*

1903–1975

*A man who has faith, intelligence, and
cultivation will show that in his work. Fine
photography is literature, and it should be.*

WALKER EVANS

Walker Evans is often described as the greatest American photographer of the twentieth century. This is somewhat ironic considering his youthful anti-Americanism, his allegiance to French literary culture and an aesthetic shaped by European modernism. His personal trajectory was from anti-establishment, anti-authoritarian college drop-out to grand old man of twentieth-century American culture. There is a wealth of primary material related to Evans, and yet what reads as biographical evidence should be treated with more than the usual degree of caution. When Evans is the source of the biographical anecdote, it often bears the same relation to actuality as Evans's photographs do to their subjects: they are elegantly crafted rhetorical gestures that make a claim on veracity but rely on the understanding that truth is a construct. For Evans, and for key artists and writers in his circle, the blending of visual and verbal poetics with more realist modes of expression provided a means to convey both fact and a more expressive truth. As the curator John Szarkowski wrote in 1971, 'It is difficult to know … whether Evans recorded the America of his youth or invented it.'[1]

Walker Evans III was born in St Louis, Missouri. When he was still a small boy the family moved to Kenilworth, a white-bread suburb of Chicago, where Evans's father, Walker Evans Jr, took up the post of copywriter at a major advertising agency. In the autumn of 1914 the family relocated to Toledo, Ohio, where Evans's father had secured a new job. It was in Toledo that Walker Evans Jr embarked on an affair with the next-door neighbour, and, after the neighbour divorced her husband in 1918, moved in with her and her two sons. Around this time Walker Evans III, now a teenager, acquired a Kodak Brownie and taught himself how to develop and print photographs. By January

1919, he, his mother and his sister had moved to New York. Despite the fact that his father continued to be a presence in his life, Evans became disaffected and disruptive at school. After graduating in 1922 he enrolled at Williams College, Massachusetts, where he became, as he called it, 'a pathological bibliophile'.[2] He did not return to Williams after his freshman year.

In March 1924 Evans found employment in the New York Public Library; two years later, having given up the library job in the autumn of 1925, he sailed for France. Evans noted that, whereas he had grown up with the injunction 'Don't stare!', the observation of others was permissible in his new surroundings.[3] He intellectualized the pleasures of looking at the pageantry of modern street life by reference to the writings of Charles Baudelaire. Evans was, he believed, destined to be a writer. In Paris, he sought to master both idiomatic French and the native body language in a quest to evade being identifiable as an American tourist, saying later, 'I was really anti-American at that time.'[4] He had arrived in Paris with a brand-new vest-pocket camera, which he used to take pictures in Paris, the South of France and Italy. It was also with this camera that he made a few self-portraits, one or two of which, together with some short stories, he sent to his friend the artist Hanns Skolle in New York.

In 1928, having returned to New York in the spring of the previous year, Evans rented an apartment in Brooklyn Heights with Skolle. Evans often spent his days photographing the city, sometimes in the company of Paul Grotz, his new friend and eventual flatmate, and sometimes with their neighbour the poet Hart Crane. Grotz, who had studied in Munich and had a Leica, was well versed in contemporary European modernism, and the two men experimented with dramatic vantage points. Despite this experimental approach, Evans's friend Dr Iago Galdston recalled that Evans had no technical knowledge of how cameras worked;[5] it was only later, around 1931, that he received some instruction. Against his better judgment, Evans showed a portfolio of his work to Alfred Stieglitz; when the latter said nothing more to him than the pictures were 'very good' and that he should 'go on working',[6] Evans was further convinced of his dislike for the artiness and pretension that he associated with Stieglitz and his followers. His own aesthetic was developed in circles that looked to the Parisian avant-garde for their cultural cues. One such cue was the work of

<u>Eugène Atget</u>, to which Evans was introduced by Berenice Abbott following her acquisition of Atget's archive in 1928.

The decisive factor in Evans's emergence as an important contemporary photographer was the friendship and patronage of Lincoln Kirstein, the young Ivy League-educated patron of the arts who was on the first advisory council of the Museum of Modern Art (MoMA) in New York. In the spring of 1930 Evans was hired to photograph some of the exhibits in a sculpture show at the museum. Later that year Kirstein published a selection of Evans's photographs in *Hound and Horn*, the quarterly literary magazine that Kirstein had founded while studying at Harvard. The series of Kirstein-engineered commissions and exhibitions that followed over the next eight years, including a book on American vernacular architecture with the poet and architect John Brooks Wheelwright, reached its apotheosis in the autumn of 1938, when Evans was accorded the first solo show at MoMA dedicated to photography: 'Walker Evans: American Photographs'.

In May 1933 Evans was commissioned to travel to Havana to take photographs for Carleton Beals's *The Crime of Cuba* (1933), a searing

Breakfast Room at Belle Grove Plantation, White Chapel, Louisiana, 1935

indictment of President Gerardo Machado and his corrupt, US-backed regime. The images Evans produced for the book were, by contrast, seemingly neutral, deploying a naturalism of style, choice of everyday subject matter and evasion of subjectivity that he equated with the prose of Gustave Flaubert.[7] As the economic crisis deepened in the United States, Evans continued to insist that he and his photography were independent of 'policies, aesthetic or political'.[8] A commission to photograph the architecture of New Orleans took Evans south in January 1935, and it was there that he met and fell in love with the married artist Jane Ninas. Evans returned to New York in late March that year to prepare for his forthcoming exhibition at the Julien Levy Gallery with Henri Cartier-Bresson and Manuel Álvarez Bravo.

It was while Jane Ninas was visiting Evans in New York in the summer of 1935 that he was given a three-month contract with the Resettlement Administration (RA), a newly established division of the Department of Agriculture. Evans and Ninas set off together via Washington DC for his first assignment, for which he was to document the coal-mining communities of West Virginia that were subject to a government plan to make homesteaders out of unemployed coal miners. Evans, however, would not work to a brief, and used this and later RA commissions to follow his own aesthetic inclinations; despite being in the pay of a liberal government, he insisted on 'NO POLITICS whatever'.[9] Evans became Senior Specialist in Information for the RA in October 1935, and in November of that year began another photographic tour of the South. In early 1936, while in New Orleans as part of this tour, he was confronted by a gun-toting Paul Ninas about his affair with Jane. Evans ended their relationship by letter.

By April 1935 Evans had befriended James Agee, a Harvard-educated poet and writer. In the summer of the following year Agee was commissioned by *Fortune* magazine to write a piece documenting the effect of the Depression on the Southern white tenant farmer. Agee requested Evans as his photographer, and the pair travelled to southern Appalachia in July 1936 in search of a representative subject. It was in Greensboro, Alabama, that they became acquainted with the farmers Frank Tingle (or 'Tengle'), Bud Fields and Floyd Burroughs. After an initial photography session with the Tingles and the Burroughses, Agee and Evans decided to stay in the area, returning to the sharecroppers' homes to talk and photograph. Received

Farmer's Kitchen, Hale County, Alabama, 1936

'as paying guests',[10] the men were treated as family, a situation that blurred the conventional boundaries between subject and observer. Agee's resulting article was rejected by *Fortune*, and the photographs were not used by the RA (now the Farm Security Administration, from which Evans was let go in March 1937). Agee decided instead to use the material for a book entitled *Three Tenant Families*, and, in the summer of 1941, what was now called *Let Us Now Praise Famous Men* was published. Evans's photographs appeared at the front of the book and bore no captions. In the preface, Agee wrote: 'The photographs are not illustrative. They, and the text, are co-equal, mutually independent, and fully collaborative.'[11]

In the summer of 1937, when Agee's marriage to Olivia ('Via') Saunders was breaking down, Evans and Via began an affair. Evans had earlier had a romance with Agee's sister Emma; according to the writer Belinda Rathbone, 'For Evans, connecting with Agee through his women was a round-about way of expressing his love for him.'[12] There is evidence to suggest that Evans may have had a couple of sexual encounters with a homosexual element, including one with Agee and his second wife, Alma, none of which he saw through.[13] Whether or not Evans was a latent homosexual, or bisexual, he was certainly not monogamous; in Via's words, 'With Walker you knew you were never the only one.'[14] After Evans dedicated the catalogue for 'American Photographs' to 'J. S. N.', he and Jane Ninas were reconciled, and were married in October 1941.

Evans joined the editorial staff of *Time* magazine in the spring of 1943, working primarily as a film critic. In September 1945 he was transferred to *Fortune*, where he became its only staff photographer, a role he would perform for the next twenty years. Many of Evans's celebrated works were generated by assignments for the magazine, including the surreptitious half-length portraits of 'the American worker' that he made on a street in Detroit, and which were published as 'Labor Anonymous' in *Fortune* in November 1946. As Evans got older, his attraction to the establishment and to objects from the past became stronger; he also became increasingly reliant on drink. He surrounded himself with the younger generation, including Robert Frank, Lee Friedlander and, in the early 1960s, Diane Arbus, and insisted on being called an artist, not a photographer. Jane, having endured his many affairs, eventually embarked on one of her own,

and the couple separated in August 1955. Some four years later, in October 1960, Evans married Isabelle Boeschenstein von Steiger, to whom he had been introduced at the beginning of the previous year.

In 1944 the critic Clement Greenburg called Evans 'our greatest living photographer after Stieglitz', but for the next fifteen years or so his career as an artist in photography floundered.[15] The rehabilitation of his reputation began in 1960 with the reprint of *Let Us Now Praise Famous Men* – expanded to include more than double the number of photographs than the original – and culminated in 1971 with a major retrospective at MoMA and a smaller one at Yale University Art Gallery. Along the way he became a visiting professor at Yale School of Graphic Design (1964) and saw the exhibition and publication of *Many Are Called* (1966), the subway portraits he had taken in the late 1930s using a hidden camera. Despite this late burst of success, or perhaps because of it, Evans could not keep himself sober. Relations with Isabelle became strained, owing in part to further extra-marital affairs, and the couple divorced in April 1973, the year in which he began taking colour Polaroids. According to Evans, 'I've never been faithful to anything but my negatives.'[16]

Walker Evans died in April 1975 shortly after suffering a massive stroke. The man who had sought through his imagery and writings to forge an American vernacular that betrayed no trace of cant, whose quotidian subject matter and 'straight' aesthetic satirized snobbery of any form, had become convinced of his own intellectual and aesthetic superiority. His 'documentary style', or 'lyric documentary', allowed him to take photographs that appeared simultaneously as straightforward records and visual poems. Evans hated the suggestion that his photographs were nostalgic, but as the architecture, automobiles, figures and dress of his pre-war photographs became divorced from their historical moment, they became less like rhetorical statements intended to show up the false promises of ideology and advertising and more like icons of Americana. As Evans recognized, he was a collector; as such, he had a fetishistic relationship to what caught his eye, wresting it from actuality and framing it for scrutiny in more elevated surroundings. Evans's celebration of vernacular American society and culture was never addressed to those that he photographed, but always to the East Coast intelligentsia to whom he was in thrall. ■

Pasha and Bayadère [Roger Fenton seated, centre], 1858

Roger *Fenton*

1819–1869

[Artists] know that the camera will present them with the most faithful transcript of nature, with detail and breadth in equal perfection, while it will leave to them the exercise of judgment, the play of fancy, and the power of invention.

ROGER FENTON

Roger Fenton appears to us as the quintessential British photographer of the nineteenth century. Hailing as he did from a Nonconformist Lancashire family who became wealthy through the cotton industry and banking, his decision to take up photography suggests he too was modern and progressive in his outlook. But Fenton was neither an industrialist nor a capitalist; rather, he chose (or perhaps was guided) to enter the world of law. The fact that he set aside his law studies to train as an artist in Paris is suggestive of a conventional bourgeois dilemma: that of whether to secure a steady but dull career, or pursue a risky one that would allow for self-expression. Back in London, he appears to have practised law, painting and photography side by side. Regarded by his peers as a leading contemporary artistic photographer, Fenton was instrumental in the establishment of a British society for photography and exhibited more widely than any other British photographer of the time. Nonetheless, the series of photographic ventures on which he embarked in the 1850s were not commercially successful. It seems that Fenton, grandson of a northern entrepreneur, found it difficult to reconcile the hard facts of business with the pleasures of artistic expression.

Born and raised at Crimble Hall, near Bury in Lancashire, Fenton was the fourth child (of seven) of John Fenton and Elizabeth Aipdaile. Although infant mortality and premature death were endemic at the time, this cannot have made any easier the loss of his eldest brother, buried on Roger's ninth birthday, or the death of his mother a year later. In December 1832 John Fenton was elected as a Whig Member of Parliament for the new constituency of Rochdale. His duties in London may have been partly responsible for Roger and his younger

brother entering University College in 1836 to study for a Bachelor
of Arts degree; as Nonconformists, they could not have studied at
either Oxford or Cambridge. In May 1839 Roger Fenton joined the
Inner Temple. After graduating in 1840, he began his law studies at
University College the following year.

In a reversal of the more familiar pattern, it was *after* his marriage –
in August 1843, to Grace Maynard – that Fenton decided to become an
artist in Paris. He can be placed in the French capital by at least May
1844, and in June that year he registered as a copyist at the Louvre,
naming Michel-Martin Drolling of the École des Beaux-Arts as his
master. That his wife was with him for at least part of his sojourn in
Paris is suggested by documentation that claims their second child,
Annie Grace, was born there. It was in 1847, it is thought, that Fenton
and his family moved back to London, where he became the pupil of
the historical painter Charles Lucy. Between 1849 and 1851 Fenton
submitted paintings to the annual exhibition of the Royal Academy of
Arts. None by his hand, however, have yet come to light.

There is no direct evidence as to when Fenton took up photog-
raphy. We know he travelled to Paris in October 1851 and, while there,
visited the Société Héliographique, conducted some technical experi-
ments and met with Gustave Le Gray and Auguste Mestral. As the
earliest photographs attributed to Fenton date to February 1852, it has
been suggested that his interest in photography was sparked by the
Great Exhibition of 1851. The exhibition certainly stimulated his and
others' desire to establish a British society for photography. Fenton
was frustrated not only with the state of photographic research and
practice, but also by the fact that the British inventor and pioneer
of photography, William Henry Fox Talbot, had taken out a series of
patents on the practice (and printing) of photography on paper. Even
those who did not wish to profit from their activities had to take out a
licence to practise photography on paper.

Fenton's early photographic endeavours were, on one level, an
attempt to forge a practice that would be exempt from Talbot's claims.
In his first known paper on photography, 'Photography in France',
Fenton promoted Gustave Le Gray's waxed-paper process as superior
to all other pre-prepared processes.[1] Fenton's first recorded photo-
graphs, street subjects close to his London home and family portraits,
were made by the waxed-paper process and the collodion process

respectively. He used the former, which was ideally suited to working in the field, during a trip to Russia in 1852 to document the construction of Charles Blacker Vignoles's suspension bridge over the River Dnieper at Kiev. Fenton used wax-paper negatives for much longer than many of his contemporaries, and only began to use collodion on glass negatives regularly in 1854, the year in which a legal ruling made them exempt from Talbot's patents.

A selection of images from Fenton's trip to Russia, including his celebrated view of the cathedral domes in the Kremlin, were among the forty-plus photographs he contributed to the first (known) public exhibition of photography, that held at the Society of Arts in London in 1852. Designed to raise the profile of photography in England, the exhibition was the work of Joseph Cundall, Philip H. Delamotte and Fenton. Earlier that summer Fenton had become a member of the committee formed to establish a photographic association in the English capital. The Photographic Society of London was inaugurated in January 1853, and Fenton was appointed honorary secretary. It was also Fenton, together with Sir Charles Eastlake, the first president of the society, who was chosen to accompany Queen Victoria and Prince Albert on their tour of the society's first exhibition in January 1854. Over the next two years Fenton would receive numerous commands to take pictures of the royal family. Although the society was open to anyone (as long as they were respectable), it is clear that it was an attempt by Fenton and his fellow 'gentlemen amateurs' to establish for themselves a power base in the photographic community.[2]

Fenton's first photographic venture had taken place in Russia; his second was occasioned by a war against Russia. In the spring of 1855 Fenton travelled to the Crimea with Marcus Sparling, a photographer formerly of the 4th Light Dragoons; his manservant William; and his 'photographic van'.[3] The van was kitted out as a travelling darkroom, a necessity now that Fenton was working with wet collodion negatives, which required preparation and development *in situ*. Fenton's photographs of the war were exhibited in London and other venues in England after his return from the Crimea in the summer of 1855. That September they were also published as a three-part portfolio, *Photographic Pictures of the Seat of War in the Crimea*. In December of the following year, however, the negatives and remaining prints from the project were auctioned off. The war was so unpopular with

the British public that such an unsentimental record of the conflict could hardly hope to be a commercial success.

Fenton's letters to his wife from the Crimea are thoughtful, funny and loving. In one of them he jokingly remarks that he is 'ashamed of being so soft'.[4] Perhaps he was distressed by his role in the war as an observer rather than a participant. If so, this might account for the fact that, in at least three photographs taken after his return from the Crimea, he appears in military garb. There can be little doubt that Fenton, who was something of a dandy, relished the transformative power of photography. The celebrated Orientalist suite that he made in the summer of 1858 was an unusual series for him, although a

Princesses Helena and Louise, 1856

conventional subject for artists of the time. Predictably laden with sensuality and other signifiers of moral laxity, they perhaps speak of some of the pleasures, rather than terrors, glimpsed on his Crimean tour.

Having been instrumental in Talbot's withdrawal from the enforcement of most of his patent rights, Fenton came to believe that he had the right to profit from the photographs he had made on commission for others. His efforts to do so led to disputes over the ownership of his negatives and some poor business decisions. In 1858 Fenton became involved with Paul Pretsch's photomechanical printing business, the Patent Photo-Galvanographic Company; this also ended badly, leaving Fenton heavily in debt. Among other issues, Talbot had threatened to sue the company for infringement of his 1852 patent on photographic engraving. As Talbot clearly understood, the 'gentleman amateur' needed legal protection no less than his commercial counterparts.

In 1860 Fenton created a remarkable series of large-format still lifes of fruit and flowers, the last major series he produced before retiring from photography. He exhibited the still lifes, together with a selection of earlier images, at the International Exhibition of 1862, held in South Kensington, London, and was awarded a gold medal. Although the quality of his work never declined, its reception became more critical in the late 1850s, symptomatic of a power shift in the British photographic community. To the rising generation of photographers, Fenton and his peers were the establishment. Their insistence on the dignity of the medium was detrimental to commercial interests.

There are numerous parallels between the life of Roger Fenton and that of his exact contemporary, Gustave Le Gray, including the fact that their involvement with photography left them in debt. While Le Gray abandoned both his family and his country to escape his monetary woes, Fenton believed that 'it won't do to shirk one's duty'.[5] After nearly a decade of endeavour, Fenton had failed to preserve photography's 'highest branches' for the professional gentleman and had failed to make them pay, and he again took up the practice of law. In 1862 Fenton's retirement from photography was announced in the pages of the *Photographic Journal*, and in 1863 his equipment and negatives were auctioned off. Poignantly, a photograph of Grace and Roger Fenton taken in about 1866, a few years before his premature death, shows that he still wore the full beard popularized by the returning heroes of the Crimean War. ■

Possible self-portrait, c. 1855

Clementina Maude,
Viscountess *Hawarden*

1822–1865

She was an earnest believer in the progress of photography,
and that it could be used as an art and abused like a daub.

OSCAR REJLANDER

The photographs made by Clementina Maude, Viscountess Hawarden (usually referred to as 'Lady Hawarden', the correct form of address for a viscountess) are often described in terms of their ambiguity. While the numerous tableaux she made featuring her daughters offer narrative cues in the form of the posing, costume and props, there are no titles to anchor the atmosphere of enchantment and longing. There is also very little primary evidence relating to either the photographer's life or her body of work. Although her photographs have been shown at major museums and are the subject of scholarly studies, they have not generated the same reams of analysis as the photographs by her contemporary Julia Margaret Cameron. And yet Hawarden's images, no less than Cameron's, resonate with many of the themes that have preoccupied artists and scholars over the last forty years, such as masquerade, doubling, female authorship and the female gaze. Much of the writing on Hawarden implicitly characterizes her as a woman who used her camera to rebel against the restrictive codes of behaviour imposed on her by virtue of her gender. While it is clear that her photographs are concerned with femininity, the scholarly readings of her work in terms of gender issues do not always offer a similarly nuanced reading of her class position. Cameron, of the merchant classes, acted like an aristocrat; Viscountess Hawarden, by contrast, acted as though she belonged to the middle classes.

Hawarden's place in Victorian society was determined by a series of unforeseeable events. She was born Clementina Elphinstone Fleeming, at Cumbernauld House near Glasgow, to a Scottish father and a Spanish mother. Admiral Fleeming was the second son of a Scottish lord whose decision to enter the navy was typical for a young man who would not inherit the family estate. It nonetheless came to

pass that he did, and Hawarden grew up as if a daughter of the aristocracy. When she was eighteen, however, her father died and the family estate passed to her uncle John. Just at the age at which she would have made her debut in society, Hawarden was suddenly divested of her social and economic status. Humiliatingly, Hawarden, her mother and her two sisters were no longer to be welcomed into London society. Instead, it was decided that they should go to Europe, where it was cheaper to live in genteel style. After a tour of the northern part of the continent, they settled in the expatriate community of Rome.

The beauty of the Fleeming girls was remarked on at this time by their uncle David Erskine, who was concerned that they might fall prey to impecunious or immoral men.[1] In fact, the opposite happened. In 1845 Clementina married the Hon. Cornwallis Maude, the heir to a title and a large estate in Ireland. So angry was Maude's family with this ill-advised love match that they would not receive their son's wife at their home. It seems that the young couple were given little support and, with a growing family, had to develop the prudence associated with families from much more modest backgrounds. In 1856, after eleven years of marriage, there was another twist of fate: her father-in-law died and her husband came into his inheritance. At the age of thirty-four, Clementina became Viscountess Hawarden. In 1857 she, her husband and their five children moved to the family estate in Ireland. It was there, soon after the move, that she took up photography.

One of the few aspects of Hawarden's character that has been recorded for posterity is her excessive devotion to her children. In a letter to her sister Anne, Hawarden's uncle Mountstuart Elphinstone wrote: 'I never saw nicer children or better brought up ... It seems strange in Clemy who could never keep her own shawl in order & whose devotion to her children seemed enough to spoil a whole generation, but her good sense and regard to duty has kept all right.'[2] An earlier letter written by her uncle, in this case to her mother, complained of Hawarden's failure to do her duty by her in-laws and produce a son and heir.[3] After giving birth to three girls in a row, she did in fact produce a son, but he was followed by another three girls, then another boy (who died a day after he was born), and then two more girls. Hawarden's photographic practice may in part be an attempt to reclaim her daughters from their ignoble position as surplus to requirement and as a

Photographic Study (Isabella Grace and Florence Elizabeth Maude, 5 Princes Gardens), c. 1863-4

financial burden in terms of their dowries. The photographs insist not only on their individuality but also on their beauty.

In 1859 the Hawardens returned to London, where they made 5 Princes Gardens in Kensington their main home. It is here that the most familiar of Hawarden's works were made: those that mainly feature her three eldest daughters posing either separately or together in distinctive domestic interiors or on one of two balconies. The fact that Hawarden – a 'great baby lover' according to her sister Anne[4] – gave birth three times during her brief period as a photographer has been used to bolster the idea of her photography as being an 'art of confinement', in that it speaks of the restriction of Victorian mothers and their daughters to the domestic realm. If so, this is not a negative: the photographs claim the domestic setting as one of creativity, imagination and transformation. Moreover, her photographic studies often address, either directly or indirectly, the interplay between the private and the public spheres in a young woman's life. A significant number of Hawarden's photographs feature her daughters between the space of the home and the space of the street – literally in terms of the balcony settings, and symbolically in terms of the use of both evening and day dress in the same image.

Other photographs by Hawarden show her daughters in their underskirts and chemises, not for their own sake but as a form of improvised costume. In the act of dressing and undressing, Victorian girls and women would move through a range of feminine identities; when seeing herself in the mirror dressed only in chemise, corset and underskirt, she might imagine herself, for example, as Coppélia or another character from the ballet. Some of Hawarden's photographs appear to explore other, more sensual pleasures. It has been noted that a large portion of her photographs show her sitters with one shoulder exposed. These studies draw on conventions from both fine and graphic art in which the female subject is depicted as if unaware of the artist's, and thus the viewer's, gaze, and so is not compromised by their appearance *en deshabillé*.

In addition to posing them in contemporary dress, Hawarden photographed her daughters in costumed tableaux exploring a range of feminine characters drawn from mythology, history, art and literature, from Greek goddesses to aristocratic coquettes. While it is tempting to see this range of female types as a pantheon of strong women intended

to counter the simpering creature found in Victorian popular culture, these were not countercultural types. In photographs by Hawarden, we sometimes see little china figurines of women in just such picturesque garb. It is again instructive, perhaps, to compare Hawarden with Cameron. The latter's female sitters were often made to impersonate female characters regarded as transgressive in their skills or actions, such as St Agnes, who chose martyrdom over marriage.

One of the most striking contrasts between Cameron and Hawarden can be found in the responses to their work on the part of the photographic community. When Cameron exhibited her photographs, she elicited hostility from her male photographer contemporaries. Hawarden's images, on the other hand, met with nothing but praise. The favourable, even effusive responses to Hawarden's photographs can be attributed in part to the investment of others in her social status. Hawarden participated twice in the annual exhibition of the Photographic Society of London, once in 1863 and again in 1864 (winning medals on both occasions). Of her contribution to the exhibition of 1863, the *British Journal of Photography* said: 'Were this lady a professional portraitist, instead of a fair amateur, she would not, in our opinion, wait long without gaining both fame and fortune.'[5] The fact that very few photographers of the period, and certainly no women, could be said to have gained 'fame and fortune' alerts us to the degree of hyperbole at work. The clumsy attempts of <u>Charles Lutwidge Dodgson</u> to make Hawarden's acquaintance – which she evaded – also speak of the fascination for, and deference to, the ruling elite.

Hawarden died of pneumonia in 1865 at the age of forty-two. In his obituary notice, the Swedish-born photographer Oscar Rejlander described her as being 'as useful as a clasp and bright as a diamond', neatly balancing the convention of praising her as a decorative ornament with the suggestion that she evinced the middle-class wish to be active and involved; elsewhere in the notice, he suggests that she had little of the airs and graces expected of an aristocrat. Hawarden's photographs remained in the family until an exhibition at the Victoria and Albert Museum in 1939 celebrating the centenary of photography led her descendants to donate nearly eight hundred prints to the museum (the distinctive torn corners of most of her photographs are thought to have been the result of a decision by the family to remove them from their original mounts). ∎

Photographer unknown, *Hannah Höch with one of her dolls, c. 1925*

Hannah *Höch*

1889–1978

*I'd like to blur the fixed boundaries that we
humans, in our self-certainty, tend to draw around
everything within our reach.*

HANNAH HÖCH

Hannah Höch was one of the first exponents of photomontage, the collaging of fragments of photographs (originals and/or reproductions) to create surreal and often provocative imagery. Photomontage was taken up near simultaneously, around 1918, in at least four countries: France, Germany, Switzerland and Russia; according to Höch, this was a corollary of the rapid growth of the photographically illustrated press, which not only provided the means to create these collages but also, with its montaged layouts, acted as a source of inspiration. Drawn into the Dada circles of post-First World War Berlin, she and her lover, the artist Raoul Hausmann, became masters of the new medium, creating startling and dreamlike forms. The suggestion that Hausmann sought to stifle Höch's creativity, and that some of her (all male) fellow Dadaists saw her as marginal to the movement, has coloured every aspect of her artistic biography. The desire to right these wrongs has inflected the subsequent recognition of her as a major artist.

Hannah Höch was born Anna Therese Johanne Höch into what has been described as 'an upper-middle-class family' in Gotha, a city in the state of Thuringia, Germany.[1] Her father, according to Höch, was in insurance and had come to Thuringia to set up an office; her mother, so she said, 'had modest artistic ambitions'.[2] The eldest of five siblings, Höch said that when she was fifteen she was pulled out of her all-girls school to care for the youngest, an arrangement that continued until her sister was six: 'This was all to my father's liking, since he shared the general turn-of-the-century bourgeois opinion that held a girl should get married and forget about studying art.'[3] In 1912, aged around twenty-two, she left home and began studying at the School of Applied Arts in Berlin-Charlottenburg. She claimed that she did not even bother to apply to the academy, despite it being where she really

wanted to go. If her freedom and her status as an art student already felt precarious, she would be denied both by the outbreak of the First World War: 'this catastrophe shattered my world.'[4]

With the onset of war, the art schools were closed down and Höch returned to her family home. While in Gotha she worked for the Red Cross. In 1915, when the schools were reopened, she enrolled in the school of the Kunstgewerbemuseum (Museum of Decorative Arts) in Berlin and was accepted into the graphic-arts class of Emil Orlik. It was while attending this school that she had the encounter – with the artist George Grosz – that would lead her to Dada.

 In 1916 Höch was making experimental art while working part-time as a graphic artist and pattern designer for Ullstein, publisher of, among other things, popular women's magazines. In time, she began to use these publications as the source material for her photo-montages. This is not to say that she saw her work as a commercial artist as lowly: she would remain committed throughout her life to the idea of art and design, including such handicrafts as embroidery, as expressions of the zeitgeist.[5] Having arrived in Berlin alienated from the values of her father, she gravitated towards a milieu alienated from the values both of the establishment and of the German Social Democratic Party, which had failed to condemn the war.[6] Although the Berlin Dadaists drew on the language of communism, their goal, according to Höch, was primarily aesthetic: 'our whole purpose was to integrate objects from the world of machines and industry in the world of art.'[7]

Höch's artistic biography is littered with competing claims for priority. In 1959, in an interview with the American writer Édouard Roditi, she was at pains to explain that it was she, when she had first met Raoul Hausmann, who was the experimental artist, embracing abstraction under the influence of Wassily Kandinsky.[8] It is generally said, however, that it was Hausmann who readily threw himself into Dada and took Höch with him. Höch credited Hausmann with the invention of photomontage against the claims of Grosz and John Heartfield, who had simultaneously conceived of a more politicized version. Höch, who characterized the medium as 'activating – that is to say, alienating',[9] maintained that there was a distinction between 'applied' (politicized) and 'free-form' photomontage, which she called a 'fantastic field for a creative human being'.[10]

Höch's position in the ranks of Berlin Dada is not easy to assess. The only female member, she is not as visible as her male peers in the history of the movement, but this may in part be due to the constant power struggles within the group. In 1920 she was one of the many contributors to the 'First International Dada Fair' in Berlin. It is estimated that she exhibited between six and eight works, including what is, perhaps, her best-known piece, *Cut with the Kitchen Knife through the Last Weimar Beer-Belly Cultural Epoch in Germany* (1919-20). Grosz and Heartfield objected to her participation,[11] and one wonders if their resistance to her was exacerbated by a review of the show in which the artists identified as '[making] a visit to the exhibition worthwhile' were named as Höch, Richard Huelsenbeck and Grosz, in that order.[12]

According to Höch, Hausmann was the most gifted of the early Berlin Dadaists, but needed constant support. 'If I hadn't devoted much of my time to looking after him and encouraging him,' she later observed, 'I might have achieved more myself.'[13] Married with a child, Hausmann would not, it is said, choose between his wife and his mistress, preferring to live partly with both. In the literature about the relationship (which, it should be noted, is written largely from Höch's point of view), Hausmann comes across as a domineering bully with a hypocritical, bourgeois attitude towards gender equality: he wanted not only emotional but also financial support from his mistress, and preached sexual revolution while claiming the experience of motherhood as something she needed and desired. Höch, who resisted both motherhood and Hausmann by undergoing two abortions,[14] later called their relationship 'a difficult and sad apprenticeship'.[15]

The 1920s saw Höch forge an artistic identity as an individual. Throughout the decade she was an active member of the November Group, a radical artists' group formed in the wake of the November Revolution in Germany (1918-19). She cemented her friendship with the German artist Kurt Schwitters, with whom she also developed a productive working relationship, and in 1924 paid her first visit to Paris, where she met many of the city's artistic and literary figures. She also journeyed to Prague, Weimar and the Netherlands. It was during the last of these travels, in 1926-7, that she met the poet Til (Mathilda) Brugman, for whom she would leave Berlin for The Hague. They became artistic collaborators as well as lovers, with Höch illustrating Brugman's writings. Höch exhibited widely in the 1920s, including

Da-Dandy, 1919

at the landmark 'Film und Foto' exhibition in Stuttgart (1929). In the second half of the 1920s and the early 1930s Höch was making the works that would constitute her series 'From an Ethnographic Museum'.

In 1932 Höch was forced to cancel an exhibition at the Bauhaus in Dessau when the school was closed down by the National Socialists. After 1933 she was prohibited from exhibiting in Germany, and yet, in 1935, she returned to live there. While recuperating from an operation, Höch met Heinz Kurt Matthies (known as Kurt), a businessman and amateur pianist. The couple's marriage, in September 1938, came not long after the denunciation of her work in Wolfgang Willrich's pro-Nazi book *The Cleansing of the Temple of Art* (1937), and one wonders whether she was motivated to wed in part by the need to acquire a new name. She and Matthies separated in 1942 and were divorced two years later.

In the spring of 1945 Berlin was liberated by the Russians, and Höch, after 'twelve years of extreme tyranny', was re-enfranchised as both a citizen and an artist.[16] She was very active in the post-war period, not only drawing on her stockpile of Ullstein imagery but also once again experimenting with abstraction. For some scholars the imagery from this period has little of the cultural significance of her earlier work. Höch, however, saw no distinction between her pre- and post-war art, and theorized her continuing commitment to photomontage in the following terms: 'Until such time as reality has been thoroughly rationalized – it will never be entirely rational – "fantastic" art will show the discrepancies between that goal and its reality. The [discovery of] this art is one of the major intellectual events of our time.'[17]

For some, it is clearly a disappointment that, when asked about the feminist readings of her work, Höch did not denigrate marriage and motherhood. But is the radical potential of her art diminished by the discovery that she was using irony to battle not for the general principle of women's emancipation but for the specific, personal sufferings of women like herself? Höch was not concerned merely with her own subjectivity, as were the bourgeois artists that Dada satirized. Ultimately, her biography compels us to ask who was more committed: the artists who sought to disassociate themselves from their youthful 'cultural bolshevism' (as the Nazis termed it), or someone like Höch, who preserved her and her fellow artists' work 'during twelve years of tyranny' at the risk of death? Höch understood that the personal was political *avant la lettre*. ■

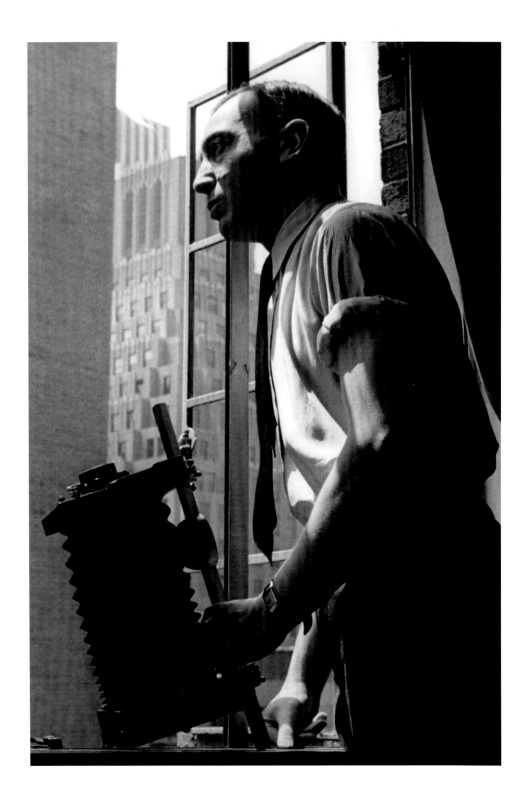

Self-Portrait in the Hotel Beaux Arts, New York, 1936

André *Kertész*

1894–1985

I express myself photographically.

ANDRÉ KERTÉSZ

André (né Andor) Kertész lived long enough to enjoy both the growing recognition of photography as an art form and the recognition of himself as a great photographer. Kertész's own version of how and why he came to take up photography, of his near sixty-year relationship with Erzsébet Salamon, of how he and Salamon (by then his wife) were stranded in the United States because of the Second World War, and of the many slights that prevented him from gaining the recognition he deserved is a compelling, if bittersweet, story. It is also one that is substantially untrue. According to Robert Gurbo, curator of the André Kertész Estate, when his archives became available for consultation, it transpired that Kertész - an inveterate hoarder - had in his possession letters and other documents that revealed that his marriage had been much less happy than he had said, that the couple had not exactly been a victim of circumstance during the war, and that some of the fault for the lack of recognition that he levelled at others was his.[1] While all autobiography is subjective, what is remarkable in this case is how Kertész's account of his life went unchallenged for so long. What biographers have now is both the story that Kertész, a self-confessed 'sentimentalist',[2] told others, and the evidence that testifies to a more nuanced and open-ended version of events. It is the interplay between the two that offers us the richest portrait of his life and art.

The second of three boys, Kertész was born into a lower-middle-class ecumenical Jewish family in Budapest. His father, Lipót Kertész, was a bookseller; his mother, Ernesztin, ran a coffee shop. When Lipót died in February 1909, Kertész temporarily abandoned his studies at Budapest's Academy for Commerce in favour of manual work, returning to the academy a couple of months later. The widowed Ernesztin raised her sons with the support of her brother, Lipót Hoffman, a successful grain merchant. Kertész received his commercial baccalaureate in 1914. It has been said that he barely

scraped the qualification.[3] While this may be true, it may equally be
the case that he preferred to suggest that he was a poor student rather
than acknowledge his need to contribute economically to the family.
Kertész, who believed himself to have the soul of a poet, found an
outlet for his heightened sense of selfhood in the high emotions of
romantic fantasy engendered by his obsession – and affair – with his
young neighbour Jolán Balog, which lasted from 1905 to 1915.[4]

A fascinating aspect of Kertész's biography is that many of the
cameras he owned in Hungary and then Paris were presents from his
family. That his very first camera, given to him in June 1912, was a
gift of this kind is less noteworthy, since it seems that it was common
at the time to give young Hungarian men a camera for a teenage
birthday.[5] It is sometimes said that the camera, an ICA, was a joint
gift from Kertész's mother to both Kertész and his younger brother,
Jenő;[6] it has also been said that it was a gift for Kertész only, from his
mother *and* Jenő.[7] What is certain is that the two brothers collabo-
rated in making and developing photographs, the lack of an enlarger
limiting them to the production of contact prints. Their summer of
artistic experimentation ended when Kertész started work as a clerk
in a bank in July 1912.[8] He nonetheless continued to take photographs
with Jenő in his spare time – a practice that was already, perhaps, a
panacea for the economic realities of life.

Two years later, in October 1914, Kertész was drafted into the
Austro-Hungarian army. He was still infatuated with his neighbour
and had already developed the melancholy cast that would stay with
him for the rest of his life. In November of that year Jenő sent him an
ICA Bébé, a handheld box camera that took 4.5 × 6-cm glass plates.
It has been suggested that Kertész refined his remarkable eye for
composition during his military service, when he had only seconds
in which to fall out of line and take a picture.[9] This theory is called
into question, however, by the fact that he carried a tripod with him
throughout the war years. Similarly, despite Kertész's characterization
of himself as having an amateur sensibility,[10] he was, it seems, creat-
ing some of his imagery with one eye on the illustrated newspapers
and magazines, sending his glass plates to Jenő with instructions to
develop the prints for reproduction in the press.[11]

In early 1915 Kertész contracted typhoid. Around six months later,
he was shot and wounded in the chest and arm. Returning to active

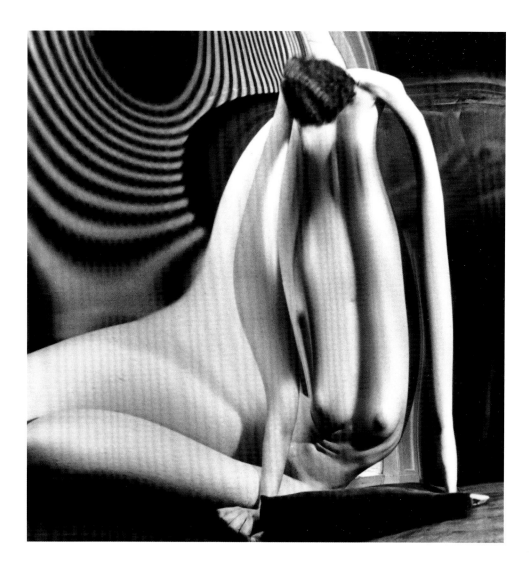

service in the autumn of 1916, he was given duties that kept him away from the front lines. On his discharge from the army in 1918 Kertész returned to Budapest, where he went back to his old job and, in his own time, photographed the aftermath of the collapse of the Austro-Hungarian Empire. He said of himself at this time, 'I was leftist, like every normal human being, absolutely leftist.'[12] It seems, however, that he distanced himself from this stance following the brutal repression of those in the arts who were suspected of communist sympathies. Three years later, in March 1921, Kertész began looking for other work but found himself subject to anti-Semitism. In 1924 he

Distortion #39, 1933

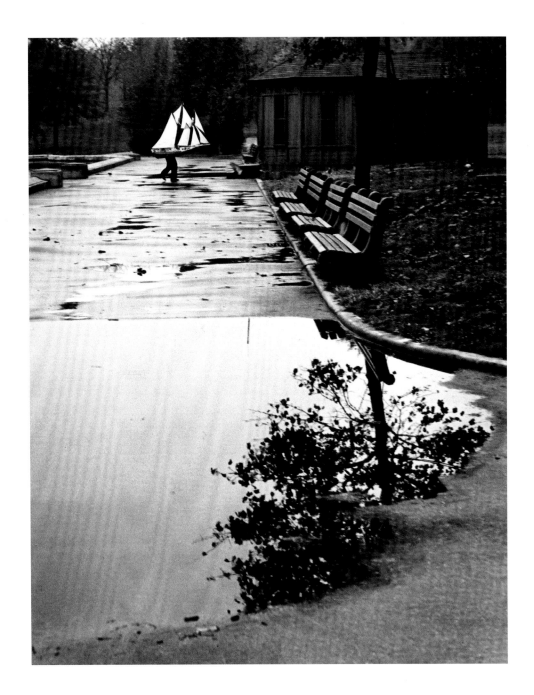

Homing Ship, Central Park, New York, 1944

was offered an apprenticeship by Pal Funk, aka Angelo, a successful Hungarian photographer with studios in Budapest, Paris and Nice. Kertész did learn from Funk but did not accept the position. His artistic affiliations at this time lay with progressive painters, designers and sculptors, such as István Szőnyi and Vilmos Aba-Novák. He was also fascinated by transformative self-portraiture, having made a series of inventive self-portraits while serving in the army.

In 1919 Kertész had fallen for Erzsébet Salamon, an art student ten years his junior. It is said that, in 1924, Salamon issued him with an ultimatum: if he would not marry her that winter, she would have nothing more to do with him until he had made something of himself.[13] Kertész, who spoke no French, duly arrived in Paris on 8 October 1925 on a temporary visa. At first, he knew only one person in the city, the Dada artist Tristan Tzara,[14] but soon grew close to the painter Lajos Tihanyi, a leading member of the Hungarian expatriate community. At some point in these early years in Paris, Kertész changed his given name to 'André'. Although he later avoided the subject of his early professional success in France, it is now acknowledged that he became 'the leading photojournalist of the time',[15] building a successful freelance practice based on social observation instead of 'breaking news'.[16] His images were bought by publications in France, Germany, Italy and London.

Kertész was simultaneously nurturing his reputation as an art photographer. In March 1927 he had a joint exhibition with the Hungarian artist Ida Thal at Au Sacre du Printemps gallery in Paris; two years later, thirteen of his photographs were shown at 'Film und Foto', the landmark exhibition of international photography held in Stuttgart. In 1933 Kertész published his first book, *Enfants*. His second, *Paris vu par André Kertész*, with an essay by Pierre Mac Orlan, followed in 1934. It was during this period of increasing commercial and artistic success that, in October 1928, Kertész married Rózsi Klein, an expatriate Hungarian violinist who adopted the professional name Rogi André when she took up photography. Kertész's marriage to Klein was not widely known during his lifetime and was relatively short-lived. He and Klein separated in 1931, the year that Salamon visited him in Paris, and were divorced in 1932, the year that Salamon joined him in the French capital. Kertész and Salamon were married in June 1933.

Kertész's resentment at his transplant from France to the United States, which began with a one-year contract from the Keystone Press Agency to establish a fashion studio in New York, coloured his relationship with the country that would become his home. With anti-Semitism having severely curtailed his commercial work in Paris, he once again found himself leaving one country for another. Arriving in New York in mid-November 1936, and adrift in the world of fashion photography, he took up work for other publications, a decision that led to his contract with Keystone being terminated. Despite this professional setback, Kertész was immediately recognized in New York as an important artistic photographer, with five of his photographs selected for the major exhibition 'Photography 1839–1937' at the Museum of Modern Art (MoMA; 1937). Kertész, however, could turn even his successes into excuses for bitterness at being separated from Paris. Later, after many professional disappointments, he complained that Beaumont Newhall, the curator of the MoMA show, had asked him to crop one of his nude 'distortions' in order to edit out the pubic area: 'I was furious. It is mutilation, it is like cutting off an arm or a leg.'[17] His time in Paris, during which he had severely struggled before finding success, was now to be his prelapsarian idyll.

In 1941 Kertész was instructed not to photograph on the street because of his status as an enemy alien. This event undoubtedly contributed to his decision to apply for US citizenship, which he was granted in 1944. It was also at this time that Salamon took the name Elizabeth Saly. In the final year of the war Kertész published *Day of Paris*, designed by Alexey Brodovitch, at that time the art director of *Harper's Bazaar*. A year later, an exhibition of the same name took place at the Art Institute of Chicago. There was, however, no money to be had from recognition as an art photographer, and in 1947 Kertész signed an exclusive one-year contract with Condé Nast to work for *House & Garden* magazine – a professional relationship that continued for the next fifteen years. This was the period of his life in which he felt himself to be truly in the wilderness. Not only was he seeing other photographers of his generation become feted as artists, but also, owing to the post-war success of his wife's fragrance business, it was she who now held the purse strings. In 1952 the couple moved into an apartment in a newly built high-rise at 2 Fifth Avenue. Ten years later, suffering from ill

health and thoroughly estranged from the world of Condé Nast, Kertész left *House & Garden*. From then on he allowed his wife to manage his affairs.[18]

Approaching seventy, Kertész began to receive the recognition that he believed had eluded him, including retrospectives in Paris and New York (1963 and 1964 respectively); the signing of an exclusive contract with New York's Light Gallery (1974);[19] and such honours as the Ordre des Arts et des Lettres (1976) and the Légion d'Honneur (1983). This artistic success was marred, however, by Kertész's increasingly poor health, which saw him hospitalized in the spring of 1976. Saly, meanwhile, had developed lung cancer, and Kertész endeavoured to nurse her between his own hospital visits. Saly died in October 1977, and it was at this point that he began to romanticize the marriage.[20] He claimed in an interview that after her death he stopped taking photographs, but then saw a glass bust in the window of Brentano's bookshop: 'It was Elizabeth.'[21] He bought it, and soon embarked on a series of Polaroid images featuring first this bust alone and then a second. He said of this intense period of photography, 'Suddenly, I'm losing myself, losing pain, losing hunger, and yes, losing the sadness.'[22] He continued to work with both a Polaroid and a 35mm camera until his death.

As other scholars have argued, the lapses and elisions in Kertész's artistic autobiography would be of less interest if he had not inferred that 'his photographs were a visual diary of his life'.[23] To present himself as a lifelong amateur in the art when he was a leading photojournalist of the interwar years is also a rather startling example of poetic licence. As both Robert Gurbo and the curator Sarah Greenough have suggested, his autobiographical impulses were those of both the artist concerned with securing their reputation and the immigrant anxious about the abandonment of their homeland. His decision late in life to meet up with Jenő, with whom, it seems, he had been in contact only by letter for a considerable period of time, is suggestive of a man making peace with the past. Perhaps he recognized the crucial role played by Jenő in his evolution as a photographer. If it had not been for the support of his family and the expectations of Saly, Kertész might never have found the means or the motivation to escape the anti-communist reprisals and growing anti-Semitism in his native Hungary. ■

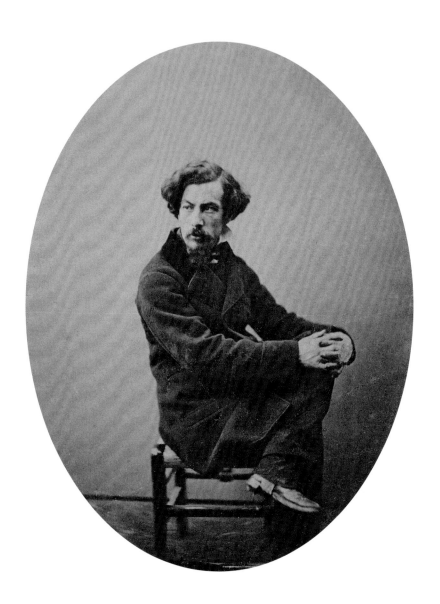

Self-Portrait, c. 1850–2

Gustave *Le Gray*

1820–1884

It is my deepest wish that photography, rather than falling into the domain of industry, of commerce, will be included among the arts. That is its sole, true place.

GUSTAVE LE GRAY

Gustave Le Gray is thought to have taken up photography in the mid-to-late 1840s while studying fine art in Rome. His rise to prominence as a leading photographer in Paris and his slow but steady decline into debt and exile is a fascinating yet sober reflection on the intersection of photography and speculative investment in the age of capital. Karl Marx identified photography as one of the new, modern industries of the mid-nineteenth century,[1] and a number of his contemporaries saw in the medium the possibility of handsome rewards and a share in the prestige of the fine arts. Le Gray was able to attract patronage and investment, but had no facility for business and a horror of debasing the medium that he practised – not least, perhaps, because it would debase the practitioner too. He would leave France to escape his debts, abandoning his wife and children, and, after a colourful voyage in the Mediterranean in the company of the writer Alexandre Dumas, would never return to Paris. Instead, he would choose to use his reputation as a photographer to the imperial French court to lead a life less ordinary.

It is hard to reconcile the upright, diligent student depicted in some accounts of Le Gray with the impecunious idler depicted in others. Even his status as a leading photographic experimenter, teacher and practitioner is not entirely secure. Some of his contemporaries complained that they could not achieve good results by his methods. This, in turn, may not be true. Le Gray, an avid self-promoter who proclaimed himself the inventor of some of the most significant technical advancements of the day, was subject to professional jealousy – not only among his Parisian peers, but also because of the economic, political and photograhic rivalry between England and France. Scholars are still trying to clarify, as Anne Cartier-Bresson has put it, 'the relationship between what he said, what he did, and what remains of his work'.[2]

Le Gray was born in Villiers-le-Bel, a commune to the north of Paris. When, as a young man, he gave up his job as a clerk in his home town to train as an artist, his parents continued to support him despite the serious misgivings of his father, who owned a haberdashery in the French capital. The master artist whom Le Gray trained with in Paris, Paul Delaroche, was also one of the earliest champions of photography, stating in a report commissioned in 1839 that 'the admirable discovery of M. Daguerre has rendered an immense service to the arts.'[3] Among those who studied painting under Delaroche in the 1840s are some of the most notable names in mid-nineteenth-century photography: Le Gray, Henri Le Secq and Charles Nègre. In the summer of 1843, when Delaroche was obliged to close his studio after a fatal hazing incident, some of his loyal pupils, Le Gray and Le Secq among them, joined him in Rome. Le Gray would remain there for four years.

Photography was a very attractive pursuit for those who did not wish to be defined by the circumstances of their birth. Not yet tainted by commerce, it seemingly promised fame and fortune. That Le Gray began to pursue photography may have been due to his personal circumstances: in 1844, while living in Rome, he had married Palmira Leonardi – the daughter of a local pedlar – without his parents' consent. Although this seems like the act of a reckless man, Le Gray apparently spent much of his time in Rome diligently studying photographic chemistry, trying to create a 'reproducible'[4] and 'permanent'[5] image. Le Gray's identification of himself at this time as a photographic scientist is corroborated by his collaboration, after his return to Paris in 1847, with the physicist and politician François Arago in the capturing of a solar eclipse on a daguerreotype plate.

On his return to Paris, a growing family now in tow, Le Gray again became a pupil at the École des Beaux-Arts and re-entered the studio of Delaroche. In addition to exhibiting his paintings, he was refining his photographic practice – first on metal and then on paper – and was noticed for his portraits and copies after artworks. A well-appointed apartment on the rue de Richelieu was leased in 1849, and his first pupils, including the writer Maxime Du Camp, were instructed. There can be little doubt that Le Gray had hit upon a modus operandi that would serve him well: that of leveraging professional capital gained in one sphere to succeed in another, less elevated one.

Le Gray, it seems, was intent on promoting himself as a superior breed of photographer, one who was uniquely placed to take on the challenges of the coming revolution in visual documentation and illustration. No major commissions emerged, however, and in the autumn of 1849 two of his three daughters died from what is thought to have been cholera. The Le Gray family left central Paris and moved to 7, chemin de Ronde, barrière de Clichy, an address just within the northern walls of the city. Among the well-known names of the many neophyte photographers who frequented his studio there were Auguste Mestral, Joseph Vigier and Adrien and Gaspard-Félix Tournachon (aka <u>Nadar</u>). In June 1850 Le Gray published the first issue of his manual, *Traité pratique de photographie sur papier et sur verre*.

Le Gray identified himself as the inventor of the waxed-paper process, one of the most significant technological developments of mid-nineteenth-century photography. Although we know that William Henry Fox Talbot, the English inventor of photography on

Forest Scene, Fontainebleau, c. 1855

paper, waxed his negatives for greater transparency, Le Gray's method differed in important ways. Le Gray recommended waxing the negative prior to exposure, as opposed to afterwards, and refined the chemistry so as to increase the sensitivity. As with Talbot's process, the fact that negatives could be sensitized in advance meant that excursions could be made – such as those by Le Gray to the forest of Fontainebleau beginning in 1849 – relatively unencumbered. The idea of there being a (loose) school of French artists in photography in the mid-1840s and 1850s, 'les primitifs de la photographie', owes much to Le Gray's teachings and writings.

In April 1851 Le Gray presented his waxed-paper process to the Société Héliographique, the Parisian photography society founded earlier that year. Along with four other founding members of the society – Le Secq, Auguste Mestral, Édouard Baldus and Hippolyte Bayard – Le Gray was chosen to take part in the 'Mission Héliographique', a project to record some of France's most important historical monuments. On his and Mestral's tour of south-west France, made between July and September 1851, Le Gray refined his waxed-paper process, experimenting with the tones, contrasts and hues of the final print. Perhaps he hoped to make his fortune as a master photographic printer. As to why he did not, there are differing explanations: some evidence suggests that he was not willing to sacrifice quality for quantity, while some implies that he was incapable of producing consistently good results.

In the 1850s photography was frequently criticized in the press for its technical shortcomings: it could not, it was said, reproduce the world in colour or capture such natural effects as clouds or waves. It distorted tonal relations, and it was impossible to expose correctly for both the sky and the foreground. Nature was considered the ultimate challenge, one that divided photographers into scientists and artists – the former seeking more accurate visual technology, and the latter an aide-memoire for use in the studio. For his part, Le Gray attempted 'to unite science with art',[6] using photographic technology to render the fugitive and inspiring 'effects' of nature.

In the edition of his *Traité* published in 1852, Le Gray claimed that 'the artistic beauty of a photographic print … nearly always lies in sacrificing certain details so as to produce an impression that sometimes achieves the most sublime art.'[7] Conventional in its approach to aesthetics, Le Gray's statement was nonetheless audacious in

its suggestion that photography was more than simply a recording device. In the mid-1850s he created a series of photographs that put theory into practice, using glass negatives coated with sensitized collodion – the second major innovation he claimed for himself. The marine studies made by the wet collodion process that he began to exhibit in 1856 were virtuoso displays of technical skill married to aesthetic effect: here at last the sea and sky were rendered together in picturesque harmony, and without blurring. Moreover, the photographs bore a rich, pleasing aubergine hue, the result of another of Le Gray's self-proclaimed innovations: gold toning. One London print-seller claimed to have taken 800 orders in two months for *The Brig* (1856), 'the lovely sea-view of Le Gray's,' as one observer described it, 'which all England is now wondering at'.[8]

It is interesting to consider what the reaction would have been had contemporary critics been fully apprised of Le Gray's methods. It was not until the twenty-first century that researchers, putting his reputation to one side, realized that he had sometimes employed 'combination printing', using one negative for the sea and another for the sky. It is likely, according to one scholar, that his most celebrated marine, *The Great Wave, Sète* (1857), was made from three negatives.[9] Le Gray, who denounced retouching in his writings, retouched his marine negatives. None of these manipulations were recognized at the time. It appeared to his contemporaries that the criticisms levelled against photography had been overcome: that it was finally possible to use science to create art.

About a year before *The Brig* was first exhibited, Le Gray had opened a richly appointed photographic studio on the upper floors of a newly constructed building at 35, boulevard des Capucines, Paris, with generous financial backing from the marquis de Briges. This enterprise appears to have been an attempt to capitalize on Napoleon III's patronage of Le Gray, who in turn styled himself as 'photographer to the Emperor'. Among the clientele his studio attracted were European royalty, foreign dignitaries, writers, journalists, and leading actors and musicians. As was the practice of the time, it is unlikely that Le Gray took many of the portraits himself, allowing his freedom from the constraints of commerce to signify his success. He travelled to Normandy (1856), Sète, on the Mediterranean coast (1857), and Brittany (1858), photographing harbours, beaches and ships at sea. We cannot say

whether it was he who removed the lens cap even for his best-known works; an 'operator' was often employed by those who wished to distance themselves from the manual aspects of photography.

Maintaining the façade of someone who worked for the love of the medium alone was expensive. In 1859 the sons of the marquis, who had died in 1857, liquidated their father's contract with Le Gray and sought recourse through the courts. Le Gray escaped his creditors in May 1860 by joining Alexandre Dumas on his yachting tour of the Mediterranean. The tour was intended to result in a book for Dumas; Le Gray's role was to supply the photographs on which the illustrations would be based. Travelling via Monaco, Genoa and Sardinia, the party headed for Palermo, where Dumas sought out the Italian general Giuseppe Garibaldi, who had just taken the city in the ongoing battle for Italian unification. Le Gray photographed both the general and the ruined city. The travellers stayed in a royal palace annexed by Garibaldi and then embarked on a trek across country with forty of the general's men. After rejoining Dumas's yacht at Agrigento, they sailed to Malta, where Le Gray and two others were set down at Valletta.

The Tugboat, 1857

Dumas claimed that, while he wished to rejoin Garibaldi, Le Gray and company wanted to travel to the Orient as planned. Others said that the men were abandoned owing to a row over Dumas's pregnant lover.

Unable to secure a passage to Italy because of the fighting, Le Gray and his two fellow travellers made a virtue out of necessity by offering to cover the conflict in Syria for a Parisian journal. By the late summer of 1860, Le Gray had become a photojournalist *avant la lettre*, supplying photographic views and portraits to *Le Monde illustré* as the basis for woodcut engravings. He next appears in 1861, in Alexandria in Egypt, where one client described him as 'skilful but expensive'.[10] In a letter to Nadar dated 1862, Le Gray claimed to have no money; whether this was true or an attempt to evade his financial responsibilities is unknown. In 1863 Palmira, then in Rome, tracked him to Alexandria via the French consul there and a request was made for a modest maintenance. There is no evidence that it was forthcoming. On her return to France in 1865 she wrote to Le Secq asking him for help. This is the last recorded document relating to Le Gray's wife.

Le Gray, it is thought, settled permanently in Cairo in 1864. There, he enjoyed the patronage of Ismaïl Pasha, the Khedive (or viceroy) of Egypt and Sudan under Turkish rule, who gave him photographic commissions and, in 1867, engaged him as drawing master to his sons on a voyage down the Nile. We know he then worked as a drawing master at the military schools in Cairo and later at the city's Polytechnic School (1871-2). He also continued to make photographic portraits and topographical studies on commission. In 1881 he was taken to court by his butcher for not paying his account; when he died three years later, he was 2,000 francs in debt. Although he died in reduced circumstances, one wonders if he saw his expatriate life as a personal triumph. Le Gray left Paris to escape a court order to pay debts of 50,000 francs, and lived and worked for a further twenty-four years without paying a sou.

Le Gray would be a major figure in the history of photography for his technical innovations alone, but he is also one of photography's most celebrated artists. That there is contradictory evidence about his life and his professional achievements perhaps provides greater rather than less insight into both: it is likely that his personal charm and talent for self-promotion blinded many, including himself, to his failings. 'I do not think', he wrote, 'there is a man in the world more exploited than I.'[11] ∎

Untitled (Solarized Self-Portrait with Camera), 1931

Man Ray

1890–1976

For me there's no difference between dream and reality.
I never know if what I'm doing is done when I am
dreaming or when I am awake.

MAN RAY

When Man Ray wrote his autobiography, he had a near-unique experience to recount: he was not an aspiring artist who had turned to photography to make his name, but an internationally renowned artist of the interwar avant-garde whose key works included paintings, sculptures, films *and* photographs. *Self-Portrait* (1963) is more than usually unreliable for an autobiography, but is typical in its ambivalence about the place of photography in his *œuvre*. According to the book, Man Ray's adoption of photography beyond the reproduction of his paintings was conceived by him as a way of living his life as an artist without the compromise of taking salaried employment. Despite making artworks that, in their conceptual innovation, elevated photography to the level of painting and sculpture, Man Ray was no less subject than his contemporaries to the view that photography was of a lower order than fine art. Late in life, the man who had grudgingly turned to photography in order to support his art practice often found himself enjoying the recognition he believed was his due, such as a major retrospective in Paris, because of his photography.

Michael Emmanuel Radnitzky was born in Philadelphia, the first of four children. His parents – Melach, a tailor, and Manya, a seamstress – were both Jewish immigrants, having arrived in the United States from Europe in 1886 and 1888 respectively. In 1897 the family moved to Williamsburg in Brooklyn. The Radnitzky's desire to assimilate is suggested by the contraction, in 1912, of their last name to Ray; it was also in that year that their eldest son, known as Emmanuel or 'Man', began to sign his paintings 'M. R.' (and not 'E. R.' as before). The Rays were supportive of their son's talents as an artist, giving him the freedom to paint at home, but 'endless were the arguments about what would be a serious occupation'.[1]

By 1906 Man Ray, it seems, was spending all his free time in galleries and bookstores. Graduating from his all-boys high school in Brooklyn in 1908, he secured a scholarship to study architecture at New York University. After spending the summer between graduation and university painting outdoors, he gave up the scholarship and resolved instead to support himself while studying art. The jobs he records getting – and usually losing – in this early period were all in the field of graphic or technical art, at which he had excelled at school. In 1912 he secured a position as a draughtsman for the Manhattan-based book publishers McGraw-Hill. He would keep the job until 1919, after which he would never work in an office again.

In October 1910 Man Ray was admitted to the National Academy of Design, New York; he also began to study at the Art Students League of New York. Two years later he attended classes at the Ferrer Center, a progressive educational institution on East 107th Street, and, in the winter of 1912–13, the venue of his first public show. According to Man Ray, in 1913 he left home by stealth, taking his belongings in stages to the studio of his friend the sculptor and poet Adolf Wolff on West 35th Street.[2] By the time of the seminal 'International Exhibition of Modern Art' (known as the 'Armory Show') in 1913, he was already well versed in European avant-garde art, having seen many of the shows that <u>Alfred Stieglitz</u> had mounted at the Little Galleries of the Photo-Secession.

It was also in 1913 that Man Ray met his first wife, Adon Lacroix (born Donna Lecoeur). He claimed to have first seen Lacroix, a Belgian-born poet, at the Ferrer Center, and that he only later learned that she was Wolff's ex-wife.[3] Man Ray and Lacroix met properly in August 1913 when the latter visited the artists' colony – in Ridgefield, New Jersey – to which Man Ray had moved that spring, and it was very quickly agreed that Lacroix would come to live with him. They both, so he said, found the social prohibitions on unmarried couples tiresome, and so got married in May 1914.[4] Their intention was to move to Paris, but the war in Europe forced them to remain in America. It was at the colony in 1915 that Man Ray met Marcel Duchamp for the first time.

According to Man Ray, his decision to become a photographer, rather than simply the owner of a camera, came shortly after his decision to relinquish his job at McGraw-Hill and devote himself to being an artist. If his account is to be believed, it also came immediately after his separation from Lacroix (owing to, so he said, her taking of

Gun with Alphabet Stencils, 1924

a lover).[5] Without telling Lacroix, he rented a space next door to their Greenwich Village apartment and set up a studio with a cot bed. In order to make his photographic practice worthy of an artist, he determined, or so he said, not to solicit sittings but rather to take portraits of those who visited his studio of their own volition. 'I never asked for money', he later wrote, 'and gave my prints away freely.'[6] Like the claim that he would never photograph anyone's work but his own, this characterization of his practice of photography as free from commercial imperatives was probably strategic: since July 1917, he had been engaged in photographing the art collection of the lawyer John Quinn.

Through his aesthetic and personal allegiances with Duchamp, Man Ray became a leading figure within New York Dada. In 1920 Man Ray, Duchamp and the arts patron Katherine Dreier established the Société Anonyme to promote avant-garde art in the United States, with Man Ray becoming the society's vice president and its photographer. In 1921 he and Duchamp collaborated on what proved to be the only issue of the magazine *New York Dada*, the cover of which features Duchamp photographed by Man Ray as his alter ego Rrose Sélavy. Of trying to bring Dada to New York, Man Ray later observed: 'The effort was as futile as growing lilies in the desert.'[7]

Convinced that important art could not thrive in the United States, Man Ray arrived in France on 22 July 1921 and was met off the train in Paris by Duchamp, who introduced him to his network of artists and writers. Man Ray photographed the members of these circles, but was careful to insist in his autobiography that he did so with no commercial motive.[8] By December of that year he had taken lodgings in Montparnasse. There, he met the artist, model and artiste Alice Prin, known as 'Kiki de Montparnasse', with whom he would be romantically involved for the next six years. Prin was the model for some of his own art, including the iconic *Le Violon d'Ingres* (1924), for which he transformed her naked back into a musical instrument. By the mid-1920s Man Ray's status as an avant-garde artist was growing: in 1926 the first exhibition at the Galerie Surréaliste was a show of his work.

It appears that Man Ray began to make money from photography at exactly the same time as he began to achieve recognition as an artist in the medium. In 1922 his portraits of Pablo Picasso and James Joyce appeared in the March issue of *Vanity Fair*, while the November issue of the magazine contained a feature on his 'rayographs' (photograms)

entitled 'A New Method of Realizing the Artistic Possibilities of Photography'. It was also in 1922 that Man Ray published *Les Champs délicieux*, a collection of rayographs with a preface by Tristan Tzara, the presiding genius of European Dada. By the end of that year, his increasing number of photographic commissions – not only in portraiture and editorial work but also in fashion – led him to move to a larger studio-apartment on the rue Campagne-Première.

Self-Portrait contains remarkably few references to the model turned photographer Lee Miller, who sought out Man Ray in 1929. Although he acknowledges in the book that 'I was in love with her',[9] the usually frank (and boastful) Man Ray does not make it clear that the two became artistic collaborators and lovers; instead, she is characterized as his photographic pupil. It is now accepted that the two together, rather than Man Ray alone, worked out how to turn solarization (the reversal of tones) into a creative tool. Her relegation to the role of muse was, it has been suggested, a key factor in her decision to end their relationship in 1932.[10] Whether or not he inhibited her artistic practice, his letters to Miller attest to the depth of his love for her and his belief in her as an artist.

By the mid-1930s Man Ray's portraiture practice was thriving. Although he was troubled by his proximity to commerce as a photographer, he enjoyed the access it gave him to the social and cultural elite. Being both an American and a European increasingly became an advantage: *Man Ray Photographs 1920–1934 Paris* (1934), edited by the influential collector James Thrall Soby, was distributed in both Paris and New York. In 1936 Man Ray acquired a house in Saint-Germain-en-Laye, to the west of Paris, and became involved with Adrienne Fidelin, a dancer from Guadeloupe. Photography, however, remained the locus for his ambivalence about creativity and capitalism. In December 1937 he published a portfolio of twelve photographs, *La Photographie n'est pas l'art*. Despite the title, the text claimed that photography, then only 'an art', could in the future be Art with a capital 'A'.

During the opening months of the Second World War, Man Ray found himself with very few photographic commissions. He was otherwise relatively unaffected by the conflict, but eventually left Europe by crossing into Spain, travelling on to Lisbon and sailing from there to New York, with Salvador and Gala Dalí as his fellow passengers. While his European peers were elated to find refuge in New York, Man

Ray claimed to be intensely depressed to be back in the country from which he had escaped.[11]

According to *Self-Portrait*, Man Ray believed it was his destiny to reinvent himself every ten years. This clearly helped him make sense of some of the difficult, transitional periods in his life. One such period began when he made the baffling decision to leave New York, in which so many of his friends were now living, for California. Shortly after arriving in Los Angeles in December 1940, he came into contact with Juliet Browner, a young model and dancer. He later wrote: 'now I had everything again, a woman, a studio, a car.'[12] In October 1946, having for the second time in his career renounced photography for painting (he had first done so in 1937), he and Juliet were married in Beverly Hills in a joint ceremony with Max Ernst and Dorothea Tanning.

Following a visit to Paris with Juliet in 1947, Man Ray again became convinced that France was his natural home. The couple sailed for Paris in March 1951, and by June that year had secured a place to live that would remain their home until 1974 and his studio until his death. Although he was making new art at this time, his growing fame hinged on his position in the pre-war avant-garde. By late 1961 he was working on his autobiography,[13] and would soon be occupied with remaking various key works for exhibition or for collectors.[14] The following May, at the Bibliothèque Nationale, his adopted country honoured him with a major retrospective of his work as a photographer. In August 1976 he was awarded the Order of Artistic Merit by the French government, and when he died later that year he was buried in France.

In his autobiography, Man Ray speaks of the harnassing of art to politics as misguided.[15] And yet, in the afterword to the paperback edition of *Self-Portrait*, Juliet Man Ray notes that her husband's reputation was boosted by the interest taken in his work by the students of 1968, and that the events in Paris 'reminded [him] of his youth in America'.[16] The suggestion that Man Ray saw his younger self as an anarchist and edited this from his official life story (as did so many artists who lived through both the 1930s and the 1950s) is fascinating. We may never know whether or not his iconoclasm was more than aesthetic. What we can glean from his views about photography's relationship to creativity and commerce is that he was perhaps, as Alfred Stieglitz recognized,[17] as much a nineteenth-century idealist as a twentieth-century radical. ■

Dora Maar, 1936

Self-Portrait, 1988

Robert *Mapplethorpe*

1946–1989

Beauty and the devil are the same thing.

ROBERT MAPPLETHORPE

A studio photographer, Robert Mapplethorpe left nothing to chance, whether taking portraits, floral still lifes or what are sometimes called his 'sex pictures', photographs that range from portraits of men in leather to the depiction of sadomasochistic acts. His decision to make art from a subject matter rarely portrayed was one way in which he made his name; his use of a cool, classicizing idiom, which drew on both high art and contemporary chic, was another. Instead of hiding his proclivities in order to find fame as an artist, he made his art out of those proclivities. Mapplethorpe did not wish to normalize marginal sexual practices, but instead pursued them for their ability to fascinate both him and his audience. Brought up in a Catholic household, he described his creative urges as founded on a desire for forbidden fruit, and made photographs that mocked the hypocrisy of a creed whose official imagery was often highly eroticized. Sacred and profane, Dionysian and Apollonian, light and shade, heaven and hell: Mapplethorpe drew on the polarities of Western culture and religion in order to suggest that they were two sides of the same coin.

Robert Mapplethorpe was born in Queens, New York, the third child of Harry and Joan Mapplethorpe (née Maxey). At the time of Robert's birth, the Mapplethorpes were living in the neighbourhood of Jamaica Estates. Around 1950 they moved to nearby Floral Park, a new suburban development built to house returning war veterans, and did not move again. Having changed jobs once at the end of the war, Harry Mapplethorpe, a distant and authoritarian father, remained with the same company for the rest of his life. His weekends were devoted to his hobbies, which included stamp collecting and photography. Joan Mapplethorpe, it appears, was artistically inclined, and Robert – slight and artistic – was her favourite, something he found out only late in life. When the number of children in the household totalled four, the family was joined by Joan's widowed diabetic

father; after his death, Joan had two more children and began to suffer from depression. It seems that the young Robert, 'a happy, mischievous boy',[1] wished that he could have more of his mother's increasingly divided attention.

Mapplethorpe's slight build was not the only thing that set him apart from his peers: there was no Catholic school in Floral Park, and so once a week he received lessons in Catholic doctrine while his classmates were taught arts and crafts. Once a year, the Mapplethorpe children would be taken by their paternal grandmother to Coney Island, where Robert had to be dragged away from its freak shows. That a young Catholic boy with a narrow-minded father was attracted to the strange and unusual is not surprising; what is surprising is the obsessional nature of that attraction, given that his childhood seems to have had no more than the average share of 1950s middle-class dysfunction.

In 1963 Mapplethorpe enrolled in the Pratt Institute in Brooklyn, his father's alma mater. A summer job as a messenger for a Manhattan bank saw him preoccupied with the idea of getting hold of a gay pornographic magazine that had had its front cover censored by the addition of black tape. Mapplethorpe, who shortly afterwards would steal some gay porn magazines from a blind vendor, presented this incident as the key to his creative urges: 'A kid gets a certain reaction, which of course once you've been exposed to everything, you don't get. I got that feeling in my stomach. It's not a directly sexual one, it's something more potent than that. I thought if I could somehow bring that element into art, if I could somehow retain that feeling, I would be doing something that was uniquely my own.'[2] Mapplethorpe may have chafed at parental and religious authority, but he found his creativity and erotic desires stimulated by their prohibition.

Mapplethorpe's time at Pratt (1963–9) began with his joining the Reserve Officers' Training Corps, in which his father had been a cadet, and ended with his immersion in the counterculture of the period. Having renounced his incipient homosexuality after almost being caught red-handed stealing the porn magazines, he went so far as to enrol in the National Society of Pershing Rifles, a military organization for college-level students. After a couple of years, however, he changed his major from advertising to graphic design, and found himself identifying more and more with the anti-authoritarian stance

of the art students. Mapplethorpe's relationship with drugs began in the summer of 1966. Drug-engendered disinhibition freed him from the constraints of parental disapproval and societal expectation.

It was in the spring of 1967 that Mapplethorpe first encountered Patti Smith – then, like Mapplethorpe, twenty years old – who would become his lover and best friend. She and Mapplethorpe set up home together as a couple, eventually coming to an arrangement whereby Smith worked to subsidize them both. According to Smith, Mapplethorpe invented a wedding ceremony on the Caribbean island of Aruba to persuade his parents that they were married.[3] Ultimately, Smith's pursuit of another man forced Mapplethorpe to confront what, in Smith, he had found a defence against: his own attraction to men.

After travelling to San Francisco in late 1968 on a journey of self-discovery, Mapplethorpe returned to New York and embarked on his first homosexual relationship. He also began to use gay pornographic imagery in his collages. Smith and Mapplethorpe soon resumed their intense friendship, however, and Mapplethorpe in time gave up his male lover and again moved in with Smith, eventually sharing a room – and a bed – with her at the Chelsea Hotel. In the spring of 1970 Mapplethorpe and Smith began living and working in a rented loft on 23rd Street. Poorly heated, the loft was decorated with Mapplethorpe's artworks: collages, jewelry and assemblages whose predominant themes were sex and religion. It was, according to numerous commentators, an intimidating place to visit.

It was at the Chelsea that Mapplethorpe and Smith met Sandy Daley, a film-maker and photographer who took Mapplethorpe under her wing and introduced him to the history of photography and to Max's Kansas City, a bar-cum-restaurant on the Lower East Side popular with New York's creative set. Using Daley's Polaroid 360, Mapplethorpe began to take his own photographs – of himself, of his then lover, the model David Croland, of Patti Smith, and of flowers – rather than relying on magazine imagery for his collage material. Mapplethorpe and Smith, who would hang out at Max's in the hope of meeting some of its more famous habitués, such as Andy Warhol, were slowly insinuating themselves into the Manhattan in-crowd. Mapplethorpe had his first solo exhibition (of his assemblages) in November 1970, while Smith made her debut as a poet in February 1971. In November of that year, *Robert Having His Nipple Pierced*, a

short film by Daley featuring Mapplethorpe, Croland and a doctor who lived at the Chelsea Hotel, with a voiceover by Smith, was shown at the Museum of Modern Art (MoMA).

It was Croland who introduced Mapplethorpe to his next two patrons. The first was John McKendry, curator of prints and photographs at the Metropolitan Museum of Art. McKendry, who was married to Maxime de La Falaise McKendry, at that time the food editor at *Vogue*, became infatuated with Mapplethorpe, and in 1971 the neophyte photographer joined him on a trip to London, using McKendry's connections to move on to Paris without him. For Christmas that year McKendry gave Mapplethorpe his first camera, another Polaroid 360, and later arranged for him to receive free film from the manufacturer. He also introduced Mapplethorpe to the great photographers of the past whose works were held by the Met, including <u>Alfred Stieglitz</u>, <u>Edward Steichen</u> and Thomas Eakins. Mapplethorpe was soon taken up by an even better-connected patron. Sam Wagstaff, a fifty-year-old collector from an old New York family, had fallen for Mapplethorpe after seeing him in a photograph at Croland's apartment. Wagstaff, who liked to surround himself with young protégés whom he could spoil, duly bought Mapplethorpe a loft at 24 Bond Street, NoHo, close to his own. At first, the two men enjoyed an intense and monogamous relationship, but after about six months Wagstaff discovered Mapplethorpe in bed with another man, at which point the latter made it plain that he did not intend to remain faithful.

In 1975, two years after his first solo photographic exhibition (at Light Gallery on Madison Avenue), Mapplethorpe received from Wagstaff a state-of-the-art Hasselblad. One of his first experiments with the new camera, which was later stolen, is the well-known self-portrait in which he reaches, grinning, into the frame. Mapplethorpe began to have his works printed on large-format paper and to move away from his practice of using coloured mounts and frames. As his images became cooler, sharper and crisper, so his private life, now based around the S&M scene, became more colourful and his subject matter more explicit. In February 1977, having secured a dealer in Holly Solomon and a showing of his 'Portraits' at her gallery, Mapplethorpe engineered a concurrent show, 'Erotic Pictures', at The Kitchen in SoHo. The following year saw the publication of *X Portfolio*,

Male Nude, Ajitto, 1981

Mapplethorpe's controversial collection of S&M images first shown at the Robert Miller Gallery, his new dealer, on West 57th Street. One of the photographs – a self-portrait in which a bullwhip has been inserted into Mapplethorpe's anus – made it clear that the artist was no voyeur. With one notorious exception, the images in *X Portfolio* do not show the blood, sweat and tears associated with acts of extreme S&M. In fact, the photographs are uncanny in their stillness. 'My approach to photographing a flower', said Mapplethorpe, 'is not much different than photographing a cock. Basically, it's the same thing.'[4] Mapplethorpe repeatedly made two proposals with his work: that the low could be high, and that the high could be low.

Mapplethorpe had established a pattern of bringing men back to his Bond Street loft for sex and then photographing them in the morning. His next sexual obsession was working-class black men, for whom he would go 'cruising' at Keller's, a bar that catered to those looking for biracial sex. He believed he had found what he was looking for in Milton Moore, a twenty-five-year-old who became the sitter for Mapplethorpe's celebrated *Man in Polyester Suit* (1980). When the relationship ended, Mapplethorpe took up with Jack Walls, an aspiring artiste. At one time the arm candy, Mapplethorpe was now the sugar daddy.

All Mapplethorpe's subjects were, in effect, still lifes – objects, faces and bodies modelled in light so as to create sculptural forms that were, increasingly, framed in the viewfinder to produce classicizing graphic compositions. Mapplethorpe, seen at work in James Crump's film *Black White + Gray: A Portrait of Sam Wagstaff + Robert Mapplethorpe* (2007), began by using natural light and only later worked mainly with studio lighting. In time, his Bond Street loft came to function also as a studio, with a small team integral to the production of his photographs. One assistant was his brother Edward, who joined the studio soon after majoring in photography at college and writing a paper on Robert. He became 'Edward Maxey' to distinguish himself from his brother.

The 1980s were Mapplethorpe's decade. In 1983 he was granted a retrospective at the Institute of Contemporary Arts in London; also that year he published *Lady*, his collaboration with the female bodybuilding champion Lisa Lyon. In 1985 Mapplethorpe's *Certain People: A Book of Portraits* was endorsed by the *New York Times*, and in 1988

his new loft on West 23rd Street, purchased for him (for $500,000) by Wagstaff, was featured in *House & Garden*. Around this time, the Institute of Contemporary Art (ICA) in Philadelphia, the Whitney Museum in New York and the National Portrait Gallery in London began planning major solo exhibitions of his work. As his star rose, however, his health deteriorated. In 1982 Mapplethorpe had begun to experience health problems that would later be recognized as HIV-related. He was eventually diagnosed with AIDS in 1986. When Wagstaff died of AIDS in 1987, Mapplethorpe was a major beneficiary of his will. He was now both rich and famous. He was also dying.

Looking much older than his forty-one years owing to the devastating effects of his battle with AIDS, Mapplethorpe nonetheless attended the private view of his Whitney retrospective in the summer of 1988. He made two further outings: a sentimental journey to Coney Island, and, in early 1989, a visit to the Warhol retrospective at MoMA. He was reunited with Patti Smith, who had moved to Detroit in 1979 to marry and raise a family, and they began to talk regularly on the phone. In consultation with his lawyer, he established the Robert Mapplethorpe Foundation to maintain his artistic legacy and support photography at the institutional level; in time, he decided that the foundation would also support medical research into HIV/AIDS. In December 1988 he watched a video of friends attending the opening of 'Robert Mapplethorpe: The Perfect Moment' at the ICA in Philadelphia. He did not live, however, to see the show become a cause célèbre regarding public funding of the arts. He was taken to Boston to receive a pioneering course of drugs, but was too ill to begin treatment.

For a man whose life was his art, Mapplethorpe nonetheless put distance between himself and his experiences when, by means of photography, he transformed them into elegant sculptures and still lifes. Aged sixteen, he had fetishized the longings engendered by prohibition; in his early twenties, he had developed the compulsion to aestheticize his desires. The juvenile urge to disobey the injunctions of church and family, together with the wish to do something wholly original, were the foundations of his aesthetic credo. Drawing on the art and photography of the past, his images are a visual embodiment of 1980s chic: graphic in design, glossy in production, cold in emotional register, and aspirational. ■

188

Lucia Moholy, *László Moholy-Nagy, c.* 1925

László *Moholy-Nagy*

1895–1946

Art is the most complex, vitalizing and
civilizing of human actions.

LÁSZLÓ MOHOLY-NAGY

It makes little sense to call László Moholy-Nagy a photographer. Intent on eroding the divisions between the various fields of cultural production, Moholy-Nagy practised what he called 'optical design', which, over the course of his lifetime, encompassed painting, drawing, photography, sculpture, film, typography and several branches of design. Highly influential in these fields, he was also noted for his writings: his aesthetic philosophy, which he developed in the early 1920s in Berlin, was refined during his time as a professor at the Bauhaus and disseminated in a series of important articles and books. After he resigned from the Bauhaus, he committed himself not only to making radically progressive art and design but also to inciting others to do the same. Emigrating to the United States in 1937, he endeavoured to recreate the Bauhaus in Chicago. Such was his identification with his aesthetic programme that when he wrote his only autobiographical text, 'Abstract of an Artist', in 1944, he did so, he claimed, in order to inculcate the novice into avant-garde, non-representational art.

Moholy-Nagy was born László Weiss in Borsod, Austria-Hungary (now Bácsborsod in Hungary). Events in his early life led him to adopt the distinctive last name by which he is known. His father, Lipot, abandoned his family in 1897, and his mother, Karolina Stein, took László and his two brothers to live with her family in Ada (in present-day Serbia). There, her brother, Gusztáv Nagy, a lawyer who lived in nearby Moholy, became the boys' guardian. In 1913 Moholy-Nagy, despite his desire to become a writer, began to study law in Budapest. Two years later he enlisted in the Austro-Hungarian Army as an officer, spending much of his time while on duty sketching on the back of military-issue postcards. On his discharge in 1918, and under the influence of the art critic Iván Hevesy, he devoted himself to painting, studying in the evenings at Robert Bereny's art school in Budapest.

Having chosen art as his vocation, Moholy-Nagy was drawn to the progressive artists promoted by Lajos Kassák in the journal *MA* (Today). As a consequence of the political and social upheavals in the years following the fall of the Austro-Hungarian Empire, Moholy-Nagy, like so many of his generation, became radicalized. In March 1919 he signed the revolutionary statement of the 'Hungarian Activists', who 'regarded artistic revolution as inseparably linked with the idea of political change';[1] also in that year he tried to join the Communist Party but was unsuccessful. He spent much of 1919 in Szeged, and then, following the suppression of the short-lived Hungarian Soviet Republic, moved to Vienna, where Kassák and those around him had exiled themselves after the closure of *MA*. Moholy-Nagy stayed in Vienna for only six weeks before relocating to Berlin.

Moholy-Nagy arrived in Berlin in early 1920 and, despite not speaking German, soon immersed himself in the latest in contemporary art. He gravitated towards Herwarth Walden, whose journal and gallery, both called 'Der Sturm', showcased various forms of abstract art, and became close friends with the Hungarian painter Lajos Tihanyi, who was at the centre of the Hungarian artistic network in Berlin. According to his own account, he learned about suprematism from El Lissitzky and other leading Russian artists, about De Stijl from Theo van Doesburg, about what was happening in New York from the avant-garde journal *Broom*, and about Dada from Tristan Tzara and others.

In July 1922, in the magazine *De Stijl*, Moholy-Nagy published 'Produktion-Reproduktion', a short essay that 'amounted to a manifesto'.[2] At the time of the essay's publication, Moholy-Nagy was making experimental photograms. In January of the previous year he had married Lucia Schulz, an ethnic German born and raised in Prague. In addition to being a writer and an editor, Schulz was a photographer. The significance of her role in bringing Moholy-Nagy to photography, in the development of the aesthetic philosophy expounded in his essay and in the creation of the photograms is still disputed.[3] Moholy-Nagy's first published photograms appeared in the fourth issue of *Broom* (March 1923), which also featured four photograms by Man Ray.

In 1922 a solo exhibition of Moholy-Nagy's work brought him to the attention of Walter Gropius, who had founded the Bauhaus school in Weimar in 1919. Gropius hired Moholy-Nagy for the school, and in 1923 he and Lucia left Berlin for Weimar. Although there was no

formal teaching of photography at the Bauhaus during Moholy-Nagy's time there, this was a significant period for avant-garde photography in Germany. In 1925 the Bauhaus moved to Dessau, where a new school had been built according to plans by Gropius. There, Moholy-Nagy and Gropius co-edited the 'Bauhausbücher', a series of books intended to disseminate the school's philosophy of applied art.

In 1936 Moholy-Nagy would present what he described as 'the eight varieties of photographic vision', from 'abstract seeing' (the photogram) to 'rapid seeing' (snapshots).[4] In addition to producing examples of these different types of vision, Moholy-Nagy experimented with 'unusual vistas, transversal shots, inclined angle shots, [distortions], shadow effects, tonal contrasts, enlargements [and] stereo photographs'.[5] He was also using his 'in camera' photographs, and those of others, to create what he called 'Fotoplastiken', Dadaist photo-collages and photomontages combined with drawing.

In 1928 Moholy-Nagy, Gropius and Herbert Bayer resigned from the Bauhaus, having become fully estranged from the direction the school was taking. Moholy-Nagy wrote a letter of resignation in which he claimed that the once revolutionary school had turned into 'a vocational training school that evaluates only the final achievement and overlooks the development of the whole man'.[6] Much of Moholy-Nagy's writing has a propagandist, tendentious tone, suggesting that he expected his (Marxist-influenced) aesthetic and political views to provoke opposition. Moholy-Nagy was seeking not only new aesthetic forms but also the development of 'the "new total man" ... who would integrate the rational, the affective and the sensory' – an *homme machine*, or artist-engineer.[7]

In 1929, having moved back to Berlin, Moholy-Nagy featured heavily in the 'Film und Foto' exhibition in Stuttgart, sealing for posterity the identification of his images with the 'New Vision' of avant-garde European photography. His second period in Berlin was just as productive as his first. Working as a freelance designer to support himself, he added set design and film to his portfolio. In 1930, at the annual exhibition of the Société des Artistes Decorateurs in Paris, he unveiled his kinetic sculpture *Light-Space Modulator* (1922–30). Moholy-Nagy used the sculpture, thought to have been conceived in part as a device to create abstract photograms, to make the short film *Ein Lichtspiel – Schwarz – Weiss – Grau* (A Lightplay – Black – White – Grey; 1930).

It was through his work in film that Moholy-Nagy, probably in the winter of 1932–3, met his second wife, Sibylle Pietzsch, a German-born actress turned scriptwriter. Following the birth of their first daughter in 1933, the couple moved to Amsterdam in response to the worsening political situation in Germany. Moholy-Nagy worked as a commercial designer in the city and became involved with the counter-surrealist group Abstraction-Création. In the spring of 1935, with the help of Herbert Read of the Institute of Contemporary Arts, the family moved to London. There, Moholy-Nagy opened a design studio with György Kepes, producing design work and films for, among other clients, London Transport.

In 1937, a year after the birth of their second daughter, the Moholy-Nagys moved again, this time to Chicago. On the basis of a recommendation from Gropius, Moholy-Nagy was to be the director of a new design school intended to bring contemporary design to American industrial production. Planned by the Association of Arts and Industries, and named by Moholy-Nagy the New Bauhaus – American School of Design, the school opened in October 1937 with thirty-five students. It closed the following year, however. In February 1939, after another spell as a commercial designer, Moholy-Nagy founded the School of Design in Chicago, hiring most of the teachers from the previous initiative.

Only recently has the idea that Moholy-Nagy ceased to experiment with photography while in Chicago been overturned. This misconception was based on his choice to work primarily in colour, a process that, at the time, could not easily be translated into prints, thus limiting its reproduction. In fact, he produced hundreds of colour slides. He was no less productive in the fields of oil painting, drawing and watercolour, a final artistic flowering possibly in response to a diagnosis of leukaemia in 1945. He died from the condition at the age of fifty-one.

Despite Moholy-Nagy's attempts to combine art, life and physiology, we know relatively little about his psychology – a consequence, perhaps, of his preoccupation, as well as that of scholars, with his intellectualism. One of his more revealing statements was prompted by his memory of seeing the *Light-Space Modulator* work for the first time: 'I almost believed in magic.'[8] One wonders if the rationality of Moholy-Nagy's progressive approach was not a wholesale rejection of the irrational but rather an attempt to gain some mastery over it. ∎

Pont Transbordeur, Marseilles, 1929

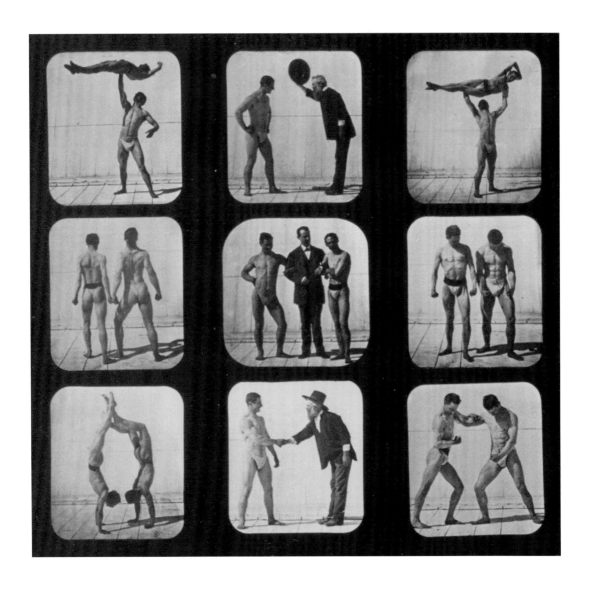

Athletes, Posturing [detail, showing Muybridge at centre top and bottom], 1879, plate 115 from *The Attitudes of Animals in Motion*, 1881

Eadweard *Muybridge*

1830–1904

I've got the picture of the horses jumping from the ground.

EADWEARD MUYBRIDGE

The inspiration that his studies of human and animal locomotion provided for such later artists as Sol LeWitt, Francis Bacon and Cy Twombly, together with the oft-made claim that the transformation of these studies into animated pictures provided the basis for the development of cinema, suggest that Eadweard Muybridge may be the most influential photographer of all time. British-born, Muybridge decided to make his name in America, beginning his working career as a publishing sales agent in New York before relocating to San Francisco. After making a sales tour through Europe, Muybridge travelled to London, where he devised inventions and made speculative investments. Having waited out the American Civil War in England, he returned to San Francisco and began a new career as a photographer. The project that made him famous – documenting animal and human movement through instantaneous photography – began with an attempt to freeze the action of a galloping horse. These revolutionary images, along with the zoopraxiscope (an animation device of his own creation), enabled Muybridge to produce moving pictures. Little is known about his years as a sales agent and bookseller, yet it would seem that these experiences were crucial to his later success. His understanding of publicity was so masterful that, on trial for the murder of his wife's lover, he gave an exclusive interview to a newspaper. The man born Edward James Muggeridge understood not only self-promotion but also self-reinvention.

Eadweard Muybridge was born in Kingston-upon-Thames, Surrey. His father, John, was a corn merchant; his mother, Susannah (née Smith), was from a local family who worked in barge transport. Writing in 1915, Eadweard's cousin Maybanke Anderson described him as 'rather mischievous, always doing or saying something unusual, or inventing a new toy, or a fresh trick'.[1] When John Muggeridge died in 1843, his widow took over the business, aided

initially by her eldest son, John, and later by Eadweard, the second
of the four Muggeridge boys. Determined to escape small-town life,
Eadweard eventually secured a position as a sales agent in New
York for the London Printing and Publishing Company. He refused
to accept a parting gift of gold sovereigns from his grandmother on
the basis that he was going 'to make a name for himself' – a process
that proved to be literal as well as figurative.[2] The name changes he
undertook have never been explained. In New York during the first
half of the 1850s he was 'Muggridge'; later, in San Francisco, he was
'Muygridge'. In London in the mid-1860s he began to appear in docu-
ments as 'Edward Muybridge'. It was not until 1881 that he adopted
the archaic spelling of his first name, thought to derive from the
medieval coronation stone preserved in his home town.

It seems that Muybridge came to appreciate the value of marketing
and promotion early on. He also understood the value of diversifica-
tion: in addition to packaging and distributing English books for the
US market, he also exported American books to England. Muybridge
was based in New York until late 1855, when he left for San Francisco;
there, he opened a bookseller's at 113 Montgomery Street. That
Muybridge enjoyed success in San Francisco is suggested by the
fact that, as well as working as a bookseller and an agent, he started
lending money. On 15 May 1860 it was announced in the *San Francisco
Daily Bulletin* that he had sold his business and stock to his brother
Thomas, and was preparing for a sales tour to New York and Europe.[3]
Muybridge might have continued in publishing were it not for the
accident he experienced on a stagecoach during his journey to New
York. In early July 1860, around three weeks after the stage set off, its
brakes failed and the driver lost control, smashing into a tree. As is
often the case with Muybridge, we know of the episode through legal
documents (in this case, those arising from the lawsuit he brought
against the Butterfield Overland Mail Company). They tell us that he
was thrown from the back of the stage, suffering a serious head injury
and remaining unconscious for more than a week.

Following a brief stay in New York after his accident, Muybridge
continued to London, where he concerned himself with suing the
stagecoach company and lodging patents for two of his inventions:
an improved metal plate-printing device (1860) and a type of early
washing machine (1861), the prototypes for which were shown at the

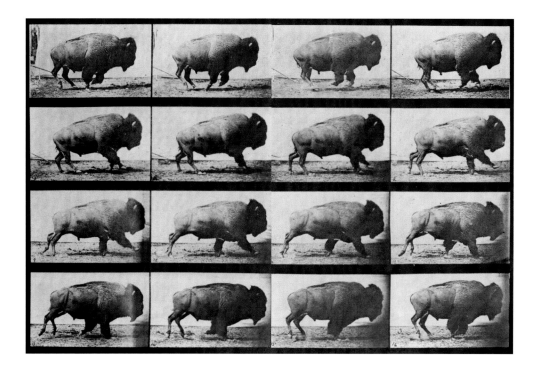

International Exhibition of 1862. After receiving a $2,500 settlement from the stage company, he became involved in speculative investment as a director of two separate ventures: a silver mine in the United States and the Bank of Turkey. Having waited out the American Civil War in London, he returned to San Francisco in late 1866 or early 1867, not as a venture capitalist or an inventor, but as a photographer.

On his return to San Francisco, and using the pseudonym 'Helios', Muybridge set himself up at the Cosmopolitan Gallery, a photographic studio run by his friend Silas Selleck. The first photographs attributable to Muybridge are stereo views of San Francisco. In his studies of the city, Muybridge himself can sometimes be spied posing as a passer-by; his wagon, a travelling darkroom with the words 'Helios Flying Studio' on the back, also appears. As well as taking local topographic views, he photographed municipal developments showcasing the expansion and wealth of his adopted town. His five-month trip to Yosemite National Park in the summer of 1867 produced 260 views, both stereoscopic and single half-plate negatives. He also made studies of the aftermath of the earthquake that hit San Francisco in October 1868.

In the late 1860s and early 1870s Muybridge received a number of important commissions, including the chronicling of a fact-finding mission to the newly acquired territory of Alaska in 1867 and the documentation of the Pacific-coast lighthouses for the Light House Board

Sequence of a buffalo (American bison) galloping, plate 700 from *Animal Locomotion*, 1887

in 1871. With his reputation as a leading San Francisco photographer growing, it is generally assumed that Muybridge was awarded these projects. The evidence suggests, however, that some – if not all – of them were the result of lobbying. Nevertheless, this did not prevent him from styling himself as an official government photographer. In 1869 he made a series of dramatic views along the route of the newly opened First Transcontinental Railroad, from Sacramento to Utah. In June 1872 he returned to Yosemite for another photographic tour, this time staying six months and taking some five hundred photographs. In addition to conventional negative formats, he also produced 'mammoth plate' negatives measuring roughly 17 × 22 in. This new format, like the unusual and precipitous vantage points Muybridge attempted, was likely in part a response to the stiff competition he faced in the market for views of California, particularly from the American photographer Carleton Watkins. The publishers of Muybridge's second round of Yosemite photographs was the San Francisco studio of Henry William Bradley and William Herman Rulofson, who had wooed Muybridge with promises of extensive marketing and distribution.

Muybridge met his future wife, the divorcee Flora E. Downs, behind the scenes at a photography studio; he would later murder her lover because, it is said, of a photograph. The couple were married in May 1871, and almost three years later, having suffered two stillbirths, Flora produced a son, Floredo Helios. Prior to Floredo's arrival, Muybridge had warned off Major Harry Larkyns, a journalist and man-about-town, after discovering that he had taken his wife to the theatre without his knowledge. Susan Smith, the midwife Muybridge had engaged to look after Flora while he travelled on business, later sued Muybridge for failure to pay her bill. During the ensuing court case, Smith handed over three letters that, in addition to proving she had not been paid, revealed that Flora and Larkyns were embroiled in an affair. According to the midwife, on 17 October 1874 Muybridge came to her house in a distressed state. He noticed a photograph of Floredo that he had never seen before, and discovered the annotation 'Little Harry' – in Flora's hand – on the mount. After a tearful visit to the Bradley & Rulofson studio, during which he instructed Rulofson to settle his affairs in the event of his death, he caught a train to Calistoga, where he hired a driver to take him to the Yellow Jacket Mine. He ascertained Larkyns's whereabouts and asked to see him. When he appeared, Muybridge

said, 'My name is Muybridge and I have a message for you from my wife', pulled out a revolver, and shot Larkyns in the chest.[4] Muybridge did not attempt to flee the scene, and was arraigned for Larkyns's murder in Napa jail until the trial, which took place in February 1875.

Despite hearing several witnesses testify to Muybridge's change of character after the stagecoach accident, the jury rejected the defence of insanity, instead acquitting him on the basis that the murder was a case of justifiable homicide. Ten days later Muybridge set off for Panama, a trip partly sponsored by the Pacific Mail Steamship Company. Calling himself Eduardo Santiago Muybridge, he photographed in Panama, Guatemala and El Salvador. The *San Francisco Daily Examiner* suggested that he had made the trip to avoid paying his wife alimony.[5] Flora, who was seeking both alimony payments and a divorce, was eventually granted the sum of $50 a month on 30 April 1875. Six weeks later she was dead, having succumbed to a sudden illness, and Floredo was taken in by a Catholic orphanage. On his return from Central America that November, Muybridge did not reclaim the boy, but later moved him to a Protestant orphanage and paid his board.

Muybridge's imprisonment and subsequent trip to Central America occasioned a hiatus in the project that would eventually make his name. It had begun in April 1872 with a routine, if prestigious, assignment: photographing the Sacramento home of the politician, wealthy industrialist and breeder of racehorses Leland Stanford. By the following spring, Muybridge was trying to determine, by means of photography, whether a galloping horse became briefly airborne. Stanford was aware of Étienne-Jules Marey's treatise *Animal Mechanism* of 1873, in which the French physiologist demonstrated the possibility of 'unsupported transit', but was determined to see the evidence in photographic, rather than graph, form. Muybridge was able to produce such evidence later that year, but the early images were so small and offered so little detail that Stanford had to employ an artist to make them legible. After a pause of four years, Muybridge returned to the project, and, in 1878, operations moved to Stanford's new ranch in Palo Alto. There, he provided Muybridge with the resources he needed to refine the technology, including an outdoor studio with a white, ruled wooden screen against which the horse's progress could be demonstrated, a track with trip wires (and strings) that would set off the cameras, a shed with a bank of twelve (later

twenty-four) cameras facing the screen, and specially designed electric 'double guillotine' shutters. By the spring of 1879 Muybridge was using a clockwork mechanism to make the exposures. These arrangements, together with his use of an ammoniac developer, allowed Muybridge to achieve exposure times shorter than anything previously recorded. He expanded the scope of his experiments to include humans, namely athletes from the San Francisco Olympic Club. Muybridge published his studies in *The Attitudes of Animals in Motion* (1881).

Had Muybridge stopped there, he would have made a name for himself in physiology, optics and photography. But having arrested time and made it possible to see what the human eye cannot, he then applied himself to the matter of turning these single images into moving pictures. Again, he was not the first to have this idea: in 1873 Marey had suggested using an animation device to analyse animal movement. In 1879 Muybridge developed his own such device, which he called the zoopraxiscope. Because the zoopraxiscope distorted the images, Muybridge could not use actual photographs, relying instead on pictures drawn (with optical adjustments) from his photographs. International interest in his projected moving pictures transformed 'Helios', the commercial photographer, into Muybridge, the scientific lecturer. In September 1881, on a lecture tour of Europe, he demonstrated the zoopraxiscope at a soirée hosted by Marey, a keen supporter of his work. Many luminaries, including Nadar, were present.

Having made a name for himself, Muybridge once again saw it tarnished. In 1882 *The Horse in Motion*, an account of the Palo Alto experiments, was published under the name of Dr Jacob Davis

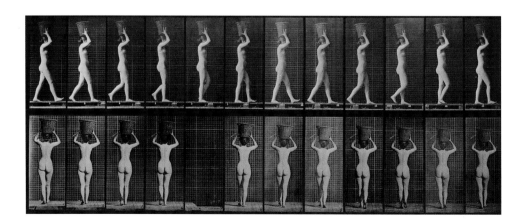

Walking and carrying a 15lb basket on head, hands raised, plate 34 from *Animal Locomotion*, 1887

Babcock Stillman, Stanford's physician. Muybridge, who was in England at the time of the book's publication, was credited merely as a technician. On his return to America, he responded by issuing proceedings against both Stanford and the publisher, and by embarking on a major project that would forever associate his name with the wonders of chronophotography (the capture of movement by means of sequential instantaneous exposures). In 1883 he petitioned a number of institutions to support further experiments. The University of Pennsylvania agreed to do so, creating a supervisory committee and allowing him to build a new outdoor studio, this time with a black backdrop that would be painted with a white 5-cm (2-in.) grid. He used between twelve and twenty-four cameras spaced 13 cm (5 in.) apart. His subjects included animals from the local zoo, students and teachers from the university, and artists' models. The shutters were controlled by an electrical time switch. Muybridge selected the 20,000 most successful individual images to create a publication, *Animal Locomotion* (1887), with 781 plates of stop-motion sequences.

Despite the appearance of exemplary scientific method, the images in *Animal Locomotion* are not free from manipulation. Muybridge acknowledged that not all of the imagery was precisely sequential, as one of the cameras would sometimes fail. But such was the bravura nature of the project, with its epic scale and wondrous display of what was invisible to the human eye, that it fascinated scientists, artists and the general public alike. On Muybridge's second European lecture tour (1889–91) he was much feted. The glories of *Animal Locomotion* eclipsed the fate of the zoopraxiscope, which by 1883 was obsolete.

In his mid-sixties, 'Professor Muybridge', as he was now often called, returned to England and settled in the area where he had grown up. A decade after his return, he died from prostate cancer. He was clearly concerned with his legacy, offering to donate his books to at least two university libraries in California and bequeathing his papers to the library in Kingston. His major legacy was, of course, *Animal Locomotion*, which has never been out of print (his reputation as a pioneer of cinema is now generally considered conceptual rather than actual). Muybridge was not always the originator of the developments attributed to him, but his brilliance lay in seeing the potential in others' ideas, and in refining, applying and promoting them. Eadweard Muybridge had indeed made a name for himself. ■

Self-portrait with wife Ernestine in a balloon gondola, c. 1865

Nadar

1820–1910

Today photography gives us a drawing that M. Ingres
wouldn't have delivered in a hundred sittings and a colour
he couldn't give us in a hundred years.

NADAR

Nadar, whose real name was Gaspard-Félix Tournachon, is one of photography's most colourful characters. Student, novelist, journalist, caricaturist, art critic, political prisoner and possibly even spy, Nadar did not abandon caricature or criticism when he added photography to his repertoire. Such variety was not unusual among his milieu: he was one of many educated men with no private means who sought to make a living from the Parisian press. What is unusual, however, is the psychological dimension to his incarnation as a photographer: his decision to make portrait photographs under his well-known moniker appears to have been motivated in part by his fraught relationship with his only sibling, Adrien, who took up photography before he did. Accounts of Nadar's life and art draw primarily on documents written by Nadar and his friends, who sent letters of support when Nadar sued his brother over the use of his name. The exuberant personality that emerges from these documents, and the inference of an aesthetic defined by bold originality, disregard for convention and a psychological rapport with his sitters, have both become staples of the literature on Nadar. This is despite the fact that we do not know which portraits are by Nadar's hand alone, which are collaborations with his brother, and which simply bear his name. Nadar was not only vibrant, energetic, amusing, fearless and politically radical, but also unreliable, impecunious, pugnacious and prone to exaggeration. If we are to paint his portrait, we must acknowledge that he prized 'colour' over dry fact.

Nadar and Adrien were born in Paris, to which their parents had moved from Lyon in 1817 to set up a small publishing imprint. We know that Nadar initially attended a local school, later studying in Versailles and, from 1833 to 1836, at the College Bourbon in Paris.

When their father fell ill in 1836, the brothers remained in the city while their parents moved back to Lyon. Evidence suggests that Nadar was a clever but disruptive pupil: in the winter of 1836–7 he was expelled from his college and asked to leave the boarding house in which he was living. When Tournachon *père* died in 1837, Nadar moved to Lyon and enrolled in a local medical school. There, he also began to write for the theatrical press. He returned to Paris a year or so later and continued his studies. Before long, he had chosen journalism over medicine.

The next ten years saw Nadar living the life we romantically characterize as 'bohemian'. It was also during this period that his public persona coalesced under his pseudonym, a contraction of the nickname 'Tournadar'.[1] Without father, patron or protector, Nadar drew around him a surrogate urban family, mainly poets, lithographers and writers. Work, food, drink, clothes and money, all of which were in short supply, were exchanged among this network, for whom the shared experience of deprivation engendered a code of honour that (allegedly) placed friendship and loyalty above all else. Nadar worked in nearly every journalistic capacity, as a paste-up artist, critic, caricaturist, feature editor and even publisher. Between 1845 and 1849 his friend Henri Murger's *Scènes de la vie de bohème* was published in instalments in *Le Corsaire-Satan*, one of the satirical journals to which Nadar contributed (the resulting novel was in turn made famous by Puccini's opera *La Bohème*), giving a name to the world Nadar and his friends inhabited. Nadar had to move addresses frequently at this time, once in the aftermath of a duel. Eventually, his creditors caught up with him and, in 1850, he spent a few days in jail. Tall, lanky and red-haired – 'la plus étonnante expression de vitalité' (the most astounding expression of vitality), as the writer Charles Baudelaire described him – Nadar would spend the rest of his life mining his credentials as an authentic bohemian.[2]

It was during Nadar's bohemian period that his politics became increasingly radical. According to the journalist and novelist Alphonse Karr, who employed him at *Le Journal*, he would express 'the most violently anarchical opinions'.[3] When the Second Republic was announced in February 1848, the new provisional government called for an expeditionary force to incite revolution in Poland. The 500-strong troop that set off from Paris a month later included 200 French

volunteers, Nadar and Adrien among them. After being arrested, imprisoned and freed in quick succession, they made their way back to Paris on foot; by the time Nadar arrived in June, the Second Republic had long since abandoned its commitment to foreign revolution. He was, allegedly, soon after sent to Germany by a political mandarin, as a spy whose mission was to seek out evidence of a Russian presence while pretending to be an artist on a painting tour.

Before Nadar was celebrated as a photographer, he was well known among men of letters as a caricaturist. In the late 1840s he edited a satirical journal, *La Revue comique à l'usage des gens sérieux*, and became a contributor to various similar Parisian magazines, including Charles Philipon's *Le Charivari*. One of Nadar's targets was the presidential candidate Louis-Napoléon Bonaparte, but following his *coup d'état* in December 1851, scurrilous journalism once again became seditious, meaning that Nadar had to find a new way of making a living. His solution was the 'Panthéon Nadar', a four-part lithograph featuring *portraits-charge* of 1,000 leading figures of the day. *Portraits-charge*, highly developed caricatures with large heads on tiny bodies, could be published only with the approval of the sitter, who usually supplied a drawing or photograph of themselves. Second Empire censorship saw Louis-Napoléon, or 'Napoleon III' as he styled himself, co-opt the now depoliticized cultural glories of the 1840s, such as caricature, in order to add prestige to his reign.

In 1853 Nadar and his mother moved into a ground-floor apartment at 113, rue Saint-Lazare, where they were joined by Adrien on his return from a sketching trip to England. In December of that year, Nadar paid for his brother to receive photography lessons from Gustave Le Gray. By early 1854 Nadar had obtained financial backing to establish a photographic studio at 11, boulevard des Capucines, from which Adrien practised as both 'Tournachon' and 'Nadar jeune'. Nadar, so he later claimed, had expected to 'assume a part in [Adrien's] enterprise', but instead found himself cut out of the business.[4] He began to take lessons of his own from Camille d'Arnaud, an editor friend who had recently taken up photography, and by the April of 1854 he was taking photographs of family, friends and acquaintances in his garden. That September he returned to Adrien's studio, which was floundering, and assisted in the purchase of items necessary to its running, such as a large camera, chemicals

and stationery. He secured an exhibition spot for his brother at the Exposition Universelle of 1855, and the submissions earned 'Nadar jeune' a first-class medal. By January 1855 the studio was back on its feet, and Adrien responded, according to Nadar, by again asking his elder brother to withdraw. He did so at a time when Nadar had begun to accrue serious debts. The 'Panthéon Nadar', the summation of his skill and fame as a caricaturist, was issued in March 1854 and withdrawn from sale that October, on the basis that one of the portraits had been published without the necessary authorization. Nadar needed capital, and he needed a new source of income: the first he got from marriage, the second from photography.

In September 1854 Nadar married Ernestine Lefèvre, a homely eighteen-year-old Norman woman who, according to Roger Greaves, had a personal fortune of 56,000 francs, 30,000 of which were swallowed up by her husband's debts.[5] Ten days after the marriage, Nadar transferred his caricature workshop to Adrien's studio. He claimed that it was his wife's money he had invested in the latter, and when Adrien broke with Nadar for a second time, in January 1855, the latter returned his operations to the apartment on rue Saint-Lazare and asked for the money back. He also put Adrien's use of the pseudonym 'Nadar jeune' to two arbiters, who ruled in the younger man's favour. Adrien responded by finding two new financial backers for his recently incorporated company Société Tournachon Nadar et Cie, by moving into larger premises at 17, boulevard des Italiens, and by using a stamp that was based on Nadar's own signature, the 'jeune' now smaller and less distinct. As scholars have noted, such machinations appear less like the cause of a rift between the brothers and more like symptoms of a pre-existing one.

Nadar continued to take photographs, write criticism and supply caricatures, even publishing some earlier, semi-autobiographical stories as a book, *Quand j'étais étudiant* (1856). When his mother moved out of the Saint-Lazare apartment, he turned it over more fully to his studio and to his gallery of caricatures, photographs, autographs, paintings and *objets d'art*. This portrait studio was defined by its difference from those on the boulevards: there was no shop sign outside and little evidence of commerce inside (although he did employ several 'operators'). Nadar wrote of one sitting: 'One sits down, one chats, one laughs, all while readying the lens; and when [the sitter]

Young Model, 1856–9

is in place, well positioned and drawn out for the decisive moment, radiating all his natural benevolence', the photograph could be taken.[6] It was said that he charged 30, 50 or even as much as 100 francs for a sitting, but it has also been noted that many of his sitters, including Baudelaire and the self-styled 'apostle' Jean Journet, would not have had that kind of money. In March 1856 – a month after his and Ernestine's first and only child was born – Nadar filed a suit against his brother, having heard that Adrien had reordered business cards in the name of 'Nadar jeune'. Initially, the judgment went against the elder brother, but he was vindicated on appeal, and on 12 December 1857 it was ruled that only he could use the name 'Nadar'. He went on to vindicate his position in a text published in the press, and, in time, his words have assumed the status of an aesthetic creed. He wrote of portrait photography as being two-tiered: the science, which anyone could master, and the artistry and sympathy with the sitter, which alone would create a psychological portrait. A second appeal, this time by Adrien, ended in failure in June 1859. Adrien's business was getting into difficulties and he was heavily in debt; Nadar's Saint-Lazare studio, which he had incorporated in 1856, was gaining in recognition and making money.

Seeing his younger brother descend into debt through a high-end photographic enterprise did not discourage Nadar from starting his own. Indeed, renting premises at 35, boulevard des Capucines – the building that formerly housed Le Gray's ill-fated studio – at 30,000 francs a year (ten times more than the rent on his first studio) was such an act of folly that there must have been a psychological dimension to the decision. Adrien counselled him against it, and perhaps this was the decisive factor. The studio opened in September 1861 with Nadar already 230,000 francs in debt. One of his financial backers was Charles Philipon, who scolded him for not reproducing his 'figures contemporaines' in *carte de visite* format, which would have made him rich.[7] Ernestine begged her husband to make the photographs himself, implying that he left everything to his operators.[8] Nadar, it seems, was rarely to be seen in the building that bore the vast, gas-lit sign 'Nadar'. Having won the right to profit from his name, it seemed to some that he had become intent on debasing it.

Nadar did want to profit from his name, but not in the way his wife and friends desired. By leveraging the air of pre-Second Empire

romance that clung to him, he was able to pursue his expensive passion for novelty and invention. Around 1861 he turned his hand to photography by artificial light, taking photographs both in the Paris catacombs and in the sewers; he also patented photographic printing by electric or gas light. In 1863, having taken aerial photographs from a balloon five years earlier, he became a founding member of the Société d'Encouragement pour la Locomotion Aérienne au Moyen d'Appareils Plus Lourds que l'Air. In order to publicize the activities of the society and attract investment, Nadar had an enormous hot-air balloon made, the circumference of which measured some 45 m (148 ft). During the siege of Paris by the Prussians in 1870, he was instrumental in setting up and running reconnaissance and postal services by hot-air balloon. In 1871, after returning to his ailing studio and attending to his financial situation, he moved to the rue d'Anjou. Appointing his then eighteen-year-old son, Paul, as 'artistic director' two years later, Nadar went into semi-retirement; in 1894, however, he set up the Atelier Nadar in Marseilles. Adrien, who filed for bankruptcy in 1872, died in 1903 after spending more than a decade in a mental institution. Nadar, having returned to Paris, died seven years later.

In 1874 the impressionists' first exhibition took place in Nadar's studio on the boulevard des Capucines. Such a connection with one of the most significant Western art movements of the later nineteenth century has sealed Nadar's reputation as the most important French photographer of his day. Many contemporary scholars find evidence of genius in his photographs, condemning others as the work of the mediocre Adrien or the efficient but uninspired Paul. To do so, however, is to ignore the fact that Adrien's photographs won awards, that Nadar was rarely to be found in the studio, and that one of the finest portraits attributed to him is a self-portrait that he could not have taken himself. When one subtracts from the 400,000 or so negatives preserved by his descendants the majority of the works done at the boulevard des Capucines address, those attributed to Tournachon Nadar et Cie, those attributed (retrospectively) to both Nadar and Adrien, and those signed 'Nadar jeune', only a tiny number can be attributed to Nadar (either to his hand or to his direction). Our assessment of both Nadar and Nadar *jeune*'s talents is substantially based on a history written by the (legal) victor. ■

Norman Parkinson photographing Tilly Tizzani for *Queen* magazine, 1962

Norman *Parkinson*

1913–1990

Don't listen to what they are saying –
photography is not an art!

NORMAN PARKINSON

Norman Parkinson, the second of three children, was born Ronald William Parkinson Smith in Roehampton, a residential suburb of south-west London. His father, William James Parkinson Smith, was a barrister turned civil servant; his mother, Louise Emily (née Cobley), was from a musical family. During the Great War his mother took Ronald and his younger sister to live with a farming family in Pishill, a village near Henley in Oxfordshire.[1] His family later settled in Putney, also in south-west London, in a home that was comfortable but not grand. It was the largesse of the Cobley maiden aunts that provided the Parkinson children with access to a world beyond middle-class suburbia. From the age of fourteen Ronald and his elder brother attended Westminster School, commuting from Putney to central London. Parkinson would recall the evacuation to Pishill as a time of great happiness.[2] Another significant feature of his childhood was, allegedly, the time he spent as a twelve-year-old observing, from the vantage point of his grandfather's Surrey garden, the girls in the garden next door. Farming and fashion became the twin poles between which he moved.

Parkinson claimed not to have distinguished himself academically. He had a strong aptitude for art, however, and in 1931, aged eighteen, he was recommended by his art master for an apprenticeship at the photographic firm of Speaight & Sons in Bond Street. The mainstay of the business was taking portraits of debutantes. Parkinson was let go at the end of the second year of his apprenticeship after, as he put it, finally pushing 'old man Speaight' to the limit by moving the camera to what he saw as a better vantage point.[3] In 1934 Parkinson opened a studio in nearby Dover Street in partnership with Norman Kibblewhite, who had also been a pupil of Speaight's. The name of the venture, the Norman Parkinson Studio, was derived from his partner's

Lisa Fonssagrives on Park Avenue, New York, American *Vogue*, 1949

first name and one of his own forenames. The partnership was short-lived, and 'Ronald Parkinson', as he was then known, took over the studio and became 'Norman Parkinson'. The studio remained in business until the outbreak of the Second World War, kept afloat not by society portraiture but by editorial and fashion work.

Parkinson had been supplying the British edition of *Harper's Bazaar* with studio photographs for some months before receiving the brief from its then art director, Alan McPeake, to work on location. At first, Parkinson was resistant to the idea of leaving the studio. However, the real-life settings lent veracity, intimacy and impact to his portraits, such as that of the American couturier Charles James, who, pictured in his hotel room at the Dorchester amid endless rolls of fabric, his tailor's scissors in hand, appears as an almost diabolical figure (*Creative Agony*, published in *Harper's* in 1937). Parkinson's approach to his on-location fashion assignments was later termed 'action realism' and 'fashion documentary': models were not mannequins, but friends walking together in the park, enjoying a round of golf or flying kites.

In the late 1930s, in addition to his duties at his studio and at *Harper's*, Parkinson was working for *The Bystander* magazine. He contributed portraits, features on society and current events, and, from 1937, a weekly series on the re-armament of Britain. In 1937 he also contributed photographs to a large photomural designed by the American photographer Francis Bruguière for the British Pavilion at that year's Exposition Universelle in Paris. Before the outbreak of war in 1939 Parkinson closed his studio, leaving behind his prints and negatives (including some colour photographs taken in 1938), most of which were destroyed during the Blitz.

Around mid-1939 Parkinson rented Paynes Place, a farm near Bushley in Worcestershire.[4] Here, he worked the land and raised livestock, as well as carrying on with his fashion work. As a member of the Territorial Army, he also accepted some photography commissions from the Air Ministry. Despite these contributions to the war effort, it has been suggested that his failure to enlist alienated him from his colleagues at *Harper's* and contributed to his decision to leave the magazine in 1940.[5] In 1941 he began to work for British *Vogue*, shortly after Audrey Withers had joined as editor. *Vogue* was one of the few magazines that was allowed to print during the war, albeit less frequently and at a smaller size. The relatively few fashion

shoots he did at this time were often set in the countryside, and these balanced the luxury and pleasure of fashion with a patriotic emphasis on simplicity and restraint.

Shortly after the war Parkinson met Wenda Rogerson, a young actress whom Cecil Beaton claimed to have discovered as a model. She and Parkinson, who had been married twice before, became husband and wife in 1947. At some point after their marriage the couple moved to Twickenham, south-west London, and in 1953 Parkinson had a suite of darkrooms built at home so that he could process his own films. His post-war fashion photography, much of which featured Wenda, juxtaposed the elegance of the clothes with real-life settings, both urban and rural.

At British *Vogue* Parkinson and Beaton were the star photographers, but the former chafed at the post-war drabness of London. In May 1949 Alexander Liberman, the then art director of American *Vogue*, agreed to sponsor Parkinson's visit to the United States, and he duly flew to New York. Revelling in the relative affluence of Manhattan, Parkinson created vibrant works using lots of colour film and, occasionally, double exposures. In 1950 he was asked by *Vogue* to cover the Paris collections, the most prestigious and gruelling brief for a fashion photographer. From 1949 until 1955 Parkinson and his family spent a few months each year in New York. Meanwhile, Parkinson had developed an excellent working relationship with the features editor at British *Vogue*, Siriol Hugh-Jones, who used him primarily as a portrait photographer. It seems that, from around 1950, Parkinson was alternating between a Rolleiflex, a Hasselblad and a Linhof; later, in around 1955, he added a Leica to his collection.

As Liberman later acknowledged, Parkinson had a special talent for 'integrating fashion with landscape'.[6] This ability came to the fore when, in the 1950s, the glossy magazines (underpinned by tourist-board funding) began to set fashion shoots in exotic locations. For Parkinson, this meant travelling to such places as Jamaica, South Africa, Tobago, Australia, the Bahamas, Cambodia and India. The model Barbara Mullen recalled that Parkinson 'enjoyed complete creative autonomy' on set.[7] Marit Allen, the fashion editor at British *Vogue* from 1964 to 1973, observed that his photographs were 'plotted right down to the last exposure'.[8] According to Hugh-Jones, Parkinson – almost 6½ ft (2 m) tall, with the appearance of a colonel

Apollonia van Ravenstein, Crane Beach Hotel, Barbados, British *Vogue,* 1973

turned dandy, and (from 1957) with his trademark Kashmiri wedding
cap on his head – had 'half-hypnotised' his sitters and models by the
time he began to shoot.[9]

Parkinson responded to the challenge of the rising stars of the
period – Terence Donovan, Brian Duffy, David Bailey – by reinventing
himself. In 1960, having decided the year before not to renew his con-
tract with *Vogue*, Parkinson took up an associate editorship at *Queen*,
the glossy fashion and celebrity magazine associated with 'Swinging
London'. It was also at this time that he began to use a motor-driven
Nikon. At *Queen*, a radical magazine for its time, he was encouraged
to indulge his more outlandish ideas. These included hiring a helicop-
ter at the time of the Paris collections and, using a Widelux panoramic
camera, photographing a model from behind – showing only the
back of her head – as she looked out over the French capital. In 1964
Parkinson was hailed by *Photography* magazine as 'the greatest living
English photographer'.[10]

Around 1963 Parkinson and his family rented a second home
in Tobago. As he had done in England, he became a gentleman
farmer, breeding livestock and creating 'Porkinson's Bangers', an
English sausage. In 1965 Parkinson rejoined *Vogue*, contributing to
the British, French, Italian and American editions. It was, he said,
Diana Vreeland, the then editor of American *Vogue*, who pushed him
to achieve 'the impossible and the unobtainable'.[11] Some of the pleas-
ures of a Parkinson fashion photograph rely on the tension between
the elaborateness of the *mise en scène* and the suggestion that some of
its elements were beyond the control of the photographer.

By the mid-1970s Parkinson was expressing a preference for
working in colour. He also felt that he had emerged as 'the natural
inheritor' of Cecil Beaton, in that he was now a favoured photographer
of the British royal family.[12] His fashion work, however, was drying
up. In 1978 Parkinson was suspended from the British and American
editions of *Vogue* owing to a legal dispute over the ownership of his
negatives. He managed to secure both his negatives and the copy-
right to his *Vogue* photographs when being wooed back to Condé Nast
by Tina Brown, editor of the new incarnation of *Vanity Fair*. While
this was a feat that few of his generation achieved, it came at a price:
Parkinson was omitted from the *Vogue Book of Fashion Photography
1919-1979*. Around this time he began to work for *Town & Country*,

which was owned by the Hearst Corporation, a rival to Condé Nast. At *Town & Country*, those who sat for Parkinson might own the jewels and clothes they wore for shoots; the opulent fantasies of the style-bible assignments were the realities of their daily lives.

Although Parkinson had become a celebrity, his carefully cultivated persona as one of the fashion crowd forestalled any serious consideration of him as an artist. He had been exhibiting his work on and off since 1935, including at the Venice Biennale of 1957, but it was not until he was in his mid-sixties that he began to gain substantial recognition from the art world and the establishment. In 1979 an exhibition of his work was mounted at the Photographers' Gallery in London; two years later, in 1981, a retrospective at the National Portrait Gallery broke all attendance records. He was made a Commander of the British Empire that year, and was given a Lifetime Achievement Award by the American Society of Magazine Photographers in 1982. His first US retrospective, at the International Center for Photography in New York, was staged in 1983, the same year his photo-biography, *Lifework* (published as *Fifty Years of Style and Fashion* in America), was released. In December 1987 New York's National Academy of Design held a retrospective of his work in honour of his seventy-fifth birthday. This belated recognition was soured by tragedy, however: two months earlier, Wenda had died in her sleep at the age of sixty-four. In 1990, Parkinson died of a cerebral haemorrhage while on location for *Town & Country* in Malaysia, aged seventy-seven.

Richard Avedon said of Parkinson that he was one of 'the very few photographers who remember[ed] that photography can be an expression of man's deepest creative instincts'.[13] Parkinson had begun by thinking of himself as an artist, but later asserted that he had spent the rest of his life trying to 'dispel' this idea.[14] Aware that fashion photography was generally considered superficial and ephemeral, he insisted his achievements were down to luck or magic, rather than his unfailing hard work, technical mastery and ambition. This may explain why his innovations have been readily attributed to other photographers. Parkinson's decision to forge a persona as 'Parks' – English gent, eccentric dandy, connoisseur of women, raconteur – was a boon to his professional career, but meant that he had to distance himself from the suggestion that he believed himself to be, and was, a great artist in photography. ∎

Lisa Fonssagrives-Penn, *Penn with Asaro Mud Man and Child, New Guinea*, 1970

Irving *Penn*

1917–2009

Photographing a cake can be art.

IRVING PENN

The literature on Irving Penn gives almost no insight into the life behind the work. Perhaps this is not so surprising. Penn, who trained as an artist in the pre-war period, joined Condé Nast in 1943 and became a staff photographer for *Vogue* that same year, was still contributing work to the magazine in the year of his death, aged ninety-two. Spanning more than half a century, Penn's career was dominated by the relationship – and tension – between high and low art. The majority of his photographs, including the many now exhibited and collected as art, were made for editorial, fashion or advertising features, and were collaborative projects subject to a brief. The literature on him, consisting primarily of photobooks and of catalogues to his exhibitions, alternates between claiming him for professionalism and technique and for art and inspiration. From the outset of his career, Penn was determined to find his own distinctive 'light'. What truly distinguishes his photography from that of his contemporaries is that his images did not, with a few notable exceptions, look to Europe for inspiration but attempted to forge an American aesthetic. This ambition has much to do with Alexander Liberman, the art director for whom Penn worked at Condé Nast.

Irving Penn was born in Plainfield, New Jersey, to Harry Penn and Sonia Greenberg, a watchmaker and a nurse respectively. From 1934 to 1938 Penn studied painting at the Philadelphia Museum School of Industrial Art (now the University of the Arts). It was there that he first encountered Alexey Brodovitch, the Russian-born designer and photographer who, in addition to his teaching duties, had recently taken up the position of art director at *Harper's Bazaar*. Brodovitch introduced his students to leading European artists and photographers, such as <u>Man Ray</u>, <u>Eugène Atget</u> and George Hoyningen-Huene. After graduation, Penn worked as the art director of *Junior League* magazine and as a freelance commercial artist. He purchased a Rolleiflex, and

some of the photographs he took as he wandered the streets of New York City were used by *Harper's*. In 1940 Penn, who had spent the summers of 1937 and 1938 working as Brodovitch's unpaid assistant at the magazine, became his paid assistant at Saks Fifth Avenue department store, which had recruited Brodovitch as director of advertising design; a year later, Brodovitch left Saks and Penn succeeded him. When Penn decided to leave the job, in 1942, and was looking for a replacement, Brodovitch put him in touch with another Russian émigré, Alexander Liberman, who had recently arrived in New York from Paris. While it was Brodovitch who determined Penn's cultural education, it was Liberman who would determine his career.

Having decided to live the life of an artist, Penn travelled to Mexico by taking short train journeys through the American South. He took with him a 4 × 5-in. view camera, a film camera and an aesthetic sensibility shaped by Atget and Walker Evans. He rented a painting studio in Coyoacán, now a suburb of Mexico City, and spent time photographing his surroundings. Whether Penn intended his year in Mexico to be a respite from New York and commercial art or a complete break from it is unclear. The paintings he made there do not survive owing to the fact that he scraped the canvases clean before returning to New York. He appears to have made a distinction between his practice of fine art and that of photography: art was the syncretic surrealism of the imagination, whereas photography was the inadvertent surrealism of the street.

In 1943 Liberman, who had worked on the journal *Vu* in Paris, became the new art director of *Vogue* and hired Penn to work with him. Aged twenty-five, Penn was asked to supervise the cover designs, suggesting ideas to such senior staff photographers as Horst P. Horst, Cecil Beaton and George Platt Lynes. When this arrangement did not work out, Liberman suggested that Penn make his own photographs, giving him a regular salary, a studio and an assistant. Penn's first cover for *Vogue* (he would produce 157 more), a colour photograph featuring accessories for the autumn season, appeared on 1 October 1943. His brief was soon extended to fashion spreads and portraits. Penn found his 'light', literally, by designing a bank of tungsten lights that would simulate a skylight in his windowless studio. His concern with forging a signature style may have been in part a response to the indentured nature of the role: in return for the salary and use of

the facilities, a *Vogue* photographer was always on call, and there was no right to refuse the work assigned.

Late in 1944 and into 1945 Penn worked as a volunteer ambulance driver and photographer for the American Field Service with the British Army, a role that took him to Italy, Austria, India and Yugoslavia. Penn continued to contribute to *Vogue* while overseas. In 1944 he had begun his 'Portraits with Symbols', a series of allegorical portraits commissioned by *Vogue* and featuring a sitter from the performing arts within a surrealistic still life composed of symbolic objects. This series is the only one of his that has failed to generate acclaim, his reputation as an all-American photographer precluding, it seems, an admiration for European surrealism.

In 1947 Penn began to make portrait photographs in a completely different idiom. For what are sometimes called his 'corner' and 'carpet' portraits, he posed sitters either in a confined space created using two screens or on a large roll of carpet unfurled over a studio prop, and allowed the detritus of a working studio also to appear in the picture. According to Liberman, 'These were existential pictures, the torn rug a memento mori at the feet of the great of the world, who were alone, cornered.'[1] According to Penn, 'limiting the subjects' movement seemed to relieve me of part of the problem of holding onto them'.[2] Penn's portraits for *Vogue* from 1950 onwards were generally busts rather than full-length figures, their sculptural shapes formed by the sitters sometimes being cropped by the frame, rather than contained within it. For *Vogue* and other periodicals, Penn photographed the great and the good, including artists, politicians and society figures, from the 1940s to the first decade of the new millennium. In time, to be photographed by Penn would itself be a gauge of one's celebrity.

In 1948 *Vogue* sent Penn to Europe with the journalist Edmonde Charles-Roux, who was to be his 'fixer'. In northern Italy Penn photographed contemporary cultural figures; in Naples, he captured people in the street and popular entertainers. He took portraits in Paris and Spain, where he also made the *Vogue* feature 'Barcelona and Picasso'. These photographs, taken on location and often in natural light, suggest that Penn was longing to work in a daylight studio. After completing a fashion shoot in Peru in December 1948, Penn flew to Cuzco in the Andes and found a daylight studio in the town. There he photographed some of the Quechua Indians who had come to

Woman with Sun Block, New York, 1966

Cuzco for the holiday festivities. As well as being published in *Vogue* at the time, the Cuzco sittings became the template for the magazine's ethnographic series, which appeared annually in the 1960s and early 1970s. For these images of the indigenous peoples of far-flung locations, Penn always used a temporary studio that allowed for disparate subjects to be photographed under uniform conditions. Penn's ethnographic portraits were later published as *Worlds in a Small Room* (1974).

In the summer of 1949 Penn began work on a new project, the series of nudes known as the 'Earthly Bodies'. Most of the models he hired for the sittings were Rubenesque, and it has been suggested that these studies were to some extent a response to the many models he photographed who had 'self-starved looks'.[3] Another theory is that the nudes were linked to his love affair with Lisa Fonssagrives – a leading model and the wife of the photographer Fernand Fonssagrives – in that the bodies were the inverse of the elegant, refined figure of the woman who, following her divorce from Fernand in 1950, would become his wife (they had a son, Tom, in 1952). According to the curator Maria Morris Hambourg, the nudes were the 'pictures closest to his heart'.[4] However, both Alexander Liberman and Edward Steichen found them problematic, and Penn did not distribute them widely.[5] In a life dominated by Liberman, *Vogue* and commercial photography, the 'Earthly Bodies' represent one of Penn's periodic acts of rebellion against all three.

The next project Penn embarked on was 'Small Trades', which he began in Paris in 1950. The project was an extension of the centuries-old tradition of portraying Paris's *petits métiers*, those who plied their trade on the city's streets. Penn was given the use of a daylight studio, and Charles-Roux, now editor of French *Vogue*, hired 'pickers' to find him subjects. Penn did further shoots for the series in London and New York, and selections from each city were published in *Vogue Britannica*, French *Vogue* and American *Vogue* in the first half of 1951. Ninety-one of the 'Small Trades' photographs were brought together in *Moments Preserved: Eight Essays in Photographs and Words* (1960), creating an ethnographic record that highlighted the picturesque nature and potential obsolescence of these artisanal *métiers*.

Liberman's introduction to *Moments Preserved* acclaimed Penn as 'one of the great new artists of light'.[6] In his introduction to *Passage:*

A Work Record (1991), however, he was far more equivocal: 'Penn is not easy to work with ... [The] matching of the imagined possibility ... with his vision was a wrenching experience for both of us.'[7] It could be argued that Penn's vision was significantly shaped by the desire to see how far he could push Liberman in terms of planning, research and budget. Penn stated that some of his best work for *Vogue* was not his, but 'ours', and that 'the germ of an idea might come from [Liberman]'.[8] According to Liberman, who was committed to making the United States a cultural powerhouse, 'I knew that whatever the subject, [Penn] would "Americanize" it. In my mind that meant make it modern, see it with the eyes of the New World.'[9]

When Penn began to experiment with platinum printing in the early 1960s he chose not to reach out to the photographic community but instead taught himself the process in his cabin darkroom at his home on Long Island. The complexity of the process he developed (a mix of platinum and palladium), combined with the time it took him to produce a print, was almost a travesty of the deadline culture of working on assignment. Penn would reprint in platinum many of the works he had made on commission for *Vogue*. He also began to produce series of images intended to be seen in platinum only, such as the photographs of the cigarette butts and other detritus he found on the streets of New York. These 'street material' images resulted in two solo exhibitions: one at the Museum of Modern Art (MoMA) in 1975, the other at the Metropolitan Museum of Art two years later.

As Penn got older he clearly wished for his work to appear more in the museum than in the magazine. Ironically, however, the retrospective of his photography held at MoMA in 1984 did much to reinvigorate his commercial practice. If it is hard to see the 'imaginative and adventurous soul' behind the work, then this was deliberate.[10] Rarely interviewed, Penn perhaps understood that a commercial photographer talking about his 'art' would compromise the persuasive powers of his pictorial statements. Instead, he developed in his commissioned work subjects that approached art and let others make the case for considering him as an artist. To have claimed himself and his photography explicitly for high art would have been to challenge directly the man who made him. Liberman's 'American Modern' could hardly admit that he had not shaken off the spell of the Old World. ∎

Sabine Renger-Patzsch, *Portrait of Albert Renger-Patzsch*, c. 1960

Albert *Renger-Patzsch*

1897–1966

*There is an urgent need to examine old opinions
and look at things from a new viewpoint.*

ALBERT RENGER-PATZSCH

Albert Renger-Patzsch's photography is generally associated with the Neue Sachlichkeit (New Objectivity) movement of Weimar Germany. Yet the photographer wished to disassociate himself from the term *sachlichkeit* because of what he saw as the corruption of the term's original meaning.[1] The label that he chose instead was 'objectivity', 'a foreign word' that he felt would 'describe accurately the position of servitude I maintain before the subject'.[2] Renger-Patzsch championed the idea that photography was 'sufficient in itself',[3] with 'its own technology and its own means',[4] and he opposed attempts to view photography as an art form akin to the fine arts. His essentialist conception of photography appears to be that of an arch-modernist. But this characterization elides some of the more traditional aspects of his engagement with the medium: his preference for a view camera mounted on a tripod (instead of a handheld device); his eschewing of any evidence of the accidental, of the temporal or of movement in his images; and his search for something 'typical' in a portrait.[5] Today, these aspects of his practice are generally accounted for by the idea that there were two main strands of 'New Photography' in Weimar Germany: that associated with the dynamic formal and conceptual experiments of László Moholy-Nagy and other photographers associated with the Bauhaus, and the detached and static imagery of Renger-Patzsch, Karl Blossfeldt and August Sander. The prevailing characterization of Renger-Patzsch as the 'photographer of objectivity' has, however, served to strip him of a subjectivity and, in turn, a biography beyond that of his photographic career.

Albert Renger-Patzsch was born in Würzburg in 1897, the third son of Ernst Karl Robert Renger-Patzsch and Johanna Frederike Dose. His father, who ran a music and general arts store in Würzburg, took his distinctive last name from the two married names of his mother,

first Renger and then Patzsch. In 1899 the family moved to Dresden, where Albert attended primary school. After spending a few years in Sondershausen, the family returned to Dresden in 1910, and all three boys attended the Kreuzgymnasium. In the first year of the First World War Albert's elder brother, Rudolf, was killed. Two years later, immediately after completing his studies in chemistry, Renger-Patzsch was drafted into the military and eventually given a job as an assistant 'in the chemical centre of the general staff'.[6] After the war, he studied chemistry for another year, at the Institute of Technology in Dresden. According to the American art historian Donald Kuspit, 'by 1921 [Renger-Patzsch] had realized that his "romantic ideas" were incompatible with a career as a chemist'.[7]

Although it is possible to paint Renger-Patzsch as a romantic, it seems that he was at war with this side of his character, constantly stressing objectivity at the expense of subjectivity, and yet consciously positioning himself as an artist. He also held that the basis of his artistry lay in technical mastery and visual clarity. In 1920 Renger-Patzsch worked as a photographer for Folkwang, a publishing house in Hagen run by the curator, photographer and critic Ernst Fuhrmann. In 1922 he became head of the company's photographic service with a remit to build a photographic archive. He later said that it was difficult for others to understand why he had decided to give up chemistry for photography, 'a profession that was not held in high esteem'.[8]

Renger-Patzsch began to make plant studies in 1922. He later supplied Fuhrmann with photographs of plants and flowers for the book series *Die Welt der Pflanze* (The World of Plants), the first two volumes of which were published in 1924. His often pin-sharp, close-up photographs were suggestive of natural laws that were 'so stable that they cannot be understood rationally nor expressed in numbers'.[9] His fascination with what might be divined in nature is also evident in the books *Baüme* (Trees; 1962) and *Gestein* (Rock; 1966), both published when he was in his sixties. According to Kuspit, Renger-Patzsch was 'known to travel 60 to 80 km to photograph a particular tree in early-morning light'.[10]

In 1923, perhaps for financial reasons, Renger-Patzsch gave up his post at the archive in Hagen and moved to Berlin to work for a picture agency. That same year, in Hamburg, he married Agnes von Braunschweig. In 1925, after a brief stint working as a bookkeeper for

Spruce Forest in Winter, 1926

a wholesale chemist in Romania, he found employment in Darmstadt with Auriga, the publishing house founded by Fuhrmann as the successor to Folkwang. Also in 1925 the first book to bear his name, *The Choir Stalls of Cappenberg*, was published under Auriga's Berlin imprint. It was in Darmstadt that he and Agnes's first child, Sabine, was born; two years later their son, Ernst, was born in Bad Harzburg, to where the couple had moved after Renger-Patzsch had left Auriga to become a freelance photographer. It has been suggested that these many changes of job and location were due to the fact that Renger-Patzsch was 'too "self-willed and uncompromising" ... to work for anyone'.[11]

In 1927 Renger-Patzsch's photography came to the attention of Carl Georg Heise, at that time the director of the Museum für Kunst und Kulturgeschichte in Lübeck. Heise became the driving force behind the publication of Renger-Patzsch's major work, *Die Welt ist schön* (The World Is Beautiful). First issued in 1928, the book contains 100 images of plants and animals, people, landscapes, architecture, machinery and commercial goods. In his introductory essay, Heise, who also edited the book, emphasized a symbolic interpretation of the photographs, and suggested that there were certain immutable forms and structures in nature that were compatible with those used in industry. The scholar Matthew Simms maintains that, in effect, the text argues for 'the harmonious coexistence of nature and technology'.[12]

Widely reviewed, *Die Welt ist schön* received many favourable responses. The curator and art historian Heinrich Schwarz described the book as 'a virtual revolution in photography'.[13] In the weekly magazine *Berliner Illustrirte Zeitung*, Thomas Mann called Renger-Patzsch 'a seeker and a finder'. He also argued against the view that the capitulation of the artistic to the mechanistic was evidence of 'the decay and downfall of the soul', and asked instead whether technology itself might not become spiritualized.[14] Many reviewers, however, took issue with the title of the book, not least the celebrated cultural theorist Walter Benjamin, whose loathing of the title appears to inform his critique of the entire book. Benjamin felt it needed 'a caption that wrenches it from modish commerce and gives it a revolutionary use value'.[15] He likened the images to advertising photography, and identified this approach as one that 'can endow any soup can with cosmic significance but cannot grasp a single one of the human connections in which it exists'.[16] Acknowledging such criticisms, Renger-Patzsch

Round Flasks, Schott Glassworks, Jena, 1934

later said of *Die Welt ist Schön* that it 'was nothing more than a book of objects; it should have been called "Things"'.[17]

In the same year as the publication of *Die Welt ist schön*, Renger-Patzsch and his family moved to the city of Essen, which was encouraging artists to settle there. Renger-Patzsch's commercial practice at this time was sustained in part by a post documenting objects in the collection of the Museum Folkwang in Essen. He was also receiving numerous industrial commissions, one of which required him to document the Fagus Factory in Alfeld, a building designed by Walter Gropius and Adolf Meyer in about 1910 for the production of shoe lasts. In general, such commissions demanded a celebration of the modern, which he achieved through the strong graphic organization of forms, both compositionally and in the cropping. Also at this time Renger-Patzsch was taking photographs in the Ruhr, possibly for an abortive book project.[18] His images of the region demonstrate a fascination with the contrasts between rural Germany and its increasingly industrialized landscape.

In 1956 Renger-Patzsch claimed to admire such photographers as Henri Cartier-Bresson and Bill Brandt on the basis that they had ushered in 'a new era in photography', one that had been 'suggested by Atget, occasionally also in Stieglitz'.[19] Writing about his own techniques in 1937, Renger-Patzsch revealed that

> *I only work with 9 × 12 cameras, a reflex camera for animals and children, and a collapsible camera for all other purposes. I use lenses of various focal lengths, generally between 8 and 30 cm, and prefer low speeds to working with huge glass monstrosities. I also work with less sensitive plates unless the object requires something else … My love for the tripod is so great that I have overcome my natural distaste for carrying packages … The developing and printing is done by the photographic dealer who needs no advice from me in this respect.*[20]

This matter-of-factness is suggestive of a desire to identify himself not with the mechanistic trappings of his chosen medium, but with the dignity he sought to confer on the subjects of his photographs.

The commercial work undertaken by Renger-Patzsch could be very mundane: photographs to demonstrate correct orthopaedic posture

(1926–8), glassware (1932), 'Hospital Buildings in Europe' (1938) and spare parts (1950s). And yet in his images the objects of industrial production were transformed, as shown in the celebrated photographs he made for Schott Glassworks in Jena, in which simple beakers are elevated to icons of design. In 1933 he made his first and only foray into teaching (despite being invited to do so many times), taking over the chair of photography at the Folkwangschule für Gestaltung in Essen. His predecessor, Max Burchartz, had resigned after the school had come under the control of the National Socialists; Renger-Patzsch remained in post for seven months before leaving without explanation.

To balance his commercial practice, Renger-Patzsch participated in numerous exhibitions. He also contributed photographs to dozens of books, the subjects of which ranged from modern industrial production to topographical studies of towns and rural districts. During the Second World War, he was commissioned to take pictures of the western defences of the German occupying forces in northern France, thereby gaining exemption from active service. It was also during the war that a large part of his archive was destroyed in an air raid on Essen. In the years that followed, Renger-Patzsch, having moved with his family to Wamel in 1944, continued to juggle commercial contracts, book publications and photography exhibitions, gaining increased recognition in the form of awards and requests for lectures.

In 1966, three years before his death, Renger-Patzsch told his friend Fritz Kempe that 'photography hasn't interested me for a long time; the object, however, does to an even greater degree.'[21] Renger-Patzsch's notion of objectivity, in which the photographer endeavoured to suppress his or her subjectivity, does not mean that he actually 'rejected any kind of artistic claim for himself'.[22] Indeed, it could be argued that his insistence on 'objectivity' was a strategic attempt to veil his subjectivity. It should not be forgotten that he also used the word 'magic' when describing material things.[23] When Renger-Patzsch said that 'There is an urgent need to examine old opinions and look at things from a new viewpoint', it is probable that he did not intend to overthrow those 'old opinions' but instead to subject traditional aesthetic concepts, such as the romanticism of the German cultural tradition, to the scientific standards of the day.[24] If romanticism could survive this stringent examination, then it would not be mere mysticism to attest to the presence of deeper meaning. ■

Self-Portrait, 1924

Alexander *Rodchenko*

1891–1956

We must revolutionize our visual thinking.

ALEXANDER RODCHENKO

Like many great photographers, Alexander Rodchenko did not prac-
tise photography exclusively. He was also a painter, a graphic designer
and a decorative artist. As a constructivist, he was committed to the
application of avant-garde principles across a range of media, includ-
ing not only photography, painting, graphics and decorative design,
but also sculpture, architecture, stage design, film, clothing, textiles,
furniture, book illustration, advertising, poetry, prose and criti-
cism. Nonetheless, it was photography that he saw as the art of the
modern era, and for which he became a committed proselytizer. He
is best known for images that exploit the capabilities of the handheld
camera, using dynamic and novel viewpoints in order to - as he saw
it - revolutionize modes of perception. In the years immediately fol-
lowing the Russian Revolution of 1917, Rodchenko devoted himself to
the creation of completely new cultural forms for a new Soviet society.
By the early 1930s, however, he was regularly being denounced as a
formalist who was interested in art for art's sake, rather than for the
betterment of society, and therefore under the spell of the bourgeois
culture of the West. It is unlikely that Rodchenko was an ideological
traitor to Russia; rather, as Lenin's communism became Stalin's col-
lectivism, he regretted the estrangement of politics and art from the
personal, the subjective and the humanistic.

Alexander Rodchenko was the second child of Mikhail
Mikhailovich Rodchenko, a peasant from the province of Smolensk
who taught himself to read while working on the railways. Having
made his way to St Petersburg, Rodchenko's father could not hold
down a job for very long; this, according to his son, led him to drink
and gambling.[1] Rodchenko's mother, Olga Evdokimovna Paltusova,
was a nanny turned laundress. By the beginning of the 1890s, the
couple and their two boys were living in an unusual set-up in St
Petersburg. Rodchenko recalled how he was 'born above the stage of

a theatre ... the Petersburg Russian Club in Nevsky', where his father worked as 'a props man'.[2] The family lived in a flat on the fourth floor, which, in Rodchenko's words, was nothing more than 'a simple attic'.[3] Rodchenko, who asserted that 'Every artistic path is a sum total of impressions: childhood, youth, surroundings and youthful illusions',[4] wrote of having no toys, no company and nothing with which to occupy himself at the club.[5] His own 'artistic path' would be determined by his inventiveness.

The chronology of significant events in Rodchenko's life varies across the many biographical and autobiographical accounts. By 1905, it seems, the family had moved to the city of Kazan; two years later, Rodchenko's father died. Rodchenko was, it appears, a confused and unhappy teenager. Training to be a dental assistant, he wanted to learn to draw; he also dreaded the prospect of military service. When he enrolled at the Kazan School of Fine Arts in, it is thought, the autumn of 1910, his artistic inspirations were Mikhail Vrubel and Paul Gauguin. By the end of 1913, however, he was working in a style inspired by futurism. His commitment to the movement solidified when the artist David Burliuk and the poets Vasily Kamensky and Vladimir Mayakovsky visited Kazan. A diary entry dated August 1913 mentions Varvara Stepanova.[6] Thought to be a fellow student, Stepanova would become his partner and artistic collaborator (and eventually, in 1941, his wife).

In March 1916, having joined Stepanova in Moscow, Rodchenko participated in 'Magazin' (The Store), the renowned futurist exhibition staged by Vladimir Tatlin in a rented shop on Petrovka Street. In addition to producing futurist paintings, Rodchenko at this time was making and creating geometric abstractions and collages made of wallpaper. In 1921, for the '5 × 5 = 25' exhibition in Moscow, he chose to show three monochrome canvases: one in red, one in blue and one in yellow. Later that year, however, he gave up painting, stating that 'We should no longer represent, only process and construct.'[7] The term 'constructivism', coined in January 1921, was intended to emphasize an alliance between purely artistic practice and more practical design work. Believing that art must have an instrumental role in society, Rodchenko served in various capacities within the Museum Bureau, the Moscow Museum of Painterly Culture and the Institute of Artistic Culture (INKhUK). Until 1930 he also taught at the Higher

State Artistic-Technical Workshops (VKhUTEMAS), which became a locus for avant-garde art and architecture.

According to his own account, Rodchenko came to photography through photomontage.[8] Beginning, it is thought, in 1918, he and Stepanova began to include clippings from newspapers, postcards and stamps in collages, some of which were published in the magazine *Kino-fot*.[9] His first major works in photomontage were the illustrations he made for Vladimir Mayakovsky's poem *Pro eto* (1923). These combined found material, mostly clippings, with photographs of Mayakovsky and his lover Lilya Brik taken by Abram Sterenberg. Also in 1923 Rodchenko began designing advertisements for such state-run grocery and department stores as Mosselprom and GUM.

Rodchenko took up photography in 1924, acquiring his first camera (probably a medium-format Iochim that took both glass plates and sheet film) and building a makeshift darkroom at home. He was at this time a member of the circle associated with the magazine *LEF* (*Levy front iskusstv*, or 'Left Front of the Arts'), which had been founded in 1923. Rodchenko designed all the covers for both *LEF* and its successor, *Novyi LEF*, many of which incorporated his photographs. His early photography consisted primarily of portraits of the various writers, painters and critics associated with the magazine. In the mid-to-late 1920s Rodchenko also worked in film, and for some critics these early portraits, with their defined outlines and coherent spatial setting, show the influence of cinema. In was in about 1925, often using a Vest Pocket Kodak roll-film camera, that he began to experiment with the unusual viewpoints that would become known in Russia as 'Rodchenko foreshortening' and 'Rodchenko perspective'.[10] Vavara, Stepanova and Rodchenko's only child, recalled that her father's method of photographing a sitter involved ceaselessly moving around them so that they rarely knew when the shot had been taken.

In 1928 Rodchenko became a member of October, an association of avant-garde artists, designers, architects and film-makers. Two years later, together with Boris Ignatovich, Rodchenko set up the photography section, a group that outlived the folding of the original October association in 1931. According to the scholar and curator Margarita Tupitsyn, the group's members advocated a 'revolutionary photography ... one that sets itself the aim of promulgating and agitating for a socialist way of life and a Communist culture'.[11] The

group was not, however, ideologically sound enough for the Russian Society of Proletarian Photo-Reporters (ROPF), whose conception of Soviet photography was more narrative and propagandist. In 1928 an article in *Sovetskoe foto* (Soviet Photo) had paired three photographs by Rodchenko with three very similar images by Western photographers – Ira W. Martin, Albert Renger-Patzsch and László Moholy-Nagy – the suggestion being that Rodchenko was plagiarizing Western models. In 1932 examples from Rodchenko's series of photographs of young Soviet scouts were published in *Proletarskoe foto* (Proletarian Photo), a journal controlled by the ROPF. Such works as *Pioneer with a Trumpet* (1930) were hailed not as triumphs of experimental photography but as wilful distortions of the image of young patriots. Repeatedly attacked in the press for its bourgeois formalism, the October group turned on Rodchenko (according to his own account) and replaced him with Ignatovich as its figurehead.[12]

Rodchenko did have strong links to contemporary art in the West. Throughout the 1920s he kept abreast of photographic developments in Europe and the United States through his network of friends and professional contacts. In 1922 Rodchenko's photographs were published in the Berlin magazine *Veshch*. In 1925 he visited Paris, where his designs for the interior of a workers' club were on show in the Soviet pavilion at the Exposition Internationale des Arts Décoratifs et Industriels Modernes. While in Paris he acquired a Debrie Sept cine camera, which took still and moving images; three years later, he purchased a Leica. In January of 1928, Alfred H. Barr, soon to become the first director of the Museum of Modern Art in New York, visited Rodchenko and Stepanova at their Moscow apartment. In 1929 fourteen of Rodchenko's works were included in 'Film und Foto', the seminal photography exhibition held in Stuttgart. In the 1930s, however, connections with the West, other than through state-run agencies, were treated with increasing suspicion.

In 1932 the state-run publishing house Izogiz commissioned Rodchenko to document Moscow, and a selection of the resulting images – including the well-known photograph featuring his daughter, *Radio Listener* – were eventually published as postcards. Here again he was said to have been inspired by cinema, particularly Walter Ruttman's *Berlin: Symphony of a Great City* (1927) and Dziga Vertov's *Man with a Movie Camera* (1929). In 1933 a law was introduced

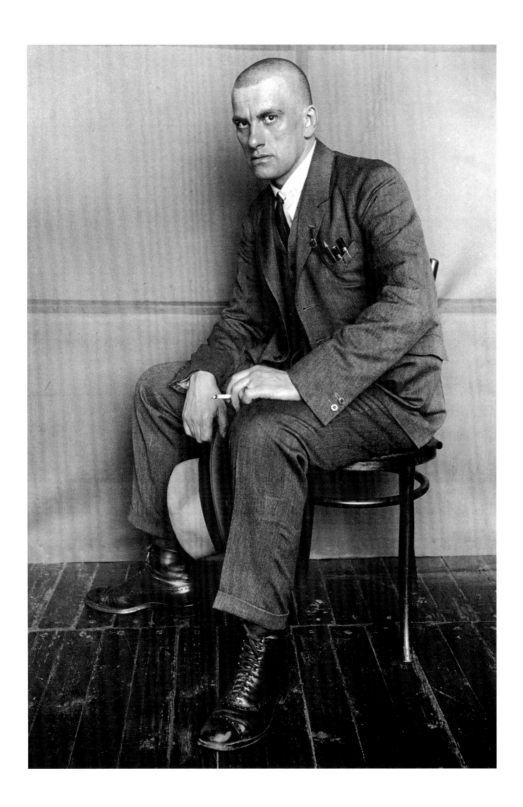

Portrait of Vladimir Mayakovsky, 1924

To the Demonstration, 1928–9

restricting the practice of photographing on the streets of Moscow, and Rodchenko began to confine his activities to official events, the circus, the theatre and commissions outside the city. That same year, again for Izogiz, he travelled to Karelia to record the construction of the White Sea–Baltic Canal, the showpiece of Stalin's first five-year plan. In 1937, a selection of his works was included in the 'First All-Union Exhibition of Photo Art' at the Pushkin Museum of Fine Arts.

Reflecting on the show at the Pushkin Museum, Rodchenko lamented that 'I should have done everything differently and better.'[13] In December 1937 his thoughts regarding change became more concrete: 'Today I thought a lot and decided that I need another decisive turn in my art. Something should be done that would be very warm, humane, universal! In answer to the advance of fascists, bootlickers and bureaucrats. Not to mock at man, but to approach him intimately, closely, tenderly as a mother would. Man is now very lonely. He is almost completely forgotten.'[14] Despite the suggestion that he was directing his criticisms at fascism, later entries in his diary suggest that his real concern may have been the human cost of Stalin's drive for collectivism, such as the forced labour used to build the White Sea–Baltic Canal. His renewed interest in photographing the theatre, ballet, the circus and other forms of entertainment appears to have been a form of resistance to official Soviet culture (the circus was also the subject of a series of paintings he made after returning to the medium in 1935). Some of these images were made with a soft-focus Thambar lens, lending them a hazy romanticism informed perhaps by both personal and political nostalgia.

During the Second World War Rodchenko continued to be denounced as a bourgeois formalist, and in 1951 he was temporarily expelled from Mosskh, the Moscow branch of the Union of Soviet Artists. The resurrection of his reputation began the year after his death, with the first solo exhibition of his work, organized by Stepanova and held at the Central House of Journalists in Moscow. Ironically, the show was not censored, and therefore demonstrated the profound engagement in the 1920s of Rodchenko's art with that of the West. Despite the geographical and ideological distance between Rodchenko and such figures as Edward Weston, the search for a new photographic language that would express the dynamism of the modern era saw them espouse a near identical photographic creed. ■

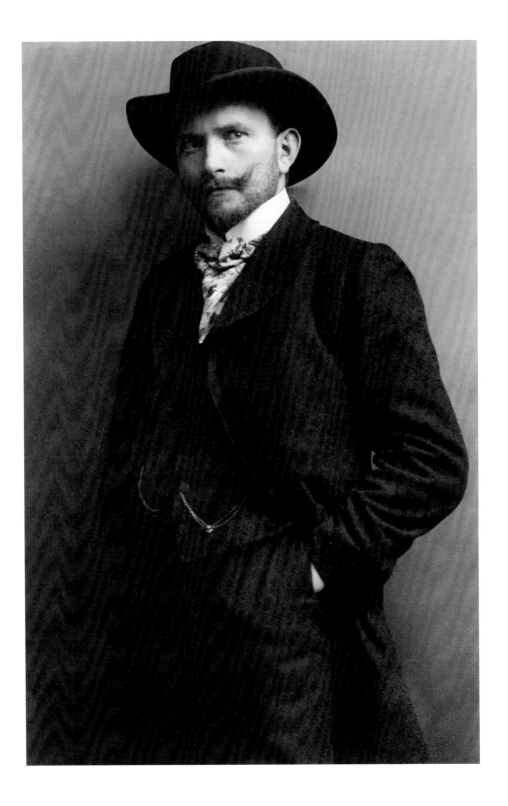

Self-Portrait, c. 1904

August *Sander*

1876–1964

*[Photography] can reproduce things with
impressive beauty, or even with cruel accuracy,
but it can also be outrageously deceptive.*

AUGUST SANDER

In his introduction to August Sander's *Face of Our Time* (1929), Alfred Döblin wrote, 'we are free to interpret his photographs in any way we wish'.[1] In fact, Sander's photography, and Sander the man, have been interpreted in very particular ways. Praise for his portrait photographs from some of the leading critics of the time has secured Sander a permanent place in the history of both photography and twentieth-century art. Yet, while there has been almost unparalleled reverence for the portraits compiled for his extensive typology of contemporary German society, *People of the 20th Century*, there has been relatively little critical interest in his landscape photographs. It is unlikely, however, that a pioneer of Neue Sachlichkeit (New Objectivity) would be avant-garde in only one genre. The evidence suggests that both Sander's portraits and his landscapes were underpinned by the same desire: to find respite from art reduced to commerce in a higher practice of photography.

Sander was born in Herdorf, in the Rhineland-Palatinate region of Germany. Herdorf was a mining town, and Sander's father was a former mine carpenter who ran a family smallholding. August Sander *père* inspired his son with his skill at drawing; his mother, who had an interest in herbs and their effect on the body, often took her son out foraging.[2] One of nine children, August attended the local Protestant elementary school and, as was the custom, worked as a slag-heap boy at a local mine. One day he helped a photographer who was on assignment at the mines, thought to be Heinrich Schmeck, to carry his equipment. When invited to put his head under the cloth, Sander was enchanted by what he saw. With help from his uncle, he saved to buy his own photographic equipment, acquiring a 13 × 18-cm camera, an Aplanat lens and a tripod. His father helped him erect a darkroom

adjacent to the family barn. Sander described his introduction to photography in terms that privileged the subject over the medium: 'I saw for the first time how one can hold fast a landscape with a camera.'[3]

Sander was called up for national service in 1897, and while stationed in Trier he spent his free time working as an assistant to a local photographer. From 1899 to 1901, having completed his military service, he moved from town to town working as a photographer's assistant. In 1901 he settled in Linz, Austria, where he worked for the Greif Photographic Studio. In 1902 he married Anna Seitenmacher, whom he had met in Trier, and a year later they had their first child, Erich. (The couple would have three more children: a second son in 1907, and twins – one of whom died shortly after birth – in 1911.) It was also in 1902 that Sander took over the Linz studio with a business partner. The partnership was dissolved soon afterwards, however, and in 1904 Sander's became the sole name above the door.

It was while based in Linz that Sander began to gain recognition for his photography, winning awards in state competitions and at international exhibitions. Although he was opposed to the practice of retouching negatives to flatter the sitter, it seems that he nonetheless favoured the hand-worked printing processes associated with pictorialism. In 1906 an exhibition at the Landhaus Pavilion in Linz featured 100 of his large-format photographs – mostly landscapes – printed in gum bichromate, pigment and bromoil, some of which were coloured. In November 1909 Sander sold the Linz studio and the family moved temporarily to Trier. The following year the Sanders relocated to Cologne, where, after a brief stint managing another concern, Sander opened his own studio.

Sander's life's work, *People of the 20th Century*, was rooted in his commercial practice. Around 1911, in need of employment, he set out on his bicycle seeking clients for portraits that he would take outdoors. The farmers of Westerwald formed the first portfolio of *People*. As those closest to the land, according to Sander, they were the archetype around which the project was built. There was, however, a subjective dimension to his search for universality. Sander later claimed that his first serious work in photography was done in his youth, and it is true that the working methods he used for his early portraits taken in his home town – the frontal pose, the crisp delineation of features and dress, all without any retouching – provided the basis of his mature

style. Sander's letterhead of 1912, featuring a landscape photograph, also signified his continued connection with the countryside.

With the advent of war in 1914, Sander was conscripted to the territorial reserve, and Anna supported the family by taking photographs of soldiers going to the front and by printing portraits of those who had fallen. During the crippling economic depression of the Weimar Republic, Sander cultivated a new clientele among occupying troops – who paid him in food – and he again became an itinerant photographer.

In late 1927 Sander's exhibition 'People of the 20th Century' opened as part of a wider art exhibition at the Cologne Kunstverein. In an essay written for the show, he described it as 'a cultural work in photographic pictures', adding, 'Nothing seemed more appropriate to me than to render through photography a picture of our times which is absolutely true to nature.'[4] The seven sections of *People of the 20th Century*, in its later, expanded form, have been summarized as 'The Farmer', 'The Skilled Tradesman', 'The Woman', 'Classes and Professions', 'The Artist', 'The City' and 'The Last People'. According to Sander, the project moves 'from people of the soil to the highest point of culture and down to the idiot in the finest gradations'.[5] This was less a visual sociology for the machine age than a distinctive updating of the premodern hierarchies of society as seen in traditional books of trades.

Face of Our Time is a selection of sixty photographs taken from the larger project. In his introduction to the book, Döblin wrote that Sander occupied a privileged position because he had the tools at his disposal for a comparative analysis of society. Commentators usually characterize Sander's approach as being part of a fully formed aesthetic and conceptual programme, overlooking the fact that his life's work was drawn from his commercial portrait practice. He did not use established sociological categories, nor was he scientific in his method; as is often noted, certain types, such as 'The Artist', are better represented than others. Some scholars claim that objectivity was his end as well as his means, but Sander said of the project that he was seeking to 'represent the revelation of the spirit through nature'.[6]

The majority of the portraits intended for *People of the 20th Century* are ethnographic in appearance, in the sense that the sitters often look like specimens displayed for inspection. Sander achieved this directness using 'Zeiss lenses, an orthochromatic plate with corresponding light filter, and clear fine-grained glossy paper'.[7] Such paper was usually

reserved for industrial or architectural photography, and enhanced the sense of an objective detachment at work. During the early 1920s, Sander had become close to the members of the Cologne Group of Progressive Artists, and examples of his objective portraits were reproduced and discussed, by Franz Seiwert, in the group's journal, *a–z*.[8]

Among the other contemporary figures who praised *Face of Our Time* was Walter Benjamin, who admired Sander's unembellished rendering of society. The idea that the project presented its subjects as they were, rather than as they would like to be seen, was a potent one in the context of the rise of National Socialism, and the plates to, and extant copies of, the book were seized and destroyed by order of the Third Reich Chamber of Culture. Despite Sander's averring that there was no political intent to his project, the arrest in 1934 of his son Erich, an activist in the Socialist Workers' Party of Germany, has left a question mark over Sander's own position. It is unclear, in particular, whether the prohibition of *Face of Our Time* two years later was down to Sander having helped his son print party flyers or the suspicion that he himself harboured anti-fascist sympathies.

In 1944 Sander embarked on a new project: studies of parts of the body – some made by cropping his existing negatives – intended to act as signifiers of class and labour. That same year Erich died in prison of untreated appendicitis, and Sander's Cologne apartment/studio was destroyed in a bombing raid; in 1946 a fire consumed what was stored in the basement, including about 25,000 of his negatives. Despite these tragedies, Sander continued to show and be recognized for his work. An exhibition of his prints at the 2nd Photokina in 1951 led to a visit in 1952 from Edward Steichen, who selected a number of works for his landmark exhibition 'The Family of Man' (1955). In 1960 Sander was awarded the Order of the Federal Republic of Germany, First Class. By this time, however, he was alone: Anna had died three years earlier.

Sander was as much a romantic who quoted Goethe as a modernist who valued objectivity. *People of the 20th Century* allowed him to assert his strong bond with the countryside while at the same time identifying with what was, to his mind, a higher metropolitan culture. The project speaks of a desire for certainties at a time of almost unparalleled social, economic and political upheaval. Perhaps the most compelling aspect of *People* is that Sander could not complete it: an intensely subjective project, it only came to an end with his death. ■

Young Farmers, 1925-7

Self-Portrait in Studio, c. 1929

Edward *Steichen*

1879–1973

All my work is commercial.

EDWARD STEICHEN

Edward Steichen may have accrued more accolades during his lifetime – and posthumously – than any other photographer of his generation. He also curated what is reputedly the most visited exhibition of all time, 'The Family of Man', originally staged at the Museum of Modern Art (MoMA) in New York in 1955. Yet to some, such as the photographer Ansel Adams, Steichen was 'the anti-Christ of photography'.[1] A central figure within the international pictorialist movement, he became the chief photographer for Condé Nast Publications in the early 1920s and, in 1929, was quoted as saying that 'Art for art's sake is dead.'[2] As curator of photographs at MoMA, he became uniquely identified with four thematic, populist exhibitions that privileged the message over the medium. What read as compromise to his detractors can be seen, however, as evidence of his commitment to dignifying, rather than disavowing, photography's role as a medium of communication.

Born in Bivange in Luxembourg, Eduard Jean Steichen, as he was christened, was the first child of Jean-Pierre Steichen and Marie Kemp, a woman he would later view as 'the guiding and inspiring influence in my life'.[3] It was allegedly Marie who, on becoming pregnant, sent her husband in search of a new life in the United States.[4] By the time she and Eduard, then aged eighteen months, were able to follow, however, Jean-Pierre was almost destitute. The family settled in Hancock, Michigan, where Marie started her own dressmaking business and opened a millinery shop. Her husband, who had been forced to give up his job in a copper mine because of poor health, took work as a clerk in the general store. By 1888 Marie was able to send their nine-year-old son to a Catholic boarding school in a suburb of Milwaukee, Wisconsin. There, she opened another millinery shop and her husband kept house.

Steichen had been encouraged by his parents to think of himself as an artist, and at the age of fifteen he left school to begin an

apprenticeship at the American Fine Art Company, a commercial art firm. A year later his mother gave him the money to buy a Kodak 'detective' camera. He soon traded in the Kodak for a 4 × 5-in. Primo folding view camera and erected a darkroom in the cellar of the family home. While at the American Fine Art Co., Steichen convinced the company to use photographic images to create better graphics for packaging and advertising, an achievement he would later character-ize as evidence of his commitment to making 'useful' photographs.[5]

Steichen's artistic aspirations far outstripped the remit of his apprenticeship. In 1896–7 he was instrumental in setting up the Milwaukee Art Students' League, a group of artistically inclined working men who came together to paint and draw. His aesthetic preferences were shaped by the art he saw in books at the local library, such as that of Whistler and Monet; his literary preferences, including Ibsen, Shaw and Thoreau, were shaped by his sister Lilian. Inspired by *Camera Notes*, the journal of the Camera Club of New York, he sought to achieve in his photography the softness he called 'diffusion'.[6] In 1898 the American Fine Art Co. offered him a paid position on wages of $50 a week. With such earnings, he became fixated on the idea of going to Paris, 'where artists of Rodin's stature' lived and worked.[7]

In April 1900, perhaps emboldened by seeing his name mentioned in *Camera Notes*, Steichen visited the Camera Club in New York to seek out the journal's editor, Alfred Stieglitz, and the two men became artis-tic confrères. From New York, Steichen sailed to France in the hope of joining an atelier in Paris. Once he had arrived in the French capital, he used the city as a base for exploring other parts of Europe. A visit to London in September 1900 led to his inclusion in the exhibition 'The New School of American Photography', organized by Stieglitz's great rival, Fred Holland Day. In 1901 the exhibition moved to Paris, where the leading French art photographer Robert Demachy called Steichen the 'enfant terrible' of the New American School.[8]

In 1902 Steichen had his first solo exhibition in a gallery in Paris, at which he showed both paintings and photographs. By this time he was combining photographic processes (such as gum bichromate) with the tools of a painter (such as brushwork and watercolour washes) in order to work the print into something that looked nothing like a photograph. He was also experimenting with colour photography. In the August of 1902 he returned briefly to Milwaukee, then moved to

New York, where he rented a home and studio at 291 Fifth Avenue, working as a portrait photographer. In October 1903 Steichen married Clara Smith, a musician from Missouri whom he had met in Paris. At the time of their meeting, Steichen was collaborating with Stieglitz on his plans for a new photography journal, *Camera Work*, the second issue of which, dated April 1903, was dedicated to Steichen's photography. After the Steichens moved into a new apartment across the hall at 293 Fifth Avenue, no. 291 became the headquarters of the Photo-Secession, a group of art photographers led by Stieglitz.

In October 1906, two years after the birth of their first child, Mary, the Steichens returned to Paris. Edward's plan was to live as a painter and to scout for contemporary art for Stieglitz to exhibit at 291. When the Stieglitzes were visiting Paris in 1907, Steichen attended the formal launch by the Lumière brothers of the autochrome colour process, and both he and Stieglitz practised it that summer with intense enthusiasm. In 1908 the Steichens rented a house at Voulangis, to the east of Paris. Their second child, Kate Rodina, named for Rodin, was born that May. Steichen, who had felt close to his father when helping him in his garden,[9] began to breed flowers; he also travelled, both within Europe and, each year, to New York.

In September 1914, with German forces advancing, Steichen and his family abandoned the villa in Voulangis and fled to the United States. Tensions between him and Clara led, in May 1915, to a decisive split, which saw Clara and Kate briefly return to France. In 1917 Steichen, who had taken US citizenship in March 1900, enlisted in the US Army. Although the name already appeared on his naturalization certificate, it was from this moment on that he signed himself 'Edward'. According to his autobiography, the decision to enlist was brought about by Stieglitz's response to the sinking of the British ocean liner RMS *Lusitania* by a German U-boat: 'It served them right.'[10]

In August 1917 Steichen became a first lieutenant in the newly formed photographic section of the US Army Signal Corps. He was sent to France that November and, during the Second Battle of the Marne in 1918, was billeted for a week in his own home in Voulangis. Also that year he worked as the officer in charge of aerial photography. Promoted to major, Steichen remained in the services beyond the end of the conflict, coordinating aerial photography for the Allies. In 1919 the French nation made him a chevalier of the Légion d'Honneur, one

of several wartime decorations that he received. It was around this time that his name was sullied in the New York press by Clara's lawsuit against a friend whom she claimed had 'alienated her husband's affections'.[11] Clara lost the case and the couple divorced in 1922.

The transformation of Steichen's photographic style from pictorialist to modernist took place gradually from 1914. Yet he did not emerge from the war, as is often suggested, with a fully fledged dedication to what would eventually become known as 'straight' photography. In the summers of 1914 and 1915, Steichen produced sharp, focused nature studies with such literal titles as *Lotus* (1915). Late in 1919 he returned to Voulangis, where he would remain, with the exception of a few visits to New York, until 1923. Depressed, he recalled Rodin's advice and looked to nature for artistic inspiration and renewal, becoming fascinated by such geometric expressions of harmony as the golden section. In the early 1920s, inspired by Einstein's theories of relativity, he made a series of abstract compositions in a modernist idiom with such titles as *Time-Space Continuum* (1920). He also photographed the same cup and saucer over and over, producing more than a thousand negatives in his determination to achieve technical mastery of his medium.

When he returned to live in New York in 1923, Steichen was again at a low ebb. An article in *Vanity Fair* identified him as 'the greatest of living portrait photographers', but also claimed that he had given up photography for painting.[12] He wrote to the editor to explain that this was not the case, and was subsequently introduced to the magazine's owner, Condé Montrose Nast. Steichen became head photographer for Nast's publications company, doing portraits for *Vanity Fair* and fashion for *Vogue*. Steichen's first images for the latter magazine were influenced by his predecessor there, the pictorialist Adolphe de Meyer, but he soon created a distinctive, glamorous idiom that drew on the newly fashionable art deco. His portraits for *Vanity Fair* featured the leading stars of the day, such as Fred Astaire, Greta Garbo and Charlie Chaplin, and married a fascination for their celebrity with the chicness of his by-now signature style.

In 1923, while visiting France for *Vogue*, Steichen returned to Voulangis. It is thought that it was on this particular trip that he burned his paintings in a symbolic declaration of allegiance to photography.[13] According to the curator and art historian Nathalie Herschdorfer, it was also on this trip that he married Dana Desboro Glover, an

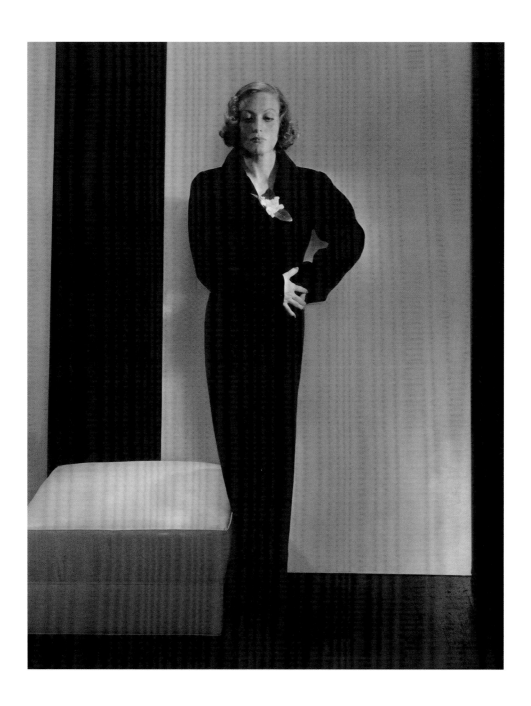

Joan Crawford in a Schiaparelli Dress, 1932

actress and amateur photographer whom he had met in New York
in 1921.[14] Between 1924 and 1931 Steichen, in addition to working for
Condé Nast, was under contract to the advertising agency J. Walter
Thompson. In 1926, by now enormously successful – with earnings
of more than $35,000 a year – but ground down by overwork, he suf-
fered a nervous breakdown.[15] Two years later he bought a farm and
97 hectares (240 acres) of land outside West Redding, Connecticut,
where he again began to cultivate flowers. The publication in 1929 of
a book on Steichen by his friend and brother-in-law Carl Sandburg,
which claimed all good art to be commercial, led to the suggestion by
critics that both men had sold out. In 1938 the man who by this time
was probably the most famous photographer in the world resigned
from Condé Nast and closed his Manhattan studio. He and Dana
travelled to Mexico, where he experimented with a 35mm Contax
camera and Kodachrome colour film. He continued to photograph,
to attend and contribute to exhibitions, and to build his and his wife's
new home at Umpawaug Farm.

In the autumn of 1941, having been rejected for service by the
US Air Force, Steichen was working on an exhibition about national
defence for MoMA. With the attack on Pearl Harbor of 7 December,
it became about war. 'Road to Victory' was shown in the summer of
1942, and proved exceptionally popular. Earlier that year, Steichen
had been made a lieutenant commander in the US Naval Reserve so
that he could supervise an aerial photography division, a job that saw
him relocate to Washington DC. In late 1943 he and his team were
sent to photograph daily life on board the USS *Lexington* in the South
Pacific; while they were there, the ship was attacked by Japanese air-
craft. In early 1945 Steichen co-curated 'Power in the Pacific', with
the advertising executive Tom Maloney, for MoMA and the US Navy.
Demobilized in October of that year, he was awarded (aged sixty-
seven) the Distinguished Service Medal for a second time.

According to Steichen, it was through Maloney's connections
at MoMA that he secured the post of curator of photographs there.
Steichen was appointed in 1946 and took up the job the following year.
That winter Ansel Adams wrote to Nancy Newhall, a former holder
of the post, to say that '[I] would rather have my prints destroyed than
allow them to fall under Steichen's control.'[16] Steichen's fifteen years
at MoMA are inextricably linked to the phenomenon that was 'The

Family of Man', the title of which was taken from a speech by Abraham Lincoln. The exhibition comprised 503 photographs selected from 10,000 images taken by 273 photographers from 68 countries, and was arranged thematically according to what humanity had in common: the life cycle from birth to death. It later visited thirty-seven countries before eventually finding, in 1995, a permanent home in Luxembourg. Steichen would later say that the genesis of the show, to date the most expensive ever organized by MoMA, was the talk his mother gave him when he was a boy about 'the evils of bigotry and intolerance'.[17]

Having given up photography after becoming a curator at MoMA, Steichen later took to photographing from the windows of his Connecticut home; he also began to film the landscape with a movie camera. In the spring of 1961 MoMA mounted a retrospective of his work. It followed on from a period of physical and emotional upheaval. In 1957 Dana had died of cancer. In his distress, his health declined, and by 1959 he had suffered two strokes. In March 1960, at the age of eighty, he married Joanna Taub, a twenty-six-year-old copywriter whom he had met the year before. According to Joanna Steichen (as she became), her husband 'was what used to be called "high strung"'; what he wanted from his intimate circle was 'quiet, doglike devotion'.[18] The marriage, so she said, was one of 'mutual disillusionment'.[19]

Although there is no evidence to suggest that Steichen was any less committed than Alfred Stieglitz to the significance of individual expression in the creative arts, he did not have the means to maintain the fiction that money did not matter. It was as if he had internalized two immigrant stories – the success of his mother and the trials of his father – using the latter to inspire him to emulate the former. Despite the diversity of his life's work, it could be said that he did not compromise his values. Steichen was unwavering in his commitment to 'the Idea' (Stieglitz's notion of a life lived for art); what changed was that he became convinced that the Idea was worth nothing if preached only to the converted. The 'theme' exhibitions for which he is often denigrated constitute only four of the more than forty exhibitions that he staged as a MoMA curator; three were born of the Second World War, and the other, that of Depression-era photography, was held at the time of the Cuban missile crisis. One might say that, in times of national crisis, he expected of photography, as he expected of himself, that it do its duty. ■

Self-Portrait, Freienwalde a.O., 1886

Alfred *Stieglitz*

1864–1946

I have all but killed myself for photography.

ALFRED STIEGLITZ

Alfred Stieglitz was one of the most influential champions of photography as an art form and one of the most influential figures in the promotion of modern art in the United States – the 'midwife to ideas', as the artist Marius de Zayas portrayed him in a caricature of 1909. In addition to being a leading art photographer, Stieglitz dedicated himself to 'the *meaning* of the *idea* photography',[1] first in the established photographic journals, and then in his own magisterial publication, *Camera Work*. Committed to the skilled artisanal craftsmanship he identified with Europe, and in revolt against the materialism of the New World, he dedicated both his journal and his galleries to the stimulation of American creativity. He became in his own lifetime one of the demigods of American culture, preaching liberty while demanding the blind faith and loyalty of the acolyte. He was famously loquacious, once subjecting two friends to a monologue that (allegedly) lasted eighteen hours.[2] A member of a clannish family, he is said to have 'shared a subliminal certainty that Stieglitz achievements, troubles, romances, virtues, illnesses, setbacks, and triumphs were of a magnitude that surpassed others'.[3] For his own part, he felt himself to be cut of an entirely different cloth from his family, and saw himself as being in revolt against the materialism and superficial culture not only of the age but also of his upbringing.

Alfred Stieglitz was born in Hoboken, New Jersey, to Edward Stieglitz and Hedwig Werner, German immigrants who had met in New York. Edward, a Jew turned atheist, prospered as a director of a wool merchant's. As the eldest, and first-born boy, of six children, Alfred was indulged, worried about and fussed over more than his other siblings.[4] He was also encouraged to identify with his parents, and became a chronic overachiever – steered by a rigid moral code – who was always trying to impress his moody and irascible father. In the summer of 1871 the family moved to Manhattan, where Alfred was

educated at the Charlier Institute, at Grammar School No. 55 and at the College of the City of New York. Beginning in 1874, the Stieglitz family spent each summer at Lake George, in the Adirondack Mountains of upstate New York, eventually purchasing a second home there in 1886. It was a place to which Alfred would return throughout his life.

In early 1881, aged forty-eight, Edward Stieglitz decided to retire and take his family to Europe. After a year at a school in Karlsruhe (also attended by his twin brothers), Alfred enrolled at the Königliche Technische Hochschule in Berlin to study for a degree in mechanical engineering; he also attended classes on other subjects at the University of Berlin. He did not enjoy his official studies, but made the most of the extra-curricular activities on offer, such as theatre, music, chess and horse racing. Evidence suggests that he was making artistic photographs at least as early as 1882.[5] In January 1883, while lodging with the sculptor and studio photographer Erdmann Encke, Stieglitz purchased a camera, a developing kit and a manual, and proceeded to teach himself the technical side of taking and making photographs. Around this time he also enrolled in the photochemistry classes of Professor Hermann Wilhelm Vogel, in which he conducted experiments that pushed the limits of the medium.

When the rest of the family returned to New York, Stieglitz and the twins stayed on in Europe. On a hiking tour through Switzerland and Italy in 1887, Stieglitz took some photographs that won him first prize in a photography competition judged by Peter Henry Emerson. In this early period his photographs were pictorial in the conventional sense of the word, in that they featured picturesque landscapes and rustic figures that seemed to belong to another age. In the spring of 1890 Stieglitz travelled to Vienna, where he studied at the state printing and photography school run by Josef Maria Eder. By the time of his return to New York, around September 1890, Stieglitz had been manoeuvred by his father and a family friend into taking a job at the newly established Heliochrome Company, a printing firm. In the following year, after encouraging two close friends also to get involved, he and his companions bought the company outright – using money provided by Stieglitz's father – and renamed it the Photochrome Engraving Company. Feeling alienated by the noise and pace of life in New York, and faced with a recalcitrant workforce, Stieglitz found himself nostalgic for Germany and its Old World values.

In early 1891 Stieglitz joined the Society of Amateur Photographers; two years later, he took on the role of unpaid co-editor of *American Amateur Photographer*. In February 1893, having borrowed a handheld camera, he produced a number of works, such as *Winter, 5th Avenue*, that encouraged him to acquire a similar camera for himself. That summer he became engaged to Emmeline Obermeyer, the sister of his friend and business partner Joseph. Stieglitz received $3,000 a year from his father, and she, independently wealthy, contributed the same. The couple were married in November 1893, and in the following spring they travelled to Europe for their honeymoon. There, Stieglitz found his new wife to be interested only in what he considered superficial: society, shopping and fashion. Their daughter, Katherine (known as 'Kitty'), was born in September 1898, and the family set up home at 1111 Madison Avenue on the Upper East Side with at least three members of staff. Stieglitz claimed in later life that he had lived in near poverty, an artistic fiction that distanced him from the aspirational values of his wife and parents.

As Stieglitz's domestic responsibilities grew, so too did his involvement with the promotion of photography. In May 1896 he was one of the founder members of the Camera Club of New York. He changed the society's journal, *Camera Notes*, from an in-house organ to an independent quarterly funded through advertising, and became its editor in July 1897. In 1898 he was involved in the selection and hanging of the 'Philadelphia Photographic Salon' at the Pennsylvania Academy of the Fine Arts, said to be the first ever exhibition of photography as an art form in an American museum.

In either 1900 or 1901, in conflict with the Camera Club for using *Camera Notes* as his pulpit, Stieglitz suffered a physical collapse and recuperated at Lake George. Such breakdowns in response to difficult situations largely of his own making would form a pattern in his life. In March 1902, at the National Arts Club in New York, Stieglitz organized the exhibition 'American Pictorial Photography Arranged by the Photo-Secession'. This was the first showing of a group that he had called into being only a few weeks earlier, and which (to quote the catalogue of a later show by the group) represented 'A Protest against the Conventional Conception of Pictorial Photography'. Stieglitz had also been working on a new journal for photography. In December 1902 the first issue of *Camera Work* (dated January 1903) appeared, a beautifully

designed and lavishly produced showcase for what Stieglitz considered to be serious works of art photography. His new friend <u>Edward Steichen</u> designed the cover, layout and typography, and in 1905 helped to establish the Little Galleries of the Photo-Secession at 291 Fifth Avenue. The Little Galleries, which eventually became known simply as 291, attracted 50,000 visitors in its first three seasons.[6]

While visiting Europe with his family in 1907, Stieglitz, together with Steichen, mastered the autochrome colour process. In 1909 Stieglitz again travelled to Europe with his family, and was admitted, via Steichen, to the Paris salon of Leo and Gertrude Stein, patrons of modernism in art and literature. Through *Camera Work* and 291, Stieglitz introduced America to a number of leading European avant-garde artists, such as Matisse, Cézanne and Picasso, several years before they became more widely known via the 'International Exhibition of Modern Art' in New York (the 'Armory Show', 1913). Stieglitz's introduction to the network of American painters living in Paris also led to his becoming a champion of the work of John Marin, Max Weber and Alfred Maurer, among others. However, the introduction of the work of fine artists into the pages of his journal alienated Stieglitz's regular subscribers. The swansong of his interest in pictorialism, of which he was a leading advocate, was the 'International Exhibition of Pictorial Photography' at the Albright Art Gallery in Buffalo, New York, staged by Stieglitz and members of his circle in 1910.

In 1915, spurred on by three friends, Stieglitz supported both the publication of *291*, the short-lived Dada journal, and the founding of the Modern Gallery, which became an affiliate of gallery 291. It was at the latter that Stieglitz briefly exhibited Marcel Duchamp's notorious *Fountain*, a porcelain urinal signed 'R. Mutt', after it had been banned from the 'American Society of Independents' show in the spring of 1917. The last issue of *Camera Work* was a double issue dedicated to the work of <u>Paul Strand</u>, an early proponent of 'straight' photography, which Stieglitz now also practised. As Stieglitz was against all forms of commercialism, everything he did operated at a loss, and most of the costs came out of his own pocket. When the final issue of *Camera Work* was published, the journal had fewer than forty subscribers.

The very last show at 291, which opened in April 1917, featured the work of Georgia O'Keeffe. Depressed and dejected by the war in Europe and by his unhappy marriage, Stieglitz was reinvigorated not

Georgia O'Keeffe, 1917

only by O'Keeffe's work but also by their epistolary contact. Their cor-
respondence, which would eventually run to more than 5,000 letters,
provides a fascinating insight into Stieglitz's magnetic appeal to both
men and women. Stieglitz gave many reasons for closing 291 and
discontinuing *Camera Work*, and while it is true that his financial
situation was precarious, that was nearly always the case. It is highly
likely, therefore, that the sense of renewal he felt as a result of his
infatuation with O'Keeffe had at least some bearing on his decision.

O'Keeffe came to New York in 1918 to continue her recuperation
from a breakdown. Emmeline Stieglitz, having come home one day
to find O'Keeffe sitting for her husband, gave him an ultimatum: stop
seeing the artist or move out of the apartment. Stieglitz chose the
latter option and joined O'Keeffe at the lodgings he had secured for
her. At first, they put up a clothes line and blanket to separate their
sleeping spaces, but by the July of 1918 the relationship had been con-
summated. The celebrated nudes that Stieglitz made of O'Keeffe, part
of his so-called composite portrait of the artist, were often taken, so
she herself recalled, after they had made love.[7] When Stieglitz's daugh-
ter arrived at the Lake George family retreat that September to find
O'Keeffe still there, despite Stieglitz's promises to the contrary, she
became estranged from her father.

Stieglitz continued to be involved with exhibitions of American
modernism, mainly at the Anderson Galleries. Partly in response to
some criticism, he determined to make a series of photographs without
naming the subjects. His show of 1923 at the Anderson Galleries
consisted of portraits, studies taken at Lake George and a group of
images titled 'Music: A Sequence of Ten Cloud Photographs' (1922),
abstractions that were intended to awaken in the viewer something of
what he felt at the time of exposure. He began to use the term 'equiva-
lents' in 1925, explaining that, 'I have a vision of life and I try to find
equivalents for it sometimes in the form of photographs.'[8] In 1923 his
daughter was diagnosed as schizophrenic while suffering from post-
partum depression. O'Keeffe, so it was said, decided to marry Stieglitz
in the hope that Kitty might feel more at peace if the two had a con-
ventional relationship. They married on 11 December 1924. Kitty did
not recover and remained institutionalized for the rest of her life.

In November 1925, in room 303 of the Anderson Galleries, Stieglitz
opened the Intimate Gallery, an exhibition space dedicated to seven

American artists, two of whom were O'Keeffe and himself, the only photographer. In the autumn of 1928 Stieglitz began an affair with Dorothy Norman, a young, married woman whom he had first met two years earlier. It was Norman, together with Paul Strand, who raised the money for a new gallery, An American Place, which opened at 509 Madison Avenue in December 1929. In 1932 the show of Stieglitz's work at the gallery, which Norman helped to run, featured the New York views he had been taking since 1930. In addition to using Norman as a model and giving her lessons in photography, Stieglitz published a book of her poems (1933). Just prior to this, O'Keeffe had suffered a breakdown, and, recognizing the role that his affair with Norman had played in her trauma, Stieglitz stopped sleeping with his mistress.[9] By the 1930s, Stieglitz, financially dependent on others all his life, was now dependent on his wife. For her part, O'Keeffe, despite being devoted to Stieglitz, was beginning to find herself more at home in New Mexico, which she had begun to visit regularly.

The retrospective of Stieglitz's work planned for 1940, due to be the first show of the newly constituted department of photography at the Museum of Modern Art in New York, fell through owing to Stieglitz taking offence at not being given due credit by the museum's director for introducing Picasso to America. After suffering a suspected attack of angina on 5 July 1946, Stieglitz, who had had a heart attack in 1938, collapsed six days later and died on 13 July. His ashes were scattered (or possibly buried) close to the shoreline of Lake George.[10]

Alfred Stieglitz, whose life straddled the nineteenth and the twentieth centuries, was a curious hybrid of both eras: a cultural prophet in the mould of John Ruskin, Ralph Waldo Emerson and Walt Whitman, and a devotee of avant-garde art. Stieglitz saw his role as a patron of the arts as being 'the struggle for the true liberation of self, and so of others'.[11] He used photography, modern art, sexual relationships and friendships with younger people as the means of achieving that liberation. Although he was a singular individual, his biography is that of a type: the child of a self-made father who values culture over riches. Stieglitz, who had two intense visual encounters – with Germany as a youth and New York as a grown man – had the divided patriotism of the immigrant. His sense of himself as an American was dependent on his bond with Europe, and he used the example of each as a stick with which to beat the other. ■

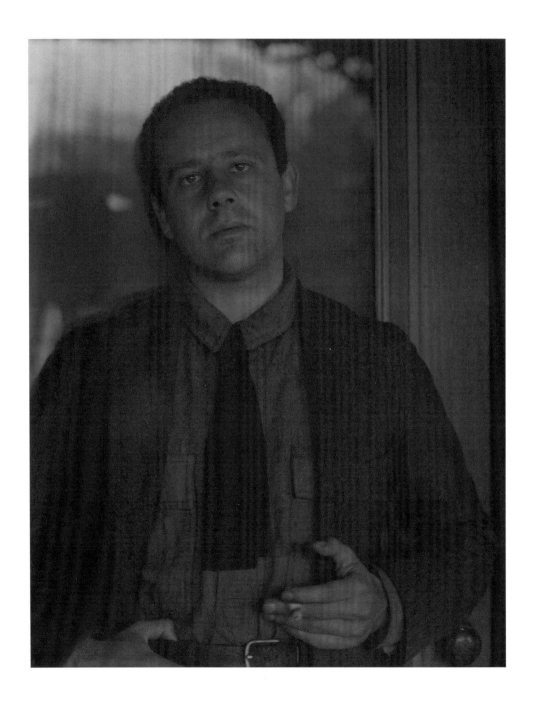

Alfred Stieglitz, *Portrait of Paul Strand*, 1919

Paul *Strand*

1890–1976

I never said I was a straight photographer.

PAUL STRAND

Paul Strand was one of the earliest proponents in the United States of so-called straight photography, a movement that rejected the notion that photography should mimic the fine arts. Although he began as a pictorialist, Strand would develop an aesthetic that embraced rather than denied photography's (apparent) objectivity. His work spoke to the desire for American avant-garde art forms, and his earliest 'straight' photographs, those taken in 1915–16, were instrumental in the grafting of modernist aesthetics on to art photography. His name is cited with those of Alfred Stieglitz and Edward Steichen as the most influential of all American photographers, and yet there is no book-length biography of Strand. The precise shading of his left-wing politics, generally agreed to be integral to his life and work, puzzles scholars to this day. It may be that the absence of a detailed biography and uncertainty about the nature of his political ideology are linked: without a fuller understanding of his life story, we cannot, perhaps, understand his politics; but perhaps we are to be denied that understanding because of his need, in the McCarthy era, to not give too much away.

Strand's parents were Mathilde Arnstein and Jacob Strand (né Stransky), a salesman for a homeware store. In 1893 the family, which was Jewish, moved into a brownstone at 314 West 83rd Street on Manhattan's Upper West Side. In 1904 Strand was enrolled in the Ethical Culture School, a progressive private school in New York. Although he was already in his teens, it seems he was deeply influenced by the school's humanistic and ethical philosophy. In 1907 he attended a class given by Lewis Hine – then a teacher of natural sciences but later a pioneer of social documentary photography – who took Strand and his classmates on a visit to Alfred Stieglitz's Little Galleries of the Photo-Secession and persuaded the school to let him build a darkroom and run a course on photography. In 1908 Strand joined the Camera

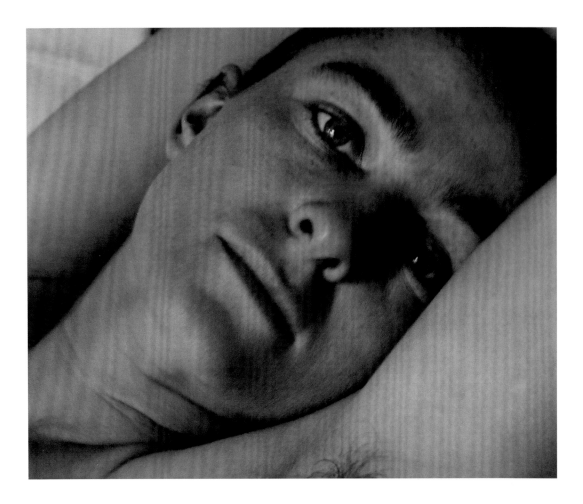

Club of New York, where he used the extensive darkroom facilities to master the complex printing techniques favoured by the pictorialists.

It seems that it was in 1911 that Strand, who had been given his first camera at the age of twelve,[1] decided to try and earn money from his hobby. In the spring of that year he cashed in his savings to travel around Europe for nearly six weeks, intending, so it is said, to take photographs and sell them to American tourists. The scheme, however, was not a success.[2] Indeed, even when he made photographs for advertising, the resulting image also served his progressive art agenda: his photograph of Hess-Bright ball bearings, for example, was also reproduced in the avant-garde magazine *Broom* in 1922. Strand's developing aesthetic saw him renounce pictorialism and embrace a celebratory, Machine Age view of photography. Although his aesthetic was, by around 1916, 'straight' (i.e. sharp as opposed to soft), Strand was still committed to making prints on platinum paper – an indication, perhaps, of his aesthetic rather than documentary ambitions.

Rebecca, New York, c. 1923

Alfred Stieglitz was a key figure in Strand's life. Not only did he become Strand's mentor, but also it was through Stieglitz that Strand met Georgia O'Keeffe. Although it is thought that the two were in love, it was Stieglitz whom she eventually took as her lover, and in January 1922 Strand married the painter Rebecca Salsbury. The friendships between Stieglitz and Strand, between the two women, and between Stieglitz and Salsbury were perhaps too intense to be sustained, and by 1924 the relationship between mentor and acolyte was said to be breaking down under the strain of personal and professional jealousies. The final break with Stieglitz came eight years later, following a period in which Strand made a series of landscapes and close-up studies of nature. In 1932 the Strands had a joint exhibition at Stieglitz's gallery An American Place. Stieglitz, it is said, gave the couple little or no support, despite their own unceasing support of his projects, and they left on a trip to New Mexico without saying goodbye.[3]

The estrangement of Strand from both his mentor and his wife – he and Salsbury separated in 1933 – cannot be discounted when examining his decision to move to Mexico, to which he had been invited by the new government. In 1934, having worked as a freelance cameraman since 1922, Strand took up an appointment as chief of photography and cinematography in Mexico's Secretariat of Education and began work on *Redes* (1934; released in the United States as *The Wave* in 1936), a feature-length story of fishermen in the bay of Santa Cruz. At the end of 1934, after the Mexican government revoked state support for film projects, Strand returned to America. Two years later he married the actress Virginia Stevens (née Balch), who, in 1940, would secure the publication of a selection of the photographs he had taken on the streets of Mexico. Once again, only Strand's idiom was straight: the photogravures were hand-pulled, and Strand had developed a lacquer that intensified the blacks.[4] This was imagery with a message, not slice-of-life realism.

Back in the United States, Strand continued his involvement with left-leaning film ventures, helping, for example, to found Frontier Films in 1936. For some observers, however, it was not film that fomented Strand's radicalism but theatre. In 1935 he joined a number of directors from the Group Theater collective on a trip to Moscow. According to one scholar, Strand was hoping to collaborate with Sergei Eisenstein, but by this time the director was considered ideologically

unsound.[5] For Strand, who 'believed simultaneously in the American, Russian and Chinese revolutions ... and never once wavered in his devotion to Stalin', culture was not an escape from politics but a battleground.[6] In 1944 he used a speech at the Museum of Modern Art in New York to denigrate the fascist threat to the arts, and in 1949, at the International Congress of Cinema in Perugia, Italy, he laid out his belief in the ability of 'dynamic realism' to change the world for the better.[7] It would seem, however, that in the McCarthy era Strand believed that reforming America had to happen outside America.

In 1949 Strand left the United States for France, moving to Paris with the photographer Hazel Kingsbury (having separated from Stevens earlier that year). From there, he embarked on a series of photobooks about particular nations and communities. Inspired by such literary sources as Sherwood Anderson's short-story cycle *Winesburg, Ohio* (1919), Strand conceptualized his project as the desire to create what he called 'The Portrait of a Village'. According to Strand, it was not until the Italian film director Cesare Zavattini introduced him to the village of his birth, Luzzara, that he found his ideal community. The title of the resulting book, *Un Paese* (1955), can mean either a village or a country, perfectly encapsulating Strand's intention of using the specifics of a particular situation to speak to the general. For him, community was not an end in itself or a lament for a simpler past, but an active solution to the ills of repression.

Hazel Strand, as she became following her marriage to Strand in 1951, was central to the photographer's modus operandi, accompanying him, for instance, to the Outer Hebrides in 1954 on the trip that would result in his best-known body of work, *Tir a'Mhurain* (1962). For their later travels together, such as to Egypt (1959), Romania (1960) and Ghana (1963-4), she would do all the research. The trip to Egypt eventually led to the publication of *Living Egypt* (1969), with text by Strand's friend James Aldridge. The Strands were inspired by Aldridge's enthusiasm for the changes taking place in Egypt under the socialist rule of Gamal Abdel Nasser. The fact that this and similar projects could take ten or more years to come to fruition signifies, like every other aspect of his mature aesthetic, that Strand's photography was more than mere reportage.

In 1955 the Strands had bought a house in Orgeval, a small village to the north-west of Paris. Around 1970 Strand's health began to fail,

and, making a virtue out of necessity, he chose to photograph in the garden, a project that resulted in the portfolio *On My Doorstep* (1976). On one level, these late works are about the dynamic tension between cultivated and wild nature, as symbolized by the photograph *Fallen Apple* (1972). As he had done in the early 1920s, Strand would again seek out the harmony between naturally occurring forms and eternal laws. At the end of his life, however, he began to give his photographs titles that insisted on their being read metaphorically.

Writing in 1922, Strand observed that, in 'the early Christian world', it was the artist alone 'who was able to indulge in the luxury of empirical thought under the camouflage of subject matter'.[8] Twenty-seven years later, his liberty at risk, the man who claimed modern photography for America had to leave the United States in order to pursue his political critique under the camouflage of subject matter and modernist aesthetics. The more we know about Strand's working methods, the more it becomes clear that it was not 'straightness' that he valued but objectivity. For him, empiricism was a political statement that he prized initially for its suggestion of individual emancipation, and later as symbolic of collective, grass-roots rationality as the counter to individual dogma. ■

Church, Ranchos de Taos, New Mexico, 1931

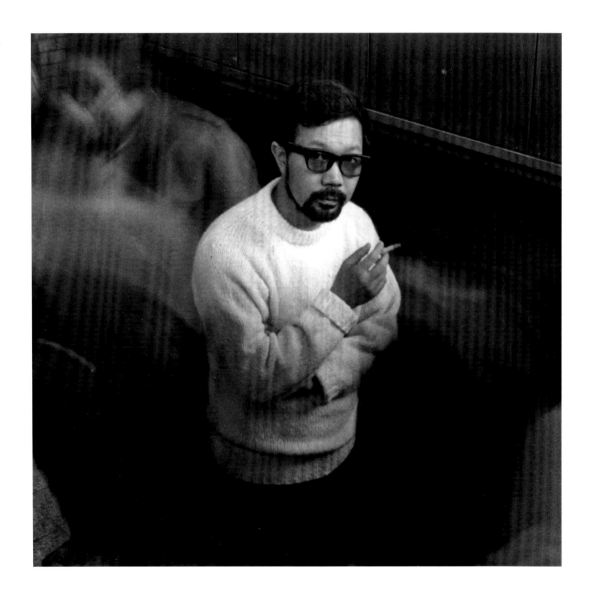

Naruaki Ohnishi, *Shōmei Tōmatsu*, 1999

Shōmei *Tōmatsu*

1930–2012

Photography comes first and language follows.

SHŌMEI TŌMATSU

The photographer who created what has been hailed as the most striking image of the dropping of the atomic bomb on Nagasaki on 9 August 1945, a wristwatch stopped for eternity at 11.02 a.m., first visited the city sixteen years after the event. Shōmei Tōmatsu, who was a teenager during the Second World War, was too young to be involved in the combat, and yet the level of destruction he experienced, passively, was cataclysmic. Hardly less traumatic were the events that he did experience first-hand: the privations of living in ruined cities, the American-led occupation with its sequestered abundance, and the transformation of Japanese society that spoke of a second capitulation, this time to the Western values that had been resisted for so long. Tōmatsu processed these national and personal traumas by means of photography. He was also intensely aware of his ambivalent relationship to the remarkable changes wrought on his country by both the occupation and its legacy – the US Army bases on Japanese soil – and dedicated more than twenty years to exploring the subject with a camera. It seems that, for Tōmatsu, experience had to be processed photographically before anything else could follow.

Born in Nagoya, a city in the Aichi Prefecture, Tōmatsu entered the Nagoya Science and Engineering School aged twelve, majoring in electronics (he would graduate in 1946). Students were mobilized during the war, and in 1944 he worked as an apprentice lathe operator, making aircraft parts at a local ironworks.[1] According to Tōmatsu, having at first gone to a shelter during the air raids, he subsequently chose to remain in his bedroom, from where he could watch the unfolding 'pageant of light' in a full-length mirror.[2] After the war he turned to petty crime, stealing vegetables from farms and bartering his mother's kimonos for food.[3] He was, it seems, alienated from his parents' generation on the basis of its militarism and the refusal, in the winter of 1945-6, to give him food, forcing him to steal in order to survive.

Tōmatsu began taking photographs in 1950 with a camera borrowed from his eldest brother. That same year he enrolled at Aichi University in the Economics Department.[4] Having joined the photography club at the university and contributed nineteen images to an exhibition there, Tōmatsu became active within the All-Japan Student Photography League.[5] It is said that Tōmatsu's early photography was transformed by a professor of Russian at the university, Mataroku Kumazawa, who critiqued the work on the basis that it was Dada-inspired and that 'there's no future in Dada'.[6] Kumazawa sought to convince Tōmatsu that signification and artistry were not exclusive to such visual idioms as surrealism, but could also be found in the everyday.

It was, it is said, Kumazawa who introduced Tōmatsu to Iwanami Photography Archives, an imprint of the Iwanami Shoten publishing company. The imprint was producing a series of small-format photo-books, each dedicated to a single aspect of life in Japan, and after graduating in 1954 Tōmatsu moved to Tokyo and worked as a photographer for the series. In 1956, having become disenchanted with what he saw as the subordination of the image to the written word, Tōmatsu went freelance, with his images appearing regularly in several Japanese photography magazines. Although broadly documentary in nature, the images in these publications were not strictly photojournalistic, privileging the picture, and its poetics, over the creation of a narrative.

The period from 1957 to 1960 was intensively creative for Tōmatsu; it was also significant in launching his career as an artist in photography. In 1957, at the first 'Eyes of Ten' exhibition, he showed his 'Barge Children's School' series, a collection of pictures that, despite its photojournalistic title, was more poetic than factual. Tōmatsu's elliptical style allowed him to address subjects without seeming to take a particular position, further distancing his work from journalism. In 1959 he had his first solo show, 'People', in Tokyo. Also that year he was one of the founders of Vivo, a photo agency modelled on the collective principles of Magnum Photos.

On 26 September 1959 Tōmatsu's home town of Nagoya was hit by a typhoon, and in the flooding that followed the house in which he had been born was swept away.[7] How this affected him is impossible to assess, but it is notable that, at this time, he was 'something of a vagrant, giving up his house [in Tokyo] and most of his belongings, sleeping at Vivo or in one of several low-end *ryokan* downtown'.[8] His

Prostitute, Nagoya, 1958

work was also changing: in the period 1960-61 he produced 'Asphalt', a series that, despite its realist mode, was composed of street subjects found not at eye level but on the surface of the road. Here, it seems, the photographer's subjectivity was being privileged over the subject.

In 1961 *Hiroshima-Nagasaki Document 1961* was published by the Japanese Council Against Atomic and Hydrogen Bombs, with photographs relating to Nagasaki by Tōmatsu. Commissioned for the project in 1960, he would continue to photograph survivors of the Nagasaki explosion, showing their deformities, after the book's publication. In 1966 Tōmatsu's own personal photoessay on the dropping of the bomb was published under the title *11.02 Nagasaki*. Among the objects that he photographed as symbolic of the devastation was the stopped watch.

Whereas *Hiroshima-Nagasaki Document 1961* was unequivocal in its anti-nuclear message, the longest project of Tōmatsu's career, that made on the fringes of the US military bases of the post-war period, is a study in ambivalence. Beginning with the series 'Base' (1959), Tōmatsu made a number of photoessays and books that addressed the 'Americanization' of Japan. Many of the images deploy a 'collage style',

Untitled (Iwakuni), from the series 'Chewing Gum and Chocolate', 1960

with a flattened picture space suggesting the cheek-by-jowl nature of the encounter between former enemies.[9] In 1972 Tōmatsu was in Naha, the capital of Okinawa Island, when it was finally returned to Japanese control. By now a husband and a father, his conflicted nostalgia for the occupation was perhaps beginning to be overlaid with another: that for pre-war Japan, a country whose loss he had not felt as his own.

Tōmatsu was influential not only as a photographer but also as a curator and teacher. He had begun lecturing in 1965 at the Tama Art University in Tokyo, and from 1966 to around 1973 was an assistant professor at Tokyo Zokei University. His contribution to education and culture in Japan would be recognized in 1995, when the Japanese government would award him the Shiju Hosho medal, but his renown was not confined to his own country. As early as 1974 his work was seen in the United States, and in 1984 a solo show that had originated in Japan embarked on a tour of Europe. Many more exhibitions in Japan, and a small but significant number overseas, followed.

Although Tōmatsu is best known for his work in monochrome, many of his projects, from 'Base' to such later series as 'The Pencil of the Sun' (1971), include works in colour. His commitment to colour photography became more intense when, having moved to Chiba Prefecture in 1987 to recover from heart surgery, he began to take Polaroids of the jetsam washed up on the local beach. He later continued this theme on film, calling the series 'Plastics'. It has been suggested that both 'The Pencil of the Sun' and 'Cherry Blossoms', a series from 1980, marked his succumbing to a nostalgia for a pre-war, seemingly unchanging Japan; as scholars have noted, however, Tōmatsu's photographs are laden with references to evanescence.

While Tōmatsu may have worked in a realist idiom, he used the present moment in such a way as to make his images resonate with the key experience of his formative years: the devastation of the Second World War and its aftermath. The teenager who felt nothing when the emperor proclaimed surrender in August 1945 internalized his disassociation from the Japan of his elders by always placing his photographs at a distance from the newsworthy or historical event.[10] In 1960 he was accused of a kind of photographic nihilism, an evasion of legible meaning that read as relativism. It seems that his critics failed to see the connection between the oblique nature of his style and the profundity of feeling and meaning that it signified. ∎

Self-Portrait, 1908

Edward *Weston*

1886–1958

I must think of Edward Weston first.

EDWARD WESTON

Edward Weston, one of the most acclaimed American photographers of the twentieth century, is known as a key proponent of the idea of photography as an autonomous, self-referential art form. Weston's biography demonstrates a fascination with, and an increasing desire for, heightened experience, and it was photography that provided him with access to what he desired and an alibi for his motivations. His brief time as a faithful and supportive husband and father came to an end with his immersion in the bohemian subculture of Los Angeles and the concomitant quest for liberation from conventional thinking and morality. His preoccupation with his selfhood, and with his life as a journey towards greater self-knowledge, informed his view of photography as a revelation of individual self and genius. Nonetheless, it might be said that the true medium of his self-expression was his journal, a document that was as much his life's work as was his photography. The man who was the most famous exponent of 'straight' photography – a reaction, in part, to the overblown aesthetic pretensions of pictorialism – chose to revise, edit, excise, bowdlerize and partially destroy his private diary. What appears in his journals as an unvarnished account of a life in photography is, in fact, as creative and crafted as a novel with Edward Weston as its hero.

Edward Henry Weston was born in Highland Park, Illinois, on the shores of Lake Michigan. He was the second child of Dr Edward Burbank Weston, a doctor in general practice, and Alice Jeannette Brett Weston; his elder and only sibling, Mary (May), had been born nine years earlier. When Weston was a baby, the family moved to Chicago. Alice Weston died when her son was four or five years old, and all he remembered of her, or so he said, was 'a pair of black and piercing eyes – burning eyes – perhaps they were burning with fever'.[1] According to the photographer and writer Nancy Newhall, Weston disliked both the woman that his father took as his second wife and

The Ascent of Attic Angles, 1921

her teenage son.[2] Edward and May, it seems, became isolated from the family unit. It was acknowledged by both siblings, and by their father, that May became Weston's surrogate mother.

Weston, by his own admission, was a poor student,[3] and he left school without a diploma.[4] In 1902, when he was about sixteen, his father gave him a Kodak Bulls-Eye camera. Weston later said that this gift motivated him to save the $11 he needed in order to buy a second-hand 5 × 7-in. camera with a ground glass and tripod.[5] Weston's rejection of the amateur camera for something that required skill and effort to use set him apart from the casual snapper. He would later distinguish his artistic from his commercial work by using an 8 × 10-in. view camera for the former and a 5 × 7-in. Graflex for the latter.[6] When Weston developed his mature style, he would contact-print his personal work and freely crop the negatives made for commissions, drawing a distinction, perhaps, between artistic integrity and commercial compromise.

Weston's journals are referred to as his 'daybooks', a name usually given to the ledgers or registers used by photographic studios to keep a record of each sitting. The two surviving daybooks primarily consist of entries from his two sojourns in Mexico, letters to Tina Modotti, and notes written in the eight years from early 1927, when he returned to California from Mexico for good. When the daybooks were published posthumously in the 1960s, Weston was an internationally celebrated photographer, but when he began writing them he was just a young man with a camera and a strong narcissistic impulse. This is not to suggest that the journals consist of the unmediated outpourings of his soul; at least as early as August 1928, when excerpts were published in *Creative Art*, they were being written with the idea of being read.[7]

All biographical information taken from the daybooks is subject to the disclaimer that they provide even less of a reliable narrative than most journals and diaries. This is because of their peculiar evolution: when they were published in the 1960s, the account of Weston's time in Mexico existed only as a transcript that had been typed and corrected from the original documents (themselves edited by Weston) by Christel Gang, his secretary and lover. The transcript was then revised according to suggestions made by Weston's friend (and, allegedly, one-time lover) Clarence B. 'Ramiel' McGehee.[8] The daybook concerning the eight years of his life post-Mexico does exist in its original form, but

this too was revised with a pencil and a razor by Weston. When Nancy Newhall edited the journal documents for publication, she removed what she called 'redundancies'.[9] The surviving journal entries are therefore at more than one remove from the original text by Weston.

Having left school, Weston took a job as an errand boy at the well-known Chicago department store Marshall Field & Company, working his way up to salesman.[10] In 1906, aged twenty, he visited May in the California town of Tropico (part of Glendale from 1918), where she was living with her husband. Deciding in California that he wanted to become a professional photographer, Weston then went back to Illinois to learn the technical side of the medium. Returning to Tropico (again without a diploma), it seems that he learned his trade by working in the studio of a local portrait photographer. On 30 January 1909 Weston married Flora Chandler, a friend of his sister. As described in the daybooks, Flora Weston is one of the great pantomime villains of the history of photography: a small-minded, bourgeois and hysterical impediment to the rightful self-liberation of her husband. The couple had four sons: (Edward) Chandler, (Theodore) Brett, (Laurence) Neil and Cole. According to Nancy Newhall, Weston's art practice developed out of his attempts to photograph his young sons in the studio he built on some land belonging to Flora's family.[11]

A leading Weston scholar, Beth Gates Warren, has suggested that his major artistic breakthrough, that of his shift from pictorialism to modernism, was greatly influenced by his relationship with Margrethe Mather. Born Emma Caroline Youngren, Mather was an anarchist and a bohemian who worked officially as a photographer and unofficially as a casual prostitute.[12] Mather and Weston met for the first time when, in 1913, she decided to pay a visit to a studio she had noticed in Tropico. By the spring of the following year they were both members of the newly founded Camera Pictorialists of Los Angeles. By then she was probably already his lover and model, and by February 1918 they were working side by side in his studio.[13] Weston's own account of his time in Tropico and his association with Mather was lost when, in early May 1923, he burned his earliest journal(s) on a bonfire.[14]

Whatever Mather's influence, Weston's conversion from pictorialism to modernism was a gradual process informed by his reading of articles on Alfred Stieglitz and Paul Strand and, in 1917, by his photographs being exhibited with their work in Philadelphia.[15] According to

Warren, Weston's photographs of Mather from 1920 show that 'he tee-tered back and forth on the brink of modernism for several months'.[16] In 1922 Weston travelled to New York, where he met such photographers and artists as Stieglitz, Charles Sheeler and Gertrude Käsebier. Despite having gone to New York with the intention of showing Stieglitz his portfolio, Weston was not 'hypnotized' by the man, and even decided that some of his own work was equal to that of the master.[17] From New York, Weston travelled to Chicago to visit family, and made composi-tions with dramatically angled shadows that merged the dynamism of modernist design with the symbolist content of his portraits.

In was in 1921 that Weston embarked on his affair with Tina Modotti, at that time a twenty-four-year-old actress. In early 1922 Modotti travelled to Mexico City to join her partner, the artist and poet Roubaix de l'Abrie Richey, but shortly after her arrival he died from the smallpox he had contracted. In March of that year Modotti put on the photography show that Richey had planned for the Palacio de Bellas Artes, including works by Weston and Mather. The success of this exhibition, which brought Weston sales from his personal rather than commercial work, was a deciding factor in his decision to move to Mexico, leaving the Tropico studio in Mather's hands. Modotti agreed to run his studio in Mexico City 'if he would teach her the craft'.[18] On 29 July 1923, after a week in which he had rekindled his affair with Mather, Weston set sail for Mexico aboard the SS *Colima*. He was accompanied by his son Chandler, then aged thirteen.

Despite creating, so he said, 'a sensation in Mexico City' with the exhibition he staged at Aztec Land in October 1923, Weston chafed at the necessity of doing commercial work at the studio at 12 Calle Lucerna.[19] Between portrait sittings, Weston and Modotti experi-mented with the genre of still life: he with toys and gourds, she with calla lilies.[20] In early 1925 Weston returned to California with Chandler, leaving Modotti in charge of the studio. Almost immediately, however, he made up his mind to return to Mexico City, and to take thirteen-year-old Brett with him.[21] Mather was evicted from their studio in Tropico around this time. Weston did not contact her; instead, he preoccupied himself with the joint exhibition he was staging with his friend Johan Hagemeyer in San Francisco, where he went on to base himself.

Weston and Brett travelled to Mexico in August 1925. On his return to the country, Weston created some of his most celebrated works,

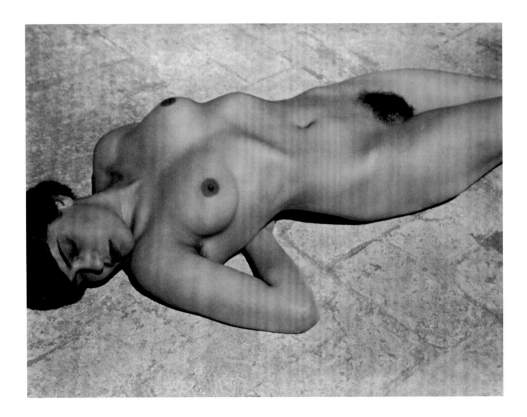

including his study of a porcelain toilet pan, *Excusado* (1925), and 'my finest set of nudes', the model for which was Anita Brenner, an anthropologist.[22] In April or June 1926 Brenner hired Weston to produce photographs for her book *Idols behind Altars* (1929), and in June that year, he, Tina and Brett, who was emerging as a photographer in his own right, set off on a trip across Mexico.

Back in Tropico in late 1926, Weston found his creativity compromised by the management of three love affairs. Artistic inspiration came once more when he met the dancer Bertha Wardell, who, in addition to acting as his model, almost inevitably became his lover. Around this time Weston became friends with the artist Henrietta Shore, and it may be her use of shells that inspired him to feature them in a new series of still lifes, although it has also been suggested that he got this idea from Mather.[23] The final stage in his conversion to modernism was his decision, by 1929, to print on glossy paper. In January of that year he and Brett moved to Carmel, California, where he began to apply to outdoor photography the close-up technique he had used for his still lifes. A few months later he grew close to Sonya Noskowiak, who, after moving in with Weston and Brett, became a sort of unofficial wife to Weston. He, in turn, taught her photography.

Mexico, Tina on the Azotea, 1923-4

In 1932 Weston's photographs were shown for a second time at San Francisco's de Young Museum, this time in an exhibition featuring the work of Group f/64, an association whose members – Willard Van Dyke, Ansel Adams and Imogen Cunningham among them – shared a commitment to straight photography. The group took its name from the smallest available aperture setting, f/64, which gives sharp and detailed renderings of the subject. Photographing in this way enabled the group to create works whose clarity enhanced the wonder and the mystery of the natural world. Although the association was short-lived, it was an important springboard for the careers of its members.

In 1934, immediately after splitting up with Noskowiak, Weston became involved with a young writer, Charis Wilson. Weston left Carmel and moved to Santa Monica, where he lived with his son Brett and, in time, Wilson. It was on the dunes at Oceano, to the north of Santa Monica, that Weston made his celebrated series of nudes showing Charis, whom he would marry in 1939, lying on the sand. In 1938, a year after Weston had become the first photographer to receive a Guggenheim Fellowship, he and Charis moved to Carmel Highlands, where Weston's son Neil built them a house. In 1941 Weston was commissioned to provide images for an edition of Walt Whitman's *Leaves of Grass* (first published 1855), a project that took him to twenty-four states. At the end of the Second World War, while Weston was working on a retrospective of his photography for the Museum of Modern Art in New York, he and Charis separated. By 1947 his photographic activities were severely limited by the effects of Parkinson's disease.

To better understand the nature of the testimony provided by Weston's daybooks, one might consider the example of the portraits of Weston made by Modotti in Mexico in 1923/24, one of which appears on the cover of an edition of the daybooks published in 1990. These works, showing Weston as a master portrait photographer, were a joke at the expense of everything he hated in photography. They are in the same vein as the photographs of Weston and Modotti taken at the pair's behest in a local portrait studio in Mexico: during the sitting, they posed as a married couple and pretended to admire the photographer's decor, props and skill as a portraitist. Weston, who was anything but literal in his person, forged a photographic style that, in its notional insistence on truth to appearances, detracts our attention from the constructed nature of everything he did and said. ∎

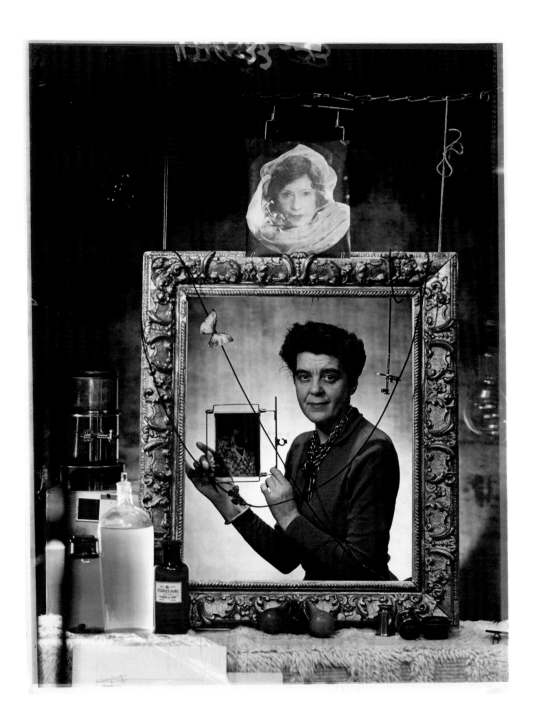

Madame Yevonde [self-portrait], 1940

Madame *Yevonde*

1893–1975

Be original or die!

MADAME YEVONDE

Yevonde Philone Cumbers, born in suburban south London in 1893, grew up in a prosperous and loving bourgeois family. A rebellious youth, she responded to the enlightened ideas she encountered at one of the several schools she attended, and later joined the women's suffrage movement. Faced with the banality of the life she was expected to lead, Yevonde decided to avoid marriage and babies by taking up a profession, and alighted on the idea of becoming a photographer by chance. She became a leading society and art photographer, and is particularly celebrated for the work she did in the 1930s using the Vivex colour process. Influenced by surrealism, particularly the work of <u>Man Ray</u>, 'Madame Yevonde' created portraits, still lifes, figure studies and advertising photographs that were unrivalled in terms of both the bravura of their colour palette and the inventiveness of their composition.

Yevonde was the daughter of Frederick Cumbers, a director of the printing-ink manufacturer Johnstone and Cumbers, and his wife, Ethel Westerton, and elder sister to Verena. In 1899 the family moved from Streatham Common, south London, to Bromley in Kent. The Cumbers sent their daughters to various schools, each of which, according to Yevonde, proved unsatisfactory. However, the alternative, being educated at home, was no better: their governesses 'were all, with a single exception, complete idiots'.[1] It was not until the age of fourteen that Yevonde finally found, after another difficult start, a school that suited her: Lingholt, a progressive boarding school in Hindhead in Surrey. Two years later, in 1909, the sisters were sent to a convent school in Verviers in Belgium. However, after yet again finding herself bored and unhappy, Yevonde instigated a move to Paris, where she and Verena studied at the Sorbonne and lodged at a supervised boarding house for female students. In 1910 Yevonde joined the women's suffrage movement, spending much of her time

in Paris encouraging French suffragettes to travel to London to attend a major demonstration.

While studying in Paris, Yevonde and her fellow students were asked to write an essay about their heroine. Choosing Mary Wollstonecraft, the political radical best known for *A Vindication of the Rights of Woman* (1792), Yevonde found herself being reprimanded in class by her (female) teacher. After class, the teacher questioned her as to why she was a suffragette, and suggested that she leave the cause to 'disappointed and disillusioned women'. When Yevonde posed the question as to why some women were 'disappointed and disillusioned', she was told: 'Because they have never had a man to love them.'[2] Back home in south London, Yevonde realized that the life of a respectable young lady of leisure, with its parties, dancing and flirtations, was not for her; she could not see the attractions of becoming a wife and mother. Instead, she devoted more of her time to the cause of women's suffrage: organizing meetings, giving talks and selling *The Suffragette* newspaper on street corners. It was, so she said, a fear of prison that prevented her from participating in further activism.

Yevonde decided to take up a profession, and, according to her auto-biography, considered being a doctor, an architect, a farmer, a writer, an actress and a hospital nurse, all of which she rejected. After seeing an advertisement in *The Suffragette* for a photographer's apprentice to Lena Connell, she went for an interview at Connell's studio in St John's Wood, north London, but turned down the role on the basis of the travelling it would require. She instead approached Lallie Charles, one of the leading portrait photographers of the day, and was accepted for a three-year apprenticeship at Charles's studio at 39a Curzon Street in London's Mayfair. She was given menial tasks at first, such as loading dark slides and numbering negatives, but progressed in time to spotting, retouching and mounting. In 1914 the studio foundered briefly, and, six months before completing her apprenticeship and with only a single photograph to her name, Yevonde decided to leave Charles's employ and open her own studio. With the financial support of her father, she took over a studio at 92 Victoria Street, London, purchasing her equipment – including a camera, a stand and a Dallmeyer 4a portrait lens – from the previous incumbent.

'Madame Yevonde', as she styled herself, began by imitating Charles's style but quickly developed one of her own, using dramatic

Joan Maude, 1932

lighting against a dark background and printing on sepia-toned plat-
inotype paper to give a more rounded, modelled effect. Like Charles,
her clientele was predominantly female. From 1914 Yevonde's por-
traits began to appear regularly in *Tatler*, *Bystander*, *The Sketch* and
other society magazines and newspapers. In 1916 she temporarily
gave up the running of her studio to work as a land girl, securing the
position of 'second cowman' on a dairy farm. Yevonde chafed at her
first salaried role: 'The farmer had bought me for the sum of fifteen
shillings a week. Short of rape or physical violence he could do with
me what he liked.'[3] With his daughter losing weight and increas-
ingly unwell, Frederick Cumbers characterized Yevonde's decision to
remain a land girl instead of returning to her studio as her 'martyr-
dom'.[4] Having fallen out with the farmer and still in poor health, she
finally gave in and returned to London.

Yevonde did in fact marry, and her youthful ideas about the nobil-
ity of self-sacrifice were subsumed into supporting the career of Edgar
Middleton, journalist, aspiring playwright and later would-be liberal
politician whose autobiography would be called *I Might Have Been a
Success* (1935). On their honeymoon in 1920, Middleton informed his
wife that he did not want to have children; this was, she later wrote, a
complete surprise to her. In another one of her heroic gestures, Yevonde
offered to give up her job and become a stay-at-home wife. Middleton
rejected the idea, and Yevonde instead found herself working full-time
and coming home to an empty flat. Middleton would return from his
office at the *Westminster Gazette* at around 10 p.m. most days of the
week, and, having done so, would work on his plays. In 1927 his first
play, *Potiphar's Wife*, opened at the Globe theatre in London, and was
a success; according to his wife, however, Middleton lost his earnings
from the play through unwise investments in the stock market. In her
autobiography, Yevonde recalled 'How happy and jolly and young and
free we were!'[5] but her account of her marriage suggests she may have
been 'disappointed and disillusioned'.

In 1921 Yevonde moved into a larger studio at 100 Victoria Street.
That same year she became the first woman to address the congress
of the Professional Photographers' Association. She was given as her
subject 'Photographic Portraiture from a Woman's Point of View', and
for her research 'visited all the women photographers in London'.[6] Her
claim that women made better portraitists then men owing to what

she saw as their greater gifts of 'personality, tact, patience and intuition' caused a minor controversy when the transcript of her lecture was published in the *British Journal of Photography*.[7] She would later give a lecture at the second annual conference of the International Federation of Business and Professional Women, held in Paris in 1936, in which she argued 'that in no phase of modern life had women's influence proved so stimulating as in photography'.[8]

From the 1920s, Yevonde produced creative figure compositions in addition to her commercial portrait work. Examples appeared in the society journals, in *Photograms of the Year* for 1921-2 and 1923-4, and at leading photographic exhibitions. She was also making her name in the new field of advertising photography with her series of adverts for Eno's Fruit Salts, which first appeared in *Bystander* in 1925. It was in the 1930s, however, that she began to produce the photographs for which she is best remembered. In the early years of that decade, Yevonde began to work with Dr D. A. Spencer's Vivex colour process, building on her earlier, black-and-white mastery of costume, staging and lighting to create intensely vibrant portraits and still lifes.

In 1932, at the Albany Gallery on Sackville Street, London, Yevonde mounted a one-woman exhibition of her work, thought to be the first photographic exhibition in England to include portraits in colour. The following year she moved to a new studio at 28 Berkeley Square in Mayfair. It was there that she exhibited in 1935 her celebrated 'Goddesses and Others' series. The costumes worn by society women to the Olympian Party, held at Claridge's on 5 March 1935 in aid of the Greater London Fund for the Blind, provided the inspiration for this series of inventive and often surrealist portraits, the props for which included a stuffed bull's head, rubber snakes and a revolver. The sitters for these modern interpretations of subjects from classical Greek and Roman mythology included Lady Alexandra Haig, the Honourable Mrs Bryan Guinness, Mrs Anthony Eden, Lady Bridget Poulett and the Duchess of Wellington.

Yevonde was committed to colour photography at a time when it was not considered a serious medium of expression, and she promoted it with the ardour and conviction that she lent all her causes. A number of the images from the 'Goddesses' series were identified in *The Times* as 'among the best direct colour photographs we have seen',[9] and in 1937 two of her series of photographs taken aboard the

ocean liner *Queen Mary* (when it was being fitted out) for *Fortune* magazine in 1936 were included in the exhibition 'Photography 1839–1937' at the Museum of Modern Art in New York. In 1940 she was elected as a Fellow of the Royal Photographic Society for her work in colour photography. That same year Yevonde published her frank and self-deprecating autobiography, *In Camera*, and produced one of her last works in colour: an allegorical self-portrait in which the photographer, distinctively dark-haired and snub-nosed, holds up the negative of one of the 'Goddesses' portraits. With the outbreak of the Second World War, the Vivex factory would close, bringing to an end Yevonde's work in colour.

Edgar Middleton died in 1939, ending a marriage of nineteen years. After his death, Yevonde moved from their flat in the Inner Temple to Dolphin Square in Pimlico, and then, during the war, to Farnham in Surrey, to escape the bombing. After the war she moved back to London, to Kensington, and in 1955 relocated her studio to 16a Trevor Street in Knightsbridge. Throughout the 1950s and 1960s, having returned to working in black and white, Yevonde continued to photograph leading artists, actors and writers, and to exhibit her work at every opportunity; she also experimented with solarization, a darkroom technique that creates highly stylized effects of contrast and shading. In 1964, at the age of seventy-one, she travelled to Ethiopia to make a photoessay on the country, and photographed its then emperor, Haile Selassie. In 1973 the Royal Photographic Society mounted a one-woman exhibition celebrating Yevonde's sixty years as a portrait photographer. When she died in 1975, she was working on a second volume of autobiography.

A romantic child fascinated with the idea of noble self-sacrifice, Yevonde claimed in her autobiography to have become a realist 'under the pressure of everyday life'.[10] Ahead of her time in terms of her political ideals and her photography, she wore her feminism and intellectualism lightly, both as a society photographer and as a wife. Nonetheless, her autobiography demonstrates that she remained opposed to all forms of hypocrisy and conventional thinking. Following Edgar's death, she wrote that she was glad her husband had not agreed to her giving up her career, concluding: 'If I had to choose between marriage and a career I would choose a career, but I would never give up being a woman.'[11] ∎

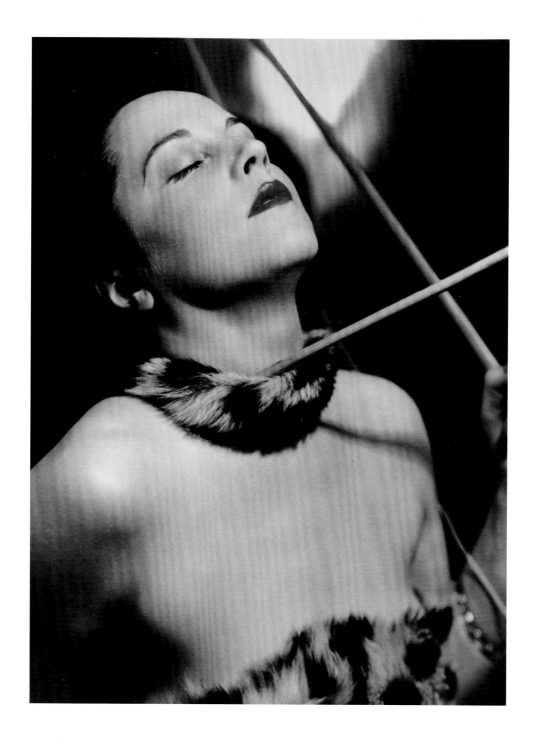

Lady Milbanke as Penthesilea, Queen of the Amazons, from the series 'Goddesses and Others', 1935

Notes

Introduction

1. Alfred Stieglitz, letter to Rebecca Strand, 22 December 1933, quoted in Belinda Rathbone, 'Portrait of a Marriage: Paul Strand's Photographs of Rebecca', in Maren Stange (ed.), *Paul Strand: Essays on His Life and Work*, New York, 1990, p. 86.
2. According to her own account, Belinda Rathbone spent five years researching and writing her biography of Walker Evans. Belinda Rathbone, *Walker Evans: A Biography*, Boston/New York, 1995, p. xv.

Adams

Epigraph: Ansel Adams, 1973, quoted in Anne Hammond, *Ansel Adams: Divine Performance*, New Haven, CT/London, 2002, p. 138.

1. Ansel Adams, *Ansel Adams: An Autobiography* [1985], with Mary Street Alinder, Boston, MA, 1986, p. 4.
2. *Ibid.*, p. 11.
3. *Ibid.*, p. 49.
4. Alfred Stieglitz, in Ansel Adams, *Ansel Adams: Letters, 1916–1984* [1988], ed. Mary Street Alinder and Andrea Gray Stillman, Boston, MA/London, 2001, p. 129.
5. Adams, *An Autobiography*, p. 9.
6. *Ibid.*, p. 23.
7. *Ibid.*, p. 50.
8. *Ibid.*, p. 54.
9. *Ibid.*
10. Adams, *Letters*, p. 26.
11. Adams, *An Autobiography*, p. 109.
12. *Ibid.*, p. 110.
13. *Ibid.*, p. 76.
14. Ansel Adams, quoted in Hammond, *Divine Performance*, p. 94.
15. Ansel Adams, quoted in John Szarkowski, *Ansel Adams at 100* (exhib. cat.), San Francisco Museum of Modern Art, 2001–2, then travelling, p. 39.
16. Adams, *An Autobiography*, p. 110. The term 'f/64' refers to what at the time was the smallest aperture achievable using a large-format view camera. It results in images that are pin-sharp from foreground to background.
17. Ansel Adams, quoted in Hammond, *Divine Performance*, p. 80.
18. Adams, *Letters*, p. 128.

19. Adams, *An Autobiography*, p. 263.
20. Szarkowski, *Ansel Adams at 100*, passim.
21. Hammond, *Divine Performance*, passim.
22. Adams, *An Autobiography*, p. 90.

Álvarez Bravo

Epigraph: Manuel Álvarez Bravo, 1971, quoted in Laura González Flores, 'Manuel Álvarez Bravo: Syllables of Light', in Laura González Flores and Gerardo Mosquera, *Manuel Álvarez Bravo* (exhib. cat.), Jeu de Paume, Paris/Fundación Mapfre, Madrid, 2012–13, p. 32.

1. Octavio Paz, quoted in Guillermo Sheridan, 'The Eyes in His Eyes: Manuel Álvarez Bravo', in Rose Shoshana (ed.), *Manuel Álvarez Bravo: Ojos en los ojos = The Eyes in His Eyes* (exhib. cat.), Rose Gallery, Santa Monica, CA, 2007, n.p.
2. See Nissan N. Perez, 'Dreams – Visions – Metaphors: Conversations with Don Manuel', in Nissan N. Perez and Ian Jeffrey, *Dreams – Visions – Metaphors: The Photographs of Manuel Álvarez Bravo* (exhib. cat.), Israel Museum, Jerusalem, 1983.
3. *Ibid.*, p. 7.
4. Manuel Álvarez Bravo, quoted in Susan Kismaric, *Manuel Álvarez Bravo* (exhib. cat.), The Museum of Modern Art, New York, 1997, p. 13.
5. *Ibid.*, p. 14.
6. Kismaric, *Manuel Álvarez Bravo*, p. 14.
7. Manuel Álvarez Bravo, quoted in *ibid.*, p. 12.
8. Manuel Álvarez Bravo, quoted in Flores, 'Manuel Álvarez Bravo', p. 19.
9. Roberto Tejada, 'Equivocal Documents', in Flores and Mosquera, *Manuel Álvarez Bravo*, p. 46.
10. Manuel Álvarez Bravo, quoted in description of *El Soñador* (1931), *The Collection Online*, www.metmuseum.org (accessed March 2014).
11. Manuel Álvarez Bravo, quoted in Kismaric, *Manuel Álvarez Bravo*, p. 37.
12. André Breton, quoted in Gerardo Mosquera, '"I accept what is to be seen"', in Flores and Mosquera, *Manuel Álvarez Bravo*, p. 36.
13. Manuel Álvarez Bravo, quoted in Kismaric, *Manuel Álvarez Bravo*, p. 36.

14. Flores, 'Manuel Álvarez Bravo', p. 31.
15. Amanda Hopkinson, *Manuel Álvarez Bravo*, London, 2002, p. 3.
16. Mosquera, '"I accept what is to be seen"', p. 34.
17. Kismaric, *Manuel Álvarez Bravo*, p. 12.
18. Perez, 'Dreams – Visions – Metaphors', p. 7.

Arbus

Epigraph: Diane Arbus, quoted in *Diane Arbus*, edited and designed by Doon Arbus and Marvin Israel, New York, 1972, p. 15.

1. Diane Arbus, quoted in Elisabeth Sussman and Doon Arbus, 'A Chronology', in Sandra S. Phillips *et al.*, *Diane Arbus: Revelations*, New York, 2003, p. 144.
2. Patricia Bosworth, *Diane Arbus: A Biography*, London, 1985, p. 9.
3. Sussman and Arbus, 'A Chronology', p. 123.
4. Diane Arbus, 'Autobiography', senior-school assignment, 1940, reproduced in Sussman and Arbus, 'A Chronology', p. 127.
5. Diane Arbus, quoted in Sussman and Arbus, 'A Chronology', p. 124.
6. *Ibid.*, p. 127.
7. *Ibid.*, p. 124.
8. Sussman and Arbus, 'A Chronology', p. 123.
9. Diane Arbus, quoted in *ibid.*, p. 125.
10. Sussman and Arbus, 'A Chronology', p. 127.
11. *Ibid.*, p. 129.
12. Diane Arbus, quoted in *ibid.*, p. 130.
13. *Ibid.*
14. Allan Arbus, quoted in Sussman and Arbus, 'A Chronology', p. 131.
15. Diane Arbus, quoted in *Diane Arbus*, pp. 8–9.
16. *Ibid.*, p. 3.
17. Susan Sontag, 'America, Seen through Photographs, Darkly', in *On Photography* [1977], London, 2008.
18. Philip Charrier, 'On Diane Arbus: Establishing a Revisionist Framework of Analysis', *History of Photography*, vol. 36, no. 4, November 2012, p. 434.
19. Diane Arbus, quoted in Sussman and Arbus, 'A Chronology', p. 176.
20. Diane Arbus, quoted in Phillips *et al.*, *Revelations*, p. 70.

Atget

Epigraph: Eugène Atget, 1926, as quoted by Man Ray in Paul Hill and Thomas Cooper, 'Interview: Man Ray', *Camera*, 2, February 1975, reprinted in Paul Hill and Thomas Cooper, *Dialogue with Photography* [1979], Stockport, 2005, p. 23.

1. Pierre Borhan, 'Atget, the Posthumous Pioneer', in Jean-Claude Lemagny *et al.*, *Atget: The Pioneer* (exhib. cat.), Hôtel de Sully, Paris/ International Center of Photography, New York, 2000-1, p. 7.
2. Sylvie Aubenas and Guillaume Le Gall, *Atget: une rétrospective* (exhib. cat.), Bibliothèque Nationale de France, Paris/Martin-Gropius-Bau, Berlin, 2007-8, p. 37.
3. Lemagny *et al.*, *Atget*, p. 185.
4. Berenice Abbott, *The World of Atget* [1964], New York, 1974, p. xi.
5. See note on epigraph, above.
6. Man Ray, quoted in Hill and Cooper, 'Interview', p. 23.
7. Pierre Mac Orlan, 'Preface', in Eugène Atget, *Atget: photographe de Paris* [1930], New York, 2008, n.p.
8. Emmanuel Sougez, quoted in Borhan, 'Posthumous Pioneer', p. 7.
9. Walter Benjamin, 'The Work of Art in the Age of Mechanical Reproduction', 1936, section VI, available online at www.marxists.org/reference/subject/philosophy/works/ge/benjamin.htm (accessed November 2014).
10. Andreas Krase, 'Archive of Visions – Inventory of Things: Eugène Atget's Paris', in Hans Christian Adam (ed.), *Eugène Atget, Paris 1857-1927*, Cologne/London, 2000, p. 87.
11. Abbott, *The World of Atget*, p. xi.
12. *Ibid.*, p. xx.
13. Eugène Atget, quoted in Lemagny *et al.*, *Atget*, p. 186.
14. Abigail Solomon-Godeau, 'Canon Fodder: Authoring Eugène Atget', in *Photography at the Dock: Essays on Photographic History, Institutions, and Practices*, Minneapolis, 1991, p. 29.
15. Abbott, *The World of Atget*, p. ix.
16. *Ibid.*, p. viii.

Avedon

Epigraph: Richard Avedon, *An Autobiography*, London, 1993, n.p.

1. Adam Gopnik, 'The Light Writer', in Mary Shanahan (ed.), *Evidence, 1944–1994: Richard Avedon* (exhib. cat.), Whitney Museum of American Art, New York, March–June 1994, p. 107.

2. Richard Avedon, quoted in Gopnik, 'The Light Writer', p. 107.
3. *Ibid.*
4. Gopnik, 'The Light Writer', p. 108.
5. David Ansen, 'Avedon', *Newsweek*, 13 September 1993, available online at www.newsweek.com/avedon-192914 (accessed September 2014).
6. Gopnik, 'The Light Writer', p. 111.
7. Richard Avedon, quoted in *ibid.*, p. 112.
8. Shanahan, *Evidence*, p. 104.
9. Carol Squiers, '"Let's Call it Fashion": Richard Avedon at *Harper's Bazaar*', in Carol Squiers and Vince Aletti, *Avedon Fashion, 1944-2000: The Definitive Collection* (exhib. cat.), International Center of Photography, New York, May–September 2009, p. 157.
10. *Ibid.*
11. Richard Avedon, quoted in *ibid.*, p. 158.
12. Quoted in *ibid.*, p. 159.
13. Squiers, '"Let's Call it Fashion"', p. 172.
14. Richard Avedon, quoted in Ansen, 'Avedon'.
15. Squiers, '"Let's Call it Fashion"', p. 170.
16. Richard Avedon, quoted in Ansen, 'Avedon'.
17. Richard Avedon, quoted in Squiers, '"Let's Call it Fashion"', p. 181.
18. Vince Aletti, 'In *Vogue* and After', in Squiers and Aletti, *Avedon Fashion*, p. 265.
19. *Ibid.*, p. 272.

Bourke-White

Epigraph: Margaret Bourke-White, diary, 6 December 1927, quoted in Vicki Goldberg, *Margaret Bourke-White: A Biography*, London, 1987, p. 77.

1. Margaret Bourke-White, *Portrait of Myself*, London, 1964.
2. See note on epigraph, above.
3. Joseph White, quoted in Goldberg, *Margaret Bourke-White*, p. 1.
4. Quoted in *ibid.*, pp. 9, 23.
5. Margaret Bourke-White, quoted in *ibid.*, p. 24.
6. *Ibid.*, p. 32.
7. Bourke-White, *Portrait of Myself*, p. 28.
8. Goldberg, *Margaret Bourke-White*, p. 127; emphasis added.
9. Editorial note, *Life*, 23 November 1936, quoted in *ibid.*, p. 177
10. Quoted in Goldberg, *Margaret Bourke-White*, p. 194.

Brandt

Epigraph: Bill Brandt, 'A Statement' [1970], in Nigel Warburton (ed.),

Bill Brandt: Selected Texts and Bibliography, Oxford, 1993, p. 32.

1. Paul Delany, *Bill Brandt: A Life*, London, 2004, p. 24.
2. *Ibid.*, p. 29.
3. Brandt, 'A Statement', p. 29.
4. Bill Jay and Nigel Warburton, *Brandt: The Photography of Bill Brandt* (exhib. cat.), Barbican Art Gallery, London, 1999, then travelling, p. 80.
5. Bill Brandt, quoted in Warburton, *Bill Brandt*, p. 6.
6. Bill Brandt, 'Pictures by Night' [1952], in Warburton, *Bill Brandt*, p. 41.
7. Brandt, 'A Statement', p. 31.
8. *Ibid.*, p. 32.
9. Chapman Mortimer, 'Introduction', in Bill Brandt, *Perspective of Nudes*, London, 1961, p. 11.
10. Bill Brandt, *Camera in London*, London, 1948, p. 11.
11. Brandt, 'A Statement', p. 30.
12. Bill Brandt, letter to Norman Hall's widow, 30 May 1978, private collection.
13. Delany, *Bill Brandt*, p. 216.
14. Bill Brandt, quoted in *ibid.*, p. 272.
15. Brandt, *Camera in London*, p. 10.
16. Bill Brandt, quoted in Jay and Warburton, *Brandt*, p. 91.

Brassaï

Epigraph: Brassaï, *Brassaï*, Paris, 1952, n.p.

1. Brassaï, 'Preface' [1978], in *Brassaï: Letters to My Parents*, trans. Peter Laki and Barna Kantor, Chicago/London, 1997, p. xx.
2. Brassaï, *Letters to My Parents*, p. 250 n. 11.
3. *Ibid.*, p. 33.
4. *Ibid.*, p. 11.
5. Brassaï, *Brassaï*, n.p.
6. George D. Painter, quoted in Anne Wilkes Tucker, 'Education of a Young Artist', in Brassaï, *Letters to My Parents*, p. 247.
7. Brassaï, *Letters to My Parents*, p. 133.
8. Brassaï, 'Preface', p. xvii.
9. Brassaï, quoted in Andor Horváth, 'Hallway to Parnassus' [1980], in Brassaï, *Letters to My Parents*, p. 231.
10. Brassaï, *Brassaï*, n.p.
11. Brassaï, 'Preface', p. xiv.
12. Brassaï, quoted in Alain Sayag and Annick Lionel-Marie (eds), *Brassaï: 'No Ordinary Eyes'* (exhib. cat.), Hayward Gallery, London, 2001, p. 171.
13. Brassaï, *Letters to My Parents*, p. 223.
14. *Ibid.*, p. 221.
15. Diane Elisabeth Poirier, trans.

Jennifer Kaku, *Brassaï: An Illustrated Biography*, Paris/London, 2005, p. 154.
16. Sayag and Lionel-Marie, *Brassaï*, p. 285.

Cahun
Epigraph: Claude Cahun, *Disavowals; or, Cancelled Confessions*, trans. Susan De Muth, London, 2007, p. 183 (originally published 1930 as *Aveux non avenus*).
1. André Breton, quoted in Gavin James Bower, *Claude Cahun: The Soldier with No Name*, Winchester, 2013, p. 22.
2. Bower, *The Soldier with No Name*, p. 5.
3. *Ibid.*, p. 8.
4. Cahun, *Disavowals*, p. 6.
5. Cahun, quoted in Kristine von Oehsen, 'The Lives of Claude Cahun and Marcel Moore', in Louise Downie (ed.), *Don't Kiss Me: The Art of Claude Cahun and Marcel Moore*, London/Jersey, 2006, p. 15.
6. Bower, *The Soldier with No Name*, p. 25.
7. *Ibid.*, p. 28.
8. Juan Vicente Aliaga and François Leperlier, *Claude Cahun* (exhib. cat.), Jeu de Paume, Paris, May–September 2011, then travelling, p. 70.

Cameron
Epigraph: Julia Margaret Cameron, letter to John Herschel, 31 December 1864, National Media Museum, Bradford.
1. Agnes Grace Weld, *Glimpses of Tennyson and of some of His Relations and Friends*, London, 1903, p. 65.
2. Alice Taylor, quoted in Henry Taylor, *Autobiography*, 2 vols, London, 1877, vol. 2, p. 39.
3. Wilfred Ward, 'Tennyson at Freshwater', *The Dublin Review*, 150, January 1912, p. 68.
4. Julia Margaret Cameron, letter to John Herschel, undated, The Royal Society, London.
5. Julia Margaret Cameron, 'Annals of My Glass House', manuscript memoir, 1874, National Media Museum, Bradford, Yorkshire.
6. Julia Margaret Cameron, letter to Maria Jackson, 5 February 1878, New York Public Library, New York.
7. Weld, *Glimpses of Tennyson*, p. 65.
8. Laura Troubridge, *Memories and Reflections*, London, 1925, pp. 34–5.
9. Alice Taylor, quoted in Taylor, *Autobiography*, vol. 2, p. 153.
10. Julia Margaret Cameron, quoted in

A. T. Ritchie, *Alfred, Lord Tennyson and His Friends*, London, 1893, p. 14.
11. George Frederic Watts, letter to Henry Taylor, 15 September 1859, National Portrait Gallery, London.
12. A. T. Ritchie, *Thackeray's Daughter: Some Recollections of Anne Thackeray Ritchie*, compiled by Hester Thackeray Fuller and Violet Hammersley, Dublin, 1951, p. 116.
13. See Julia Margaret Cameron, *Victorian Portraits of Famous Men & Fair Women*, with introductions by Virginia Woolf and Roger Fry, London, 1926.

Capa
Epigraph: Robert Capa, quoted in Alex Kershaw, *Blood and Champagne: The Life and Times of Robert Capa*, London, 2002, p. 5.
1. Richard Whelan, *Robert Capa: A Biography*, London/Boston, 1985, p. 4.
2. *Ibid.*, pp. 8–9.
3. *Ibid.*, p. 19.
4. *Ibid.*, p. 21.
5. Kershaw, *Blood and Champagne*, p. 13.
6. Whelan, *Robert Capa*, p. 47.
7. *Ibid.*, p. 49.
8. Kershaw, *Blood and Champagne*, p. 13.
9. 'Bob Capa Tells of Photographic Experiences Abroad', interview on weekday-mornings radio show *Hi Jinx*, WEAF, 20 October 1947, available online at www.icp.org/robert-capa-100 (accessed August 2014).
10. Bernard Lebrun and Michel Lefebvre, with Bernard Matussière, *Robert Capa: The Paris Years, 1933–54*, trans. Nicholas Elliot, New York, 2012, p. 108.
11. *Ibid.*, p. 6.
12. A. D. Coleman, 'Robert Capa on D-Day', *Photocritic International* (blog), June–December 2014, www.nearbycafe.com/artandphoto/photocritic/major-stories/robert-capa-on-d-day (accessed January 2015).
13. Whelan, *Robert Capa*, pp. 270–1.
14. Kershaw, *Blood and Champagne*, p. 6.
15. Quoted in *ibid.*, p. 74.

Cartier-Bresson
Epigraph: 'La photographie et une intelligence.' Henri Cartier-Bresson, quoted in Yves Bourde, 'L'Univers noir et blanc d'Henri Cartier-Bresson', *Photo*, no. 15, December 1968, p. 95.
1. See Claude Cookman, 'Henri Cartier-

Bresson, Master of Photographic Reportage', in Philippe Arbaïzar *et al.*, *Henri Cartier-Bresson: The Man, the Image and the World – A Retrospective*, London, 2003.
2. Henri Cartier-Bresson, in *Henri Cartier-Bresson: The Impassioned Eye*, dir. Heinz Bütler, Fondation Henri Cartier-Bresson *et al.*, 2003.
3. Jean Leymarie, 'A Passion for Drawing', in Arbaïzar *et al.*, *Henri Cartier-Bresson*, p. 325.
4. Pierre Assouline, *Henri Cartier-Bresson: A Biography*, London, 2012, p. 21.
5. Henri Cartier-Bresson, *Images à la sauvette*, Paris, 1952, n.p.; translated from the French by the author.
6. Clément Chéroux, *Henri Cartier-Bresson: Here and Now* (exhib. cat.), Centre Pompidou, Paris, February–June 2014, p. 19.
7. Henri Cartier-Bresson, quoted in Agnès Sire, 'Scrapbook Stories', in Martine Franck *et al.*, *Henri Cartier-Bresson: Scrapbook – Photographs 1932–1946* (exhib. cat.), Fondation Henri Cartier-Bresson, Paris/International Center of Photography, New York, 2006–7, p. 27.
8. Chéroux, *Henri Cartier-Bresson*, p. 22.
9. *Ibid.*, p. 23.
10. André Pieyre de Mandiargues, quoted in Peter Galassi, *Henri Cartier-Bresson: The Modern Century* (exhib. cat.), The Museum of Modern Art, New York, April–June 2010, then travelling, p. 25.
11. Henri Cartier-Bresson, quoted in Cookman, 'Henri Cartier-Bresson', pp. 393–4.
12. Truman Capote, quoted in Sire, 'Scrapbook Stories', p. 21.
13. Henri Cartier-Bresson, *The Decisive Moment*, New York, 1952, n.p.
14. Chéroux, *Henri Cartier-Bresson*, p. 219.

DeCarava
Epigraph: Roy DeCarava, quoted in Elton C. Fax, *Seventeen Black Artists*, New York, 1971, p. 187.
1. *Ibid.*, p. 168.
2. Roy DeCarava, quoted in Peter Galassi and Sherry Turner DeCarava, *Roy DeCarava: A Retrospective* (exhib. cat.), The Museum of Modern Art, New York, January–May 1996, then travelling, p. 12.
3. Roy DeCarava, interview with Terry Gross, *Fresh Air*, National Public Radio, Washington DC, 8 May 1996.

4. Roy DeCarava, quoted in Fax, *Seventeen Black Artists*, p. 176.
5. Galassi and Turner DeCarava, *Roy DeCarava*, p. 18.
6. Roy DeCarava, quoted in *ibid.*, p. 19.
7. Roy DeCarava, quoted in Ivor Miller, '"If It Hasn't Been One of Color": An Interview with Roy DeCarava', *Callaloo*, vol. 13, no. 4, Autumn 1990, p. 847.
8. Benjamin Cawthra, *Blue Notes in Black and White: Photography and Jazz*, Chicago/London, 2011, p. 221.
9. Roy DeCarava, quoted in Fax, *Seventeen Black Artists*, p. 184.
10. Cawthra, *Blue Notes in Black and White*, p. 242.
11. Roy DeCarava, quoted in Fax, *Seventeen Black Artists*, p. 186.
12. Roy DeCarava, in *Conversations with Roy DeCarava*, dir. Carroll Parrott Blue, WNET-TV/PBS, 1983.

Dodgson
Epigraph: Charles Lutwidge Dodgson, diary, 7 March 1872. For all subsequent references to Dodgson's diary, see Edward Wakeling (ed.), *Lewis Carroll's Diaries: The Private Journals of Charles Lutwidge Dodgson (Lewis Carroll)*, 10 vols, Luton, 1993-2007.
1. Roger Taylor and Edward Wakeling, *Lewis Carroll, Photographer: The Princeton University Library Albums*, Princeton, NJ/Oxford, 2002, p. 240.
2. Dodgson, diary, 27 August 1855.
3. Taylor and Wakeling, *Lewis Carroll*, p. 13.
4. Dodgson, diary, 16 January 1856.
5. Charles Lutwidge Dodgson, letter to Alice Hargreaves (née Liddell), 1 March 1885, quoted in Morton N. Cohen, *Lewis Carroll: A Biography*, London, 1995, p. 101.
6. Dodgson, diary, 27 June 1863.
7. *Ibid.*, 4 August 1855.
8. See Catherine Robson, *Men in Wonderland: The Lost Girlhood of the Victorian Gentleman*, Princeton, NJ/Oxford, 2001.
9. Dodgson, diary, 29 May 1880.
10. Charles Lutwidge Dodgson, letter to Mrs Hunt, 8 December 1881, quoted in Wakeling, *Diaries*, vol. 7, 2003, p. 280 n. 511.
11. Charles Lutwidge Dodgson, letter to Mrs Henderson, 1881, quoted in Cohen, *Lewis Carroll*, p. 168.

Doisneau
Epigraph: Robert Doisneau, *Doisneau:*

Portraits of the Artists, Paris/London, 2008, p. 9.
1. Robert Doisneau, quoted in Peter Hamilton, *Robert Doisneau: A Photographer's Life*, New York/London, 1995, p. 180.
2. Robert Doisneau, quoted in Agnès Sire and Jean-François Chevrier, *Robert Doisneau: From Craft to Art*, Göttingen, p. 24.
3. *Ibid.*, p. 21.
4. Hamilton, *Robert Doisneau*, p. 26.
5. Robert Doisneau, quoted in *ibid.*
6. Quoted in Sire and Chevrier, *Robert Doisneau*, p. 18.
7. Hamilton, *Robert Doisneau*, p. 50.
8. *Ibid.*, p. 46.
9. *Ibid.*, p. 62.
10. *Ibid.*, p. 70.
11. *Ibid.*, p. 92.
12. Edmonde Charles-Roux, quoted in *ibid.*, p. 226.
13. Robert Doisneau, quoted in Kate Bush and Mark Sladen (eds), *In the Face of History: European Photographers in the Twentieth Century* (exhib. cat.), Barbican Art Gallery, London, 2006-7, p. 229.
14. *Ibid.*
15. Hamilton, *Robert Doisneau*, p. 338.
16. Robert Doisneau, quoted in *ibid.*, p. 234.

Emerson
Epigraph: P. H. Emerson, 'Photography: A Pictorial Art', *Amateur Photographer*, vol. 3, no. 76, 19 March 1886, p. 139.
1. Stephen Hyde, 'Introduction', in John Taylor, *The Old Order and the New: P.H. Emerson and Photography, 1885-1895* (exhib. cat.), National Museum of Photography, Film and Television, Bradford/J. Paul Getty Museum, Los Angeles, 2006-7, p. 12.
2. P. H. Emerson, *Caóba, the Guerilla Chief: A Real Romance of the Cuban Rebellion*, London, 1897, p. 217.
3. P. H. Emerson, *The English Emersons: A Genealogical Historical Sketch of the Family from the Earliest Times to the End of the Seventeenth Century*, London, 1898, p. 114.
4. *Ibid.*, p. 127.
5. Emerson, 'A Pictorial Art', p. 188.
6. *Ibid.*, p. 187.
7. P. H. Emerson, *Naturalistic Photography for Students of the Art*, London, 1889, p. 9.
8. P. H. Emerson, *Naturalistic Photography for Students of the Art*, 2nd edn, London, 1890, p. 24; emphasis in original.

9. Emerson, *The English Emersons*, p. 120.
10. Bayley's actual words were that the book '*had been compared to* a bombshell dropped *into the midst of* a tea party'. R. Child Bayley, 'Pictorial Photography', *Camera Work*, vol. 18, April 1907, p. 24; emphasis added. As this comparison has never been attributed to an original source, one wonders if it was Emerson's.
11. P. H. Emerson, *The Death of Naturalistic Photography*, 1890, reprinted as 'A Renunciation', *British Journal of Photography*, vol. 38, no. 1,603, 23 January 1891, p. 55.
12. P. H. Emerson, *Further Notes on the Emerson alias Emberson Family of Counties Herts and Essex*, London, 1919, p. 15.
13. P. H. Emerson, *Penultimate Notes on the Emerson alias Emberson Family of Counties Herts and Essex*, Eastbourne, 1925, p. 17.
14. 'Peter Henry Emerson', *Luminous Lint*, www.luminous-lint.com/app/photographer/Peter_Henry_Emerson/A/ (accessed February 2014).
15. P. H. Emerson, *The Emersons alias Embersons of Ipswich, Massachusetts Bay Colony (1638), and of Bishop's Stortford, co. Herts., England (1578)*, Southbourne, Hants, 1912, p. 47.

Evans
Epigraph: Walker Evans, quoted in James R. Mellow, *Walker Evans*, New York, 1999, p. 75.
1. John Szarkowski, 'Introduction', in *Walker Evans*, New York, 1971, p. 20.
2. Walker Evans, quoted in Belinda Rathbone, *Walker Evans: A Biography*, Boston, MA, 2000, p. 20.
3. *Ibid.*, p. 29.
4. Walker Evans, quoted in Mellow, *Walker Evans*, p. 54.
5. Rathbone, *Walker Evans*, p. 35.
6. Alfred Stieglitz, quoted in Mellow, *Walker Evans*, p. 88.
7. *Walker Evans at Work: 745 Photographs Together with Documents Selected from Letters, Memoranda, Interviews, Notes*, New York, 1982, p. 70.
8. Walker Evans, quoted in Mellow, *Walker Evans*, p. 374.
9. Walker Evans, quoted in Jordan Bear, 'Walker Evans: In the Realm of the Commonplace', in Jeff L. Rosenheim *et al.*, *Walker Evans* (exhib. cat.), Fundación Mapfre, Madrid, p. 28.

10. Walker Evans, quoted in *Walker Evans at Work*, p. 125.
11. James Agee, 'Preface', in James Agee and Walker Evans, *Let Us Now Praise Famous Men* [1941], London, 2001, p. 10.
12. Rathbone, *Walker Evans*, p. 169.
13. *Ibid.*, p. 72.
14. Via Saunders, quoted in Mellow, *Walker Evans*, p. 360.
15. Clement Greenburg, quoted in *ibid.*, p. 495.
16. Walker Evans, quoted in Rathbone, *Walker Evans*, p. 279.

Fenton
Epigraph: Roger Fenton, 1852, quoted in Larry J. Schaaf, *Roger Fenton – A Family Collection: Sun Pictures, Catalogue Fourteen* (exhib. cat.), Hans P. Kraus Jr, New York, 2005, p. 24.
1. Roger Fenton, 'Photography in France', *Chemist*, vol. 3, no. 29, February 1852, p. 222.
2. Robert Hunt, letter to William Henry Fox Talbot, 19 March 1852, available online at http://foxtalbot.dmu.ac.uk/letters/letters.html (accessed July 2014).
3. Schaaf, *Roger Fenton*, p. 38.
4. Roger Fenton, letter to Grace Fenton, 13 May 1855, available online at http://rogerfenton.dmu.ac.uk/index.php (accessed January 2014).
5. *Ibid.*

Hawarden
Epigraph: Oscar Rejlander, 'In Memoriam', *British Journal of Photography*, 27 January 1865, p. 58.
1. David Erskine, letter to Mountstuart Elphinstone, 7 September 1842, quoted in Virginia Dodier, *Clementina, Lady Hawarden: Studies from Life, 1857–1864* (exhib. cat.), Victoria and Albert Museum, London, 1999, p. 18.
2. Mountstuart Elphinstone, letter to Anne Bontine, 5 August 1854, quoted in Dodier, *Clementina, Lady Hawarden*, p. 19.
3. Mountstuart Elphinstone, letter to Catalina Paulina Elphinstone Fleeming, 18 July 1847, quoted in Dodier, *Clementina, Lady Hawarden*, p. 19.
4. Anne Bontine, letter to Mountstuart Elphinstone, 20 May 1856, quoted in Dodier, *Clementina, Lady Hawarden*, p. 19.
5. Anonymous, 'Exhibition', *British Journal of Photography*, 15 January 1863, p. 31.

Höch
Epigraph: Hannah Höch, foreword to the catalogue of her solo exhibition at the Kunstzaal De Bron, The Hague, 1929, reprinted in Dawn Ades *et al.* (eds), *Hannah Höch* (exhib. cat.), Whitechapel Gallery, London, January–March 2014, p. 140.
1. Daniel F. Herrmann, 'The Rebellious Collages of Hannah Höch', in Ades *et al.*, *Hannah Höch*, p. 9.
2. Hannah Höch, 'A Glance over My Life' [1958], in Ades *et al.*, *Hannah Höch*, p. 234.
3. *Ibid.*
4. *Ibid.*
5. Hannah Höch, 'On Embroidery' [1918], in Ades *et al.*, *Hannah Höch*, p. 72.
6. Hannah Höch, interview with Édouard Roditi, 1959, in Ades *et al.*, *Hannah Höch*, p. 184.
7. *Ibid.*, p. 187.
8. *Ibid.*, p. 183.
9. Hannah Höch, quoted in Dawn Ades, 'Hannah Höch and the "New Woman"', in Ades *et al.*, *Hannah Höch*, p. 29.
10. Hannah Höch, 'A Few Words on Photomontage' [1934], in Ades *et al.*, *Hannah Höch*, p. 142.
11. Ades, 'Hannah Höch and the "New Woman"', p. 23.
12. Adolphe Behne, 'Dada' [1920], in Ades *et al.*, *Hannah Höch*, p. 73.
13. Höch, interview with Roditi, p. 188.
14. Ades, 'Hannah Höch and the "New Woman"', p. 29.
15. Hannah Höch, quoted in *ibid.*
16. Hannah Höch, 'Fantastic Art' [1946], in Ades *et al.*, *Hannah Höch*, p. 233.
17. *Ibid.*

Kertész
Epigraph: André Kertész, quoted in Michel Frizot and Annie-Laure Wanaverbecq, *André Kertész* (exhib. cat.), Jeu de Paume, Paris, 2010–11, then travelling, p. 13.
1. Robert Gurbo, in Robert Gurbo and Bruce Silverstein (eds), *André Kertész: The Early Years* (exhib. cat.), Bruce Silverstein Gallery, New York, October–November 2005, pp. 8–9.
2. André Kertész, quoted in Anne Hoy (ed.), *Kertész on Kertész: A Self-Portrait*, New York/London, 1985, p. 38.
3. Gurbo and Silverstein, *André Kertész*, p. 14.
4. Sarah Greenough *et al.*, *André Kertész* (exhib. cat.), National Gallery of Art,

Washington DC/Los Angeles County Museum of Art, 2005, p. 4.
5. Colin Ford, 'Photography: Hungary's Greatest Export?', in Peter Baki *et al.*, *Eyewitness: Hungarian Photography in the Twentieth Century* (exhib. cat.), Royal Academy of Arts, London, 2011, p. 13.
6. Gurbo and Silverstein, *André Kertész*, p. 14; Greenough *et al.*, *André Kertész*, p. 5.
7. Frizot and Wanaverbecq, *André Kertész*, p. 328.
8. *Ibid.*
9. Gurbo and Silverstein, *André Kertész*, p. 16.
10. Greenough *et al.*, *André Kertész*, p. 60.
11. Gurbo and Silverstein, *André Kertész*, p. 18.
12. André Kertész, quoted in Greenough *et al.*, *André Kertész*, p. 12.
13. Greenough *et al.*, *André Kertész*, p. 2.
14. Frizot and Wanaverbecq, *André Kertész*, p. 12.
15. Greenough *et al.*, *André Kertész*, p. xii.
16. *Ibid.*, p. 80.
17. André Kertész, quoted in Hoy, *Kertész on Kertész*, p. 90.
18. *André Kertész: The Polaroids* (exhib. cat.), intro. by Robert Gurbo, Southeast Museum of Photography, Daytona Beach, 2007–8, p. 10.
19. Frizot and Wanaverbecq, *André Kertész*, p. 331.
20. *The Polaroids*, p. 12.
21. André Kertész, quoted in *ibid.*, p. 17.
22. *Ibid.*, p. 20.
23. Greenough *et al.*, *André Kertész*, p. xiv.

Le Gray
Epigraph: Gustave Le Gray, 1852, quoted in Sylvie Aubenas *et al.*, *Gustave Le Gray, 1820–1884* (exhib. cat.), J. Paul Getty Museum, Los Angeles, July–September 2002, p. 44.
1. Karl Marx, *Capital: A Critique of Political Economy* [1867], online edition based on first English edition of 1887, www.marxists.org/archive/marx/works/download/pdf/Capital-Volume-I.pdf, p. 293 (accessed January 2014).
2. Anne Cartier-Bresson, in Aubenas *et al.*, *Gustave Le Gray*, p. 291.
3. Paul Delaroche, quoted in *ibid.*, p. 210.
4. Léon Maufras, quoted in *ibid.*, p. 337.
5. Nadar, quoted in *ibid.*, p. 22.
6. Léon Maufras, quoted in *ibid.*, p. 337.
7. Gustave Le Gray, quoted in *ibid.*, p. 48.
8. *Journal of the Photographic Society*,

22 December 1856, quoted in Ken Jacobson, *The Lovely Sea-View: A Study of the Marine Photographs Published by Gustave Le Gray, 1856-1858*, Petches Bridge, 2001, p. 51 n. 33.

9. Hope Kingsley, *Seduced by Art: Photography Past and Present* (exhib. cat.), The National Gallery, London, 2012-13, then travelling, p. 169.

10. Le comte de Chambord, quoted in Aubenas *et al.*, *Gustave Le Gray*, p. 180.

11. Gustave Le Gray, letter to Nadar, 1862, quoted in *ibid.*, p. 188.

Man Ray
Epigraph: Man Ray, quoted in Manfred Heiting (ed.), *Man Ray, 1890-1976*, new edn, Cologne, 2012, p. 140.

1. Man Ray, *Self-Portrait* [1963], Boston, MA, 1998, p. 15.

2. *Ibid.*, p. 33.

3. *Ibid.*, p. 36.

4. *Ibid.*, p. 47.

5. *Ibid.*, pp. 71-2.

6. *Ibid.*, p. 80.

7. *Ibid.*, p. 88.

8. *Ibid.*, p. 100.

9. *Ibid.*, p. 138.

10. Philip Prodger, *Man Ray/Lee Miller: Partners in Surrealism*, London/New York, 2011, p. 31.

11. Man Ray, *Self-Portrait*, p. 259.

12. *Ibid.*, p. 267.

13. Terence Pepper, *Man Ray Portraits* (exhib. cat.), National Portrait Gallery, London, February-May 2013, then travelling, p. 206.

14. *Ibid.*, p. 207.

15. Man Ray, *Self-Portrait*, p. 290.

16. *Ibid.*, p. 314.

17. *Ibid.*, p. 261.

Mapplethorpe
Epigraph: Robert Mapplethorpe, quoted in Patricia Morrisroe, *Robert Mapplethorpe: A Biography*, London, 1995, p. 89.

1. Patti Smith, *The Coral Sea* [1996], New York/London, 2012, p. 21.

2. Robert Mapplethorpe, quoted in Morrisroe, *Robert Mapplethorpe*, p. 26.

3. Patti Smith, *Just Kids*, London, 2010, p. 66.

4. Robert Mapplethorpe, quoted in Keith Hartley, *Robert Mapplethorpe* (exhib. cat.), Scottish Gallery of Modern Art, Edinburgh, 2006, p. 11.

Moholy-Nagy
Epigraph: László Moholy-Nagy, *Vision in Motion* [1947], Chicago, 1961, p. 28.

1. Krisztina Passuth, *Moholy-Nagy*, London, 1985, p. 10.

2. Herbert Molderings, 'Light Years of a Life: The Photogram in the Aesthetic of László Moholy-Nagy', in Renate Heyne *et al.* (eds), *Moholy-Nagy: The Photograms: Catalogue Raisonné*, Ostfildern, 2009, p. 15.

3. See Heyne *et al.*, *Moholy-Nagy: The Photograms*, p. 307.

4. László Moholy-Nagy, 'A New Instrument of Vision', extract from 'From Pigment to Light', *Telehor*, vol. 1, nos. 1-2, 1936, reprinted in Liz Wells (ed.), *The Photography Reader*, London, 2002, pp. 93-4.

5. Oliva María Rubio, 'The Art of Light', in *László Moholy-Nagy: The Art of Light* (exhib. cat.), PhotoEspaña 2010, Madrid, then travelling, p. 14.

6. László Moholy-Nagy, quoted in Passuth, *Moholy-Nagy*, p. 398.

7. Rubio, 'The Art of Light', p. 12.

8. László Moholy-Nagy, *The New Vision and Abstract of an Artist*, trans. Daphne M. Hoffman, New York, 1946, p. 74.

Muybridge
Epigraph: Eadweard Muybridge, 1873, quoted in Phillip Prodger, *Time Stands Still: Muybridge and the Instantaneous Photography Movement*, Oxford, 2003, p. 141.

1. Maybanke Anderson, quoted in Marta Braun, *Eadweard Muybridge*, London, 2010, p. 14.

2. Eadweard Muybridge, quoted in *ibid.*, p. 17.

3. Quoted in *ibid.*, p. 25.

4. Eadweard Muybridge, quoted in *ibid.*, p. 94.

5. Quoted in Stephen Herbert, 'Chronology', in Hans Christian Adam (ed.), *Eadweard Muybridge: The Human and Animal Locomotion Photographs*, Cologne, 2010, p. 772.

Nadar
Epigraph: Nadar, 1855, quoted in Maria Morris Hambourg *et al.*, *Nadar* (exhib. cat.), Musée d'Orsay, Paris/The Metropolitan Museum of Art, New York, 1994-5, p. 71.

1. Elizabeth Anne McCauley, *Industrial Madness: Commercial Photography in Paris, 1848-1871*, New Haven, CT, 1994, p. 106.

2. Charles Baudelaire, quoted in Hambourg *et al.*, *Nadar*, p. 31.

3. Alphonse Karr, quoted in *ibid.*, p. 14.

4. Nadar, quoted in *ibid.*, p. 20.

5. Roger Greaves, quoted in McCauley, *Industrial Madness*, p. 115 n. 37.

6. Nadar, 1880, quoted in Hambourg *et al.*, *Nadar*, p. 23.

7. Charles Philipon, quoted in *ibid.*, p. 27.

8. Ernestine Lefèvre, quoted in *ibid.*

Parkinson
Epigraph: Norman Parkinson, quoted in Robin Muir, *Norman Parkinson: Portraits in Fashion* (exhib. cat.), National Portrait Gallery, London, 2004-5, p. 9.

1. Louise Baring, *Norman Parkinson: A Very British Glamour*, New York, 2009, p. 16.

2. *Ibid.* It is said his time in Pishill was so important to him that, around forty years later, he bought the farm. David Wootten, *Norman Parkinson* (exhib. cat.), Chris Beetles, London, May-June 2010, p. 127.

3. Norman Parkinson, *Lifework*, London, 1983, pp. 22-3.

4. Baring, *Norman Parkinson*, p. 46.

5. Martin Harrison, *Parkinson: Photographs, 1935-1990*, London, 1994, n.p.

6. Alexander Liberman, quoted in Baring, *Norman Parkinson*, p. 76.

7. Barbara Mullen, quoted in *ibid.*, p. 78.

8. Marit Allen, quoted in *ibid.*, pp. 144-5.

9. Siriol Hugh-Jones, quoted in *ibid.*, p. 83.

10. Quoted in Muir, *Norman Parkinson*, p. 8.

11. Parkinson, *Lifework*, p. 114.

12. Norman Parkinson, quoted in Baring, *Norman Parkinson*, p. 186.

13. Richard Avedon, quoted in Harrison, *Parkinson*, n.p.

14. Parkinson, *Lifework*, p. 33.

Penn
Epigraph: Irving Penn at the opening of his studio, 1953, quoted in 'American Photographer Penn Dies', BBC News, http://news.bbc.co.uk/1/hi/8296030.stm (accessed August 2013).

1. Alexander Liberman, 'Introduction', in Irving Penn, with Alexandra Arrowsmith and Nicola Majocchi, *Passage: A Work Record*, New York, 1991, p. 6.

2. Penn, *A Work Record*, p. 50.

3. Irving Penn, quoted in Maria Morris Hambourg, 'Irving Penn's Modern Venus', *ArtNews*, February 2002, available online at www.artnews.com/

2009/10/01/when-irving-penn-shot-real-women (accessed August 2013).

4. Maria Morris Hambourg, *Earthly Bodies: Irving Penn's Nudes, 1949–50* (exhib. cat.), The Metropolitan Museum of Art, New York, January–April 2002, then travelling, p. 14.

5. *Ibid.*, p. 7.

6. Alexander Liberman, 'Introduction', in Irving Penn, *Moments Preserved: Eight Essays in Photographs and Words*, New York/London, 1960, p. 8.

7. Liberman, 'Introduction', in Penn, *A Work Record*, p. 7.

8. Penn, *A Work Record*, p. 286.

9. Liberman, 'Introduction', in *ibid.*, p. 8.

10. Edmonde Charles-Roux, quoted in Virginia A. Heckert and Anne Lacoste, *Irving Penn: Small Trades* (exhib. cat.), J. Paul Getty Museum, Los Angeles, 2009–10, p. 22.

Renger-Patzsch
Epigraph: Albert Renger-Patzsch, quoted in Donald B. Kuspit, *Albert Renger-Patzsch: Joy before the Object*, New York/Malibu, 1993, p. 8.

1. Albert Renger-Patzsch, 'Masters of the Camera Report' [1937], in Ann Wilde *et al.* (eds), *Albert Renger-Patzsch: Photographer of Objectivity*, London, 1997, p. 168.

2. *Ibid.*

3. *Ibid.*, p. 166.

4. Albert Renger-Patzsch, 'Goals' [1927], in Wilde *et al.*, *Albert Renger-Patzsch*, p. 165.

5. Renger-Patzsch, 'Masters of the Camera Report', p. 167.

6. Jürgen Wilde, 'A Short Biography', in Wilde *et al.*, *Albert Renger-Patzsch*, p. 171.

7. Kuspit, *Albert Renger-Patzsch*, p. 4.

8. Albert Renger-Patzsch, 'A Lecture that was Never Given' [1966], in Wilde *et al.*, *Albert Renger-Patzsch*, p. 169.

9. Albert Renger-Patzsch, quoted in Thomas Janzen, 'Photographing the "Essence of Things"', in Wilde *et al.*, *Albert Renger-Patzsch*, p. 10.

10. Kuspit, *Albert Renger-Patzsch*, p. 7.

11. *Ibid.*, p. 4.

12. Matthew Simms, 'Just Photography: Albert Renger-Patzsch's *Die Welt ist schön*', in *History of Photography*, vol. 21, no. 3, Autumn 1997, p. 199.

13. Heinrich Schwarz, quoted in Kuspit, *Albert Renger-Patzsch*, p. 5.

14. Ulrich Ruter, 'The Reception of Albert Renger-Patzsch's *Die Welt ist schön*', in *History of Photography*, vol. 31, no. 3, Autumn 1997, p. 193.

15. Walter Benjamin, quoted in Janzen, 'Photographing the "Essence of Things"', p. 14.

16. *Ibid.*

17. Renger-Patzsch, 'A Lecture', p. 169.

18. Janzen, 'Photographing the "Essence of Things"', p. 16.

19. Albert Renger-Patzsch, quoted in Kuspit, *Albert Renger-Patzsch*, p. 28.

20. Renger-Patzsch, 'Masters of the Camera Report', p. 168.

21. Albert Renger-Patzsch, quoted in Janzen, 'Photographing the "Essence of Things"', p. 7.

22. Janzen, 'Photographing the "Essence of Things"', p. 7.

23. Albert Renger-Patzsch, 'Goals', p. 165.

24. Albert Renger-Patzsch, quoted in Kuspit, *Albert Renger-Patzsch*, p. 8.

Rodchenko
Epigraph: Alexander Rodchenko, quoted in Alexander Lavrentiev *et al.*, *Alexander Rodchenko: Revolution in Photography*, Moscow, 2008, p. 1.

1. Alexander Rodchenko, 'Autobiographical Notes', in Alexander Lavrentiev (ed.), *Aleksandr Rodchenko: Experiments for the Future – Diaries, Essays, Letters, and Other Writings*, trans. Jamey Gambrell, New York, 2005, p. 34.

2. Alexander Rodchenko, quoted in Lavrentiev *et al.*, *Revolution in Photography*, p. 205.

3. *Ibid.*

4. *Ibid.*

5. Rodchenko, 'Autobiographical Notes', p. 36.

6. Lavrentiev, *Experiments for the Future*, p. 50.

7. Alexander Rodchenko, quoted in Helen Luckett and Alexander Lavrentiev, *Alexander Rodchenko: Revolution in Photography* (exhib. pamphlet), Hayward Gallery, London, February–April 2008, p. 12.

8. Alexander Rodchenko, 'Reconstructing the Artist', in Lavrentiev, *Experiments for the Future*, p. 297.

9. Lavrentiev *et al.*, *Revolution in Photography*, pp. 205–6.

10. John E. Bowlt, 'Long Live Constructivism!', in Lavrentiev, *Experiments for the Future*, p. 19.

11. Margarita Tupitsyn, quoted in Bernard Vere, 'Avant-Garde Photography in the Soviet Union',

in Juliet Hacking (ed.), *Photography: The Whole Story*, London, 2012, p. 210.

12. Rodchenko, 'Reconstructing the Artist', p. 297.

13. Alexander Rodchenko, quoted in Lavrentiev *et al.*, *Revolution in Photography*, p. 211.

14. *Ibid.*

Sander
Epigraph: August Sander, quoted in *August Sander* (exhib. cat.), intro. by Christoph Schreier, National Portrait Gallery, London, 1997, p. 21.

1. Alfed Döblin, 'Faces, Images, and Their Truth', in Manfred Heiting (ed.), *August Sander, 1876–1964*, Cologne/London, 1999, p. 102.

2. Gabriele Conrath-Scholl identifies Sander's mother as Justine Sander (née Jung). See Heiting, *August Sander*, p. 243.

3. August Sander, quoted in *August Sander: Photographs of an Epoch, 1904–1959* (exhib. cat.), Philadelphia Museum of Art, March–April 1980, p. 15.

4. August Sander, quoted in *August Sander* (NPG exhib. cat.), p. 21.

5. *Ibid.*, p. 36.

6. *Ibid.*

7. August Sander, quoted in Susanne Lange, 'A Testimony to Photography: Reflections on the Life and Work of August Sander', in Heiting, *August Sander*, p. 108.

8. Lange, 'A Testimony to Photography', p. 108.

Steichen
Epigraph: Edward Steichen, quoted in Carl Sandburg, 'Steichen, the Photographer' [1929], in Ronald J. Gedrim (ed.), *Edward Steichen: Selected Texts and Bibliography*, Oxford, 1996, p. 122.

1. Ansel Adams, letter to Nancy Newhall, 7 January 1946, quoted in Ansel Adams, *Ansel Adams: Letters and Images, 1916–1984*, ed. Mary Street Alinder and Andrea Gray Stillman, Boston, MA, 1988, p. 166.

2. Edward Steichen, quoted in Sandburg, 'Steichen, the Photographer', p. 123.

3. Edward Steichen, *A Life in Photography*, London, 1963, n.p.

4. Joanna Steichen, *Steichen's Legacy: Photographs, 1895–1973*, New York, 2000, p. 11.

5. Edward Steichen, quoted in Penelope

Niven, *Steichen: A Biography*, New York, 1997, p. 34.
6. Steichen, *A Life in Photography*, n.p.
7. *Ibid.*
8. Robert Demachy, quoted in *ibid.*
9. Niven, *Steichen*, p. 13.
10. Alfred Stieglitz, quoted in Steichen, *A Life in Photography*, n.p.
11. Clara Steichen, quoted in Niven, *Steichen*, p. 470.
12. Quoted in Nathalie Herschdorfer, 'Chronology', in Todd Brandow and William A. Ewing (eds), *Edward Steichen: Lives in Photography* (exhib. cat.), Jeu de Paume, Paris, October–December 2007, then travelling, p. 300.
13. Steichen, *A Life in Photography*, n.p.
14. Herschdorfer, 'Chronology', p. 300.
15. Niven, *Steichen*, p. 519.
16. Ansel Adams, letter to Nancy Newhall, 7 January 1946, quoted in Adams, *Letters and Images*, p. 166.
17. Steichen, *A Life in Photography*, n.p.
18. Joanna T. Steichen, 'The Soul of the Photographer', in Brandow and Ewing, *Edward Steichen*, p. 248.
19. Steichen, *Steichen's Legacy*, p. 15.

Stieglitz
Epigraph: Alfred Stieglitz, quoted in Kathleen Hoffman, *Alfred Stieglitz: A Legacy of Light*, New Haven, CT/London, 2011, p. 412.
1. Alfred Stieglitz, quoted in Sarah Greenough and Juan Hamilton (eds), *Alfred Stieglitz: Photographs and Writings*, 2nd edn, Boston, MA, 1999, p. 197; emphasis in original.
2. Richard Whelan, *Alfred Stieglitz: A Biography*, New York, 1997, p. 513.
3. Sue Davidson Lowe, *Steiglitz: A Memoir/Biography*, London, 1983, p. xx.
4. *Ibid.*, pp. 7–8.
5. Whelan, *Alfred Stieglitz*, pp. 71–2.
6. Pam Roberts, 'Alfred Stieglitz, 291 Gallery and Camera Work', in Simone Philippi and Ute Kieseyer (eds), *Camera Work: The Complete Photographs, 1903-1917*, Cologne, 1997, p. 26.
7. Quoted in Whelan, *Alfred Stieglitz*, p. 403.
8. Alfred Stieglitz, quoted in Roberts, 'Alfred Stieglitz', p. 33.
9. Whelan, *Alfred Stieglitz*, p. 544.
10. *Ibid.*, p. 82.
11. Stieglitz, quoted in Hoffman, *A Legacy of Light*, p. 30.

Strand
Epigraph: Paul Strand to Richard

Benson, quoted in Catherine Duncan, 'An Intimate Portrait', in *Paul Strand: The World on My Doorstep, 1950-1976* (exhib. cat.), Museum Folkwang, Essen, 1994, then travelling, p. 21.
1. Nancy Newhall, *Paul Strand Photographs, 1915-1945*, New York, 1945, p. 3.
2. Naomi Rosenblum, 'The Early Years', in Maren Stange (ed.), *Paul Strand: Essays on His Life and Work*, New York, 1990, p. 36.
3. Newhall, *Paul Strand Photographs*, p. 48.
4. *Ibid.*, p. 7.
5. Mike Weaver, 'Dynamic Realist', in Stange, *Paul Strand*, p. 199.
6. Ben Maddow, quoted in Fraser McDonald, 'Paul Strand and the Atlanticist Cold War', *History of Photography*, vol. 28, no. 4, Winter 2004, p. 364.
7. Weaver, 'Dynamic Realist', p. 200.
8. Paul Strand, 'Photography and the New God', *Broom: An International Magazine of the Arts*, November 1922, p. 252.

Tōmatsu
Epigraph: Shōmei Tōmatsu, quoted in Ivan Vartanian *et al.* (eds), *Setting Sun: Writings by Japanese Photographers*, New York, 2006, p. 32.
1. Leo Rubinfien *et al.*, *Shomei Tomatsu: Skin of the Nation* (exhib. cat.), Japan Society, New York, 2004-5, then travelling, p. 212.
2. Shōmei Tōmatsu, quoted in Ian Jeffrey, *Shomei Tomatsu*, London, 2001, p. 3.
3. Rubinfien *et al.*, *Skin of the Nation*, p. 13.
4. According to Ian Jeffrey, it was the Law and Economics Department. Jeffrey, *Shomei Tomatsu*, p. 3.
5. Rubinfien *et al.*, *Skin of the Nation*, p. 212.
6. Mataroku Kumazawa, quoted in *ibid.*, p. 15.
7. Jeffrey, *Shomei Tomatsu*, p. 7.
8. Rubinfien *et al.*, *Skin of the Nation*, p. 30.
9. Jeffrey, *Shomei Tomatsu*, p. 13.
10. Rubinfien *et al.*, *Skin of the Nation*, p. 18.

Weston
Epigraph: Edward Weston, letter to Tina Modotti, 3 June 1925, quoted in Edward Weston, *The Daybooks of Edward Weston*, ed. Nancy Newhall, 2 vols, New York, 1990, p. 121.

1. Weston, *Daybooks*, p. 53.
2. Nancy Newhall, 'Introduction', in *ibid.*, p. xvii.
3. Weston, *Daybooks*, p. 3.
4. Sarah M. Lowe, *Tina Modotti and Edward Weston: The Mexico Years* (exhib. cat.), Barbican Art Gallery, London, April-August 2004, p. 11.
5. Weston, *Daybooks*, p. 3.
6. Ben Maddow, *Edward Weston: His Life*, New York, 1989, p. 249.
7. Beaumont Newhall, 'Foreword', in Weston, *Daybooks*, p. xiii.
8. Beth Gates Warren, *Margrethe Mather & Edward Weston: A Passionate Collaboration* (exhib. cat.), Santa Barbara Museum of Art, 2001, p. 21.
9. Newhall, 'Introduction', p. xvi.
10. *Ibid.*, p. xviii.
11. *Ibid.*, p. xix.
12. Warren, *Margrethe Mather & Edward Weston*, p. 13.
13. *Ibid.*, p. 21.
14. *Ibid.*, p. 32.
15. Newhall, 'Introduction', p. xx.
16. Warren, *Margrethe Mather & Edward Weston*, p. 23.
17. Weston, *Daybooks*, pp. 5–6.
18. Lowe, *Tina Modotti and Edward Weston*, p. 17.
19. Weston, *Daybooks*, p. 25.
20. *Ibid.*, p. 19.
21. *Ibid.*, p. 113.
22. Edward Weston, quoted in Lowe, *Tina Modotti and Edward Weston*, p. 28.
23. Warren, *Margrethe Mather & Edward Weston*, p. 35.

Yevonde
Epigraph: Madame Yevonde, quoted in Robin Gibson and Pam Roberts, *Madame Yevonde: Colour, Fantasy and Myth* (exhib. cat.), Royal Photographic Society, Bath/National Portrait Gallery, London, 1990, p. 19.
1. Madame Yevonde, *In Camera*, London, 1940, p. 16.
2. Quoted in *ibid.*, p. 24.
3. Yevonde, *In Camera*, p. 115.
4. *Ibid.*, p. 129.
5. *Ibid.*, p. 158.
6. *Ibid.*, p. 148.
7. Madame Yevonde, 'Photographic Portraiture from a Woman's Point of View', *British Journal of Photography*, 29 April 1921, pp. 251–2.
8. Yevonde, *In Camera*, p. 268.
9. *The Times*, 11 July 1935.
10. Yevonde, *In Camera*, p. 21.
11. *Ibid.*, p. 284.

Picture Credits

Index

Acknowledgments

I offer grateful thanks to my family in London, El Perelló and Cardiff, who accepted my neglect of them (seemingly) without complaint; to my collaborators at Thames & Hudson, London, in the making of this book: Tristan de Lancey, Mark Ralph, Maria Ranauro, Jon Crabb and Louise Ramsay; to Professor Jos Hackforth-Jones, director of Sotheby's Institute of Art, London, for moral and other support; to Sabina Jaskot-Gill for her invaluable research; to my colleagues at the institute; and to my fellow tutors on the MA in Photography.

I would also like to thank the students (both current and former) on the MA in Photography; they have taught me much.

This book is dedicated to Ian.

Dr Juliet Hacking

Frontispiece: David Seymour, *Richard Avedon and Fred Astaire on the set of 'Funny Face', Jardin des Tuileries, Paris, 1956*

Note on Hungarian and Japanese names: In traditional usage, the family name precedes the given name. In this book, in accordance with the usual practice when writing in English, the order has been inverted.

Lives of the Great Photographers
© 2015 Thames & Hudson Ltd, London

Text © 2015 Juliet Hacking

First published in 2015 in hardcover in the United States of America by Thames & Hudson Inc., 500 Fifth Avenue, New York, New York 10110

thamesandhudsonusa.com

Library of Congress Catalog Card Number 2015932465

ISBN 978-0-500-54444-0

Printed and bound in China by C & C Offset Printing Co. Ltd